SAMUEL F. B. MORSE'S

Gallery of the Louvre

AND THE

ART OF INVENTION

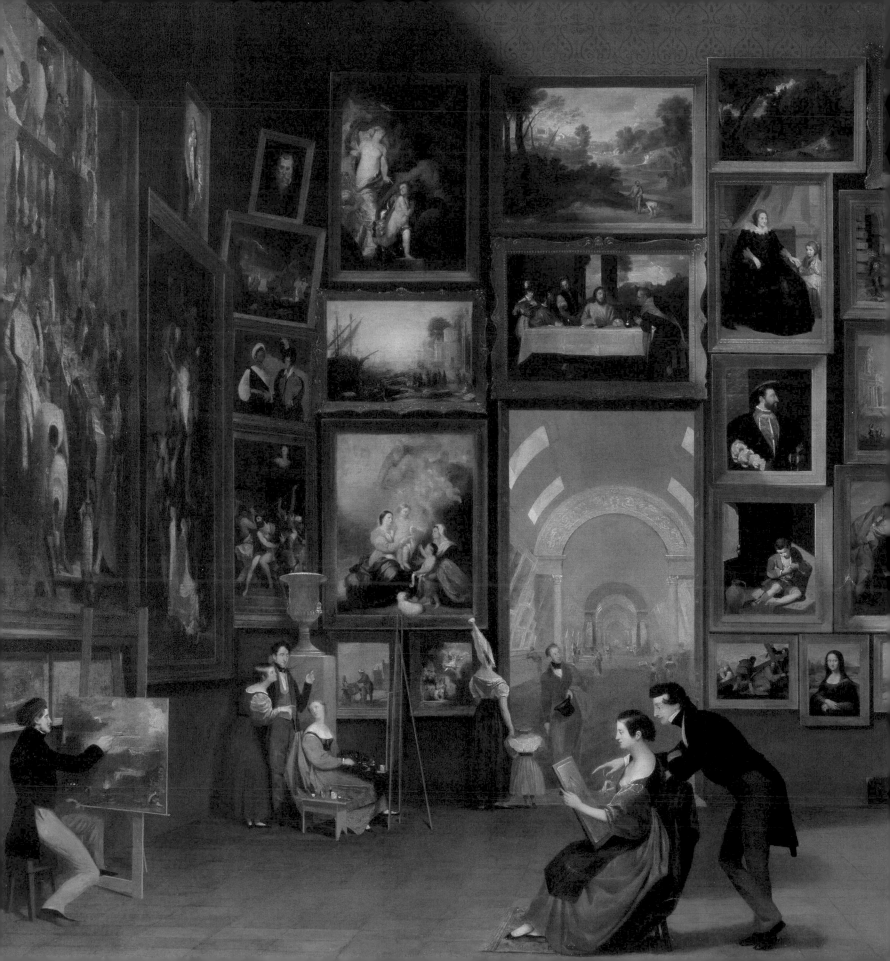

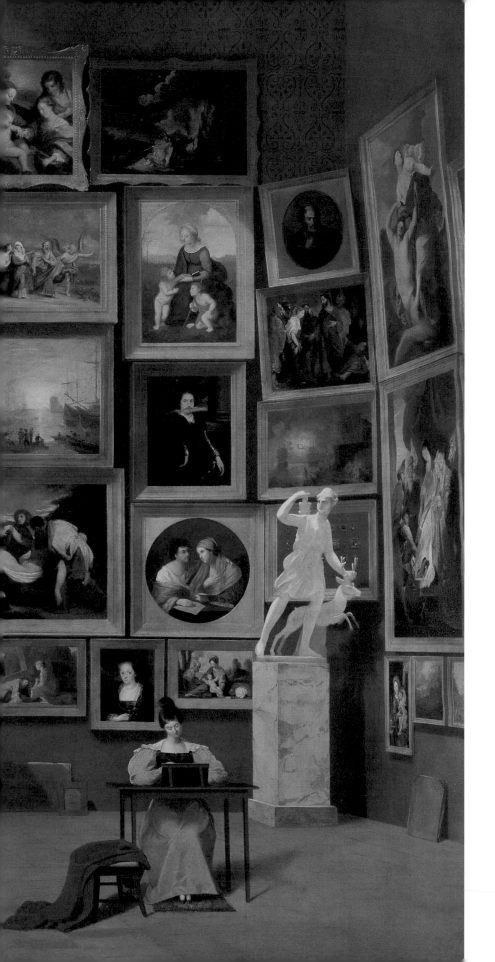

SAMUEL F. B. MORSE'S

Gallery of the Louvre

AND THE

ART OF INVENTION

EDITED BY

Peter John Brownlee

WITH ESSAYS BY

*Jean-Philippe Antoine, Wendy Bellion, David Bjelajac,
Peter John Brownlee, Rachael Z. DeLue, Sarah Kate Gillespie,
Lance Mayer and Gay Myers, Andrew McClellan, Alexander Nemerov,
Tanya Pohrt, Richard Read, and Catherine Roach*

TERRA FOUNDATION FOR AMERICAN ART
DISTRIBUTED BY YALE UNIVERSITY PRESS,
NEW HAVEN AND LONDON

Contents

Director's Foreword

KNOWN TODAY primarily for his role in the development of the electromagnetic telegraph and Morse code, Samuel F. B. Morse began his career as a painter. His monumental *Gallery of the Louvre* was the culmination of an extended period of study in Europe. Upon his return to the United States, Morse exhibited the work only twice, in New York and New Haven, where it was praised by critics and connoisseurs but rejected by the public. Crushed by the response, Morse soon ceased painting altogether, moving on to his more successful experiments in communications technology. It would take nearly 150 years for the painting to assume its place as an icon of early American art.

Chicago businessman Daniel J. Terra made his fortune in printing inks and photographic chemicals. He began collecting art as early as 1937, then turned his focus to collecting the art of the United States around 1976, inspired in part by the bicentennial of the nation's independence. In 1982 Terra grabbed the attention of the art world when he purchased Samuel F. B. Morse's *Gallery of the Louvre* for $3.25 million, at the time a record for an American painting. To Mr. Terra, *Gallery of the Louvre* epitomized the American spirit of vitality, initiative, and drive for self-improvement. He immediately sent it on an extended tour of museums across the United States, attracting widespread acclaim that helped reestablish the importance of Morse's painting for the study of early American art history. In that spirit, the Terra Foundation for American Art has continued to research and exhibit the painting, which serves as a cornerstone of the Foundation's renowned collection of historical art of the United States, dating from the colonial period to 1950.

The painting underwent an extensive conservation treatment in 2010–11, a process documented in the award-winning documentary *A New Look: Samuel F. B. Morse's "Gallery of the Louvre,"* produced by Sandpail Productions. Following the treatment, the painting went back on tour for a series of extended exhibitions at the Yale University Art Gallery, the National Gallery of Art, and the Pennsylvania Academy of the Fine Arts, where it was the subject of an extensive array of public lectures, teacher programs, copying classes for practicing artists, and scholarly study days and symposia.

We thank our colleagues at these institutions for their collaboration in the exhibition of the painting and especially for their work in developing the innovative and engaging programs that generated the essays included in this book. Texts by scholars of American and European art shed new light on Morse's painting as well as his complex persona as an erudite artist, scientist, inventor, deeply spiritual Calvinist, and political xenophobe. We are also extremely pleased that two essays by international scholars of historical American art appear alongside texts by their U.S. counterparts. The inclusion of their essays exemplifies the international exchange of ideas and perspectives that is integral to our mission. Indeed, the institutional collaboration, deep research, and international dialogue that animate the exhibition of Morse's painting and the essays

6

in this book reflect the Foundation's belief that art has the power to distinguish cultures as well as to unite them.

As the painting embarks on another extended tour of museums across the United States and beyond, we look forward to sharing the new scholarship included in this volume and the dialogue and exchange that it inspires.

ELIZABETH GLASSMAN
PRESIDENT AND CHIEF EXECUTIVE OFFICER
TERRA FOUNDATION FOR AMERICAN ART

Acknowledgments

THIS PROJECT BEGAN in earnest with the extensive conservation treatment of *Gallery of the Louvre* undertaken by Lance Mayer and Gay Myers beginning in late 2010. Over the course of the treatment, we spent many hours together, examining Morse's canvas and conducting interviews for a video documentary of the painting and its conservation produced for the Terra Foundation by Sandpail Productions. Thanks also go to the other interviewees: Paul Staiti, Henry de Phillips, and at the Musée du Louvre, Vincent Delieuvin, Jean Habert, Guillaume Kientz, and Stephane Loire. Research in the Samuel F. B. Morse Papers at the National Academy of Design was facilitated by Bruce Weber and Diana Thompson. Conversations with Paul Staiti, Sarah Cash, Annie Storr, and Lisa Gitelman prodded our thinking along the way.

The contents of this book were developed and honed over a series of study days and symposia held at the Yale University Art Gallery (April 2011), the National Gallery of Art (April 2012), and the Pennsylvania Academy of the Fine Arts (April 2013). Our sincere thanks go to everyone at those institutions who helped to realize the special installation of the exhibition, *A New Look: Samuel F. B. Morse's "Gallery of the Louvre,"* and all its attendant programs and publications.

At the Yale University Art Gallery, special thanks go to Helen A. Cooper, Keely Orgeman, Patricia Garland, Kate Ezra, Elizabeth Harnett, Adrienne Webb, and Janet Miller, as well as to those who participated in a study day held on April 1, 2011: Patricia Johnston, Laurence Kantor, Edward Larkin, Lance Mayer and Gay Myers, Alexander Nemerov, Jules D. Prown, Catherine Roach, and Paul Staiti.

At the National Gallery of Art, we thank Nancy Anderson, Charles Brock, Franklin Kelly, D. Dodge Thompson, Mark Leithauser, Patricia Donovan, Lynn Russell, Susan Arensberg, Faya Causey, Alison Peil, and Ben Masri-Cohen, as well as those who participated in a study day and public symposium held on April 20–21, 2012: Jean-Philippe Antoine, David Bjelajac, Lance Mayer and Gay Myers, Andrew McClellan, Olivier Meslay, Alexander Nemerov, Richard Read, and Catherine Roach.

At the Pennsylvania Academy of the Fine Arts, we are grateful to Robert Cozzolino, Anna O. Marley, Monica Zimmerman, and Gale Rawson, as well as to those who participated in a study day held on April 20, 2013: Wendy Bellion, Rachael Z. DeLue, Sarah Kate Gillespie, Michael Leja, Elaine Reichek, Tanya Sheehan, and Jennifer Zwilling.

A number of individuals at the Terra Foundation played important roles throughout: Elizabeth Glassman, President and Chief Executive Officer; Elizabeth Hutton Turner, former Vice President of Collections and Curatorial Affairs; Amy Zinck, Vice President; Donald H. Ratner, Executive Vice President and Chief Financial Officer; Cathy Ricciardelli, Registrar; Katherine Bourguignon, Associate Curator; Alissa Schapiro, Collection Associate; Shari Felty, Collection Assistant; Bonnie Rimer, Consulting Conservator; Francesca Rose, Program Director, Publications; Veerle Thielemans, European Academic Program Director; Carrie Haslett, Program

Director, Exhibition and Academic Grants; Jennifer Siegenthaler, Program Director, Education Grants and Initiatives; Sara Jatcko, Program Associate, Education Grants and Initiatives; Amy Gunderson, Grants Manager; and Charles Mutscheller, Manager of Communications. Special thanks are due to Elizabeth Kennedy, the Terra Foundation's former Curator, for her research on *Gallery of the Louvre* stemming from the exhibition *American Artists at the Louvre* (2006), which returned Morse's painting to the Musée du Louvre for the first time since its creation. Special thanks also go to Elizabeth Hutton Turner, who was instrumental in catalyzing the book's production and initiating the painting's national tour. The work of former Terra interns and research assistants Bree Lehman, Annelise K. Madsen, Eleanore Neumann, and Naomi Slipp was critical at various stages of the project. Thanks go to Michael Tropea for post-conservation photography of the painting. We also would like to thank the San Diego Museum of Art and Amy Galpin for permission to reprint, in slightly modified form, Alexander Nemerov's essay, "The Forest of the Old Masters: The Chiaroscuro of American Places," originally published in *Behold, America! Art of the United States from Three San Diego Museums*, edited by Amy Galpin (San Diego: Museum of Contemporary Art San Diego, The San Diego Museum of Art, Timken Museum of Art, 2012), 96–114.

Finally, in compiling and preparing the manuscript for publication, thanks go to editor Nancy Grubb as well as to the anonymous readers, whose comments and suggestions helped to tighten the prose and the cohesiveness of the volume's contents. Thanks, too, to Emily D. Shapiro for her editorial advice and to our colleagues at Marquand Books, especially Ed Marquand, Adrian Lucia, Jeff Wincapaw, Gina Glascock-Broze, Susan E. Kelly, and Melissa Duffes.

PETER JOHN BROWNLEE, ASSOCIATE CURATOR
TERRA FOUNDATION FOR AMERICAN ART

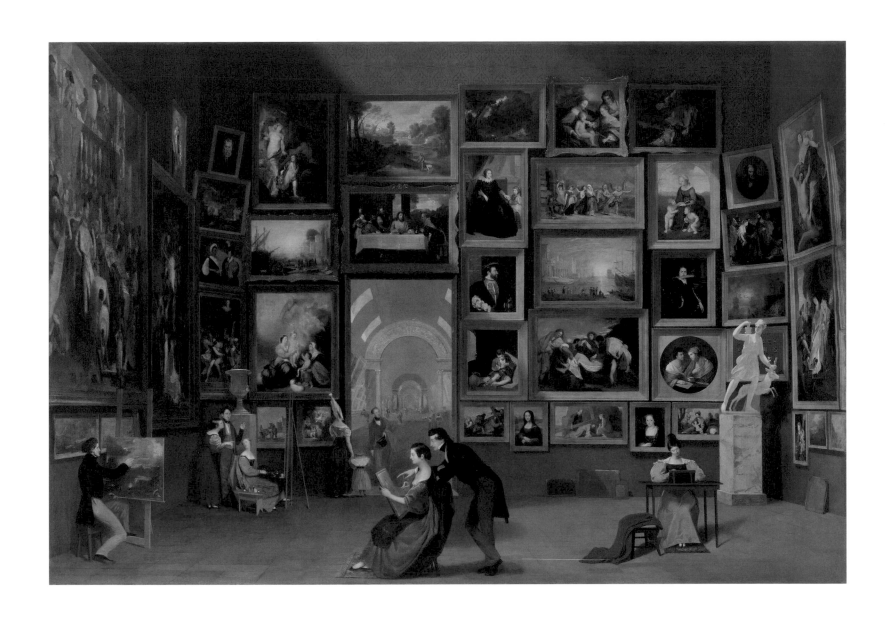

Key to the People and Art in Samuel F. B. Morse's *Gallery of the Louvre*

IN AN EFFORT to educate his American audience, Samuel Morse published *Descriptive Catalogue of the Pictures, Thirty-seven in Number, from the Most Celebrated Masters, Copied into the "Gallery of the Louvre"* (New York, 1833). (See Appendix.) The updated version of Morse's key to the pictures presented here reflects current scholarship. Although Morse never identified the people represented in his painting, this key includes the possible identities of some of them. Exiting the gallery are a woman and little girl dressed in provincial costumes, suggesting the broad appeal of the Louvre and the educational benefits it afforded.

PEOPLE

A Samuel F. B. Morse

B Copyist, possibly a Miss Joreter, who took lessons from Morse at the Louvre, or Susan Walker Morse, daughter of Morse

C James Fenimore Cooper, author and friend of Morse

D Susan DeLancey Cooper, wife of Cooper

E Susan Fenimore Cooper, daughter of James and Susan DeLancey Cooper

F Richard West Habersham, artist and Morse's roommate in Paris

G Horatio Greenough, artist and Morse's roommate in Paris

H Copyist, possibly Morse's recently deceased wife, Lucretia Pickering Walker, or a Miss Joreter

ART

1 Paolo Caliari, known as **Veronese** (1528–1588, Italian), *Wedding Feast at Cana*

2 Bartolomé Estebán **Murillo** (1618–1682, Spanish), *Immaculate Conception*

3 Jean **Jouvenet** (1644–1717, French), *Descent from the Cross*

4 Jacopo Robusti, known as **Tintoretto** (1518–1594, Italian), *Self-Portrait*

5 Nicolas **Poussin** (1594–1665, French), *Deluge (Winter)*

6 Michelangelo Merisi, known as **Caravaggio** (c. 1571–1610, Italian), *Fortune Teller*

7 Tiziano Vecellio, known as **Titian** (1488/9–1576, Italian), *Christ Crowned with Thorns*

8 Anthony **van Dyck** (1599–1641, Flemish), *Venus at the Forge of Vulcan*

9 Claude Gelée, known as **Claude Lorrain** (c. 1602–1682, French), *Disembarkation of Cleopatra at Tarsus*

10 Bartolomé Estebán **Murillo** (1618–1682, Spanish), *Holy Family*

11 David **Teniers II** (1610–1690, Flemish), *Knife Grinder*

12 **Rembrandt** Harmensz van Rijn (1606–1669, Dutch), *The Angel Leaving the Family of Tobias*

13 Nicolas **Poussin** (1594–1665, French), *Diogenes Casting Away His Cup*

14 Tiziano Vecellio, known as **Titian** (1488/9–1576, Italian), *Supper at Emmaus*

15 Cornelis **Huysmans** (1648–1727, Flemish), *Landscape with Shepherds and Herd*

16 Anthony **van Dyck** (1599–1641, Flemish), *Portrait of a Lady and Her Daughter*

17 Tiziano Vecellio, known as **Titian** (1488/9–1576, Italian), *Francis I*

18 Bartolomé Estebán **Murillo** (1618–1682, Spanish), *Beggar Boy*

19 Paolo Caliari, known as **Veronese** (1528–1588, Italian), *Christ Carrying the Cross*

20 **Leonardo** da Vinci (1452–1519, Italian), *Mona Lisa*

21 Antonio Allegri, known as **Correggio** (c. 1489–1534, Italian), *Mystic Marriage of Saint Catherine of Alexandria with Saint Sebastian*

22 Peter Paul **Rubens** (1577–1640, Flemish), *Lot and His Family Fleeing Sodom*

23 Claude Gelée, known as **Claude Lorrain** (c. 1602–1682, French), *Sunset at the Harbor*

24 Tiziano Vecellio, known as **Titian** (1488/9–1576, Italian), *Entombment*

25 Eustache **Le Sueur** and his studio (1616–1655, French), *Christ Carrying the Cross*

26 Salvator **Rosa** (1615–1673, Italian), *Landscape with Soldiers and Hunters*

27 Raffaello Santi, known as **Raphael** (1483–1520, Italian), *Madonna and Child with the Infant Saint John the Baptist*, called *La Belle Jardinière*

28 Anthony **van Dyck** (1599–1641, Flemish), *Portrait of a Man in Black* (the artist Paul de Vos?)

29 Guido **Reni** (1575–1642, Italian), *The Union of Design and Color*

30 Peter Paul **Rubens** (1577–1640, Flemish), *Portrait of Suzanne Fourment*

31 Simone **Cantarini** (1612–1648, Italian), *Rest on the Flight into Egypt*

32 **Rembrandt** Harmensz van Rijn (1606–1669, Dutch), *Head of an Old Man*

33 Anthony **van Dyck** (1599–1641, Flemish), *Jesus with the Woman Taken in Adultery*

34 Joseph **Vernet** (1714–1789, French), *Marine View by Moonlight*

35 Guido **Reni** (1575–1642, Italian), *Deianeira Abducted by the Centaur Nessus*

36 Peter Paul **Rubens** (1577–1640, Flemish), *Tomyris, Queen of the Scyths*

37 Pierre **Mignard** (1612–1695, French), *Madonna and Child*

38 Jean-Antoine **Watteau** (1684–1721, French), *Pilgrimage to the Isle of Cythera*

39 Borghese Vase (1st century BC, Greek)

40 *Artemis with a Doe*, called *Diana of Versailles*. Roman copy after Greek original attributed to **Leochares** (4th century BC, Greek)

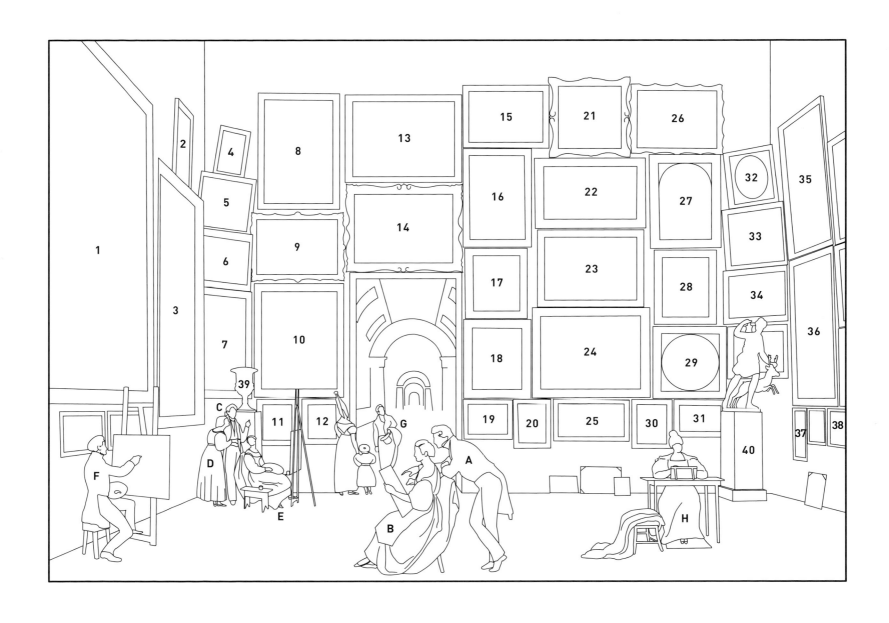

PLATE 2
Key to the People and Art in
Samuel F. B. Morse's *Gallery of the Louvre*

Introduction

Samuel F. B. Morse's *Gallery of the Louvre* and the Art of Invention

PETER JOHN BROWNLEE

IN NOVEMBER 1829, Samuel F. B. Morse (fig. 1) boarded a ship bound for London, the first stop on what would become a nearly three-year tour of England, Italy, and France. He was at the height of his artistic powers. Still reeling from the premature death of his beloved wife, Lucretia Pickering Walker Morse, as well as the loss of both his parents, and still struggling to secure his reputation as a great American artist, Morse embarked on a period of intense study and prodigious copying that culminated in his grand *Gallery of the Louvre* (plate 1). The picture, which measures approximately six feet by nine, depicts an imagined installation of artworks in the Salon Carré at the Musée du Louvre in Paris, compressing thirty-eight paintings, two sculptures, and numerous figures into a single composition. Morse's selection of old master paintings was guided by the teachings of his mentors Washington Allston and Benjamin West and by his own pedagogical aims as president and professor of painting at the National Academy of Design in New York, which he helped to form in 1825–26; it also reflects the taste of his American patrons and peers. But in addition, his strategic arrangement of pictures effectively demonstrates various approaches to the treatment of color, light, line, and composition that exemplified for Morse the capacity of the fine art of painting to reproduce the intellectually stimulating effects of natural phenomena. These he addressed in his famed *Lectures on the Affinity of Painting with the Other Fine Arts*, first delivered at the New York Athenaeum in the spring of 1826.

In the first of his four lectures, Morse claimed that the "principal intention" of the fine arts— painting, sculpture, music, poetry, landscape gardening, oratory, and theater—"is to please the Imagination."[1] In the second lecture he explained that "all the Fine Arts refer to Nature as the source whence they draw their materials, and the Imitation of Nature is always recommended to the student in any of these Arts." But Morse was careful to parse two variants of the imitation so fundamental to reproducing these phenomena, and their effects, in the fine arts. "There is then an Imitation which copies exactly what it sees, makes no selections, no combinations, and there is an Imitation which perceives principles, and arranges its materials according to these principles, so as to produce a desired effect. The first may be called *Mechanical* and the last *Intellectual Imitation*."[2] As an assemblage of copies artfully arranged to produce certain desired effects, *Gallery of the Louvre* involves both, with a decided emphasis on the latter.

In the second lecture Morse also explained the "universal principle" of "connexion."[3] His "Salon style" arrangement of pictures in *Gallery of the Louvre*, like his artistic outlook and general worldview, was clearly guided by selection, recombination, and connectivity. *Gallery of the Louvre* fuses the adoration and imitation of the old masters and the experimental techniques favored by the English painter Joshua Reynolds, as well as by West and Allston, with a genre of gallery paintings that were premised on the relational mode of exhibiting pictures. Intended to

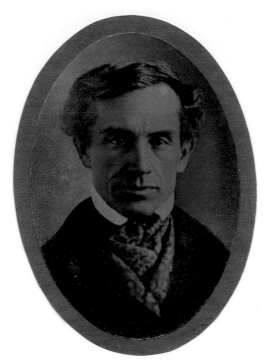

FIG. 1 Louis-Jacques-Mandé Daguerre (French, 1781–1851).
Samuel Finley Breese Morse, 1840. Photographic print on board, print:
4¾ × 3¼ in. (12 × 8 cm); board: 5½ × 4 in. (14 × 10 cm). Macbeth
Gallery records, Archives of American Art, Smithsonian Institution,
Washington, D.C., (DSI-AAA) 2880

highlight stylistic similarities or to emphasize formal
or thematic relationships, this mode of display was
founded on seventeenth-century art theory and
typified the Louvre's installations prior to its rear-
rangement by national school in the late eighteenth
century (see the essay by Andrew McClellan in this
volume). Instead of simply selecting and arranging
what he considered to be the most exemplary and
artistically significant pictures in the Louvre's collec-
tion, a claim standard to the critical literature on
the painting, Morse made his choices according to
specific practical and theoretical formulations that
he had developed over approximately twenty years,
from his early training in London to his ascendancy
as an artist of considerable renown.

The period between the end of the War of 1812—
when Morse was an aspiring artist in London—and
the early 1830s, when the seasoned painter com-
pleted *Gallery of the Louvre*, witnessed extensive polit-
ical, economic, technological, and cultural change in
the United States. Territorial expansion, a vast influx
of Irish and German immigrants, the relocation of
Native Americans from eastern woodlands to west-
ern plains, and the ascendancy of Andrew Jackson,
the nation's seventh president, altered the character
of the nation. The technology of interchangeable
parts invented by Eli Whitney and others revolution-
ized industrial manufacturing. In 1825 the opening
of the Erie Canal connected the western hinterlands
with trading centers in the East, establishing New
York as the nation's new economic and cultural
capital. The building of canals, turnpikes, and roads,
plus the development of steam-powered ships and
early forms of the railroad, collapsed distances and
facilitated the flow of agricultural and machine-made
goods as well as people and information in various
forms. Though the nation remained largely agricul-
tural until the dawn of the twentieth century, immi-
gration and urbanization increased the size and
density of America's cities. Developments in paper
making and printing technology facilitated the publi-
cation and dissemination of newspapers, periodicals,
pamphlets, and books. And major cities saw the grad-
ual establishment of fine art galleries and art organi-
zations such as the American Academy of the Fine
Arts, the National Academy of Design, and later the
American Art-Union, which cultivated a growing
public for fine art prints, paintings, and sculpture.
It is easy to see how this flowering of culture, tech-
nology, and commerce made conditions ripe for the
introduction of Morse's electromagnetic telegraph
in 1844. But these interrelated developments, as the
essays in this volume suggest, also made a painting
like *Gallery of the Louvre* possible, if not entirely
probable—nor, as Morse would learn to his chagrin,
profitable.[4]

Simultaneously engaged in artistic, scientific,
technological, and even political pursuits throughout
this period, Morse demonstrated a capacity for asso-
ciative thinking and a propensity for carrying out
thought in action across multiple forms. These vari-
ous strands of his complex intellect have attracted
the attention of generations of scholars who have

maintained that the artist constructed *Gallery of the Louvre* to serve as an instrument for teaching and as a vehicle for improving cultural awareness and aesthetic taste in the United States. Specifically how the painting carried out this work has been left relatively unexamined. Biographers in the mid-twentieth century hailed Morse as the "American Leonardo" and later as America's "lightning man."[5] Art historian Paul Staiti's exhaustive critical biography remains the most comprehensive study of the artist and inventor.[6] Staiti's Morse is an eighteenth-century intellectual thoroughly embedded in a nineteenth-century world and an adamant, if conflicted, champion of American cultural nationalism. Taking the *Kunstkammer* and the gallery picture as his points of departure in creating *Gallery of the Louvre*, Morse, as Staiti notes, transformed those elite genres into a demonstration of democratic access to the highest forms of culture.[7]

However, as Staiti also asserts, Morse approached democracy and the cultural "others" who exercised it with a suspicion that often freighted, and thus compromised, the egalitarian aspects of his cultural output.[8] Though his readiness to experiment and innovate continued throughout his career, Morse became ever more outspoken in his cultural conservatism. He painted *Gallery of the Louvre* during the same period in which he completed the manuscript for *Foreign Conspiracy against the Liberties of the United States* (1835), the first of several diatribes against what he saw as the contagion of foreign influence, particularly those elements associated with the pope and the Catholic Church.[9] The painting has been interpreted as a compilation of scenes divested of their overtly Catholic subject matter, first by the secularizing effects of Napoleonic plunder and second by Morse's aestheticization of them in his painting. Setting aside their religious content, as some have proposed, Morse's emphasis on the potential of these masterpieces of Renaissance and Baroque painting to enlighten his fellow Americans and to raise the standard of cultural taste in his native country accorded with the artist's strongly Calvinist faith.[10]

Other scholars, whose work is collected here, examine the painting in relation to the study of natural history or to the vogue for single-painting exhibitions and related forms of visual entertainment, such as the moving panorama. Others locate in the painting the seeds of Morse's experiments with the daguerreotype, the electromagnetic telegraph, and Morse code.[11] Indeed, the painting culminates Morse's ascent as a fine artist, emblematizes his transition from painter to inventor, and exemplifies the hybrid complexity of this thinking. However, the painting's poor public reception demonstrates the artist's failure to connect with his intended audience. Though underappreciated in its time, *Gallery of the Louvre* embodies an intersection of art, religion, science, and technology. Thoroughly of its cultural moment, as the essays in this volume attest, the painting continues to invite and reward divergent yet interrelated lines of speculation and study regarding its conception, design, and execution.

MORSE'S EARLY CAREER

Born in Charlestown, Massachusetts, on April 27, 1791, to Jedidiah Morse—a Congregational minister and a geographer—and Elizabeth Ann Finley Breese Morse, Samuel Finley Breese Morse grew up with the young nation, and came to embody its great intellectual and artistic promise as well as its many ideological contradictions. His worldview was shaped by Calvinism and by the millennialist belief that the founding of the United States of America was divinely predestined to initiate a thousand years of peace; by his academic and scientific training under the scientist Benjamin Silliman, the Reverend Timothy Dwight, and others at Yale University; and by his artistic training under the tutelage of Allston, whom the young Morse first met in Boston in 1810 (fig. 2). The episteme into which Morse emerged as a young scholar and artist was framed by the Enlightenment thinking of previous generations and structured by a belief in an ordered universe and a stable social hierarchy led by a patrician elite.

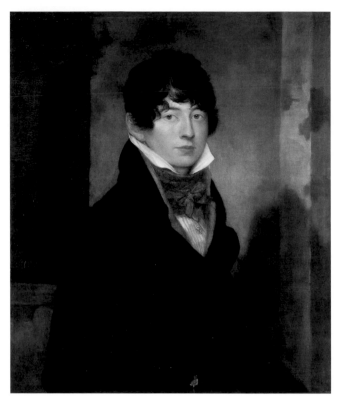

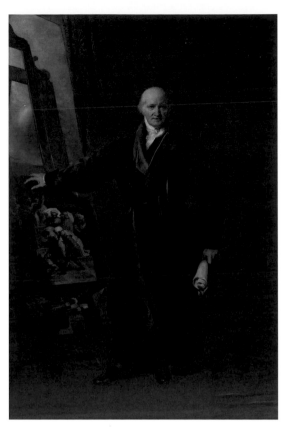

FIG. 2 Washington Allston (American, 1779–1843). *Self-Portrait*, 1805. Oil on canvas, 31⅝ × 26½ in. (80.3 × 67.3 cm). Museum of Fine Arts, Boston, 84.301. Photo © 2014 Museum of Fine Arts, Boston

FIG. 3 Sir Thomas Lawrence (English, 1769–1830). *Portrait of Benjamin West*, 1818–21. Oil on canvas, 107 × 69½ in. (271.1 × 176.5 cm). Purchased by subscription, Wadsworth Atheneum, Hartford, Connecticut, 1855.1

As a young man, Morse devoted his many talents to becoming a fine artist. On July 13, 1811, he sailed for London, where he joined Allston and a circle of American artists that included John Singleton Copley, Benjamin West, and John Trumbull, as well as the British painter Charles Robert Leslie, who quickly became Morse's constant companion. On the strength of a drawing that Morse made after a plaster cast of the *Laocoön*, he was admitted to the Royal Academy of Arts. The Academy's first president, Joshua Reynolds, set the terms for artistic theory and practice in his *Discourses on Art* (delivered as lectures to Academy students between 1769 and 1790) and by the example of his painting, which manifested his preference for the Italian Renaissance, his notions of artistic imitation, and his predilection for experimental media and techniques.[12] The model set forth by Reynolds was elaborated by his successor as

president, Benjamin West, a painter of grand manner history paintings who is depicted lecturing on color in Sir Thomas Lawrence's portrait (fig. 3). Reynolds, West, and others at the Academy stressed the importance of innovation in the painting of erudite subjects and technical prowess that included accurate anatomical drawing and proper perspective as well as the ability to re-create the look and feel of old master paintings. Morse's official program of study in London was dictated by West and the methods of the Academy but overseen by Allston, who served as his private master.[13]

Morse's first major painting at the Academy, *Dying Hercules* (fig. 84), exhibited in 1813, won him critical acclaim and clearly demonstrates how thoroughly he had absorbed the Academy's mandates under Allston's guiding hand. The reclining figure echoes that of the *Laocoön*, but the painting was, more

pointedly, a direct response to Allston's *Dead Man Restored to Life by Touching the Bones of the Prophet Elisha* (fig. 4), completed while Morse was laboring on his *Hercules*. Though focused on a single figure, Morse's painting adopts the vertical format of *Dead Man Restored to Life* and reflects Allston's interest in anatomy as well as physiology, as seen most vividly in their depictions of the transformation of the flesh—from death to life in Allston's picture and from life to death in Morse's. Reanimation was a topic of much scientific and cultural debate at the time, with several scientists extolling the potential of the galvanic battery for that purpose. After all, these were the years that witnessed the birth of the monster in Mary Shelley's *Frankenstein* (1818).[14]

FIG. 4 Washington Allston (American, 1779–1843). *Dead Man Restored to Life by Touching the Bones of the Prophet Elisha*, 1811–13. Oil on canvas, 156 × 122 in. (396.2 × 309.9 cm). Courtesy of Pennsylvania Academy of the Fine Arts, Philadelphia. Pennsylvania Academy Purchase, by subscription, 1816.1

Buoyed by his success in London, Morse returned home in 1815 to a cultural climate not favorably disposed to grand manner history paintings. In 1818 he married Lucretia Pickering Walker, with whom he would have three children in the seven years before her death. Morse had written to his parents from London, informing them of his ambition "to be among those who shall revive the splendour of the 15th century, to rival the genius of a Raphael, a Michael Angelo, or a Titian." But his wish "to shine, not by a light borrowed from them, but to strive to shine the brightest" was not to be, or at least not in the form he anticipated at this early stage of his career.[15] Instead, like other painters of his generation, he was forced to turn to portrait painting for financial support. During much of this period, Morse traveled up and down the Eastern Seaboard, painting portraits in Boston, New York, Washington, D.C., and Charleston, South Carolina, where he also helped establish the short-lived South Carolina Academy of Fine Arts—a forerunner to his more successful efforts in founding the National Academy of Design in New York a few years later. Though he often lamented the lack of taste in his home country and expressed doubts about his chosen profession, Morse persisted. His portraits from this period clearly evince an evolving talent.

Morse's experience as a portraitist and his desire to advance a strong and elevated national art came together in *The House of Representatives* (fig. 5). Compiling nearly one hundred portraits of congressmen, delegates, and other figures painted from life, the painting is a grand and complex picture. Morse arrived in Washington in November 1821 and set up a studio adjacent to the House floor, where he spent nearly four months painting portraits of the various individuals he would eventually include in his mammoth canvas. He finally completed the painting in January 1823 and sent it directly to Boston for display, the first stop on an ill-fated tour that also included exhibition venues in Manhattan and Albany, New York; Hartford and Middletown, Connecticut; and Springfield and Northampton,

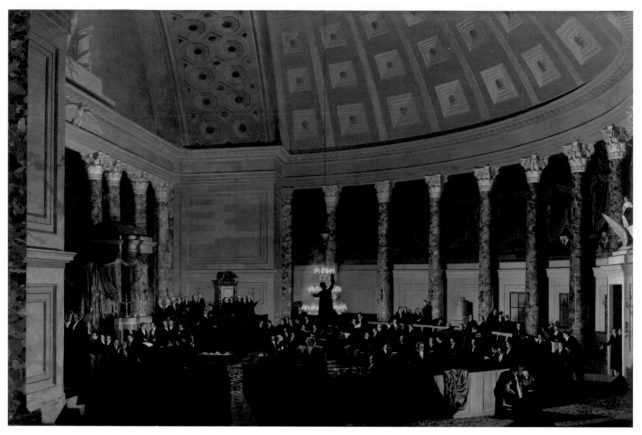

FIG. 5 Samuel F. B. Morse. *The House of Representatives*, completed 1822, probably reworked 1823.
Oil on canvas, 86⅞ × 130⅝ in. (220.6 × 331.8 cm). Corcoran Gallery of Art, Washington, D.C., 11.14

Massachusetts. Morse sought to capitalize on popular interest in the grand revolutionary scenes painted by John Trumbull for the Capitol Rotunda and in the spectacular pestilence and plague of Rembrandt Peale's *The Court of Death* (fig. 37). Lacking the pictorial and narrative drama that attracted crowds to these and other single-painting exhibitions, *The House of Representatives* was a commercial failure and attracted only modest notice in the press. Disappointed, Morse abandoned the tour and shipped his rolled canvas to Charles Robert Leslie in London, who attempted to sell the painting for his old friend.[16] Morse had miscalculated the interests of a public more inclined to favor mummies, circuses, and minstrel shows. It would not be his last such miscalculation.

Out of necessity, Morse returned to portraiture, painting in New Haven, New York, and elsewhere in a desperate attempt to support his family while continuing his chosen profession. One commission led to another, forcing him to return to the itinerancy he loathed. The paired portraits of David Curtis DeForest and his wife, Julia Wooster DeForest (1823; The Yale University Art Gallery), exemplify the series of pendants Morse executed during the 1820s, which are some of the finest and most accomplished paintings of his entire career. In spite of the prosaic nature of such portraiture, he still found opportunities for technical experimentation: for example, for his exquisite portrait of his wife, Lucretia, and their two oldest children, Susan and Charles, he ground his pigments with milk, which perhaps contributed to the picture's pearly quality (fig. 6).

Returning to New York from another extended period of itinerancy in November 1824, Morse bested a group of competitors that included Henry Inman,

Rembrandt Peale, Thomas Sully, and John Vanderlyn, among others, winning a prized commission from the City of New York to paint a full-length portrait of the Revolutionary War hero the Marquis de Lafayette, who was then at the beginning of his triumphal "farewell" tour of the United States. The prestige of this commission revitalized Morse, but his enthusiasm was overshadowed by the news that Lucretia, then recovering from the birth of their third child, Finley, had died unexpectedly. Still mourning his wife, Morse busied himself with painting the full-length portrait of Lafayette (1825–26; Art Commission of the City of New York, City Hall) during the early part of 1826, while also devoting a significant portion of his time to establishing the National Academy of Design in New York.

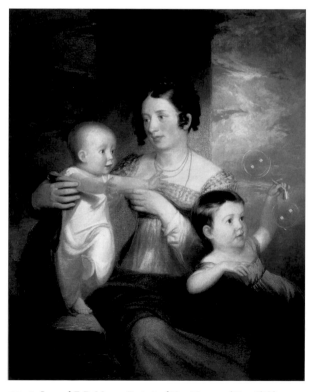

MORSE AND THE ACADEMY

Modeled on London's Royal Academy, which Morse had experienced firsthand, the National Academy of Design was formed to provide instruction for American artists and a space for the annual exhibition of their work. Morse served the Academy as president and professor from 1826 to 1845 (a tenure interrupted only by his resignation to travel abroad between late 1829 and 1832). He immediately set to work on a program of lectures that would outline the need for such an institution and articulate its founding principles, as well as communicate his persistent ambition to advance a national art. In late March and early April 1826, Morse delivered four lectures at the New York Athenaeum, presented in tandem with a series of four talks on poetry by William Cullen Bryant. Professing affinity between a steam engine and "a page of verse, the sounds of an instrument, a colored canvas, a pile of buildings, a statue, and a decorated pleasure ground," Morse laid out a set of principles for his own synthesizing artistic practice, one that embraced "the arts of design" as well as the science of art.[17] These lectures, reflective of his particular turn of mind and his absorption of the ideas and practices of Reynolds, Allston, and Silliman, among others, would eventually provide a blueprint for *Gallery of the Louvre*.

With the elevated goal of stimulating the imagination, Morse's *Lectures* exemplified the "intellectual imitation" derived from careful observation, astute selection, and calculated recombination that formed the basis for his intellectual and artistic output. He had deployed these principles in composing *Dying Hercules*, and he returned to them in crafting the lectures, which drew on sources ranging from Aristotle's *Poetics* and the journals of Leonardo da Vinci to the *Discourses* of Reynolds and West. Morse's combination of ideas selected from these and other philosophers and artists, both ancient and modern, gave the *Lectures* novelty as well as intellectual heft.

Morse labored over the lectures for months. Perhaps this process illuminated the need to deepen his

knowledge of the finest European collections of art, to gather treatises and prints that would be useful to Academy students, and to hone his skills as a painter and colorist by copying works of great significance. (In his fourth lecture on painting, Morse apologized for having to illustrate his points with black-and-white engravings after old master paintings.)[18] In the fall of 1829 he again traversed the Atlantic to spend an extended period in England, Italy, and France in order to increase his knowledge of the western tradition and to improve his mastery of painting through close study and careful copying. He hoped that these pursuits, in addition to being entirely appropriate for the president of the National Academy of Design, would also prepare him for the commission he had long sought: to execute a mural painting in the

Capitol Rotunda, a project that he hoped would finally establish him as one of America's preeminent artists. (That commission would never come to pass.) He underwrote the trip with commissions from collectors and art patrons such as Stephen Salisbury of central Massachusetts and Robert Donaldson of North Carolina for copies of old master works (fig. 7). These men were eager for copies of often-unspecified paintings by Raphael, Bartholomé Estebán Murillo, or Nicolas Poussin. For Charles Walker, Morse's brother-in-law, the artist painted a scaled-down copy of Jacopo Tintoretto's *Miracle of Saint Mark* (fig. 8); other than pencil sketches, this is the only copy from the list known to be extant. These commissions may have been influenced by Morse's lectures, since these were among the artists he discussed and illustrated. Perhaps he anticipated that these copies, or others like them, would not only help fund his travel and give him important lessons in composition and coloring but also prove useful for illustrating future lectures.

Morse embarked for London in late 1829 and passed through Paris early the next year, when he made a brief visit to the Louvre and noted several pictures he intended to copy upon his return to Paris. This was followed by an extended stay in Italy, where he studied and sketched in the finest collections for over a year. Morse's diaries record visits to the Vatican, where he obtained permission to copy works by Salvator Rosa and others; to the Borghese and Doria palaces; and to private and public galleries in Rome, Florence, and Milan, where he studied and sometimes copied works by Leonardo, Claude Lorrain, Raphael, Titian, and Veronese. Morse filled his sketchbooks with notes and drawings documenting the paintings he saw, with extensive annotations indicating colors and other details relevant to the production of full-color copies.[19] His pencil sketches illustrate his system of shorthand notation of a painting's hues and saturations (fig. 9). Full of comments regarding strong examples of rich coloring or fine drawing, excellent composition or dramatic expression, Morse's travel diaries and sketchbooks docu-

FIG. 7 Samuel F. B. Morse. List of Commissions, general correspondence bound volume, 11 Feb 1828–13 July 1832, image 194. Samuel F. B. Morse Papers, 1793–1944, Library of Congress, Washington, D.C., Manuscript Division

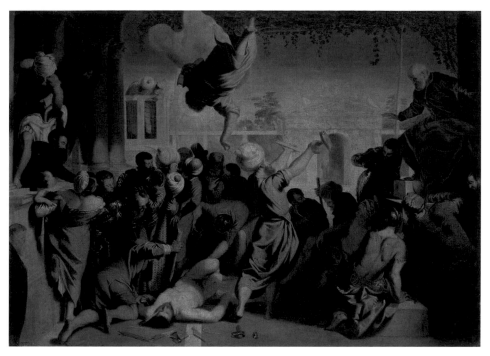

FIG. 8 Samuel F. B. Morse. *Miracle of Saint Mark*, 1831. Oil on canvas, 27 × 38⅜ in. (68.6 × 97.5 cm). Copy after Jacopo Tintoretto, *Miracle of Saint Mark*, 1548. Oil on canvas, 164 × 214 in. (416 × 544 cm). Gallerie dell'Accademia, Venice. Gift of Edward L. Morse, Museum of Fine Arts, Boston, 18.653.

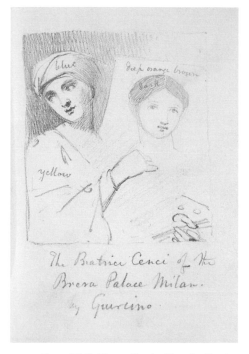

FIG. 9 Samuel F. B. Morse. *Sketch of Beatrice Cenci*, Notebooks—2 August–12 September 1831 and diary fragments, pg. 4. Samuel F. B. Morse Papers, 1793–1944, Library of Congress, Washington, D.C., Manuscript Division

ment his activities and impressions. Together with the canon of the greatest masters of the sixteenth and seventeenth centuries instilled in him by his mentors, plus the list of commissions underwriting his trip, they helped shape the agenda for his time at the Louvre.

COMPOSING *GALLERY OF THE LOUVRE*

Morse returned to Paris in September 1831 and quickly fell in with James Fenimore Cooper (fig. 10), already the celebrated American author of *The Pioneers* (1823) and *The Last of the Mohicans* (1826), whom Morse had come to know as a member of the Bread and Cheese Club, a literary and artistic circle established in New York in 1824. They found Paris reeling from the revolution of the previous year, and they were swept up in the fervor of the July Monarchy—a topic that preoccupied Morse and his Paris cohort, which included Cooper, the sculptor Horatio Greenough, and the landscape painter

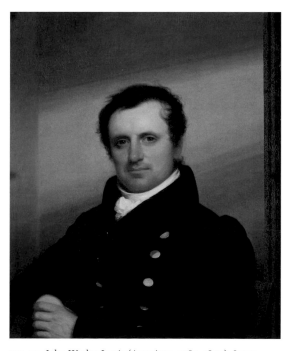

FIG. 10 John Wesley Jarvis (American, 1781–1840). *James Fenimore Cooper*, 1822. Oil on canvas, 30 × 25 in. (76.2 × 63.5 cm). Fenimore Art Museum, Cooperstown/The New York Historical Society, N0146.1977

Thomas Cole. In addition, a cholera epidemic was sweeping the city, forcing officials to pile corpses in the streets—a grisly detail reported by Morse in his letters back home.[20] These events, along with Morse's increasingly xenophobic critique of what he saw as the excesses of Catholic Europe, formed the backdrop for his creation of *Gallery of the Louvre*. As president and professor of painting at the National Academy of Design, Morse may have selected and arranged the artworks in his grand composition primarily to offer lessons in composition, chiaroscuro, and coloring. But other factors were certainly at play.

Compiling his selections from the Louvre—the most dazzling and comprehensive collection in Europe—into a single canvas posed numerous challenges. Morse worked diligently to depict the relatively compact space of the Salon Carré in proper perspective, which was critical to the efficacy of his design. To help him render this grand architectural space in two dimensions, Morse likely employed a camera obscura or other such mechanical device, as he had in composing *The House of Representatives*.[21] To introduce greater depth into the composition, and to offer respite for the eyes from so many pictures to see, Morse situated his composition on the vertical axis of the entrance into the Grande Galerie, where several of his selections would actually have been hanging. Enabling a recession into space denied by the Salon's strict square ("*carré*"), the rectangle of the open doorway into the Grand Galerie—grandly scaled and dotted with figures strolling and admiring works of art throughout the elongated hall—can almost be read as if it were another painting.

Morse's conception of his gallery picture necessitated careful thought regarding which pictures to include and numerous calculations for artfully scaling and arranging them. *Gallery of the Louvre* takes liberties with the scale of most, if not all, of its pictures.[22] To carry out his work at the Louvre, Morse positioned himself in front of his chosen masterworks; he either painted them directly into his large canvas or made scaled-down sketches and finished copies on smaller supports, like that of *Francis I*

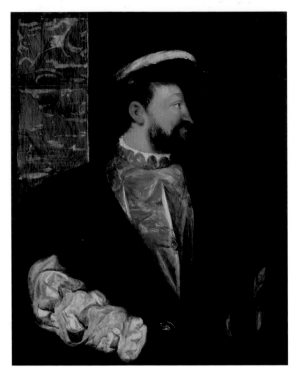

FIG. 11 Samuel F. B. Morse. *Francis I, Study for "Gallery of the Louvre,"* 1831–33. Oil on panel, 10 × 8 in. (25.4 × 20.3 cm). Copy after Titian. Gift of Berry-Hill Galleries in honor of Daniel J. Terra. Terra Foundation for American Art, Chicago, C1984.5

(fig. 11; see also fig. 48). The discovery by the conservators Lance Mayer and Gay Myers of tiny pinholes at the corners of Veronese's *Christ Carrying the Cross*, just to the right of the doorway, suggests that in addition to rendering his copies directly onto a designated portion of his canvas, Morse also made sketches of individual works on bits of paper or other malleable surface and pinned these in place to test their fit and determine their *part* to the painting's *whole*.[23]

Working assiduously, with breaks only to eat and sleep, Morse completed most of the painting—the architecture and the pictures—in Paris; he did not finish the figures populating the gallery or the frames on the pictures until after returning to New York. He boasted in a letter to his brothers, "It is a great labor but it will be a splendid and valuable work, it excites a great deal of attention from strangers and the

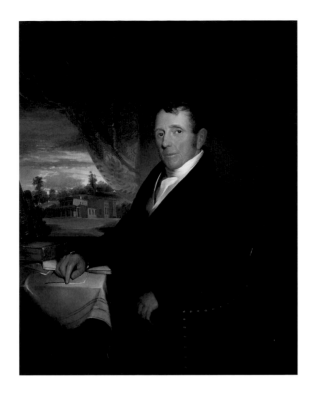

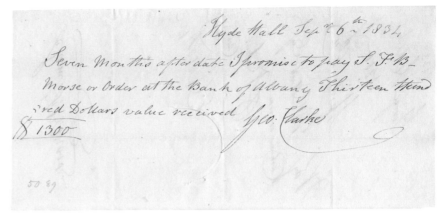

French artists, I have many compliments upon it. I am sure it is the most *correct* of *its kind* ever painted, for every one says I have caught the style of each of the masters."[24] Racing to finish the painting prior to the Louvre's annual closure in August, Morse blended varnishes into his pigment mixtures to enhance the old master qualities of his painting as well as to quicken the drying process. He rolled his canvas and set sail for home in October 1832. Not until unrolling the canvas in early 1833, intending to finally finish it, did Morse discover the damage caused by his materials and techniques. His attempts at repair often caused even more harm. For example, he undertook some hasty measures to fix certain passages of damage in the coat of his self-portrait at center; in that of the copyist at left, thought to be Morse's friend Richard West Habersham; and in several other passages throughout the composition, including losses in the lower portion of the wall at right.

Upon its completion, Morse exhibited the painting in a rented second-floor room at the corner of Broadway and Pine Street in Manhattan in the fall of 1833. He also produced a catalogue that included a description of the Louvre's extensive collections, a brief narrative of his own project, and an annotated key to the painting (see the Appendix in this volume). Though *Gallery of the Louvre* drew praise from critics and connoisseurs, it failed to attract a popular audience.[25] And so Morse sent the painting on to New Haven, where its lackluster performance was repeated. It is thought that during their time together in Paris, Cooper had agreed to buy the painting directly from Morse, an arrangement perhaps corroborated by the discovery of the pencil inscription "Co" in the skirt of the seated figure in the group that has long been identified as the Cooper family. But this did not come to pass. Following its disappointing reception in New Haven, Morse sold the painting and its frame to George Hyde Clarke, a relative of Cooper's whose portrait Morse had painted in 1829 overlooking Hyde Hall, his manor on the northwestern shore of Otsego Lake (figs. 12 and 13). As part of their negotiations, Morse offered to paint in the

figures of Clarke and his family—presumably in place of the Coopers—but Clarke apparently declined. The painting hung for a time at Hyde Hall and descended through the Clarke family until 1884, when it was placed on long-term loan at Syracuse University; in 1892 it entered the institution's collection. In 1982 the Chicago businessman and collector Daniel J. Terra purchased the painting for a then-record sum and sent it on an extended tour, grander than Morse could ever have envisioned. A decade later the painting became part of the collection of the Terra Foundation for American Art, which exhibits it regularly in museums in the United States and abroad in order to advance the Foundation's mission of bringing American art to the world and the world to American art.

GALLERY OF THE LOUVRE AND THE LECTURES OF 1826

Despite being eclipsed initially by its failure to connect with audiences, *Gallery of the Louvre* remains a grand achievement of great complexity. The compositional design and conceptual underpinnings of the picture were made clearer by the extensive conservation treatment of 2010–11 (see the essay by Lance Mayer and Gay Myers in this volume). Elements of Morse's pedagogical program may be traced in his strategic placement of artworks throughout the composition, which collectively emphasize the dialogic nature of the painting. Though the reasons for his selection and arrangement of these specific pictures are not documented, compelling clues to the artist's intentions are evident in his 1826 *Lectures*. In them, Morse constructed an idealized viewer and a manner of viewing the complicated picture he would execute a few years later.

Early in the second lecture, Morse articulated the principles in the "works of the Creator which serve as the common basis of the Fine Arts." Drawing on the tenets of Lord Kames and John Locke, he began by describing the continual flow of thought, the succession of ideas constantly passing through the mind, which subject it to what he called the "universal *law of Change*" governing all things. Motion, or the "progress of change," is "abundantly seen in nature," Morse wrote, and has a "powerful effect in retarding or quickening the natural progress of our ideas." Grounding this principle in the processes of visual perception and mental cognition, he continued: "The eye while in the act of perception cannot keep its attention long fixed upon a single point with more facility than the mind can keep its attention fixed upon a single idea." He goes further, with special relevance to viewing *Gallery of the Louvre*: "*There is a motion of the eye as it travels over objects in a state of rest, which affects the imagination in a similar manner to the motion of objects passing in review before it and according to the order in which they are surveyed.*"[26] Here, physical movement in the natural world is akin to the flow of thoughts and ideas that occupy the mind and animate the fine arts. The motion of the eyes scanning his painting approximates the act of strolling through the gallery.

With the principal aim "to *excite the Imagination* by visible representations of natural objects," painting utilizes materials uniquely addressed to the eye. These are composed of "*Lines, Forms, Lights, Darks,* and *Colors,*" the latter of which, Morse argued, could be arranged to produce a sense of motion as "our eye naturally follows the same color, and quietly passes through its gradations into others."[27] To this end, Morse punctuated his canvas with bold reds, beginning at far left with the red robe of the musician thought to represent Titian in Veronese's *Wedding Feast at Cana* (fig. 75) and continuing on to Anthony van Dyck's monumental *Venus at the Forge of Vulcan* at upper left, before darting across the canvas to the edge of the red chair in his *Portrait of a Lady and Her Daughter*. From there, the viewer's eyes are led across the wall to the flowing robes in Rubens's *Tomyris, Queen of the Scyths* (fig. 77) at far right, which in turn draw the gaze down to the deep red robe draped near the foot of the seated copyist at

right. Tracing the color blue, instead, leads the eye along a different path. Color was for Morse but one way to structure the perceptual experience of viewing the painting.

"The law of *Order*," Morse wrote, "governs all our perceptions and sensations, it regulates the progress of motion, and is necessary to the permanence of any impression."[28] Though our natural tendency is, as Morse suggested, to survey a whole before its parts, he wrote that "it is accordant with the law of *order* that every picture should have some part which attracts the eye first . . . one principal spot around which all that is introduced must rally."[29] In *Gallery of the Louvre*, it is the entrance to the Grande Galerie that anchors the constellation of images. As the central point in the picture that first draws the gaze, it also references the space in which Morse's selections typically hung. But it was the principle of novelty that would help maintain the viewer's interest and prolong the time spent before a work of art. "It seems to result naturally from the law of change," wrote Morse, "for as all things proceed in conformity to this law, new situations, new appearances, new combinations must constantly occur." The Salon-style hang, employed deliberately for the purpose of comparison and contrast, vividly enacts this principle in Morse's picture. As demonstrated so cleverly in *Gallery of the Louvre*, "no object seems so insulated as not to bear some relation to another, none so feebly related that it will not be found difficult to separate it from all others."[30]

Morse elaborated the various ways in which all things are linked or connected—by Contiguity, Variety, Uniformity, Resemblance, Gradation, Contrast, Congruity, Unity, and Mystery—and marshaled each as evidence of the providential design underlying both natural phenomena and how they are interpreted in poetry, landscape gardening, or painting. He quickly passed over contiguity, "the first and most common . . . the most *accidental* of all *relations*," which suggests that the arrangement of paintings in *Gallery of the Louvre* is anything but casual. Each

selection, each placement, I would argue, manifests Morse's schema. He stressed the interlocking principles of "*Variety* and *Uniformity*," which "appear every where and intimately blended," just as portraits, landscapes, and historical paintings from various national schools jostle against one another throughout *Gallery of the Louvre*, though within a relatively uniform network.[31]

Other links include "*Resemblance*," which "furnishes the foundation for that extensive comparison" and "is the basis of all Analogy."[32] Hung in the highest register, the two bust portraits of elderly men—Tintoretto's *Self-Portrait* at upper left and Rembrandt's *Head of an Old Man* at upper right—represent one such pairing of similar images. Other pairs include Titian's *Francis I* and Van Dyck's *Portrait of a Man in Black* and the latter's *Portrait of a Lady and Her Daughter* and Raphael's *Madonna and Child with the Infant Saint John the Baptist*. But resemblance, taken at a quick glance, directs attention to subtle, and telling, differences upon closer inspection. Witness in the lower right quarter of the canvas the two different scenes of Christ carrying the cross—one by Veronese, the consummate Venetian colorist, and one by the French painter Eustache Le Sueur. These two paintings alternate with two portraits that contrast the bold colors of Peter Paul Rubens's *Portrait of Suzanne Fourment* and the subtle blending of light and dark in Leonardo's *Mona Lisa*. Resemblances between these works encourage viewers to look beyond subject matter to consider more intently differences in each work's style and handling.

Gradation "is that imperceptible change which conceals the steps of its progress even in passing from one extreme to the other."[33] This can be seen in the landscape that forms the backdrop to the *Mona Lisa* as well as in two strategically placed paintings by Claude Lorrain: the sunrise *Disembarkation of Cleopatra at Tarsus* (fig. 81) at left and *Sunset at the Harbor* at right. But it is also apparent in Morse's arrangement of pictures in *Gallery of the Louvre*, which gently guides the viewer's roving gaze from

landscape to portrait to historical painting. His masterful handling of the fall of light, seen in the strong diagonal shadow extending from upper left to lower right and in the play of lights and darks on the frames of individual pictures, exemplifies the artist's application of gradation. This compositional device, which binds the painting's diverse contents and facilitates the smooth and uninterrupted scan of the viewer's gaze across its surface, is underscored by the strong lighting and muted earth tones of Murillo's humble *Beggar Boy* (fig. 73), located on the right side of the doorway. This effect has recently been made more legible by the intervention of conservators to correct damages along the path taken by this light.

The opposite of gradation, according to Morse, is contrast, which strengthens "the impression of two extremes."[34] "Qualities brought into contrast with each other are rendered more obviously and distinctly different," Morse wrote. "The opposition of the essential ingredients of each is made more palpably apparent."[35] In *Gallery of the Louvre* he invited his viewer to compare and contrast the approach taken by each of its juxtaposed artists, perhaps as representative of their different national schools. For contrast within individual pictures, one may look to Salvator Rosa, represented by *Landscape with Soldiers and Hunters* at top right, or to Caravaggio, represented by *Fortune Teller* at far left. Both artists are distinguished, wrote Morse, for the "stormy vehemence" and "violent *Contrasts*" in their works. But throughout the canvas, other strong contrasts abound.[36] Nevertheless, it is *Congruity*, the "consistency or propriety of objects or circumstances with each other," as Morse wrote, that governs his gallery picture.[37]

Morse's selection of individual pictures as examples of strong design or color, of contrast or gradation, demonstrates his erudition, while the overall assemblage exemplifies his use of intellectual imitation to combine individual components—in this case, old master paintings—into a harmonious and instructive whole. These various components, which he carefully selected for their individual char-acteristics as well as for their complex interrelationships, reflect the theoretical underpinnings of *Gallery of the Louvre* and contribute to its compositional unity. Morse cited the example of the steam engine, in which the various valves and levers, in spite of their diversity, "all unite to produce one result."[38] As a tightly orchestrated constellation of pictorial components, *Gallery of the Louvre* illustrates the same point. But one element of Morse's intended unity, in the absence of any written documentation of his intent, has imbued the painting with a certain "mystery." The last of the principles he articulated, "*Mystery*" is defined as that "quality in the works of Nature which by exciting the curiosity keeps alive the attention in investigating them."[39]

Like the identity of the various figures he included, Morse's intentions in painting *Gallery of the Louvre* are not entirely known. But the overriding sense of connection that links his major works encourages us to think they were developed as instrumental parts of a greater whole. Indeed, if Morse's *Lectures* provided a kind of blueprint for the construction of *Gallery of the Louvre*, as I have suggested, the painting itself provided intellectual and material scaffolding for the conceptualization of his next great invention. Not only did Morse utilize a canvas stretcher in building an early prototype of his telegraphic transmitter (fig. 65), he also employed the artists' material asphaltum, combined with linseed oil and turpentine, to coat and protect his conductor wire.[40] Painters such as Allston and his student Morse added this brown, tarlike substance to their pigment mixtures in order to give their paintings the antique look of the old masters. But asphaltum could be quite volatile, causing colors to darken rapidly or damaging a painting's surface as it dried. It was likely the agent responsible for the bubbling and cracking seen throughout the entire left side of Morse's painting. Thus, the same material that may have helped give Morse's copies the look and feel of old master paintings was, ironically, both a detriment to his canvas and a protective element for his telegraphic wires.

In more ways than one, Morse's grand painting, a picture filled with copies and copyists, exemplifies his unique art of invention rather than mere imitation—a complex "engine" of carefully calibrated interrelated parts. Created in a period of intense economic and technological development, *Gallery of the Louvre* marries Old World sensibilities and the tenets of European art history with New World ingenuity. Wedding his vast erudition and intellectual prowess to mechanical skill and creative invention, Morse sought to capitalize on Americans' lack of familiarity with the old masters and their taste for visual entertainments such as popular single-painting exhibitions and panoramas. Though an acolyte of Reynolds, West, and especially Allston, Morse was also a student of Robert Fulton, Silliman, and other men of science and technological innovation. The classrooms and laboratories of Yale University; Allston's Boston studio; the lecture halls, ateliers, and exhibition spaces of London's Royal Academy as well as those of the newly formed National Academy of Design; and the great galleries of the Louvre all became part of his intellectual matrix for bringing together the mechanics of the universe with the manipulations of art. However, as articulate as Morse could be in his writings, he never fully spelled out the connections linking his written and his visual productions, leaving scholars to ponder his intentions and the complex formulas involved in creating *Gallery of the Louvre*. Indeed, it is this sense of mystery that continues to arouse interest in the painting and that has elicited the lively spirit of inquiry that animates the essays in this volume.

Notes

1 Samuel F. B. Morse, *Lectures on the Affinity of Painting with the Other Fine Arts*, ed. Nicolai Cikovsky, Jr. (Columbia: University of Missouri Press, 1983), 49. Also instructive are Morse's working notes made in preparation for the *Lectures*, now housed in the Samuel F. B. Morse Papers, Academy Archives, National Academy of Design, New York.

2 Ibid., 58–59.

3 Ibid., 63.

4 Daniel Walker Howe, *What Hath God Wrought: The Transformation of America, 1815–1848* (New York: Oxford University Press, 2007); and Charles Sellers, *The Market Revolution: Jacksonian America, 1815–1846* (New York: Oxford University Press, 1994).

5 Carlton Mabee, *The American Leonardo: A Life of Samuel F. B. Morse* (New York: Alfred A. Knopf, 1943); Kenneth Silverman, *Lightning Man: The Accursed Life of Samuel F. B. Morse* (New York: Alfred A. Knopf, 2003). Another biography of note is William Kloss, *Samuel F. B. Morse* (New York: Harry N. Abrams in association with the National Museum of American Art, Smithsonian Institution, 1988). Morse's time in Paris forms the subject of two chapters in historian David McCullough's *A Greater Journey: Americans in Paris* (New York: Simon and Schuster, 2011).

6 Paul J. Staiti, *Samuel F. B. Morse* (Cambridge: Cambridge University Press, 1989).

7 Ibid., 236–37.

8 Ibid., 191–93.

9 *Foreign Conspiracy against the Liberties of the United States: The Numbers of Brutus, Originally Published in the "New-York Observer"* (New York: Leavitt, Lord, 1835).

10 Patricia Johnston, "Samuel F. B. Morse's *Gallery of the Louvre*: Social Tensions in an Ideal World," in *Seeing High and Low: Representing Social Conflict in American Visual Culture*, ed. Patricia Johnston (Berkeley: University of California Press, 2006), 42–65.

11 In this volume and elsewhere, Rachael DeLue, Tanya Pohrt, Sarah Kate Gillespie, Jean-Philippe Antoine, and others have examined these aspects of Morse's career in relation to *Gallery of the Louvre*. See also Lisa Gitelman, "Modes and Codes: Samuel F. B. Morse and the Question of Electronic Writing," in *This Is Enlightenment*, ed. Clifford Siskin and William Warner (Chicago: University of Chicago Press, 2010), 120–35.

12 Joshua Reynolds, *Discourses on Art*, 1769–90, ed. Pat Rogers (New York: Penguin Books, 1992).

13 Staiti, *Morse*, 15.

14 While a student at Yale, Morse attended lectures on electricity by Silliman and Jeremiah Day. Ibid., 6.

15 Morse to Jedidiah Morse, May 3, 1815, Samuel F. B. Morse Papers, 1793–1944, Manuscript Division, Library of Congress, Washington, D.C.

16 Leslie tried selling the painting to the art patron George Wyndham, third Earl of Egremont, who was "wholly indifferent to it." See Paul Staiti, *"The House of Representatives,"* in *Corcoran Gallery of Art: American Paintings to 1945*, ed. Sarah Cash (Washington, D.C.: Corcoran Gallery of Art, 2011), 70–71.

17 Morse, *Lectures*, 47.

18 "With respect to the illustrations generally that I am about to use in this lecture, I have to ask the indulgence of my audience. Although they explain the points to be illustrated, yet many of them are so small that I am aware that they can not be seen by all in the room, nor in the hasty selection of examples I was under the necessity of making, could I choose larger. I was compelled to take these as they are or copy them of a proper size, a labor of many months." Morse, *Lectures*, 91–92.

19 Samuel F. B. Morse, Diaries—22 December 1829–3 May 1830; 4 May 1830–3 March 1831; 4 March–31 July 1831; 2 August–12 September 1831; and diary fragments, Samuel F. B. Morse Papers, 1793–1944, Manuscript Division, Library of Congress, Washington, D.C.

20 "I have but a little space to add, that the Cholera is again on the increase in Paris, 100 deaths per day." Morse to Sidney and Richard Morse, July 18, 1832, Samuel F. B. Morse Papers, 1793–1944, Manuscript Division, Library of Congress, Washington, D.C.

21 Staiti, *Morse*, 80.

22 In fact, all copyists were required to resize their reproductions to avoid confusion between copies and originals.

23 On the relation between part and whole, see Morse, *Lectures*, 67–69.

24 Morse to Sidney and Richard Morse, July 18, 1832, Samuel F. B. Morse Papers, 1793–1944, Manuscript Division, Library of Congress, Washington, D.C.

25 "They who were in the room when we first visited it, (and there were many who had been in the Louvre,) spoke in no measured terms of its richness, variety, and correctness. . . . We know not which most to admire, in contemplating this magnificent design, the courage which could undertake such an [*sic*] herculean task, or the perseverance and success with which it has been completed. We have never seen any thing of this kind before in this country. Its effect on us is different from that made by any other painting." "Mr. Morse's Gallery of the Louvre," *New-York Mirror: A Weekly Gazette of Literature and the Fine Arts* 11 (November 2, 1833): 142.

26 Morse, *Lectures*, 62–63.

27 Ibid., 86–87, 88, 90.

28 Ibid., 63.

29 Ibid., 92.

30 Ibid., 63.

31 Ibid., 65.

32 Ibid., 66.

33 Ibid.

34 Ibid.

35 Ibid., 59.

36 Ibid., 105–6.

37 Ibid., 67.

38 Ibid., 69.

39 Ibid.

40 "Morse's Magnetic Telegraph," *Niles' National Register* (Baltimore), June 22, 1844, 261.

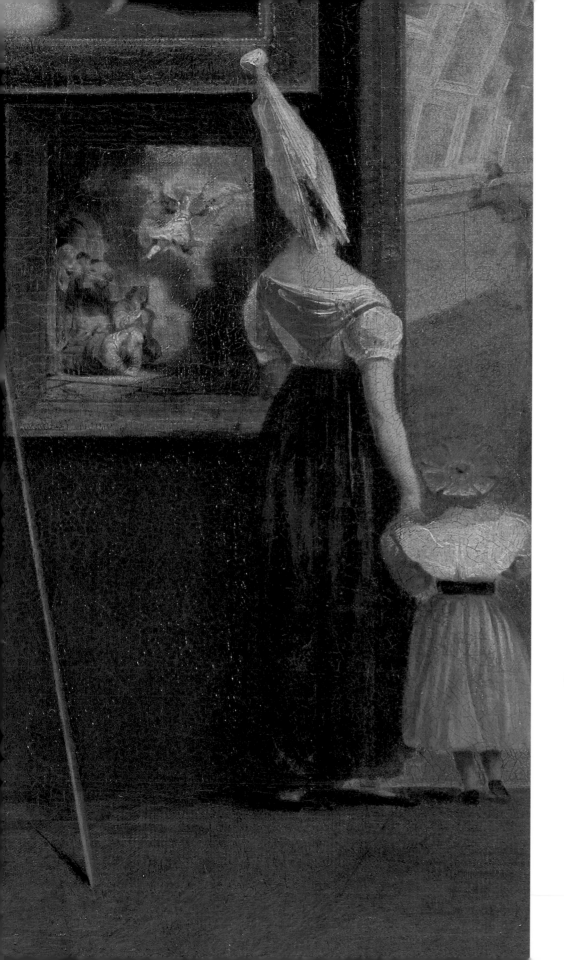

Contexts

"The most splendid . . .
collection of works of art
in the world":
Morse and the Louvre

ANDREW MCCLELLAN

AS MORSE SAILED HOME from France in 1832, his large painting of the Louvre rolled up in storage belowdecks, he alternated between confidence and despair about the prospects of the fine arts in America. Despite a career marked to that point mostly by professional frustration and meager patronage, he hoped his arresting image of the Louvre would break through the stubborn Yankee lack of interest in the fine arts and spark a culture of public enlightenment. He also hoped it would make a splash when exhibited in New York and generate some much-needed income.

Ambitious in scale, Morse's *Gallery of the Louvre* (plate 1) was equally ambitious in purpose. Although the picture turned out to be a flop when exhibited to the public in 1833, today it offers fascinating insights into the early development of American art in relation to European tradition. The painting argues for the importance of tradition, for the formative role of the past in the creation of contemporary art. Related to that purpose, the picture also celebrates the Musée du Louvre—in Morse's words "the most splendid . . . collection of works of art in the world"—both as a training ground for artists and as a tourist attraction.[1] Finally, the picture served as an advertisement for Morse's skill as a painter and as a mentor: with its illusionistic depiction of architectural space and famous masterpieces, the canvas demonstrates his command of the art of painting, while his profiled self-image front and center identifies him as a master teacher. Morse depicts himself at ease in this sanctuary of greatness, explicating the canon to the next generation of artists.

More than a place of public recreation, the Louvre is represented by Morse as a site of artistic training and inspiration. Vignettes of aspiring artists studying and copying the old masters are distributed across the shallow space of the Salon Carré, the antechamber to the Grande Galerie seen through the open doorway. Copying had long been central to artistic training in Europe and eventually became part of American art education as well. Informing the practice of copying was the belief that all great art was built upon the art of the past. Art theory of the early modern period held that innovation was grounded in imitation; originality could be measured only in relation to tradition, and tradition was cumulative. Put simply by Joshua Reynolds— first president of Britain's Royal Academy of Arts, whose *Discourses on Art* (1769–90) offered an Enlightenment summa of academic doctrine—"that artist who can unite in himself the excellences of the various great painters, will approach nearer to perfection than any one of his masters."[2]

The establishment of the first art academies in seventeenth-century Europe institutionalized the imitation of earlier art as the founding principle of an artistic career. Aspiring painters drew after engravings and ancient sculpture before moving on to copy details and, ultimately, whole old master paintings. The purpose of copying was to absorb both the technical procedures and the narrative powers of

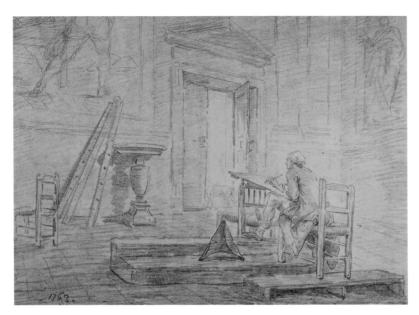

respected masters. Drawing, or *disegno*, was the vehicle of composition—the rational, storytelling function of art—while copying in oil refined painting technique, specifically the mimetic and visually persuasive functions of color (*colore*) and its modification through the handling of light and shade (*chiaroscuro*). Copy drawings preceded copies in oil, but each was vital and many artists continued to do both well into their careers. Morse illustrates both in action, with the female student at center drawing and the man and woman at left working in oil.

The most developed academic system in Europe belonged to the French. The Académie Royale de Peinture et de Sculpture had been founded in Paris in 1648 with the goal of creating a native school of art that would surpass the achievement of the Italian Renaissance. Emulation required systematic study, and the French went right to the source, establishing a branch of its Academy in Rome in 1666. Every year the best students were sent to Rome "to wrest from genius its secret" through direct study of antiquity and the Italian masters.[3] Young students spent their days copying the great monuments of the Eternal City (fig. 14). Their culminating project, known as

the *envoi* (from the verb "to send"), was to execute a faithful copy of an ancient sculpture or famous painting to be sent back to Paris to decorate the buildings and grounds of the royal properties (some of the statues can still be seen in the gardens of Versailles and the Tuileries). In the words of Louis XIV's minister Jean-Baptiste Colbert, the plan was ultimately to collect "all that is beautiful in Italy."[4] These imported copies would also motivate young students in Paris as they moved up the academic ladder. Morse's picture was intended to serve a parallel purpose for the United States, supporting the pedagogic role of the plaster casts and painted copies already available in private and nascent public collections.

Italian painting was the basis of emulation in the seventeenth century, but other national schools were added to the canon with the passage of time. It followed from academic logic that each generation would contribute artists worthy of study by the next. And because the French academic model was itself imitated in other countries, the number of models multiplied not just over time but also across Europe. Following the counsel of Joshua Reynolds, artists of Morse's generation were expected to absorb an expanding field of old masters from different historical moments and regional traditions. We see this range in *Gallery of the Louvre*, with its works by Italian, Dutch, Flemish, Spanish, and French masters. Although Italy remained the chief destination for all ambitious artists (Morse went there himself and dutifully made copies just before painting the Louvre), the lessons of Dutch or Spanish painting could not be learned in Rome or Venice. The only place to see all the schools assembled together and displayed for purposes of contrast and comparison was a museum, and the Louvre was the greatest of museums, recognized for the breadth and depth of its collections and for offering liberal access to them.

From the late seventeenth century until the Revolution, the Palais du Louvre had been the seat of the Académie Royale, which offered drawing classes and lectures on theory; the palace also housed the studios and apartments of academicians. Above the studios,

from 1737 on, the Academy hosted regular public exhibitions of new work by its members in the Salon Carré (the same gallery we see in Morse's painting), creating competition among artists for critical favor and patronage. For much of the eighteenth century, prior to the establishment of the Musée du Louvre, private collections in Paris served young artists as informal academies. Pressure to open those collections to the public and to rearrange them to make them more useful as sites of instruction increased during the Enlightenment, paving the way for the first public museums.

The first suggestion for a public gallery in France came in a critique of the exhibition of new work by royal academicians held in the Salon Carré in 1746. In his *Réflexions sur quelques causes de l'état présent de la peinture en France* (1747), Étienne La Font de Saint-Yenne lamented what he saw as the dire state of contemporary art under the sway of Rococo taste. He called on the government of Louis XV to mount a display of the king's pictures in the Louvre, near both the Salon and the Académie Royale, as a means of putting contemporary art back on the right track. It was largely the absence of proper models of study, he claimed, that had perverted French art in the early eighteenth century. Three years later, in 1750, the first public collection of art duly opened—not in the Louvre, as La Font had hoped, but in the Palais du Luxembourg, featuring one hundred old master paintings and a handful of framed drawings. (No known images of the gallery survive.) Selected works on display became the focus of lectures at the Academy and were also copied by students in preparation for their studies in Rome.[5]

In 1779 the Luxembourg gallery closed to make way for a grander plan to build a museum in the Grande Galerie of the Louvre, the impressive thirteen-hundred-foot-long gallery adjoining the Salon Carré. The ambitious scheme, guided by Louis XVI's minister of culture, Comte d'Angiviller, envisioned the Louvre as a monument to, and an engine of, French artistic superiority. The excitement and grandeur of the enterprise is captured in Hubert

FIG. 15 Hubert Robert (French, 1733–1808). *Project for the Grand Gallery of the Louvre*, ca. 1789. Oil on canvas, 18⁵⁄₁₆ × 22⅝ in. (46.5 × 57.5 cm). Musée du Louvre, Paris, R.F. 1952-15

Robert's imaginary view dating from the late 1780s (fig. 15). The coming of the French Revolution terminated the Crown's oversight of the Louvre and forced d'Angiviller into exile, but it gave the museum project a more prominent profile and even greater pedagogic responsibility. The year 1793 marked both the opening of the Musée du Louvre and the abolition of the Académie Royale—two events that were more than casually related. As a royal institution marked by rank and privilege, the Academy was declared incompatible with the political and social reforms sweeping the country. Radical artists wanted a system of education "more in keeping with liberty . . . one that doesn't raise students into servitude and commit them to a narrow path." They pushed instead to "evoke the memory of the great masters in such a way that their wise and immortal masterpieces will inspire the artist . . . to use them as his guide. It will be clear we are calling for the creation of the national museum."[6] Revolutionaries envisaged the Louvre becoming an "imposing school," as the

artist Jacques-Louis David put it, in which aspiring artists could study at will and choose their own masters from the history of art.[7]

After 1789, property belonging to the monarchy, the Catholic Church, and émigré aristocrats opposed to the Revolution was nationalized, with the best of their art sent to the museum to enhance its value as a site of public instruction. From the mid-1790s, Napoleon Bonaparte and the French army further enriched the Louvre by appropriating art in the wake of their victorious march through Europe. Where Colbert had sought to acquire copies of "all that is beautiful in Italy," Napoleon seized the originals as the booty of war. The terms of the treaty he signed with the Papal States, for example, yielded one hundred masterpieces from Rome, many of which had been copied by French students over the previous century. A song written to celebrate the arrival of Italian art on French soil proclaimed: "Rome is no more in Rome / It is all in Paris."[8] Young French artists no longer had to make the pilgrimage to the Eternal City; its masterpieces could now be copied in the Grande Galerie overlooking the Seine.

The Louvre did indeed become an imposing school. On all but two days of the week the museum was reserved for artists' study, and the practice of copying exploded. By 1797 some five hundred artists had sought permission to copy, and rules were introduced to keep boisterous students in line.[9] Although the academic system was soon restored, along with the custom of apprenticing students to established masters—the age-old structure had worked pretty well, after all—copying at the museum remained de rigueur. It continued to be an article of faith through the nineteenth century that young artists had to study the "excellences of the various great painters." Jean-Auguste-Dominique Ingres told his pupils: "Go to the old masters, talk to them—they are still alive and will reply to you. They are your instructors; I am only an assistant in their school."[10] At the end of the century, Paul Cézanne was no less insistent in his advice: "Keep good company, that is: Go to the Louvre."[11]

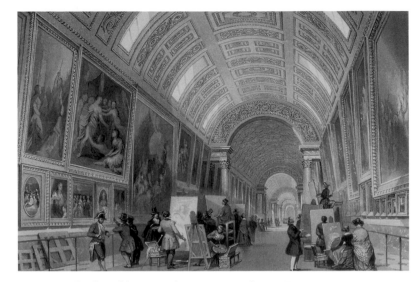

FIG. 16 *Grand Gallery of the Louvre, Showing Visitors and Artists Copying Paintings at Easels, from France Illustrated*, with drawings by Thomas Allom and descriptions by Rev. G. N. Wright, 1845. Steel engraving by J. B. Allen, 7⅛ × 4¹³⁄₁₆ in. (18.1 × 12.3 cm). Private collection

Routine studio practice in the nineteenth century had students working with their master in the morning, studying at the Louvre in the afternoon, and then drawing from a model at the Academy by night. Louvre archives for 1834 record requests to copy from 307 artists and 784 students.[12] An average of about one thousand copy permits a year were issued through the middle decades of the century. On copy days, visitors encountered a thicket of easels and copyists of both sexes (fig. 16). Many of the copyists were hacks who eked out a living by making copies for visiting tourists, but surviving copies by the likes of Théodore Géricault, Eugène Delacroix, Edgar Degas, and Cézanne testify to the ubiquity of the practice among even the most talented artists. Not coincidentally, Morse's painting features the works that were most often reproduced by students and professional copyists, notably Titian's *Entombment*, Correggio's *Mystic Marriage of Saint Catherine of Alexandria with Saint Sebastian* (fig. 82), Bartolomé Esteban Murillo's *Immaculate Conception*, Veronese's *Wedding Feast at Cana* (fig. 75), and Leonardo da Vinci's *Mona Lisa*.

For the young artists who studied in the Louvre, copying was viewed not as an end in itself—a subser-

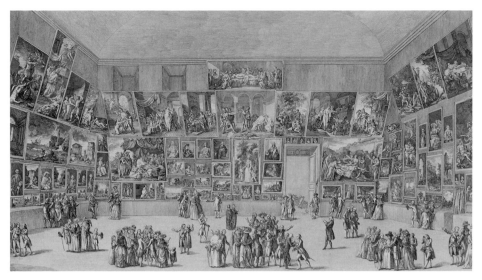

FIG. 17 Pietro Antonio Martini (Italian, 1738–1797). *View of the Salon of 1785*. Etching, 10⅞ × 19⅛ in. (27.6 × 48.6 cm). A. Hyatt Mayor Purchase Fund, Majorie Phelps Starr Bequest, 2009, The Metropolitan Museum of Art, New York, 2009.472. Photo © The Metropolitan Museum of Art. Image source: Art Resource, NY. Note Jacques-Louis David's *Oath of the Horatii*, above left of the door.

vient act of imitation—but rather as part of a creative process that would lead to a distinctive, mature style. The ultimate goal for ambitious French artists after 1800 was to gain a place one day in the museum's collection, which was reserved for those whose posthumous reputation stood the test of time. State control over artistic production allowed for the mapping of aspiration and emulation onto what were essentially contiguous spaces of the Palais du Louvre. Beginning in 1775, d'Angiviller had commissioned large history paintings and statues of illustrious French men with the intention that those well received at the Salon would pass next door into the museum and join the ranks of history's great artists (fig. 17). David and others created their most ambitious work with this final destination in mind. Although that scheme was undermined by the Revolution, when the Académie Royale was renamed and relocated, a trajectory was established that enticed young artists to dream that juvenile study in the Louvre might one day be rewarded with a place on its walls. (In 1818 the Musée du Luxembourg was opened as a kind of waiting room for worthy modern art hoping to win final passage to the Louvre.)

This was precisely the message delivered by the exhibition of recent French painting that greeted Morse when he returned to the Louvre from Italy in 1831. Easily discernible in Nicolas Sébastien Maillot's view of this exhibition (fig. 18) are three works—Anne-Louis Girodet de Roucy-Trioson's *Deluge* (1806), David's *Intervention of the Sabine Women* (1799), and Géricault's *Raft of the Medusa* (1818–19)—that were on their way to a permanent place in the Louvre and the French canon (note Géricault's *Raft* to the left in Thomas Allom's engraving of the Grande Galerie, fig. 16). Morse had little regard for recent French painting, but he must surely have been impressed by institutional efforts to assert the strength of the French tradition and the continuity between past and present.[13] His ambition for American art was that works by native artists would one day line the walls of an equivalent to the Salon en route to a national museum, where they would in turn inspire future generations.

Assimilation into the canon was, after all, the common aspiration of all national "schools" of art. Over the centuries, writers had layered regional and national traditions onto the master narrative of Renaissance art created by the artist and writer

FIG. 18 Nicolas Sébastien Maillot (French, 1781–1856). *View of the Salon Carré of the Louvre in 1831*, 1831.
Oil on canvas, 49⅝ × 55¹⁵⁄₁₆ in. (126 × 142 cm). Musée du Louvre, Paris

Giorgio Vasari in the mid-sixteenth century, but the French went further in boldly asserting their prominence in the galleries of a public museum. (That Morse juxtaposed French works with famous masterpieces in his Salon Carré underscores the success of French museum policy.) Other nations followed France's lead. During his two stays in London, Morse witnessed efforts by the British Institution, founded in 1805, to promote the worth of modern British art alongside the old masters (fig. 27).[14] For Morse, all that was required to raise an American school to similar respectability was patience, patronage, and organization.

Morse surely viewed his epic painting of the Louvre as a step in the right direction. At the National Academy of Design in New York (which he helped found in 1826), he could teach drawing and theory through lectures and with the aid of antique casts and live models. Advancing the art of painting, however, required examples for artists to learn from, which would also inform the public. "In order to create a taste," Morse had written earlier, "pictures, first-rate pictures, must be introduced into the country, for taste is only acquired by a close study of the merits of the old masters."[15] But originals were still rare in the United States, and until they could be imported in ample quantity, copies would have to suffice. Morse's *Gallery of the Louvre* offers faithful reproductions in reduced format of thirty-eight paintings by twenty-eight artists spanning five countries and three centuries. Inspired by an exhibition of old masters on view in the Salon Carré when he passed through Paris in 1830, and ignoring the installation of modern French art he found upon his

return a year later, Morse assembled an eclectic gallery of highlights suiting a range of interests and artistic categories.

Comparison between Morse's painting and another near-contemporary representation of the Salon by the British painter John Scarlett Davis (fig. 29) is instructive. The greater diversity of national schools and genres in Morse's selection is particularly noteworthy and surely explained by the perceived needs of a still young and untutored American public. The major artists of the High Renaissance and the Baroque north and south of the Alps are represented, as are a range of genres—history, religion, portrait, landscape, and genre painting (the lowest genre, still life, is acknowledged only indirectly, in the delicate painting of materials on the low table in the left-hand corner). Morse reduced the heavy presence of Venetian paintings seen in Davis's Salon Carré to make way for Rembrandt and Peter Paul Rubens, for Claude Lorrain, Nicolas Poussin, and Joseph Vernet, for Raphael, Leonardo, and Guido Reni. He manipulated the scale of various canvases and arranged the paintings to produce a pleasingly symmetrical and balanced grouping of different subject types and schools in the dominant area to the right of the door. Armchair connoisseurs could have quibbled over his inclusion of three works by Murillo and the omission of certain masterpieces featured by Davis (notably, Annibale Carracci's powerful *Virgin and Child with Saints Luke and Catherine* and Anthony van Dyck's *Charles I*), but by and large Morse's choice follows consecrated taste.

In choosing to mix artists, national schools, and genres, Morse intervened in a decades-old debate about how best to arrange paintings in a public museum. When it opened in 1750, the Luxembourg gallery had featured a similarly eclectic arrangement, the purpose of which was to stimulate comparative analysis of different artists. Known as a "comparative hang," it was grounded in the art theories of Roger de Piles and André Félibien, who had divided painting into the constituent parts of drawing, color, composition, and expression—an approach encapsulated

298 *The* Balance *of* PAINTERS.				
NAMES.	Composition. Deg.	Design. Deg.	Colouring. Deg.	Expression. Deg.
C.				
The *Caracches*	15	17	13	13
Da Caravaggio, Polydore	10	17	0	15
Correggio	13	13	15	12
Da Cortona, Pietro	16	14	12	6
D.				
Diepembeck	11	10	14	6
Dominichino	15	17	9	17
Durer, Albert	8	10	10	8
G.				
Giorgione	8	9	18	4
Gioseppino	10	10	6	2
Guerchino	18	10	10	4
H.				
Holbein, Hans	9	10	16	13
I.				
Jordano, Luca	13	12	9	6
Jourdaens, James	10	8	16	6
L.				
Lanfranco	14	13	10	5
Van Leyden, Lucas	8	6	6	4
M.				
Michael Angelo Buonarotti	8	17	4	8
Michael Angelo da Caravaggio	6	6	16	0
Mutiano	6	8	15	4
P.				
Palma the elder	5	6	16	0
Palma the younger	12	9	14	6
				Par-

FIG. 19 Roger de Piles, "The Balance of Painters" (1708), from *The Principles of Painting* (London: J. Osborn, 1743). Huntington Art Library, Rare Books 475905

in de Piles's controversial "Balance of Painters," first published in 1708 as an appendix to his book *The Principles of Painting* (fig. 19). Aspiring artists, but also would-be connoisseurs, were expected to reckon with these parts. The rankings that de Piles ascribed to artists were subjective—comically so, in places—but the purpose of the Balance was serious enough and grounded in artistic and connoisseurial practice. De Piles no doubt expected art lovers to take issue with his numbers and to use his provocative chart as a point of departure for debate or a visit to a well-rounded collection. In Félibien's treatise *Entretiens sur les vies et sur les ouvrages des plus excellens peintres* (1666–88; Conversations on the lives and on the works of the most excellent painters), he staged a fictive visit to the Tuileries palaces, where selected

works from the royal collection were displayed briefly in the seventeenth century. To bring comparative viewing to life, Félibien dramatized the visit in dialogue form. "Enter the gallery," says an experienced connoisseur to his young companion, "and you will see excellent works by the great masters. It is there that each of them displays his strengths, and taken together their works form a marvelous concert. . . . That which is peculiar to one, and which is not to be found in others, testifies to the vast extent of this art, which no one can master in all its parts."[16] The discourses of de Piles, Félibien, and their followers offered flexible guidelines for the arrangement of art collections in eighteenth-century Paris, including the royal display at the Luxembourg.

After 1750, however, this comparative mode of viewing was contested by a growing number of writers, connoisseurs, and collectors who—influenced by Enlightenment taxonomic impulses (notably, the Linnaean genus-species classification of flora and fauna)—favored organizing old masters by nationality and chronology. Continuing tension between the two approaches can be found in a scheme drafted by French artists in 1791, recommending that the completion of the new national museum at the Louvre be linked with comprehensive academic reform. Their proposal specified: "The paintings will be classified in a manner to facilitate comparison among the different schools, and to demonstrate their history and progress."[17] The debate came to a head when the Musée du Louvre opened in August 1793 with a comparative display harking back to the Luxembourg that was harshly criticized by David and fellow revolutionaries, who were keen to tie the museum to Enlightenment thought. David and friends won out, and within a year the Louvre staff was replaced and the Grande Galerie rearranged by national school and chronology. Politics aside, the two hanging systems were clearly incompatible and could not coexist.

Although the newer taxonomy of period and place prevailed, artistic practice remained focused on the "parts" and thus on selective consumption of the past.[18] Moreover, on occasion, as in the temporary old master shows staged in the Salon Carré, circumstance relaxed the taxonomy that governed the arrangement in the Grande Galerie and revived an opportunity for comparative viewing. Morse fully embraced the selective imitation of past art, as he made clear in his lectures on the fine arts delivered at the New York Athenaeum in 1826.[19] *Gallery of the Louvre* can be construed as a visual supplement to the position he adopted in his lectures, presenting a comparative display as an ideal environment for contemplation and active learning.

Morse's privileging of the pedagogic came at the expense of other ways he could have represented the Louvre to American viewers. Most foreign visitors were initially taken most by the breathtaking architecture and sweeping vista inside the Grande Galerie. One Thomas Jessop from the north of England wrote: "The effect upon a stranger's mind when he 1st enters this magnificent museum is better conceived than described. The eye is lost in the vast and original perspective."[20] Sir John Dean Paul concurred; setting foot in the Grande Galerie, he found the first "coup d'oeil . . . almost overpowering."[21] Standard views of the museum show a smattering of art lovers mingling with copyists against a dominant backdrop of that "vast and original perspective" (fig. 16, for example). So dazzling were the space and the parade of accumulated masterpieces that many found it hard to concentrate on individual pictures. "The first time I entered the Louvre, I saw nothing," wrote a tourist from the Netherlands in 1852; "everything was confused and indistinct."[22] Morse downplayed architectural drama and countered potential bewilderment by relocating highlights of the collection to the manageable confines of the Salon Carré (which he also reduced in scale) and by telescoping the Grande Galerie in the frame of the doorway, making it appear no larger than Jean Jouvenet's *Descent from the Cross* on the left wall.

Morse also chose not to show the museum on one of its public days. Until as late as 1855, the Louvre was open to the general public only on weekends,

with weekdays reserved for artists and tourists. Young copyists dominate the scene. Poised on either side of the doorway separating the Salon and the Grande Galerie are a woman and child and an elegantly dressed man. The former, attired in exotic (Breton?) costume, instantiate the trope of the foreign visitor in museum images dating back to the pair of gesturing "Turks" at the threshold of Hubert Robert's imaginary view of the Louvre (fig. 15). Exotic sightseers have the obvious function of signifying the universal drawing power of the museum. As the woman and child leave Morse's Salon Carré, the man, top hat in hand, approaches its entrance, his body language signaling hesitation and curiosity in contrast to the casual ease among the artists and friends. Is this visitor perhaps an avatar for the idealized art lover Morse hoped would see his exhibition in New York and patronize his work?

Morse's image of refined and studious consumption of art contrasts with impressions of the Louvre on weekends, when attendance would rise above ten thousand and the sight, sounds, and even smells of the crowds competed with the paintings for attention. Public days at the Louvre inspired satire more than study (fig. 20). Ambitious artists stayed home while Honoré Daumier and fellow connoisseurs of the human condition were in their element. Morse scholars have noted his ambivalence toward the general public, craving its support yet disdainful of its "boorishness and ill manners."[23] One imagines that *Gallery of the Louvre* might have enjoyed more popular success as an exhibition if he had sought to entertain rather than to educate, but Morse was an ambitious artist whose hope was to elevate American taste to the point that the pleasures of serious art would be their own reward.

But even judged by his own ambitions, Morse's painting is compromised by contradiction. The future of American art depended on a period of apprenticeship to the European masters, accessed not through scarce and expensive originals but through commissioned copies executed by Morse and others. The most enthusiastic review of *Gallery*

FIG. 20 Honoré Daumier (French, 1808–1879). *A day when you do not pay. Twenty five-degree heat (Un jour où l'on ne paye pas. Vingt-cinq degrés de chaleur)*, from "Le Public du Salon," in *Le Charivari*, May 17, 1852. Printer: Charles Trinocq, Paris; Publisher: Maison Martinet-Hautecoeur, Frères, Paris. Lithograph, second state of two (Delteil), 9⅝ × 8½ in. (24.5 × 21.6 cm). A. Hyatt Mayor Purchase Fund, Marjorie Phelps Starr Bequest, 1980, The Metropolitan Museum of Art, New York, 1980.1114.2. Photo © The Metropolitan Museum of Art. Image Source: Art Resource, NY

of the Louvre in the New York press thanked Morse for introducing Americans to the "great magicians" of the old world: "We have never seen anything of the kind before in this country. . . . He has been able in so high a degree to enchant us with the vivid thoughts of the great magicians of his charming art."[24] Morse's predicament was that the success of his image of the Louvre depended on the fidelity with which he imitated the distinctive manners of *other* artists—in other words, on his own displacement.

FIG. 21 *Paris, Palais du Louvre, La Grande Galerie [Patras]*. Postcard

"Every one says I have caught the style of each of the masters,"[25] he boasted in a letter home in 1832, but Morse was no longer an apprentice; he was a mature artist in his early forties yearning to create original compositions of lasting fame. His celebration of the Louvre and his selfless imitation of others perpetuated the perceived superiority of the canon even as it hindered appreciation of his own creative stake in the painting. What constitutes his imaginative contribution—the "curating" of the Salon Carré—could easily have been mistaken by American viewers as a transparent record of the room to go along with his faithful rendering of individual paintings. The problem for artists in the academic tradition was how to master and transcend the example of the old masters and how, at the same time, to break through the prevailing taste for those same masters among collectors and the public—a taste cultivated by the Louvre and other new museums.

Morse appears to acknowledge the value of creation over imitation in the figure of the male painter on the left (tentatively identified by David Tatham as Morse's Paris roommate Richard West Habersham).[26] Among those at work in the Salon Carré, he is the only one whose canvas can be seen, and it is surely significant that what he is painting is

not a copy but a landscape of his own design. By the 1830s in Europe, the academic tradition that Morse upheld, which bound the present to the past, was beginning to break down. To be sure, artists continued to study at the Louvre and to encourage their pupils to do the same, yet the gap between sources of inspiration and finished work grew wider. The tension between tradition and innovation at the heart of the Romantic movement pulsed through the exhibition commemorated by Maillot. Gustave Courbet would soon advise students to study the old masters not just to emulate their work but the better to discover their own artistic personalities. He also suggested that the best way to create an energetic art of the future would be to burn down the Louvre.[27]

As the nineteenth century progressed, the market for copies also changed. The number of copyists and of copies mushroomed after midcentury, diluting their value. In 1873 a misguided venture by the critic Charles Blanc to create a "Museum of Copies" closed within two months due to lack of public interest.[28] By the 1890s the rise of commercial photography caused the market for copies to collapse entirely. At the same time, museum postcards eliminated the need for painted gallery views as souvenirs (fig. 21). Unwittingly, Morse's contributions to the development of photography fueled the obsolescence of his painting of the Louvre—another act of self-displacement.

Morse gave up painting for more rewarding and lucrative pursuits, while his *Gallery of the Louvre* changed hands and remained largely out of the public eye. Later in life he claimed indifference to the fate of his art, but he would surely be surprised by his great picture's newfound celebrity and place of honor in the halls of America's museums, which over the last century and a half have established themselves as worthy rivals of the mighty Louvre.

Notes

1 Morse, quoted in Paul J. Staiti, *Samuel F. B. Morse* (Cambridge: Cambridge University Press, 1989), 189.

2 Joshua Reynolds, *Discourses on Art*, 1769–90, ed. Robert R. Wark (New Haven: Yale University Press for the Paul Mellon Centre for Studies in British Art, 1975), 103.

3 A. Lecoy de la Marche, *L'Académie de France à Rome* (Paris: Didier, 1874), 366.

4 See Francis Haskell and Nicholas Penny, *Taste and the Antique: The Lure of Classical Sculpture, 1500–1900* (New Haven: Yale University Press, 1981), chap. 6.

5 See Andrew McClellan, *Inventing the Louvre: Art, Politics, and the Origins of the Modern Museum in Eighteenth-Century Paris* (Berkeley: University of California Press, 1999), chap. 1.

6 *Adresse, mémoire et observations présentés à l'Assemblée Nationale par la Commune des arts* (Paris: n.p., 1791), 8. (All translations mine.)

7 Jacques-Louis David, *Convention Nationale: Second rapport sur la nécessité de la suppression de la commission du muséum* (Paris: Imprimérie Nationale, [1794]), 4.

8 *La décade philosophique* (10 thermidor year VI), 230–32.

9 Paris, Archives Nationales, F21 569 (1), folio 19. On copying at the Louvre in the nineteenth century, see Albert Boime, *The Academy and French Painting in the Nineteenth Century* (New Haven: Yale University Press, 1986); Theodore Reff, "Copyists in the Louvre, 1850–1870," *Art Bulletin* 46 (December 1964): 552–59; Paul Duro, "Copyists in the Louvre in the Middle Decades of the Nineteenth Century," *Gazette des Beaux-Arts* 111 (April 1988): 249–54; Paul Duro, "The 'Demoiselles à copier' in the Second Empire," *Women's Art Journal* 7 (1986): 1–7; and Jean-Pierre Cuzin and Marie-Anne Dupuy, *Copier créer: De Turner à Picasso: 300 oeuvres inspirées par les maîtres du Louvre* (Paris: Réunion des Musées Nationaux, 1993).

10 Ingres, quoted in Boime, *The Academy and French Painting*, 124.

11 Cézanne, quoted ibid.

12 Cuzin and Dupuy, *Copier créer*, 43.

13 The disdain of American artists for French painting is discussed by Paul Staiti, "Les artistes américains et la révolution de juillet," in *Les artistes américains et le Louvre*, ed. Elizabeth Kennedy and Olivier Meslay (Paris: Hazan, 2006): 54–71.

14 On the British Institution, see Peter Fullerton, "Patronage and Pedagogy: The British Institution in the Early Nineteenth Century," *Art History* 5 (March 1982): 59–72.

15 Morse to his parents, March 12, 1814, quoted in Staiti, *Morse*, 31.

16 André Félibien, *Entretiens sur les vies et sur les ouvrages des plus excellens peintres*, 2nd ed. (Paris: Sébastien-Mabre Cramoisy, 1685), 2:3. For more on the relation between art theory and reception in this period, see McClellan, *Inventing the Louvre*, chap. 1.

17 "Mémoire et plan relatifs à l'organisation d'une École Nationale des Beaux-Arts qui ont le dessin pour base. Par une société d'artistes," in *Regulating the Académie: Art, Rules and Power in ancien régime France*, ed. Reed Benhamou (Oxford: Voltaire Foundation, 2009), 278.

18 See, for example, the entry on "Imitation" in Claude-Henri Watelet and Pierre-Ch. Levesque, *Dictionnaire des arts de peinture, sculpture et gravure* (Paris: L. F. Prault, 1792), 3:137–38.

19 Samuel F. B. Morse, *Lectures on the Affinity of Painting with the Other Fine Arts*, ed. Nicolai Cikovsky, Jr. (Columbia: University of Missouri Press, 1983), esp. lecture 4.

20 Thomas Jessop, *Journal d'un voyage à Paris en Septembre–Octobre 1820*, ed. F. C. W. Hiley (Paris: H. Champion, 1928), 57.

21 [John Dean Paul], *Journal of a Party of Pleasure to Paris* (London: Cadell and Davies, 1802), 36, 39.

22 Jean Galard, ed., *Visiteurs du Louvre* (Paris: Réunion des Musées Nationaux, 1993), 77.

23 Morse, undated note, quoted in Staiti, *Morse*, 198.

24 Quoted in Staiti, *Morse*, 199.

25 Morse to his brothers, July 18, 1832, quoted in Staiti, "Les artistes américains," 68.

26 David Tatham, "Samuel F. B. Morse's *Gallery of the Louvre*: The Figures in the Foreground," *American Art Journal* 13 (Autumn 1981): 44.

27 See Reff, "Copyists in the Louvre," 552; and Galard, ed., *Visiteurs du Louvre*, 160–61.

28 Paul Duro, "'Un livre ouvert à l'instruction': Study Museums in Paris in the Nineteenth Century," *Oxford Art Journal* 10 (1987): 44–58.

Images as Evidence? Morse and the Genre of Gallery Painting

CATHERINE ROACH

SAMUEL F. B. MORSE'S *Gallery of the Louvre* (plate 1) is one of three extant canvases from 1831 that depict the northwest wall of the Salon Carré: the other two examples were painted by the French artist Nicolas Sébastien Maillot and the English artist John Scarlett Davis (figs. 18 and 29). The number of images of this space both reflects the cultural importance of the Louvre at this moment and illustrates the early-nineteenth-century resurgence of the genre of gallery painting. The question of how these three gallery paintings of the Louvre relate to each other, and to the actual contents of the Salon Carré, raises larger methodological questions about the use of images as historical evidence. Scholarship has tended to treat Morse's *Gallery of the Louvre* as a creative endeavor and Maillot's and Davis's works as visual documents. In fact, all three may include significant inventions on the part of the painter. The conventions of the genre allowed artists to transform existing displays in order to create programmatic statements. Gallery pictures therefore rarely constitute exact records, but instead represent a rich source of information about past attitudes toward art. By selectively repainting the contents of the Louvre, each artist commented on the status of his national school in relationship to the established European tradition. Morse's contribution to the genre was not the concept of rehanging a gallery to convey a message, but rather the specific message he crafted for his American audience.[1] Whereas Maillot and Davis constructed visual lineages based on past associations, Morse of necessity looked to the future. His painting is larger and his

sampling of the Louvre's collection more diverse. By reproducing a variety of periods and styles, Morse claimed the contents of the Louvre as the raw materials out of which an American school of art might be created.

The genre of gallery painting emerged from the complex culture of the seventeenth-century Netherlands. Even as rising prosperity fueled a growing market for easel paintings, the region was rent by religious and political conflicts, including fierce debates about the proper use of images. Some of the first examples of the genre, produced in Spanish Hapsburg–ruled Antwerp, contrast splendid compilations of images with donkey-headed men wreaking havoc, a biting commentary on Protestant iconoclasts.[2] These earliest gallery pictures promote the assembled images as sources of knowledge and contrast them with ignorant destruction. Patrons quickly discovered that the genre also lent itself to self-promotion, and they commissioned images highlighting their own collecting acumen and social ambitions. Most famous among these are the gallery paintings created by David Teniers II for Archduke Leopold Wilhelm, who became regent of the Southern Netherlands in 1647 (fig. 22). Distributed as diplomatic gifts, Teniers's images spread the fame of Leopold Wilhelm's collection, built from works that had become available for acquisition as a result of the English Civil War.[3] The series is closely related to another project that Teniers undertook for his patron—an illustrated catalogue of the archduke's collection titled the *Theatrum Pictorium* (1660).

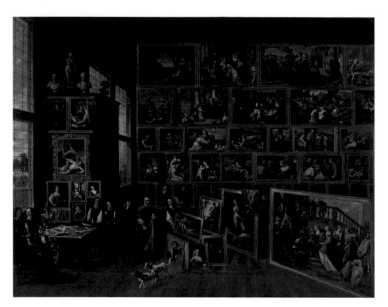

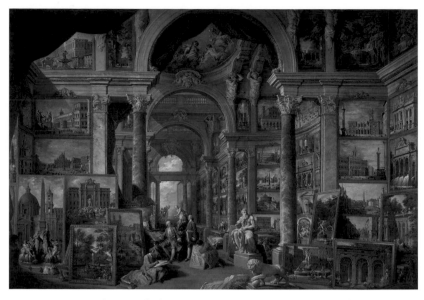

FIG. 22 David Teniers II (Flemish, 1610–1690). *Archduke Leopold Wilhelm in His Picture Gallery*, 1651. Oil on canvas, 50 × 64½ in. (127 × 163.8 cm). Petworth House and Park, National Trust, United Kingdom, 486159

FIG. 23 Giovanni Paolo Panini (Italian, 1691–1765). *Picture Gallery with Views of Modern Rome*, 1757. Oil on canvas, 67 × 96¼ in. (170.2 × 244.5 cm). Museum of Fine Arts, Boston, 1975.805. Photo © 2014 Museum of Fine Arts, Boston

Teniers made reduced oil replicas of Leopold Wilhelm's paintings to serve as models for the engraved plates in the catalogue.[4] By miniaturizing the collection, each of Teniers's projects yielded a portable synopsis of a gathering of artworks, providing surrogates that could travel more easily through space and over time.[5] Morse would later push this concept to its logical conclusion when he presented *Gallery of the Louvre* to audiences in America as a substitute for the Louvre.

Yet even though such images offered a sense of visual access to the collection, they were actually translations. Both Teniers's gallery pictures and the *Theatrum Pictorium* present *his* versions of the archduke's paintings by Raphael, Tintoretto, Veronese, and others. As originated in the seventeenth century, gallery paintings visualized power: the power of ownership, for the patron, and the power of association and arrangement, for the artist. Designed to promote patrons' taste and wealth, they also allowed artists to assert their own status. Paradoxically, the assemblage of so many miniature copies gave the artist an opportunity to demonstrate his originality through their

rendering and location. By re-creating a work, one could lay claim to it; by placing it in conjunction with other works, one could make a statement about its significance. Valued because they could compellingly evoke the contents of a specific collection, these early examples of the genre nonetheless often featured invented spaces and arrangements.[6]

Gallery paintings began to appear throughout Europe in the eighteenth century. In Italy, Giovanni Paolo Panini adapted the format for local collectors and Grand Tourists, creating a new variation on the genre: imaginary halls hung with paintings depicting the wonders of Rome. Morse admired Panini's work; in 1834 an art dealer asked for Morse's opinion on four Paninis under consideration for purchase by the Boston Athenaeum, including *Picture Gallery with Views of Modern Rome* (fig. 23). Morse confidently judged them "undoubtedly original works of Pannini" and "the finest pictures of their class I have ever seen."[7] His familiarity with the artist may have been gained during Morse's visits to London, as Panini was popular with British collectors,[8] or in Rome in 1830. An intriguing link between his *Gallery of the Louvre*

and Panini's own gallery pictures is their grand scale: whereas Teniers and his later imitators painted smaller, cabinet-size pictures, Panini's gallery pictures could be as large as six and a half by nine feet, providing an important precedent for Morse's monumental canvas.

Panini remained popular with British collectors well into the nineteenth century. In 1821 the influential patron George Beaumont acquired a Panini gallery painting he deemed "most amusing."[9] This purchase reflects interest in the genre in Britain, where Morse studied between 1811 and 1815. As had been the case in Antwerp two centuries earlier, early-nineteenth-century London was home to a flourishing art market. Just as earlier Continental collectors had benefited from English political upheaval, London's picture trade expanded during the French Revolution. This development in turn fostered interest in images of collections both new and old. Since the seventeenth century, dynastic and trade ties had brought Netherlandish artists and

artworks, including numerous historical examples of gallery paintings, to England.[10] In the 1820s, four images of picture galleries attributed to Teniers were shown at London's collector-run exhibition society, the British Institution.[11] Teniers's *Archduke Leopold Wilhelm in His Picture Gallery* hung at the country house of Petworth,[12] where the third Earl of Egremont made his collection available to favored artists for study.

The British royal collections held several examples of the genre, including a *Cabinet of Pictures* attributed to the Flemish painter Gonzales Coques. Scholars have speculated that this painting, which hung in Queen Charlotte's sewing room at Kew, might have inspired her to commission perhaps the most famous British gallery painting, Johann Zoffany's *The Tribuna of the Uffizi* (fig. 24).[13] This iconic image features Grand Tourists amid Florence's art collections, rehung according to the artist's preferences. It has long been thought that Morse saw this painting at a British Institution exhibition in 1814, but that belief

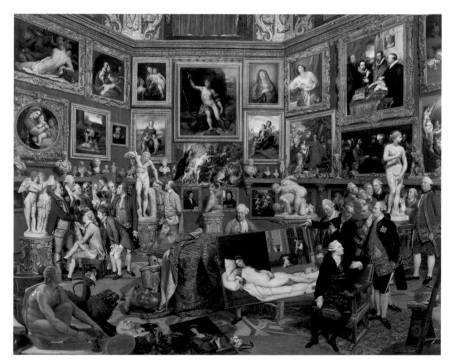

FIG. 24 Johann Zoffany (German, 1733–1810). *The Tribuna of the Uffizi*, 1772–77. Oil on canvas, 48⅝ × 61 in. (123.5 × 155 cm). The Royal Collection, United Kingdom

FIG. 25 John Pasmore II (British, active 1835–45). *Benjamin West's Gallery*, 1831–45. Oil on canvas, 29½ × 24¾ in. (74.9 × 62.2 cm). The Ella Gallup Sumner and Mary Catlin Sumner Collection Fund, Wadsworth Atheneum, Hartford, Connecticut

FIG. 26 Hubert Robert (French, 1733–1808). *View of the Grande Galerie of the Louvre*, 1796. Oil on canvas, 45¼ × 57¹⁄₁₆ in. (115 × 145 cm). Musée du Louvre, Paris, R.F. 1975-10

is based on a misunderstanding of the Institution's exhibition schedule that conflates two separate events.[14] Beginning in 1813, the Institution hosted two annual exhibitions: a winter contemporary art exhibition and a summer historical art exhibition. Morse attended the contemporary art exhibition of 1814 in order to view paintings by his mentor, Washington Allston.[15] But Zoffany's *Tribuna* was not on view at this exhibition; instead, it was part of the historical art exhibition held earlier in the year, between May and late August. Morse's correspondence indicates that he was in London until early July, so he certainly had the opportunity to see the painting, but as of yet no historical evidence places him at the exhibition.[16] If he did attend, Zoffany's painting would have been hard to miss: it was displayed on the first wall visible to visitors entering the space.[17] Morse might have seen a later image of the Tribuna painted by his American colleague Amasa Hewins in the early 1830s (Museum of Fine Arts,

Boston); the two men traveled together from Florence to Venice in the summer of 1831, before Morse returned to France and began to paint *Gallery of the Louvre*.[18] Hewins's painting provides a vivid sense of the architecture and scale of the Tribuna, but he emphasizes the overall composition rather than delineating the individual styles of the pictures-within-the-picture, as did Zoffany and, later, Morse.

Morse would not have needed to see these paintings to be familiar with the genre, however. Gallery paintings abounded in early-nineteenth-century Britain. The availability of historical examples by artists such as Teniers, Panini, and Zoffany, combined with the proliferation of novel kinds of display spaces, led to new essays in the genre. Artists took as their subjects not only private collections but also a more recent phenomenon—urban exhibition spaces. The result transformed the meaning of the genre. Previously, gallery paintings had celebrated elite, private collecting. Now the ownership depicted was

often collective and national, in the case of spaces like London's National Gallery, or entrepreneurial, in the case of exhibition spaces with paid admission, such as Benjamin West's Gallery (fig. 25). In his pioneering book on Morse, Paul Staiti argues that *Gallery of the Louvre* represents a "radical departure" from previous gallery paintings: "What had for centuries been a stereotype of aristocratic genre painting became in Morse's hands an image of bourgeois education."[19] Rather than being responsible for this departure, however, Morse was actually participating in a larger trend. Images of galleries as sites of education can be found on both sides of the Channel, including Hubert Robert's *View of the Grande Galerie of the Louvre* of 1796 and John Scarlett Davis's *Interior of the British Institution* of 1829 (figs. 26 and 27). Robert depicts a state museum and Davis a privately funded exhibition society, but both feature diverse audiences (including women and children) studying artworks. Moreover, rather than representing a radical break, this appropriation of an elite genre sought elevation through association. By emphasizing

education, these images held out the possibility, in theory, of social mobility, but they also preserved the notion of social distinction, now marked by intellectual cultivation as well as by simple rank. As Patricia Johnston has shown, Morse does not so much banish the connoisseur from his image as usurp that role for himself.[20] In *Gallery of the Louvre*, both Morse and his friend James Fenimore Cooper point to works of art, echoing earlier gestures of authority seen in gallery paintings by Teniers and Zoffany, among others.

Some of these new gallery paintings reflected the actual arrangements of the spaces they depicted, such as *Benjamin West's Gallery*, by John Pasmore II, which indicates the same hanging order as the exhibition catalogue and a contemporaneous engraving (although it also simplifies the hang, omitting many smaller pictures).[21] Others, however, preserved the element of fantasy inherent in the genre from its beginnings. We are extremely fortunate to have the three oil paintings made in 1831 depicting the Salon Carré: Morse's *Gallery of the Louvre*, John Scarlett Davis's *Salon Carré and the Grand Galerie of the Louvre*,

FIG. 27 John Scarlett Davis (English, 1804–1845). *Interior of the British Institution*, 1829. Oil on canvas, 44½ × 56 in. (113 × 142.2 cm). Yale Center for British Art, New Haven, Paul Mellon Collection, B.1981.25.212

1831, and Nicolas Sébastien Maillot's *View of the Salon Carré of the Louvre in 1831*. Morse and Davis present an overlapping, but not identical, selection of old masters; Maillot shows a display of the French School. The existence of three paintings, all purporting to show the same wall of the same room in the same year yet depicting three different hangs, provides an excellent opportunity to examine how we use gallery paintings as evidence. To date, the Davis and Maillot have been treated as potential sources of information about the actual contents of the room, while Morse's depiction has been seen as a creative interpretation. Yet all three painters may have taken artistic liberties. Moreover, these liberties were not taken at random: they were made in the service of specific programs.

For many years it has been accepted as fact that, upon his return to Paris from Italy in 1831, Morse found to his dismay that the government ushered in by the July Revolution had rehung the Salon Carré with French paintings, rather than the customary selection of highlights from the European pantheon.[22] The actual contents of the room have yet to be determined, however. As Staiti acknowledges, the notion that the room was hung with French works rests on accepting a single painting, Maillot's *View of the Salon Carré of the Louvre in 1831*, as an accurate record.[23] But the conventions of the gallery painting genre, which include invention and narrative, should make us cautious of relying upon such images as evidence.

Determining what was on view in the Salon Carré at any given moment is extremely difficult because of the special nature of this space. Usually it held a selection of the Louvre's most impressive works; contemporary catalogues simply note that works "of diverse schools" could be found there.[24] But every two years, it also served as the venue for the exhibition of contemporary art to which it gave its name, the Salon. The Salon was in session in May 1831 when Morse's friend Thomas Cole complained about visiting the Louvre only to find that "the works of the old masters were covered with the productions of

FIG. 28 Detail of Nicolas Sébastien Maillot, *View of the Salon Carré of the Louvre in 1831*, 1831. Musée du Louvre, Paris. See fig. 18

modern painters."[25] Cole meant "covered" literally: in order to accommodate the display of new works, the royal architect Pierre-François-Léonard Fontaine devised what he called "a mobile framework of fir planks which stands in front of the old paintings."[26] This clever innovation spared administrators the curatorial headache of having to rehang the permanent display after every Salon. The older paintings could remain undisturbed behind the temporary wooden barriers, waiting to be revealed at the end of the contemporary art exhibition.

Fontaine's invention suggests that the arrangement of the permanent collection in the Salon Carré may have been fairly stable. Yet Maillot's *View of the Salon Carré of the Louvre in 1831* shows something entirely different: not a sampling of all the schools nor a display of new French works, but a survey of the French School of painting from the seventeenth century to the present (figs. 18 and 28). Maillot, a minor painter of history and genre, also held the post of picture restorer for the Musée Royal (as the Louvre was then known) and thus would have been very familiar with its contents.[27] Until now, Maillot's image has been taken as evidence of what Morse

actually saw in 1831. But could it be that Maillot's painting presents an imaginary scene, showing what the display could have been, rather than what it was? The specificity of the work's title when it was exhibited at the Salon in 1833—*Le Grand Salon et la Grande Galerie un jour d'étude, peint en 1831* (The Grand Salon and the Grande Galerie on a study day, painted in 1831)—certainly suggests direct observation of a specific hang.[28] In addition, an American newspaper article published in 1833 urged travelers to view one of the paintings seen in the Maillot, Théodore Géricault's *Raft of the Medusa* (1818–19), in "the ante-chamber of the Louvre gallery"; if this phrase alludes to the Salon Carré, it matches Maillot's image.[29] However, in 1832, Maillot contributed a work titled *Vue du Salon et de l'entrée de la Grande Galerie du Musée Royal, présentant l'exposition d'un tableau de chaque maître qui ont le plus illustré l'école française* (View of the Salon and of the entrance to the Grande Galerie of the Musée Royal, displaying a painting by each master who best illustrates the French School) to an exhibition held to raise funds for the victims of cholera.[30]

It is possible that Maillot created two different views of the same room within a year, but his time available for painting was limited by his duties as restorer. Could the works displayed in 1832 and 1833 instead be one and the same painting, exhibited under two different titles? Certainly the two works were similar, if not identical; at least eleven artists represented in the Louvre's canvas also appeared in the work shown in 1832.[31] The title given to the work exhibited in 1832 implies a fictional gallery, designed to highlight the achievements of the nation's painters. If so, it would not be unique. For instance, in 1824 the British painter William Frederick Witherington presented a visual argument on behalf of his national school in *A Modern Picture Gallery* (Wimpole Hall, National Trust, United Kingdom). This work depicted an invented collection of actual works by British artists, designed both to highlight their achievements and to protest the lack of a space devoted to displaying them.[32] Maillot's *View of the*

Salon Carré of the Louvre in 1831 might similarly present a visual argument, suggesting how the French authorities should fill this prominent space rather than recording its current contents.

Maillot's gallery picture presents an intriguingly selective vision of the French School: of the twelve works I have been able to identify, five date from the lifetime of Louis XIV and seven from the late eighteenth and early nineteenth centuries.[33] Charles Le Brun's monumental *Battle of the Granicus* (1665) hangs at the top of the center wall, above Anne-Louis Girodet de Roucy-Trioson's *Scene from a Deluge* (1806) and Géricault's *Raft of the Medusa*—a juxtaposition that suggests a transmission of the grand history-painting tradition directly from the Baroque to the Romantic, suppressing the Rococo altogether. A key figure in the history-painting tradition in France, Jacques-Louis David, is sidelined: just a portion of his *Intervention of the Sabine Women* (1799) is visible at far right, bisected by the edge of the canvas. But it remains to be discovered whether the hang I have just analyzed was an invention or an actual installation.

Determining whether Maillot's painting reflects a historical display offers rich potential for future research: archival records as well as tourists' letters and diaries may yield some clues as to the contents of the Salon Carré in this period. Absent such information, the visual contents of Morse's, Maillot's, and Davis's paintings provide some tantalizing suggestions. Intriguingly, two works appear in all three canvases: just visible at left in the Maillot is the frame of a very large composition, which is surely Veronese's *Wedding Feast at Cana* (fig. 75), next to Jean Jouvenet's *Descent from the Cross* (fig. 76). Both works also appear in that same position in Morse's and Davis's paintings. It seems probable that this arrangement was in place in 1831, especially since the massive size of Veronese's *Wedding Feast* likely meant that it was not often moved. Nonetheless, I would prefer to have corroborating evidence before definitively coming to such a conclusion—not because images can never serve as reliable evidence,

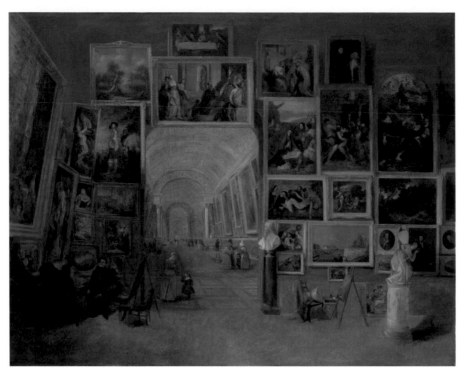

FIG. 29 John Scarlett Davis (English, 1804–1845). *The Salon Carré and the Grande Galerie of the Louvre, 1831*, 1831. Oil on canvas, 44¹¹⁄₁₆ × 57¹⁄₁₆ in. (113.5 × 145 cm). Government Art Collection, United Kingdom, 14296

but because gallery paintings constitute a different kind of evidence, often telling us more about how artists thought about art than about how curators actually arranged it. This does not mean that we should stop seeking to mine these images for information; for instance, the fact that four images of the Salon Carré, including the three discussed here, show paintings hanging diagonally across a corner of the room suggests that this was in fact a standard display practice.[34] But we must carefully evaluate the contents of gallery paintings along with visual and textual evidence, remaining aware that artists often had agendas other than straight-forward documentation.

John Scarlett Davis created *The Salon Carré and the Grand Galerie of the Louvre, 1831* (fig. 29) the same year that Morse began painting his view. Thirteen years Morse's junior, Davis had also studied at the Royal Academy schools in London. Earlier in his career, he had supported himself by working as a copyist and painting portraits—which, like Morse,

he disdained. His gallery paintings depicting the British Institution and the Naval Gallery, Greenwich, brought Davis to the attention of patrons and opened a different avenue of artistic production. It is just possible that these two ambitious artists met in Paris and discussed their paintings of the Louvre. Morse stopped in France briefly in January 1830, but he had already left for Italy when Davis arrived in Paris in December of that year. Davis remained in Paris until at least February 1831, when he informed his mother that he had "nearly completed my works of the Louvre" and planned to move on to Venice in the next two or three months.[35] It is not clear whether Davis's projected trip ever took place or if he was still in Paris when Morse returned from Italy in September.[36]

As tempting as it is to speculate about specific connections between Morse and Davis, they may simply have both been engaged in the established genre of the gallery picture. Strong formal similarities

link their two images of the Salon Carré, but this may ultimately tell us more about visual conventions of the time than about a shared artistic project. Both artists chose a view into the Grande Galerie, as did Maillot. As a glance at the illustrations for this essay makes clear, a view through a doorway, suggesting a further abundance of artworks in a space beyond, is a common feature of gallery paintings. Similarities in staffage may also be ascribed to generic conventions. Both the Morse and the Davis images include self-portraits alongside a female artist, and both show a woman in rustic costume holding hands with a child, poised in the doorway. But the mother and child motif appears in earlier images by Hubert Robert, as well (see fig. 26, for example).

Both Morse and Davis show the Salon Carré hung with old masters. Previous accounts have stated that Morse's and Davis's pictures have seven paintings in common; in fact, there are nine.[37] Of these, four appear in precisely the same position in both paintings: Jouvenet's *Descent from the Cross*, Rembrandt's *The Angel Leaving the Family of Tobias* (fig. 86), and two paintings by Veronese: *Wedding Feast at Cana* and *Christ Carrying the Cross*. Two works appear in roughly the same position in both: Titian's *Supper at Emmaus* (fig. 80) and his *Entombment*. The final three works appear in completely different spots: Titian's *Christ Crowned with Thorns* is placed on a different side of the door in each painting, while Cornelis Huysman's *Landscape with Shepherds and Herds* and Correggio's *Mystic Marriage of Saint Catherine of Alexandria with Saint Sebastian* (fig. 82), shown side by side on the very top row at the center of Morse's picture, appear on the same wall but separated and near the viewer's eye level in Davis's canvas. The fact that certain paintings appear in both works may simply indicate their canonical status at the time: four of those paintings also appear on a list of the Louvre's most frequently copied paintings from the 1850s.[38] But the similar location of six out of the nine paintings seen in both works does raise the tantalizing possibility that they reflect, to some extent, an actual hang. In that case, either Morse and Davis

each partially re-created an earlier display of old masters that was later replaced by the installation of the French School seen in Maillot's painting, or Maillot's painting is not a reliable document.[39] But even if Morse and Davis were working from what was or had been in the room, each artist used the existing hang only as a starting point for his own arrangement and his own message.

Davis's painting has been dismissed as "prosaic, even banal" in comparison to Morse's.[40] Another author suggests that "it is unlikely that his picture has any polemical message."[41] And yet Davis is known to have painted polemically: in his painting of the British Institution in 1829 (fig. 27), he rearranged the hang in order to emphasize the achievements of the British School.[42] He juxtaposed works by British painters of the previous generation, including Joshua Reynolds and Thomas Gainsborough, with Continental masterpieces, asserting British painting's ability to hang alongside the best of European art. His depiction of the Salon Carré similarly conveys a message, and by ignoring it, we would forfeit the opportunity to understand what was unique about Morse's own message. Davis sought to make a claim for his national school's existing status within the European tradition, selectively reproducing works that bolstered that claim. Morse, in contrast, hoped that his nation could one day make a similar claim. He reproduced a wider variety of artists and styles, to be used as the basis for future successes of American art—including his own achievements.

The differences between these two canvases highlight a key function of gallery pictures in the early nineteenth century: to tell stories about the status of the artist and his national school. Although Morse and Davis were both educated in the British academic system, they represented different national perspectives, and this can be seen in their images of the Louvre. For both men, travel abroad heightened their sense of national identity. "How can I be of service in refuting the calumny, so industriously spread against [America], that she has produced no men of genius? . . . I should like to be the greatest

men of genius? . . . I should like to be the greatest painter *purely out of revenge*," declared Morse after three years in London.[43] For his part, Davis wrote from France that the French were "centuries behind England in all that is connected with the fine arts."[44] Despite Davis's brash claim, artists from both Britain and the United States struggled with a sense of belatedness when comparing their national schools to those of Europe. Geographically detached from the Continent, and predominantly Protestant, both countries had a fraught relationship to the European artistic heritage, and these images attempt to negotiate that relationship. The two artists' choices reflect their different personal outlooks, national allegiances, and intended audiences.

These two paintings present very dissimilar visions of the Louvre's collection, and through it, of the European tradition. Davis's selection has a strong emphasis on Northern painting, especially Flemish and Dutch art of the seventeenth century. The Italian schools are represented mostly by Venice, with a smattering of Bolognese and Roman works. Morse's painting, in contrast, presents a survey of all the major schools—Florentine, Roman, Bolognese, Venetian, Dutch, Flemish, and Spanish—as befits a work trying to compress the Louvre onto one canvas for the benefit of an American public. Morse also allows much more room for French art than Davis, including not only two French artists active in Rome in the seventeenth century—Claude Lorrain and Nicolas Poussin—but also the eighteenth-century artist Jean-Antoine Watteau.[45] The only eighteenth-century painter included by Davis is Canaletto (represented by the large view of Venice to the right of the doorway, now attributed to Michele Giovanni Marieschi), who was enormously popular with British collectors.[46]

Davis's emphasis on Northern examples creates a visual lineage for his own national school. It had long been a sore point that Britain's most famous artists hailed from abroad. In 1762 Horace Walpole complained, "Flanders and Holland have sent us the greatest men we can boast," and he asked "why a nation that produced Shakespeare, should owe its glory in another walk of genius to Holbein and Van Dyck."[47] Nonetheless, these foreign-born practitioners gave the British School an important foothold in the European pantheon, and Davis's image plays up these connections. At right, a small circular self-portrait by Anthony van Dyck appears alongside portraits of other Continental luminaries—a bust of Raphael and a self-portrait by Rembrandt. Van Dyck's likeness hangs above *Tournament at the Château de Steen*, by his mentor, Peter Paul Rubens. The inspiration that Rubens continued to offer contemporary artists is embodied in the replica of his *Hélène Fourment and Her Children* leaning against the wall below. In histories of British art, Rubens was a key figure, both as Van Dyck's teacher and as the most prominent artist to have benefited from English patronage, having traveled to London at the behest of Charles I.

Davis invokes this connection at left by depicting Van Dyck's *Charles I* (fig. 30) alongside Rubens's *Triumph of Truth* from the Marie de Médicis cycle. This juxtaposition signals that Charles, like the French queen, was a patron of Rubens. Davis's prominent placement of Van Dyck's portrait may also constitute a lament for what might have been. Charles I was the greatest collector in British history, but also one of its worst kings. After he was dethroned and executed in 1649, the new government sold his personal goods, including his art. Davis's contemporaries mourned the loss of works that could have formed the basis of a national collection to rival the Louvre's.[48] In fact, two of the works seen in both Davis's and Morse's paintings, Titian's *Supper at Emmaus* and his *Entombment*, had previously been owned by Charles I. Davis's painting also includes Titian's *Fête Champêtre*, which had been owned by the royalist Earl of Arundel.[49] Davis thus creates the opportunity for viewers to contemplate the different consequences for art collections resulting from the English Civil War and the French Revolution. The English sold their beheaded king's art abroad, forfeiting the chance to establish a great national collection; the French made their beheaded king's art national property, available

FIG. 30 Anthony van Dyck (Flemish, 1599–1641). *Charles I*, ca. 1636. Oil on canvas, 104¾ × 81½ in. (266 × 207 cm). Musée du Louvre, Paris inv. 1236

element to Davis's program. Collecting in Britain had recently undergone a revival, stimulated by the turmoil of the French Revolution and the conflicts that followed. London could boast its own National Gallery, founded in 1824. The image of Charles I may suggest a historical precedent for this new generation of English collectors, thus flattering Davis's patron, Charles Long, Baron Farnborough. Long, who commissioned a series of views of famous Continental galleries from Davis, also served as art adviser to both George IV and William IV.

Morse employed a different tactic to signal the rise of his own national school. He could not, as Davis did, use works in the Louvre's collections to highlight his nation's contribution to the European canon. In 1831 the Louvre collections did not include any works by American artists, or even any plausible proxies such as Davis had found in Rubens and

Van Dyck. Instead, Morse predicted future successes for American art. He placed an image of himself prominently in the foreground, offering himself as the successor to the artistic splendors he re-created on his canvas. The difference between the messages of the two pictures also highlights an important difference between the circumstances of their creation. If Davis's painting mourns the lost opportunity for a national collection, Morse created his for a nation that had not yet had such an opportunity. Morse hoped to stimulate interest in such a collection and to stimulate patronage of the arts. But he was working on speculation, whereas Davis was working on commission. Davis had, essentially, to please an audience of one. Morse hoped to attract hundreds, if not thousands. His was a more modern, collective model of patronage, one that mirrored the concept of collective national property embodied in the Louvre. As Tanya Pohrt explores elsewhere in this volume, this patronage model also entailed much greater risk for the artist.

To understand the nature of Morse's invention, we must also understand that he was working within an inventive genre. Gallery pictures cannot be taken as definitive evidence of historical displays. But they do constitute important evidence of artists' predilections and prejudices. The same quality that makes them unreliable records—artists' tendency to rearrange a display when re-creating it on canvas—is what makes these images such revealing cultural artifacts. They constitute an artist's particular vision of the collection and of the canon that he or she selectively reproduced. Nationalism is a key theme for all three artists who painted the northwest wall of the Salon Carré in 1831. But Morse's vision of the Louvre's collections is more expansive and voracious than that of his French and British counterparts. He claimed a diverse sample of European art, from Florentine serenity to Rococo excess, as the foundation for future American successes in the realm of art.

Notes

1 David Tatham was first to point out Morse's adherence to established conventions in this regard. David Tatham, "Samuel F. B. Morse's *Gallery of the Louvre*: The Figures in the Foreground," *American Art Journal* 13 (Autumn 1981): 41.

2 Victor I. Stoichita, *The Self-Aware Image: An Insight into Early Modern Meta-Painting*, trans. Anne-Marie Glasheen (Cambridge: Cambridge University Press, 1997), 123–24.

3 Jonathan Brown, *Kings and Connoisseurs: Collecting Art in Seventeenth-Century Europe* (Princeton: Princeton University Press, 1995), 160.

4 See Ernst Vegelin van Claerbergen, ed., *David Teniers and the Theatre of Painting* (London: Courtauld Institute of Art Gallery, 2006).

5 Stoichita, *Self-Aware Image*, 105.

6 For further examples, see Zirka Zaremba Filipczak, *Picturing Art in Antwerp: 1550–1700* (Princeton: Princeton University Press, 1987); and Ariane van Suchtelen and Ben van Beneden, *Room for Art in Seventeenth-Century Antwerp* (Zwolle: Waanders, 2009).

7 Morse to Franklin Dexter, October 24, 1834, Boston Athenaeum Letters (1807–1887) B.A. 22, Boston Athenaeum Archives. Morse presumably saw the Paninis that were sold to the Athenaeum when they were shown at New York's American Academy of the Fine Arts in 1834. But there is also an intriguing possibility that he had seen them earlier, in the home of James Le Ray, a Frenchman with landholdings in upstate New York, who apparently brought the paintings to the United States in 1780. Fernando Arisi, *Gian Paolo Panini* (Piacenza: Casa di Risparmio di Piacenza, 1961), 212.

8 Alastair Laing, "Giovanni Paolo Panini's English Clients," in *Roma Britannica: Art, Patronage, and Cultural Exchange in Eighteenth-Century Rome*, ed. David R. Marshall, Susan Russell, and Karin Wolfe (London: British School at Rome, 2011), 113–20.

9 Felicity Owen and David Blayney Brown, *Collector of Genius: A Life of Sir George Beaumont* (New Haven: Published for the Paul Mellon Centre for Studies in British Art by Yale University Press, 1988), 207.

10 Christopher Brown, *Scholars of Nature: The Collecting of Dutch Painting in Britain, 1610–1857* (Hull: Ferens Art Gallery, 1981).

11 Algernon Graves, *A Century of Loan Exhibitions, 1813–1912*, vol. 3 (New York: Burt Franklin, 1914), 1289–91.

12 Vegelin van Claerbergen, *David Teniers and the Theatre of Painting*, 70.

13 Desmond Shawe-Taylor, *The Conversation Piece: Scenes of Fashionable Life* (London: Royal Collection Publications, 2009), 130.

14 David Tatham wrote that Morse "would have seen [Zoffany's *Tribuna*] in London in 1814 when it was exhibited at the British Institution along with Allston's *Diana* and *Dead Man Restored*." Tatham, "Figures in the Foreground," 41.

15 Samuel F. B. Morse, *Samuel F. B. Morse: His Letters and Journals*, ed. Edward Lind Morse (Boston: Houghton Mifflin, 1914), 1:122.

16 Ibid., 1:147.

17 *Catalogue of Pictures by the Late William Hogarth, Richard Wilson, Thomas Gainsborough, and J. Zoffani* (London: W. Bulmer, 1814), no. 2.

18 Amasa Hewins, *Hewins's Journal: A Boston Portrait-Painter Visits Italy*, ed. Francis H. Allen (Boston: Boston Athenaeum, 1931), xiv, 55.

19 Paul J. Staiti, *Samuel F. B. Morse* (Cambridge: Cambridge University Press, 1989), 192–93.

20 Patricia Johnston, "Samuel F. B. Morse's *Gallery of the Louvre*: Social Tensions in an Ideal World," in *Seeing High and Low: Representing Social Conflict in American Visual Culture*, ed. Patricia Johnston (Berkeley: University of California Press, 2006), 45.

21 *West's New Gallery, Newman Street, Oxford Street* (London: C. H. Reynell, 1822), 15. For the engraving, see Helmut von Erffa and Allen Staley, *The Paintings of Benjamin West* (New Haven: Yale University Press, 1986), 150.

22 See, for example, Staiti, *Morse*, 189; and Johnston, "Morse's *Gallery of the Louvre*," 41.

23 Paul Staiti, "American Artists and the July Revolution," in *American Artists and the Louvre*, ed. Elizabeth Kennedy and Olivier Meslay (Chicago: Terra Foundation for American Art; Paris: Musée du Louvre, 2006), 64.

24 *Notice des tableaux exposés dans le Musée Royal* (Paris: Vinchon, 1831), preceding page 1.

25 Cole, quoted in Louis L. Noble, *The Life and Works of Thomas Cole, N.A.*, 3rd ed. (New York: Sheldon, Blakeman, 1856), 125–26. The Salon opened on May 1, 1831. Cole arrived in Paris in early May and left on May 14. That Cole was viewing the Salon is confirmed by the fact that he praises a *Tempest* by Ary Scheffer, who exhibited a work by that title in that year's Salon. Pierre Sanchez and Xavier Seydoux, *Les catalogues des Salons*, vol. 2 (Paris: Échelle de Jacob, 1999), 267.

26 Christiane Aulanier, *Histoire du Palais et du Musée du Louvre: Le Salon Carré* (Paris: Éditions des Musées Nationaux, 1950), 61.

27 Claire Mangien, "Les Maillot, restaurateurs de couche picturale au Musée Royal (1818–1848)," *La Revue des Musées de France* 60 (February 2010): 88. In 1820 Maillot had restored Jean-Baptiste Greuze's *Self-Portrait,* seen in the oval frame at the extreme lower right of his picture of the Salon Carré.

28 Aulanier, *Histoire du Palais,* 61.

29 "Wreck of the Medusa," *New Hampshire Sentinel,* June 20, 1833, 1.

30 Aulanier, *Histoire du Palais,* 61.

31 *Explication des ouvrages de peinture, sculpture, architecture et gravure, exposés à la galerie du Musée Colbert, le 6 mai 1832, au profit des indigens des douze arrondissemens de la ville de Paris, atteints de la maladie épidémique* (Paris: Dezauche, 1832), 34–35.

32 Giles Waterfield, *Palaces of Art: Art Galleries in Britain, 1790–1990* (London: Dulwich Picture Gallery, 1991), 78–79.

33 They are, from left to right: Left wall: Jean Jouvenet, *Descent from the Cross* (1697). Center wall, top: Charles Le Brun, *Battle of the Granicus* (1665). Center wall, middle row: Anne-Louis Girodet de Roucy-Trioson, *Scene from a Deluge* (1806); Pierre-Paul Prud'hon, *Justice and Divine Vengeance Pursuing Crime* (1808) (directly below the Le Brun); Théodore Géricault, *Raft of the Medusa* (1818–19). Center wall, bottom row: Achille Etna Michallon, *The Death of Roland* (1819) (left of door); Amable Louis Claude Pagnest, *Le Chevalier de Nanteuil-Lanorville* (1817) (second work to the right of door); Claude Lorrain, *Ulysses Returning Chryseis to Her Father* (c. 1644) (farthest right). Right corner: Hyacinthe Rigaud, *Louis XIV* (1701). Right wall, second row from top: Simon Vouet, *Presentation in the Temple* (c. 1640) (next to Rigaud); Jacques-Louis David, *The Intervention of the Sabine Women* (1799) (far right). Right wall, bottom row: Jean-Baptiste Greuze, *Self-Portrait* (late eighteenth century) (far right). These identifications were made while looking at Aulanier, *Histoire du Palais,* plate 47.

34 The fourth is François Joseph Heim, *Charles X Distributing Prizes to Artists at the Salon of 1824* (1827), Musée du Louvre.

35 John Scarlett Davis to Anne Davis, February 19, 1831, John Scarlett Davis Correspondence, Hereford Record Office, Hereford, England.

36 On the basis of watercolors and drawings, Tony Hobbs places Davis in Paris until early 1832. Tony Hobbs, *John Scarlett Davis: A Biography* (Almeley, England: Logaston Press, 2004), 50.

37 There may be a tenth: the painting above Jouvenet's *Descent from the Cross* in Davis's canvas has been tentatively identified as Pierre Mignard's *Madonna and Child,* which appears on the opposite wall in Morse's image. For a key to the Davis, see Mary

Beal and John Cornforth, *British Embassy, Paris: The House and Its Works of Art* (Paris: Government Art Collection, 1992), 59.

38 Aug. Marc-Bayeux, "Les copistes du Louvre," in *Paris qui s'en va, et Paris qui vient* (Paris: A. Cadart, 1859), 4.

39 Staiti raises another possibility, that Morse and Davis "worked in some relation to each other." Staiti, "American Artists and the July Revolution," 71 n.23.

40 David McCullough, *The Greater Journey: Americans in Paris* (New York: Simon and Schuster, 2011), 64.

41 Beal and Cornforth, *British Embassy,* 58.

42 This painting is the subject of a chapter in my current book project on pictures-within-pictures in nineteenth-century British painting.

43 Morse to E. L. Morse, May 2, 1814, in Morse, *Letters and Journals,* 1:133.

44 John Scarlett Davis to Anne Davis, February 19, 1831, Hereford Record Office.

45 Watteau's composition is bisected by the edge of the canvas. This treatment, like Maillot's partial inclusion of David's *Sabine Women,* may suggest unease or ambivalence.

46 *Notice des tableaux,* 154.

47 Horace Walpole, *Anecdotes of Painting in England,* vol. 1 (Twickenham: Strawberry Hill, 1762), vi.

48 One history lamented the command for "the dispersion and destruction of the royal collections," remarking that "to the commencement of the reign of Charles the First all lovers of art and literature look with joy, and to the conclusion with sorrow." Allan Cunningham, *The Lives of the Most Eminent British Painters, Sculptors, and Architects,* vol. 1 (London: John Murray, 1829), 41, 31.

49 Brown, *Kings and Connoisseurs,* 63.

Morse's Models

RACHAEL Z. DELUE

SAMUEL F. B. MORSE was not the first artist to paint a picture of a celebrated art collection, nor was he the first to edit or embellish the collection he depicted. But Morse went further than others in pictorially reorganizing his subject, the Louvre's Salon Carré. He reinstalled the Salon Carré for many reasons. Clearly, he had a point to make, and his aspiration for *Gallery of the Louvre* (plate 1) to be widely viewed by audiences in the United States suggests that he believed his point to be an important one. Yet what concerns me here is not so much Morse's message but rather his models. What, aside from hubris, prompted Morse to think he could reorganize the Louvre, one of the world's most revered museums? What would have made it possible for him to imagine doing such a thing? And just what models existed to inspire such an enterprise? Instead of asking what Morse's picture means, this essay considers the conditions—artistic, intellectual, social, political—that allowed *Gallery of the Louvre* to come into being. Morse knew the tradition of gallery pictures represented by Hubert Robert (figs. 15 and 26), John Scarlett Davis (figs. 27 and 29), Nicolas Sébastien Maillot (fig. 18), and others, but other models existed as well—some more likely or more obvious than others. Elucidating a selection of them—namely, natural history, geography, and writing—illuminates not only Morse's project but also certain concerns of American painting in the early decades of the nineteenth century.

NATURAL HISTORY

In an 1822 letter to his son Rembrandt Peale, Charles Willson Peale described his ongoing work on *The Artist in His Museum* (fig. 31), a self-portrait commissioned by the trustees of Peale's Philadelphia museum to honor his many contributions to the art and culture of the United States. In the letter Peale said that he had depicted himself in the portrait "Bringing the beauties of Nature into public view."[1] This statement reflects his desire to educate the public and thus fashion an intelligent, rational, and productive citizenry for the young American nation.[2] Less obvious is the idea, implicit in the remark, that "Nature" required relocation in order to be seen. Nature, after all, exists everywhere, and to see it, one need only look. But Peale's undertaking as museum director involved extracting and reorganizing nature so that it could be closely studied and also so that its *re*-presentation would tell a specific story—one not necessarily evident in the jumble and confusion of nature on its own. Peale selected certain specimens and arrayed them so that their display yielded a pointed narrative about the God-given harmony, hierarchy, and fixity of the natural world, a narrative designed to address the anxieties of Peale's moment and to advocate for maintaining the status quo at a time of immense social and political change.[3]

Peale belongs in an essay about Morse's models for a number of reasons. To start, the paintings that Morse depicted in *Gallery of the Louvre*, stacked from floor to ceiling, call to mind the dozens of portraits

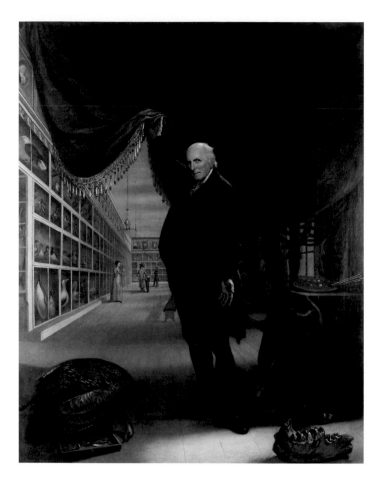

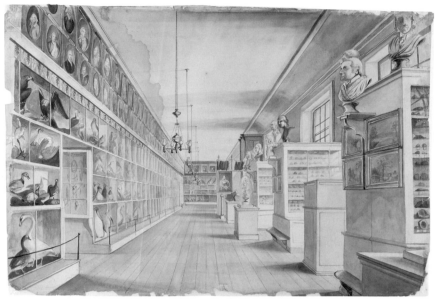

FIG. 31 Charles Willson Peale (American, 1741–1827). *The Artist in His Museum*, 1822. Oil on canvas, 103¾ × 79⅞ in. (263.5 × 202.9 cm). Courtesy of Pennsylvania Academy of the Fine Arts, Philadelphia. Gift of Mrs. Sarah Harrison (The Joseph Harrison, Jr. Collection), 1878.1.2

FIG. 32 Charles Willson Peale (American, 1741–1827) and Titian Ramsay Peale (American, 1799–1885). *The Long Room—Interior of Front Room in Peale's Museum*, 1822. Watercolor over graphite pencil on paper, 14 × 20¾ in. (35.6 × 52.7 cm). Founders Society Purchase, Director's Discretionary Fund, Detroit Institute of Arts, 57.261

hanging cheek by jowl in Peale's museum. Morse's paintings resemble even more the diorama boxes that lined the museum's long gallery, visible both in Peale's self-portrait and in a sketch he produced with his son Titian Ramsay Peale (fig. 32). Morse's plain brown and boxlike frames (which were presumably not those that actually adorned the Louvre's most prized works), along with the striking contrast of these frames to the colorful scenes within them, transform the walls of the Salon Carré into an array of cases populated with lifelike specimens—in this case, specimens not from nature but from the history of art. The copyists Morse depicted working in the Salon Carré, in turn, parallel the visitors to Peale's museum, for both are engaged in studying the specimens on view. The telescoping effect produced by the receding Grande Galerie in Morse's painting—which

is echoed by similar effects in several of the paintings in his Salon Carré, including Claude Lorrain's *Disembarkation of Cleopatra at Tarsus* (fig. 81) and *Sunset at the Harbor*—mirrors the exaggerated recession of the main gallery in Peale's picture.

Both Peale's museum, which put nature on public view by restaging it in two-dimensional and three-dimensional form, and Morse's *Gallery of the Louvre*, which made the museum's choice specimens accessible to American audiences by putting them into a single painting, employed a form of artifice in order to edify. In crafting their monumental self-portraits—Morse stands front and center in his, as does Peale—both men produced pictures populated by other pictures in order to tell a story about nature or art. And both set about their work under the sign of natural history, a discipline still developing as a

science in the 1830s, though already distinct from the natural history of the late eighteenth century, when Peale had founded his museum. Morse's painting resembles Peale's picture and calls to mind Peale's museum not by happenstance but because natural history appears to have provided a template for Morse's own work.[4]

Sophisticated, well read, and ambitious, Morse considered himself an heir to the artistic tradition he represented on the walls of the Salon Carré, and he believed that exposing American audiences to this tradition would help cultivate an intelligent and educated populace. Although he was a man of the arts, Morse was also familiar with the science of his day, having mastered the breadth of knowledge typical of learned men of the period. This is clear from his discussion of the pictorial principle of "*Connexion*" in terms of taxonomic relationships in his *Lectures on the Affinity of Painting with the Other Fine Arts*, delivered in four installments in 1826 for the New York Athenaeum:

> In the works of creation we perceive connexion binding the various parts of animal existence together. Man himself in exterior appearance stands not insulated and distinct from the animal world; witness the negro, the ouran outan, the baboon, the monkey by gradual and downward steps blending the human face divine, with the unseemly visage of the brute. Where is the line that severs the connection between beasts and birds, while the bat still holds his midway parley between them? The vegetable, animal, and mineral kingdoms themselves, distinct as they appear from each other, have had their limits the subject of dispute among the ablest naturalists, nor can they be clearly defined. The sea anemone may well connect the vegetable with the animal, while the arborescent coral, at the same time *stone, plant,* and *animal*, embodies in itself the three kingdoms of nature, an illustrious example of the universal principle of *Connexion*.[5]

Morse's remarks here epitomize the natural history of his time and its obsession with similarity, difference, interrelationship, and chains of being, as exemplified by Peale as well as the influential work of the German naturalist Alexander von Humboldt, whom Morse met in Paris while at work on *Gallery of the Louvre*. The link that Morse draws between people of African descent and simians shocks the twenty-first-century reader, but such a remark was par for the course in discussions of divinely designed and stable hierarchies of being in the period.[6] Morse's facility with the fundamental claims of natural history and his consideration here of the fixed web of relationships among species suggests his investment in natural history as a mode of knowing. He understood the Louvre's greatest art to offer universal understanding as well as a blueprint for human civilization; natural history in the nineteenth century promised the same, making it an obvious model for Morse.

Natural history in Morse's time constituted an approach to the physical world through observation, description, and classification. The divine origin of existence was taken for granted, but the scientific method privileged sensory data over accepted truths or inherited beliefs, and natural history's practitioners sought out system and order in their study of the natural world and its inhabitants.[7] The natural historian's pursuit began with fieldwork, which involved traversing a certain territory; observing that territory's plant and animal inhabitants; selecting specimens to collect or, alternatively, to sketch; extracting those specimens from their natural environments and relocating them to another space, in actual or sketched form; and then arraying them in a manner conducive to further scrutiny.[8] These activities are compellingly similar to those undertaken by Morse for *Gallery of the Louvre*. He systematically traversed the Louvre's galleries, spending days surveying the more than one thousand paintings on view in order to identify which ones to reproduce in his view of the Salon Carré. After identifying a candidate, he sometimes made a small copy of that work, which served as a preparatory study for the final version. Other times, he copied a painting

directly onto his large canvas, which he wheeled through the halls of the Louvre on an oversize easel.[9] The figures that Morse incorporated into his rendition of the Salon Carré serve as surrogates for his questing and capturing, for they are at work copying their chosen specimens (old master paintings) "from nature," as did he.[10]

Morse did not collect actual specimens, of course, just pictures. In this way he combined two operations of natural history, collecting and picturing, into one. Such suturing is not at all at odds with the strategies of natural history itself—in particular, natural history illustration in the late eighteenth and early nineteenth centuries. Images of flora and fauna described but also *re*-presented nature to the viewer, transforming it in myriad ways to make it visually legible. Natural specimens and environments were often distorted or reconfigured by their illustrators in order to ensure the efficacy of the resulting images as information.[11] Take, for example, the Philadelphia botanist William Bartram's sketch of *Canna indica*, or red canna, a perennial native to the tropical Americas (fig. 33). Bartram observed *Canna indica* during his travels in the American Southeast, and the flowering plant clearly made an impression on him. "The Canna Indica," he wrote, "grows here in surprising luxuriance, presenting a glorious show; the stem rises six, seven and nine feet high, terminating upwards with spikes of scarlet flowers."[12]

Bartram's drawing, in which a single plant towers over the landscape behind it, reflects his delight in such an impressive vegetal display. But the disparity in scale between the specimen and its backdrop also allows Bartram to illustrate on a single surface the finer details of the plant and its riverside environs. Another specimen of *Canna indica*, much smaller than the one featured front and center, appears at right, properly sited in its natural habitat. Yet even this plant appears outsize in relation to the landscape. In order to communicate the expansiveness of the region, Bartram showed the meadow receding into the distance, so that only the area immediately adjacent to the base of the flower registers as drawn

FIG. 33 William Bartram (American, 1739–1823). *Canna Indica L.*, 1784. Brown ink on paper. Violetta Delafield-Benjamin Smith Barton Collection, American Philosophical Society, Philadelphia, APSimg2245/661.020

correctly to scale. The three-celled seed pod, or capsule, and the two seeds that Bartram placed on the shoreline on either side of the featured specimen simultaneously exacerbate and complicate the effect of recession. On the one hand, the fine detail of the cross-sectioned capsule and the careful shading of the seeds accord with the detail of the foreground, but these plant parts, seated comfortably in the landscape as if relaxing and enjoying the river view, are gargantuan in relation to their putative setting. Clearly, Bartram wished to offer yet another view of *Canna indica*, this one entailing a partial dissection, and he could do so only by excerpting the capsule and seeds from the specimen and showing them in an alternate guise. But he need not have deposited the parts on the river's bank as he has done, with their cast shadows suggesting that they are a natural feature of the landscape. More typically, a botanical

illustrator would place such details alongside an isolated specimen, with each part occupying the same pictorial plane and thus clearly a "specimen" rather than masquerading as an element in an actual, witnessed view of the world. Bartram, however, chose to incorporate capsule and seeds into the landscape backdrop, thus creating a bizarre yet captivating dissonance among all parts of the scene.

In *Gallery of the Louvre*, Morse similarly reorganized the appearances of the actual by relocating pictures dispersed across the Louvre into a single gallery, altering scalar relationships and producing physical adjacencies as fictional—and as seemingly natural—as Bartram's riverbank and *Canna indica*'s extracted parts. Unlike Bartram's drawing, which borders charmingly on the surreal, Morse's painting bears no obvious distortions, but like Bartram and all manner of other picture makers within the sciences at the time, Morse fabricated in order to convey what he understood to be the truth. In his *Lectures*, Morse distinguished between "Mechanical" and "Intellectual" imitation. The first, he stated, "copies exactly what it sees"; the second "requires genius and mental cultivation" rather than mere technical skill and "perceives principles, and arranges its materials according to these principles, so as to produce a desired effect."[13] The operations by which Morse's picture came into being—exploration, observation, copying, rearrangement, and display— strikingly parallel those that gave rise to Bartram's fantastic scene. In both cases, the act of pictorial relocating, whether of old master paintings or plant anatomy, calls to mind yet another standard practice of natural history: travel. Peale and Bartram journeyed far afield in the course of their work, and so did their specimens, which were either sent to fellow naturalists or patrons in other parts of the world or received into their own collections as gifts from these far-flung colleagues. The success of Peale's project, re-creating the world in miniature in a Philadelphia gallery, depended on the donation of specimens and artifacts from around the globe. Bartram regularly sent the specimens he gathered on his travels to his

English patron, the botanist John Fothergill, who financed his expedition in the American Southeast.[14] Such exchanges underscore the circulatory nature of natural history, made possible by the global mobility of people and things that had arisen during the age of exploration.[15]

Morse, too, participated in such a network. He traveled to Paris in order to collect and then he sent his specimens, encased in a grandly scaled canvas, back to the United States. As an array, they resembled the installation of Peale's museum and, more broadly, the collection cabinets that had originated within European court culture in the early modern period. Natural history as a scientific pursuit arose in part from this culture and from its habits of collecting, as exemplified by the *Kunstkammer*, or curiosity cabinet (fig. 34). Some Renaissance *Kunstkammern* contained primarily works of fine art and served as private picture galleries for their owners and guests. Many others encompassed a much more diverse assortment of objects coveted and collected for their beauty, novelty, or rarity that, collectively, served to inspire awe in visitors and convince them of the culture, erudition, and status of the collector.[16]

FIG. 34 Domenico Remps (Italian, 1620–1699). *Cabinet of Curiosities*, 1699. Oil on canvas, 39 × 53¹⁵⁄₁₆ in. (99 × 137 cm). Museum of Still Lifes, Villa Medici, Poggio a Caiano (Prato), Italy

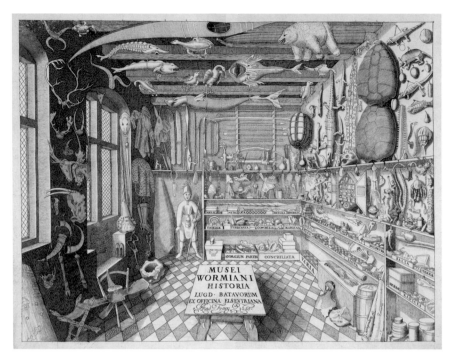

FIG. 35 G. Wingendorp, *Musei Wormiani Historia*, frontispiece to Ole Worm, *Museum Wormianum. Seu, Historia rerum rariorum, tam naturalium, quam artificialium, tam domesticarum, quam exoticarum, quae Hafniae Danorum in aedibus authoris servantur* (Lugduni Batavorum, Apud Johannem elseverium, Acad. Typograph, Leiden, 1655). Engraving. Goertz Collection, Department of Rare Books and Special Collections, Princeton University, Goertz 10117

The *Museum Wormianum*, a cabinet founded in 1620 by the Danish doctor and antiquarian Ole Worm, for example, exemplifies the eclectic if proto-systematic nature of such collections (fig. 35).[17]

Morse's painting of the Salon Carré of course bears little resemblance to Ole Worm's cabinet, but it does call to mind early modern habits of collecting and display and, in particular, the criterion of variety that governed such display. The panel partially obscured by the statue of Diana on the right side of Morse's picture exemplifies this. The panel contains a selection of about twelve objects that appear to be portrait miniatures or cameos.[18] One pays attention to this piece because of the eye-catching red of the ground to which the objects are attached, which stands in stark contrast to the adjacent *Diana* sculpture, and because the specimen-like array differs so much from the paintings around it. Simultaneously

a condensation of Morse's painting—a cluster of pictures within a picture metonymically related to the reinstalled gallery as a whole—and an evocation of the strategies of display associated with collection cabinets (including Peale's museum) and the objects on view within them (including works of art and mineral specimens), this panel registers the genealogy of Morse's project. Closely comparable to the mineral cases visible in the watercolor sketch of Peale's long gallery and to the specimen arrays characteristic of *Kunstkammern* and curiosity cabinets, including examples from the American context—Thomas Jefferson's "Indian Hall" at Monticello, for instance, or Thomas Dent Mütter's collection of medical specimens, oddities, illustrations, and devices that he displayed in a cabinet setting for use in study and teaching before donating it to the College of Physicians of Philadelphia in 1858—

Morse's display of miniatures and cameos helps one understand the logic of his painting as a whole and its indebtedness to the cultures of natural history.[19]

In a letter home, Morse wrote confidently about *Gallery of the Louvre*, saying "I have many compliments upon it. I am sure it is the most *correct* of *its kind* ever painted, for every one says I have caught the style of each of the masters."[20] "Caught the style" is a figure of speech, to be sure, but a telling one: Morse's characterization of his copying as a kind of hunt aligns his project with that of the period's natural history, for which the accurate observation, description, and study of specimens depended in part on transforming animated life into a specimen, by killing and dissecting a living thing on site in order to draw it or, similarly, by revivifying an animal through taxidermy, making it at once seemingly animate yet utterly lifeless, frozen for all time. The statue of Diana, goddess of the hunt, evokes and embodies just such a state of captured life, while also serving as a surrogate for an animated Morse pursuing his quarry in the halls of the Paris museum. Morse did something similar to taxidermy when he "caught" the likenesses of the paintings he collected and copied, extracting them from their natural habitats by approximating their surface appearances—skinning them, one could say, as an animal would be skinned and stuffed in order to put it perpetually on view, making its exterior stand in for its whole. In his *Lectures*, Morse spoke about the power of painting and poetry to quicken the emotions and to breathe life into brute matter.[21] There is reason to believe that this classical trope fundamentally shaped his approach to painting the Louvre.

In 1859 Oliver Wendell Holmes, in his now-classic essay "The Stereoscope and the Stereograph," prophesied that, in the wake of photography's proliferation, form would be "henceforth divorced from matter":

> We have got the fruit of creation now, and need not trouble ourselves with the core. Every conceivable object of Nature and Art will soon scale off its surface for us. Men will hunt all curious, beautiful, grand objects, as they hunt the cattle in South America, for their skins, and leave the carcasses as of little worth. The consequence of this will soon be such an enormous collection of forms that they will have to be classified and arranged in vast libraries, as books are now. The time will come when a man who wishes to see any object, natural or artificial, will go to the Imperial, National, or City Stereographic Library and call for its skin or form, as he would for a book at any common library.[22]

Holmes issued his prediction many years after Morse first experimented with photography, but it is tempting to imagine that Morse, one of the earliest adapters of the daguerreotype (see the essay by Sarah Kate Gillespie in this volume), found himself drawn to the process because of its potential as a collecting and preservation technique, one that could achieve what he had attempted in *Gallery of the Louvre*.[23]

GEOGRAPHY

Morse's father, the Reverend Jedidiah Morse, was a Congregational pastor and the nation's most prominent scholar of geography during his lifetime. Known in the United States and Europe as "the father of American geography," he wrote many books on the subject, including *Geography Made Easy* (1784), *The American Geography* (1789), and *The American Gazetteer* (1797), as well as a children's primer, *Elements of Geography* (1795), that became a classroom staple. Both *Geography Made Easy*, the first geography textbook published in the United States, and *The American Geography* went through multiple editions, becoming best sellers.[24] Samuel Morse's classmates at Yale gave him the nickname "Geography," a moniker inspired by his Yale-educated father's renown as a scholar in that field.[25]

Geography, like natural history, is a science of description. As Jedidiah Morse wrote in his introduction to the seventh edition of *The American Geography*, published in 1819 under the title *The American Universal Geography* (a change dating to 1812), the

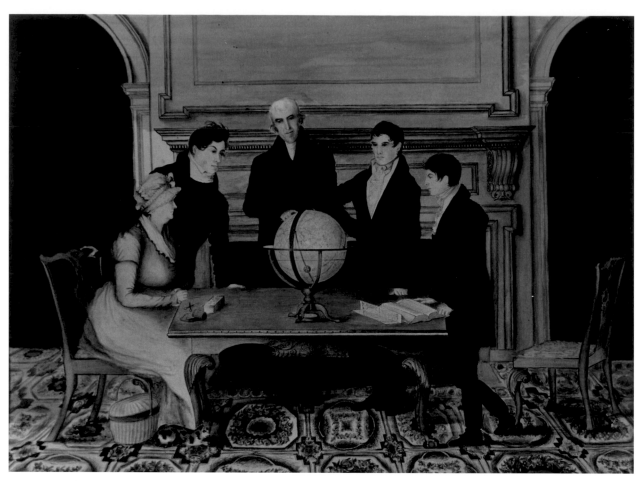

FIG. 36 Samuel F. B. Morse. *The Morse Family*, ca. 1810. Watercolor on paper, 12 × 15 in. (30.4 × 38.1 cm). Division of Work & Industry, National Museum of American History, Smithsonian Institution, IAP 08630547

term *geography*, from the Greek *geographia*, "literally signifies a description of the earth." A branch of "mixed mathematics," geography "treats of the nature, figure, and magnitude of the earth; the situation, extent, and appearance of different parts of its surface; its productions and inhabitants."[26] The term's basic units—*geo* and *graphy*—eloquently capture the idea of a science that aims to write or draw the known world. A practice with ancient roots, geography came into its own as an academic discipline in the eighteenth and nineteenth centuries, becoming part of the core curriculum at universities and stimulating the formation of national geographic societies in Europe and the United States.

In his many publications, Jedidiah Morse supplemented written descriptions with maps: sixty-three maps, to be exact, in the 1819 edition of *The American Universal Geography*, including a foldout illustration of a globe at the front of the volume—depicting the same globe that sits on the table in the younger Morse's family portrait (fig. 36). Maps serve to delineate terrain, but in order to communicate relevant spatial information so that the viewer understands what is being shown (or the particular claims that a mapmaker wishes to convey), maps must reorganize by reducing the real, condensing vast expanses by eliminating superfluous information, by generalizing topographical features, and by distorting scale and relative location. The task of the geographer or cartographer is radical distillation, extracting germane data from a complex, multipart whole and configuring it in a new context, thus making that

whole seeable in unprecedented ways.[27] As both Susan Schulten and Martin Brückner have demonstrated, cartographic literacy was paramount for Jedidiah Morse. He paid careful attention to the manner in which he presented geographical knowledge, and he experimented extensively with diverse methods of reduction and distillation. He created, for instance, experimental "word maps," in which he arranged the names of countries in a blank rectangular field according to their geographic locations, connoting relationships among terrains by figuring them as relationships among words or letters on a page, thus solidifying the association between the idea of a "nation" and geographical space and making the gleaning of geographical knowledge from a cartographic presentation a matter of both seeing and reading.[28]

All of this calls to mind the junior Morse's undertaking in the Louvre and suggests geography as another, readily available model for his painting. *Gallery of the Louvre* might be understood as itself a kind of map, simultaneously a reduction and a strategic reconfiguration of Paris's most famous museum, complete with its own legend and key in the form of Morse's *Descriptive Catalogue of the Pictures*, printed in 1833 to accompany the painting on exhibition in New York (see the Appendix in this volume). Morse's painting boiled down the Louvre's immense collection (not easily navigable by the average visitor) to what he considered its most salient attributes; he did his best to edit out extraneous, insignificant, or distracting aspects of the gallery's vast and intricate landscape, including modern French painting. His pictorial geography described its terrain, but it also aimed to put things in their proper place, as did the discipline of geography, which was driven by both scientific and sociopolitical motives. Jedidiah Morse intended his publications to set the geographic record straight. Europeans, he said, "have been the sole writers of American Geography, and have too often suffered fancy to supply the place of facts." To remedy this he labored to establish an accurate spatial order for the globe.[29] His preface to *The American*

Universal Geography recounts the history of the book's publication and describes the extensive revisions and improvements contained in each edition; the explanation of the alterations to the 1819 publication runs nearly two pages. "Many things," Jedidiah Morse explained, "which the recent wonderful changes in the state of the world had rendered incorrect and useless, have been omitted to give room for the abundant new matter furnished by the numerous publications produced in these eventful times."[30]

Clearly, Morse the father understood geography as a process of constant revision and recalibration, not unlike the ceaseless amending of Linnaean taxonomy, for he closed his prefatory remarks by assuring his readers that his work would "continue to receive improvements, as the materials for the purpose shall come into existence." Geography, he declared elsewhere, "is a speceies [sic] of composition."[31] In much the same manner, Morse the son understood his task as an American artist in Paris, explorer of the Louvre's vast terrain, to be one of judicious surveying, the results distilled and composed in a single image-cum-map that delineated Morse's sense of what was important in the history of art for audiences back home. That Morse returned to the United States after his sojourn in France with his painting in tow makes his endeavor even more akin to that of an explorer of territory on his way home with newly charted maps in hand, ready to display these novel images for all those willing to look and to learn. Jedidiah had his geographies, and Morse had his painting. Each possessed an epic map of his view of the cosmos, and they both wanted to show it to the world.

WRITING

Morse created a visual image of the Salon Carré, and picture making was his primary occupation in the 1830s, but words mattered a great deal to him as well, so much so that various verbal forms also offer possible models for *Gallery of the Louvre*, alongside natural history and geography. Nicolai Cikovsky, Jr., has compared Morse's *Lectures* to a library because of

the myriad sources on which they drew. I would add a parallel comparison, prompted by Morse's gathering of illustrations (mostly engravings from New York collections) to demonstrate his points while lecturing, making his spoken lectures into aggregates of both pictures and words, the verbal (if oral) analogue of a *Kunstkammer* and its descriptive inventory or Ole Worm's cabinet and its detailed catalogue.[32] The adjacency of painting and text that would have arisen when a visitor to the exhibition of Morse's painting consulted the catalogue that Morse had written to accompany it illuminates the attention the artist paid to writing and its components while he was at work fashioning his painting, as does his effort to transform that painting into textual form in the first place, translating the visual into the verbal so that audiences could look at and also, in a sense, read his work.

Morse was equally an artist and a writer. In addition to his *Lectures*, he wrote a discourse on art academies, published in 1827, and he published several political tracts.[33] Neither Morse nor his peers would have understood his writing to exist in a sphere wholly apart from his painting, a point of view underscored by his *Lectures*, where he followed many other writers on art in characterizing the natural affinity between painting and poetry. But Morse's sense of the relationship of writing to his practice extended beyond the truism of *ut pictura poesis*.[34] Indeed, the very process by which he composed his *Lectures* mirrored his naturalist-like creation of *Gallery of the Louvre*: reading widely and extracting choice ideas from a vast inventory of texts, selecting pictorial examples from local collections to form a miniature gallery onstage, and then re-presenting these texts and images for his audience.

As Peter John Brownlee argues in his introduction to this volume, Morse's lectures, delivered in New York prior to his travel to Paris, themselves served as a model for the painting. Morse proposed that the chief aim of painting—to excite the imagination—could be achieved through the use of a discrete set of elements: line, form, shading, and color. He

described these as different from yet analogous to the elements of poetry, an art that shared the goal of exciting the imagination. The chief materials of poetry, Morse wrote, "are words," which the poet subjects to manipulation and arrangement, just as the artist manipulates his chosen medium, which for Morse was paint. "Not only does all that belongs to the construction of sentences become important," he insisted, "but whatever pertains to *words*, to *syllables*, and even *letters*." In the case of both painting and poetry, then, their respective elements of design, when arrayed as a composition, collectively produce the desired effect. Morse underscored this affinity by way of a negative example: just as painting constitutes much more than the imitation of natural appearances with color on a flat surface, he wrote, poetry must not be described merely as an "Art of delineating on paper by means of pen, ink, and words, the signs of our ideas."[35]

While in Paris, Morse and his friend the author James Fenimore Cooper were inseparable, and Cooper was a constant presence in the museum while Morse painted. "He is with me two or three hours at the Gallery . . . ," Morse wrote to his brothers, "every day as regularly as the day comes. I spend almost every evening at his house in his fine family."[36] Cooper learned much about art from Morse during their many conversations, and Morse likely received, in turn, a lesson in literature from his friend, who was by then a well-known author.[37] Morse's belief in the functional analogy of words and pictorial form, combined with the influence of Cooper, may have inclined the artist to envision his painting as akin to a verbal narrative. Although the "plot" of *Gallery of the Louvre*, if one indeed exists, may not share the intricacy and density of the story line of a historical novel like Cooper's *Last of the Mohicans* (1826), the painting teems with characters, "live" and painted, and offers several set pieces: the Cooper family interacting, Morse instructing a young woman, an artist at work copying, an unidentified woman painting a miniature, a mother and child admiring the view of the Grand Galerie, another figure peering into the

Salon Carré, and Diana on the hunt.[38] The majority of the paintings selected by Morse for his reinstallation of the gallery stage a drama from a textual source, and the horizontal procession, from one side of the canvas to the other, of all the characters depicted in the scene—seated and standing within the gallery or arrayed in rows on its walls—calls to mind the motion of the eyes scanning a page of text from left to right or, in a more general sense, a narrative unfolding in time and space.

As Paul Staiti has noted, Rembrandt Peale wrote in 1824 of the need to make the finest examples of European art available to American audiences. "To advance with confidence," Peale stated, "we must know what has been done by those who have preceded us; we must study examples of their highest skill; we must possess FAC-SIMILES of their most valued masterpieces."[39] Morse's painting, which reproduces many of the Louvre's greatest works and depicts the very activity, copying, through which he put these works on view, addresses this need. Yet, also noted by Staiti, Morse had a low opinion of copying as an end in itself, believing the slavish imitation of other artists to be an obstacle to creativity.[40] Peale's use of the term "fac-simile" is telling in this regard, for in the first half of the nineteenth century, as today, it referred equally to the exact copying of an image and the precise reproduction of a text.[41] Morse's painting, then, approximated the facsimile form, but it also diverged from the disciplined exactitude of a facsimile by *rewriting* the story of the Louvre.

Morse's *Descriptive Catalogue* amplified that rewriting. On its own, the catalogue is a relatively straightforward account of Morse's painting and its subject, the Louvre; but as an aid to viewing, it functions more complexly. One cannot know exactly how viewers used Morse's text and the numbered key that accompanied it, but moving the gaze back and forth between image and words would have produced an episodic experience of viewing: look at the painting, check the key, look back at the painting to confirm before moving to another part of the

canvas. This process would have mirrored that of reading one of Jedidiah Morse's geographies, which required transferring attention back and forth between detailed text and foldout maps.[42] Morse's descriptive catalogue also called to mind a typical guidebook of the period, a description of terrain that unfolded as a series of descriptions of notable sights, separated by mundane landscapes left unmarked in the guide. A strategy associated with the picturesque, such episodic singling out of scenery aimed to generate effects of variety and surprise. Morse's mundane frames separate from one another the noteworthy canvases he put on display, a strategy of separation comparable to that of the guidebook or to the barely adorned interludes between the scenes of a moving panorama. The result in Morse's case would have been a mode of viewing that proceeded purposefully by stops and starts, as the viewer paused at each picture to take in the view. Morse's sights, of course, were paintings, not places, and the viewer encountered them all in one stop, but the structure of this encounter, again, mimicked in miniature the structure of a picturesque tour as verbalized in a written guide. Morse's viewer, written key to the painting in hand, would have consumed *Gallery of the Louvre* both in a single glance and over time in a virtual space, reading real words on a page while tracking their figurative counterparts, the paintings, as demarcated stops on a tour in the fictionalized Salon Carré.

In reading, perceiving the whole by way of a series of its parts is necessary to achieve full understanding, a state reached only after the act of reading is complete. I am suggesting that this is how Morse wanted his painting to operate. Morse was no semiotician *avant la lettre*, but as a painter very much invested in words, he presented his viewer with something to be read as well as with something to see. Recall that Jedidiah Morse called geography a form of "composition," and that earlier I likened Morse's composing within the Salon Carré to the idea of geography as a compositional art. So it is worth emphasizing that, in characterizing geography as

composition, Morse senior (and other geographers of the period) drew a direct connection between the work of geography and the acts of writing and reading, fashioning geography as a form of textuality despite the centrality of the visual to its practice. As Brückner points out, geography texts combined images and words, relying on both to produce their narrative of the relationships among different locales.[43] Describing and understanding the world entailed observing, mapping, writing, and reading its terrain, translating the visual into the verbal (prose, but also charts, graphs, and keys) and vice versa—a set of operations that parallels the operations by which *Gallery of the Louvre* came into being and how it was meant to be received, as well as the accoutrements that aided these processes, including Morse's descriptive catalogue and key.

Geography and natural history in Morse's day were close cousins; the half-prose, half-inventorying descriptions of the character and inhabitants of cities, states, and countries in Jedidiah Morse's books closely resemble the textual collecting and characterization of flora, fauna, and landscape of a naturalist's text, as with Bartram's *Travels*. It would have thus been easy and usual for Morse to draw on all three occupations—natural history, geography, and writing—in conceiving and executing his painting. Perhaps it was the literary quality of *Gallery of the Louvre* that, many years later, prompted the artist Violet Oakley to transform Morse's life story into a play in nine acts. The play was performed in April 1939 and then published as a book. And perhaps, also, it was Oakley's desire to revivify Morse, to bring him back to life, that propelled her desire to, as she wrote, "inspire others with a more vivid realization of the character of this Man of Destiny—who poured out his life so freely for them and for the world."[44] Such a production, which put Morse on display and mapped the trajectory of his career through the imagery and words of theater, fittingly encapsulated the operations of his most famous painting.

✣ ✣ ✣

There exist many possible models for Morse's painting in addition to those discussed in this essay, and *Gallery of the Louvre* harbors a diversity of possible meanings. It has been suggested, for instance, that the unidentified woman painting a miniature in *Gallery of the Louvre* may be Morse's wife, Lucretia Pickering Walker Morse, who died in 1825 after the birth of their third child while Morse was in Washington, D.C., working on a portrait commission.[45] Morse was disconsolate over Lucretia's passing and actively mourned her for years, undertaking a number of artistic projects that directly or indirectly paid homage to her.[46] If he did indeed depict her in *Gallery of the Louvre*, this may have been yet another form of homage. But even if *Gallery of the Louvre* bears no such autobiographical meaning, one wonders if it told another story about mortality, one directly relevant to the context in which Morse painted it. Death surrounded Morse in Paris in the form of a cholera epidemic. The disease struck London in 1831, moved to Paris in 1832 (ultimately killing eighteen thousand there), and made its way to New York that summer.[47] Many Americans left Paris when cholera hit, but Morse did not. He saw firsthand the black-draped churches, the ceaseless funerals, and the constant stream of bodies, dying or dead, being carted to and from the city's many hospitals. Morse wrote to his brothers in New York of his terror of the disease and the thousands of deaths it had caused; he described his perseverance in the face of it, assuring them that God would spare him, a good Christian—a sentiment that reflected the then-widespread conviction that cholera afflicted only the degraded and the damned (in truth, it disproportionately affected the poor).[48] The epidemic may have served for Morse as a *memento mori* writ large, one that made his absent wife ever more present in his thoughts and also drove him to vanquish from his Salon Carré Théodore Géricault's *Raft of the Medusa*, laden with dead and dying men (their rendition aided by Géricault's study of decaying corpses and the diseased on their deathbeds). To counter such a morbid scene, Morse curated a celebratory image of creative life,

one underpinned by the assured claims of natural science, the epic reach of geography, and the vigorous power of words.[49] When Morse abandoned painting for telegraphy in 1837, the work of his brush ceded to another form of mark-making—the creation of a geometrical pattern by an electrical current that pressed notches into a spooling strip of paper—but his ambitions remained unchanged. With telegraphy, Morse held fast to his vision of universal knowledge while reimagining its medium of exchange, just as he had reimagined the most important gallery of the Louvre, so that he could claim, along with Peale, to bring the world into public view.

Notes

1 Charles Willson Peale to Rembrandt Peale, August 2, 1822, in Lillian B. Miller, ed., *The Selected Papers of Charles Willson Peale and His Family*, 1996, vol. 4, quoted in *American Art to 1900: A Documentary History*, ed. Sarah Burns and John Davis (Berkeley: University of California Press, 2009), 148.

2 David Brigham, "'Ask the Beasts and They Shall Teach Thee': The Human Lessons of Charles Willson Peale's Natural History Displays," in *Art and Science in America: Issues of Representation*, ed. Amy R. W. Meyers (San Marino, Calif.: Huntington Library, 1998), 11–34; and Christopher Looby, "The Constitution of Nature: Taxonomy as Politics in Jefferson, Peale, and Bartram," *Early American Literature* 22, no. 3 (1987): 252–73.

3 For further discussion, see Brigham, "'Ask the Beasts'"; Christopher Looby, "The Constitution of Nature"; and Susan Stewart, "Death and Life, in That Order, in the Works of Charles Willson Peale," in *Visual Display: Culture beyond Appearances*, ed. Lynne Cooke and Peter Wollen (Seattle: Bay Press, 1995), 31–53.

4 As David McCullough points out, Morse also followed in the footsteps of Thomas Jefferson in endeavoring to bring exemplars of European arts and letters to the U.S.; Jefferson purchased both books and paintings (mostly copies) while in Paris, hoping to encourage the development of American intellectual culture. David McCullough, *The Greater Journey: Americans in Paris* (New York: Simon and Schuster, 2011), 65.

5 Samuel F. B. Morse, *Lectures on the Affinity of Painting with the Other Fine Arts*, ed. Nicolai Cikovsky, Jr. (Columbia: University of Missouri Press, 1983), 64.

6 Brigham, "'Ask the Beasts'"; and Paul J. Staiti, *Samuel F. B. Morse* (Cambridge: Cambridge University Press, 1989), 197.

7 For natural history in the period, see Sue Ann Prince, ed., *Stuffing Birds, Pressing Plants, Shaping Knowledge: Natural History in North America, 1730–1860* (Philadelphia: American Philosophical Society, 2003); Dorinda Outram, "New Spaces in Natural History," in *Cultures of Natural History*, ed. N. Jardine, J. A. Secord, and E. C. Spary (Cambridge: Cambridge University Press, 1996), 249–65; Amy R. W. Meyers, ed., *Knowing Nature: Art and Science in Philadelphia, 1740–1840* (New Haven: Yale University Press, 2011); and Lee Alan Dugatkin, *Mr. Jefferson and the Giant Moose: Natural History in Early America* (Chicago: University of Chicago Press, 2009).

8 For further discussion of fieldwork, see Outram, "New Spaces in Natural History"; Brigham, "'Ask the Beasts'"; and Robert McCracken Peck, "Preserving Nature for Study and Display," in Prince, *Stuffing Birds,* 11–25.

9 McCullough, *Greater Journey*, 66.

10 Morse wrote to his brothers: "*I am diligently occupied every moment of my time at the Louvre finishing the great labor which I have there undertaken. I say finishing I mean that part of it which can only be completed there, viz. the copies of the pictures, all the rest I hope to do at home in N.York, such as the frames of the pictures, the figures, etc. It is a great labor, but it will be a splendid and valuable work.*" Morse to Sidney and Richard Morse, July 18, 1832, Samuel F. B. Morse Papers, 1793–1944, Manuscript Division, Library of Congress, Washington, D.C.

11 See Martin Kemp, "'The Mark of Truth': Looking and Learning in Some Anatomical Illustrations from the Renaissance and Eighteenth Century," in *Medicine and the Five Senses*, ed. W. F. Bynum and Roy Porter (Cambridge: Cambridge University Press, 1993), 3–23; Michael Gaudio, "Swallowing the Evidence: William Bartram and the Limits of Enlightenment," *Winterthur Portfolio* 36 (Spring 2001): 1–17; and David Knight, "Scientific Theory and Visual Language," in *The Natural Sciences and the Arts: Aspects of Interaction from the Renaissance to the 20th Century* (Stockholm: Almqvist & Wicksell International, 1985), 106–32.

12 William Bartram, *Travels through North and South Carolina, Georgia, and East and West Florida, the Cherokee Country, the Extensive Territories of the Muscogulges or Creek Confederacy, and the Country of the Chactaws* (Philadelphia: James and Johnson, 1791), 424.

13 Morse, *Lectures*, 59.

14 Stephanie Volmer, "William Bartram and the Forms of Natural History," in *Fields of Vision: Essays on the "Travels" of William Bartram*, ed. Kathryn E. Holland Braund and Charlotte M. Porter (Tuscaloosa: University of Alabama Press, 2010), 71–80.

15 Outram, "New Spaces in Natural History"; Whitaker, "Culture of Curiosity"; Daniela Bleichmar, *Visible Empire: Botanical Expeditions and Visual Culture in the Hispanic Enlightenment* (Chicago: University of Chicago Press, 2012); and Anthony Alan Shelton, "Cabinets of Transgression: Renaissance Collections and the Incorporation of the New World," in *The Cultures of Collecting*, ed. John Elsner and Roger Cardinal (London: Reaktion Books, 1994), 177–203.

16 Whitaker, "Culture of Curiosity"; Shelton, "Cabinets of Trangression"; Horst Bredekamp, *The Lure of Antiquity and the Cult of the Machine: The Kunstkammer and the Evolution of Nature, Art, and Technology*, trans. Allison Brown (Princeton: Markus Wiener Publishers, 1995); and Arthur MacGregor, *Curiosity and Enlightenment: Collectors and Collections from the Sixteenth to the Nineteenth Century* (New Haven: Yale University Press, 2007).

17 Ejvind Slottved and Ditlev Tamm, "A Cabinet of Specimens," in *The University of Copenhagen: A Danish Centre of Learning since 1479* (Copenhagen: University of Copenhagen, 2009), 47–49; and Ole Worm, *Museum Wormianum. Seu, Historia rerum rariorum, tam naturalium, quam artificialium, tam domesticarum, quam exoticarum, quae Hafniae Danorum in aedibus authoris servantur* (Amstelodami: Apud Ludovicum & Danielum Elzevirios, 1655).

18 Peter John Brownlee, "Key to the Art and People in Samuel F. B. Morse's *Gallery of the Louvre*," in *A New Look: Samuel F. B. Morse's "Gallery of the Louvre"* (Washington, D.C.: National Gallery of Art, 2011), n.p.

19 For further discussion of this history, see Claire Perry, "The Hall of Wonders," *The Great American Hall of Wonders: Art, Science, and Invention in the Nineteenth Century* (Washington, D.C.: Smithsonian American Art Museum, 2011), 1–19; Charles Coleman Sellers, *Mr. Peale's Museum: Charles Willson Peale and the First Popular Museum of Natural Science and Art* (New York: W. W. Norton, 1980), 225; David Brigham, *Public Culture in the Early Republic: Peale's Museum and Its Audience* (Washington, D.C.: Smithsonian Institution Press, 1995), 107–8; Joyce Henri Robinson, "An American Cabinet of Curiosities: Thomas Jefferson's 'Indian Hall' at Monticello," in *Acts of Possession: Collecting in America*, ed. Leah Dilworth (New Brunswick, N.J.: Rutgers University Press, 2003), 16–41; Gretchen Worden, *Mütter Museum of the College of Physicians of Philadelphia* (New York: Blast Books, 2002); and Wendy Bellion, *Citizen Spectator: Art, Illusion, and Visual Perception in Early National America* (Chapel Hill: University of North Carolina Press, 2011), chaps. 2, 4.

20 Morse to his brothers, July 18, 1832, Samuel F. B. Morse Papers, 1793–1944, Manuscript Division, Library of Congress, Washington, D.C. Italics in original.

21 Morse, *Lectures*, 72.

22 Oliver Wendell Holmes, "The Stereoscope and the Stereograph," *Atlantic Monthly* 3 (June 1, 1859): 738–48.

23 For Morse and the daguerreotype, see Carleton Mabee, *The American Leonardo: A Life of Samuel F. B. Morse*, rev. ed. (New York: Purple Mountain Press, 2000), chap. 19; Kenneth Silverman, *Lightning Man: The Accursed Life of Samuel F. B. Morse* (Cambridge, Mass.: Da Capo Press, 2004), 189–91, 195–202, 305–7; and William Kloss, *Samuel F. B. Morse* (New York: Harry N. Abrams in association with the National Museum of American Art, Smithsonian Institution, 1988), 143–47.

24 Silverman, *Lightning Man*, 3–20; Susan Schulten, *Mapping the Nation: History and Cartography in Nineteenth-Century America* (Chicago: University of Chicago Press, 2012), 17–18.

25 Mabee, *American Leonardo*, 16, 19; McCullough, *Greater Journey*, 75–76.

26 Jedidiah Morse, *The American Universal Geography; or, A View of the Present State of All of the Kingdoms, States, and Colonies in the Known World*, vol. 1, 7th ed. (Charlestown, Mass.: Lincoln and Edmands, 1819), 2.

27 For the history of cartography in the U.S., see Schulten, *Mapping the Nation*.

28 Ibid., 17; Martin Brückner, *The Geographic Revolution in Early America: Maps, Literacy, and National Identity* (Chapel Hill: University of North Carolina Press, 2006), 113–16, 119, 154–58.

29 Jedidiah Morse, quoted in Kloss, *Morse*, 12.

30 Morse, *American Universal Geography*, iii.

31 Ibid., iii–iv; and Jedidiah Morse, *Geography Made Easy. Being a Short, But Comprehensive System of That Very Useful and Agreeable*

Science, 1784, quoted in Brückner, *Geographic Revolution in Early America*, 151.

32 Cikovsky, introduction and "Bibliography: Sources Used by Morse," in Morse, *Lectures*, 21–26, 139–41.

33 Samuel F. B. Morse, *Academies of Art: A Discourse* (New York: G. and C. Carvill, 1827); *Foreign Conspiracy against the Liberties of the United States: The Numbers of Brutus* (New York: Leavitt, Lord, 1835); and *Imminent Dangers to the Free Institutions of the United States through Foreign Immigration* (New York: E. B. Clayton, 1835).

34 For further discussion of this concept, see Rensselaer W. Lee, *Ut Pictura Poesis: The Humanistic Theory of Painting* (New York: W. W. Norton, 1967).

35 Morse, *Lectures*, 87, 88, 72, 86. Italics in original.

36 Morse to his brothers, July 18, 1832, Samuel F. B. Morse Papers, 1793–1944, Manuscript Division, Library of Congress, Washington, D.C.

37 Staiti, *Morse*, 179, 193.

38 The specific identity of the figures is debated. See David Tatham, "Samuel F. B. Morse's *Gallery of the Louvre*: The Figures in the Foreground," *American Art Journal* 13 (Autumn 1981): 38–48, for an early, groundbreaking attempt to identify the individuals depicted.

39 Rembrandt Peale, "The Fine Arts," *The Philadelphia Museum, or Register of Natural History and the Arts* 1 (1824): 1, quoted in Staiti, *Morse*, 195. Capitalization in original.

40 Staiti, *Morse*, 196.

41 "Facsimile, n.," OED Online, June 2013, Oxford University Press, accessed August 6, 2013, http://www.oed.com/vicw/Entry/67476?rskey=PVwnH4&result=1.

42 For the "Key to the Pictures," see the Appendix in this volume. Brückner describes this shuttling back and forth in *Geographic Revolution in Early America*, 164.

43 Brückner, *Geographic Revolution in Early America*, chap. 4.

44 Violet Oakley, *Samuel F. B. Morse: A Dramatic Outline of the Life of the Father of Telegraphy and the Founder of the National Academy of Design* (Philadelphia: Cogslea Studio Publications, 1939), xiv.

45 Cikovsky, introduction to Morse, *Lectures*, 10; Staiti, *Morse*, 118; "Key to the People and Art in Samuel F. B. Morse's *Gallery of the Louvre*," Terra Foundation for American Art, accessed August 7, 2013, http://www.terraamericanart.org/samuel-f-b-morses-gallery-of-the-louvre/.

46 Samuel F. B. Morse to Jedidiah Morse, February 13, 1825, in Samuel F. B. Morse, *Samuel F. B. Morse: His Letters and Journals*, ed. Edward Lind Morse (Boston: Houghton Mifflin, 1914), 1:267. Morse to an unidentified friend, n.d., ibid., 1:268, 269. Staiti, *Morse*, 128–30, 135.

47 Staiti, *Morse*, 191; Silverman, *Lightning Man*, 117; McCullough, *Greater Journey*, 85–94; R. J. Morris, *Cholera 1832: The Social Response to an Epidemic* (London: Croom Helm, 1976); John Noble Wilford, "How Epidemics Helped Shape the Modern Metropolis," *New York Times*, April 15, 2008, accessed August 7, 2013, http://www.nytimes.com/2008/04/15/science/15chol.html?pagewanted=all&_r=0#.

48 Staiti, *Morse*, 191.

49 Darcy Grimaldo Grigsby, *Extremities: Painting Empire in Post-Revolutionary France* (London: Yale University Press, 2002), chap. 4; Jonathan Miles, *The Wreck of the Medusa* (New York: Atlantic Monthly Press, 2007), chap. 1; and Jonathan Crary, "Géricault, the Panorama, and Sites of Reality in the Early Nineteenth Century," *Grey Room*, no. 9 (Autumn 2002): 5–25. In the years leading up to Morse's project at the Louvre, the American George Cooke painted a full-scale copy of Géricault's painting, which was exhibited in 1831 at the American Academy of the Fine Arts in New York. Perhaps Morse hoped to doubly displace his French counterpart's work, first by banishing it from the Salon Carré and then by exhibiting his own monumental painting, at once a "copy" and an original work of art, in the same city where Cooke showcased his copy of Géricault. Nina Athanassoglou-Kallmyer, with contributions by Marybeth De Filippis, "New Discoveries: An American Copy of Géricault's *Raft of the Medusa*?" *Nineteenth-Century Art Worldwide* 6 (Spring 2007), accessed July 18, 2013, http://www.19thc-artworldwide.org/index.php/spring07/140-new-discoveries-an-american-copy-of-gericaults-raft-of-the-medusa.

Gallery of the Louvre as a Single-Painting Exhibition

TANYA POHRT

TRANSLATING THE grand manner history painting favored in Europe into themes and ideas that might resonate with his own young republic, Samuel F. B. Morse created two monumental paintings for exhibition to American audiences. First he explored the workings of democracy and law making in *The House of Representatives* (fig. 5), and then, ten years later, he rendered the Louvre's Salon Carré in *Gallery of the Louvre* (plate 1), reproducing thirty-eight of the museum's old master paintings in an idealized installation, aimed to shape taste and encourage art appreciation in America. Both *The House of Representatives* and *Gallery of the Louvre* were made on speculation as stand-alone showpieces, intended for tour to multiple cities, where they would be artfully installed—perhaps in a rented room, an independent gallery, or a municipal building—and exhibited to paying spectators.

Despite Morse's ambitions for and optimism about both projects, *The House of Representatives* and *Gallery of the Louvre* failed as exhibition pieces, proving so unsuccessful with the public that admission fees could not cover exhibition expenses and the planned tours were cut short.[1] As a talented artist, a well-connected member of the elite, the leading founder and president of the National Academy of Design, and later the inventor of the electromagnetic telegraph, Morse was no fool. How is it that he was unable to connect with the public, failing not once but twice? Morse's missteps are puzzling and invite a reexamination of his approach to exhibitions, particularly with *Gallery of the Louvre*. Some of the

problems with the 1823 tour of *The House of Representatives* derived from inexperience, but that should not have been the case ten years later. Morse's approach to single-painting exhibitions was a lopsided one, embracing the elements he admired—the potential to educate the public and to cultivate the fine arts—while ignoring the necessity that artists operate as entrepreneurs, making their work accessible and engaging to mass audiences. While studying in London, Morse had written to his parents that he would not lower "my noble art to a trade, of painting for money, of degrading myself and the soul-enlarging art which I profess to the narrow idea of merely getting money."[2] The lingering reluctance to compromise his "noble art" made Morse shy away from the business end of exhibitions, uneasy with the publicity, display, and promotion that were necessary to attract and inform viewers.

If Morse's second exhibition piece did not benefit from the hard lessons of *The House of Representatives*, it *did* reflect the artist's progress in another area: his efforts in establishing and presiding over the National Academy of Design. Just as the new Academy was a site for the study and exhibition of fine arts, so too did *Gallery of the Louvre* make a statement about the value of European old masters, reconceived by an American artist for American audiences. Had the painting been intended for display at the National Academy, to be viewed and valued within the framework of Morse's accomplishments there, it would have been considered an unqualified success. Instead, Morse naively expected the general public to

respond to his work as positively as his supportive audience of colleagues, imagining that the uninitiated would need only to see his painting in order to understand and appreciate it.

Morse's tendency to link independent exhibitions and emerging art academies was not misplaced. Indeed, the two enterprises were closely connected in this era, sharing a number of methods and goals. Early exhibitions in America were independent out of necessity, produced in the absence of other options for artists, and those who engaged in touring exhibitions were also active in early academies and art associations. Morse had been experimenting with ways to cultivate the arts and collaborate with other artists since about 1819, first helping form the South Carolina Academy of Fine Arts in Charleston. Morse's work on *The House of Representatives* and *Gallery of the Louvre* alternated with his institution-building ventures, as he shifted from theory to practice and back again.[3] The experience of forming the artist-run National Academy of Design spurred him to create *Gallery of the Louvre* as both a demonstration of the possibilities ahead and as an articulation of his beliefs about art. While preparing the painting for exhibition, Morse acknowledged being distracted by art politics and the ongoing clash between the American Academy of the Fine Arts and his National Academy of Design. "My time for 10 or 12 days past has been occupied in answering a pamphlet of Col. Trumbull," he wrote to his friend James Fenimore Cooper. With his upcoming exhibition on his mind, Morse's published rebuttal reiterated the necessity that artists control art academies, emphasizing the important role of exhibitions in attracting visitors and generating income.[4]

Practicing what he preached, Morse believed that *Gallery of the Louvre* would succeed because his subject was an important and original one. Not all Americans could travel to Paris and see the Louvre themselves, so his painting offered an introductory view of the museum's impressive architecture and the art it contained. The painting had been composed under the watchful gaze of an interested public within the Louvre's galleries, where, as Morse wrote to his brothers, it "excites a great deal of attention from strangers and the French artists, I have many compliments upon it."[5] Heady with this early praise, he imagined that a similarly positive response would greet the painting when it went on display in New York. However, once it was removed from the immediate surroundings of the Louvre, without the original paintings and architecture for context and comparison, the project fell flat. When the painting was exhibited in the artist's rented exhibition room at Broadway and Pine Street, untutored visitors had little context for understanding the composition, and Morse did little to generate excitement in it, failing to produce any promotional material to explain his ideas and goals. He thought that audiences would flock to his masterpiece; that they did not was a source of confusion, sadness, and anger, contributing in no small part to his decision to abandon painting in 1837.[6]

THE EMERGENCE OF TOURING PAINTINGS

Between roughly 1815 and 1830—in an era when social and political change accompanied improvements in transportation and communication networks—Morse and a handful of other American artists started to experiment with a new entrepreneurial model: producing large history paintings on speculation for public display. They were inspired by John Trumbull's 1818–19 tour of his *Declaration of Independence* (1818; U.S. Capitol Rotunda); by independent exhibitions of single paintings in London; and by economic necessity following the financial Panic of 1819, when the portrait commissions that had sustained many painters became scarce. By encouraging the creation of ambitious American art for the public to enjoy, the single-painting tour was an appealing opportunity to expand audiences for fine art—at a price. Admission fees, which were generally twenty-five cents per visitor, enabled artists to spread the cost of labor and materials across many spectators, and paintings could be rolled up and

FIG. 37 Rembrandt Peale (American, 1778–1860). *The Court of Death*, 1820. Oil on canvas, 152 × 295 × 7 in. (386.1 × 749.3 × 17.8 cm). Detroit Institute of Arts

taken to new cities when local interest waned. Yet success depended on creating a painting with a subject and in a style that the public would find compelling enough that they would pay to see it, something that was difficult to predict and laborious to achieve.

Artists including William Dunlap, Charles Bird King, Rembrandt Peale, Thomas Sully, and John Vanderlyn, as well as Morse, were part of a loose network of artists and artist-run exhibition venues that facilitated the production and display of history paintings along the Eastern Seaboard.[7] Calling on the public to assume a collective role in advancing the arts, Rembrandt Peale wrote several newspaper articles in 1820 promoting independent exhibitions. Working to publicize a tour of his painting *The Court of Death* (fig. 37), Peale, noted that history painting could be supported only by this type of "public gratification." "The American artist labors under peculiar difficulties. Without the facilities which are found in the academies and galleries of Europe, his task can be accomplished only by greater ardor, as his labor is of greater difficulty." Peale reminded readers of their patriotic duty to support the arts: "To succeed in the

degree necessary to prompt the artists to follow it up with other great efforts, will require the advantages of a lively curiosity, a decided and universal interest in the advancement of the noble arts, a patriotism which shall delight in fostering native talent, and a liberality which shall not withhold its reward till the artist be insensible to it." Luckily for Peale, *The Court of Death* was a great success, helping motivate Morse and others to try exhibitions of their own.[8]

GALLERY OF THE LOUVRE

The Court of Death offered viewers a sensational scene of vice and virtue dominated by the figure of Death as judge. *Gallery of the Louvre* was very different in style and effect. Avoiding dramatic subject matter, Morse presented an idealized compilation of old master paintings, re-creating the wonders of the French Louvre for American audiences, as he had earlier tried to make the impressive interior of the House of Representatives the setting for a painting about American democracy, not realizing that in both cases, many of the ideas encoded in these paintings

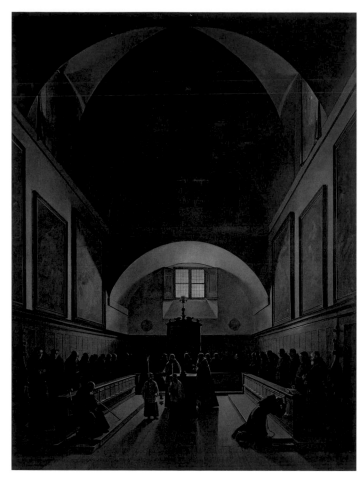

places. Such pleasures of vicarious escape helped make François-Marius Granet's illusionistic *Choir of the Capuchin Church in Rome* (fig. 38) highly successful as an exhibition painting in America.[9]

Morse's virtual tour of what he considered to be the greatest old masters of the Louvre offered the potential for a persuasive lesson in art appreciation, but his goal was partly thwarted by the comparatively small size of the canvas. At approximately six by nine feet, *Gallery of the Louvre* is large, but not large enough to do justice to the subject or to satisfy the public's expectations based on other single-painting exhibitions. Thomas Sully's *Passage of the Delaware* (1819; Museum of Fine Arts, Boston) and William Dunlap's *Christ Rejected* (1821–22; no longer extant), for example, both measured twelve by eighteen feet—a scale that allowed them to render life-size figures in compositions that would be legible even from a distance.

For Morse, the logistics of composing a painting at the Louvre larger than six by nine feet and then transporting it home may have been too daunting, but at half the size of many contemporary exhibition paintings, *Gallery of the Louvre* did not achieve sufficient visual impact. The thirty-eight paintings that Morse depicted within the gallery are certainly identifiable, but they are quite small, not of a size to be adequately studied and appreciated individually. Indeed, many reviews of the painting used the term "miniature," as when the *Commercial Advertiser* described it as containing "faithful miniature copies of the most popular and distinguished paintings."[10]

Morse did not paint on a scale large enough to convey the majesty of the Louvre's interior, but his framing of the space and his use of spectators within the scene attempt to evoke the experience of being in this inspiring space. Had he positioned himself in a corner, Morse could have included more of the side walls, creating a composition with greater depth and potentially greater illusionism. Instead, he chose a viewpoint that favored visual access into the long Grande Galerie, offering an almost direct view down the seemingly endless art-filled corridor. The male

would not translate effectively to mass audiences. For viewers who had never been to Paris and who knew little about the former palace's historical and cultural importance, *Gallery of the Louvre* had limited appeal. John Vanderlyn had a similar problem with his static panorama of Versailles (1818–19; Metropolitan Museum of Art), overestimating the attraction of the famous French palace and grounds. In both cases, it was not enough just to accurately reproduce beautiful and historically significant tourist destinations. Viewers wanted action, drama, and a painting that might inspire an imaginative reverie, transporting them from the present to more exciting times and

figure crossing the threshold enlivens the transition between the two rooms. His gesture and raised head convey his awe at first glimpsing the four high walls hung Salon style. The impact of this visitor's reaction is somewhat stifled by the presence of Morse himself in the foreground, however, and by the seated young woman whom he instructs. These two figures offer visual interest and appropriately model the process of learning to make art, but they also hold the viewer's gaze and block virtual entry into the Grande Galerie, diminishing the importance of that space to the overall composition. The disjunction between this prominent couple and the space they occupy may be due in part to the fact that the figures were added later, after Morse had returned to New York.[11] But their awkward placement also suggests some equivocation on the part of the painter regarding his compositional priorities. Was the painting primarily a view of the Louvre's interior or a lesson in art appreciation and modes of conduct?

Morse's descriptive pamphlet for the painting does little to clarify his message. The *Descriptive Catalogue of the Pictures, Thirty-seven in Number, from the Most Celebrated Masters, Copied into the Gallery of the Louvre* (see the Appendix in this volume) reads like a travel guide in parts and devotes more attention to the distant and visually inaccessible Grande Galerie than it does to the Salon Carré, the putative subject of the painting. According to the text, the painting offers "not only a perspective view of the long gallery, which is seen in its whole length of fourteen hundred feet through the open doors of the great saloon, but accurate copies, also, of some of the choicest pictures of the collection." This contradiction is but one of many oddities in Morse's catalogue. Some artists, including Rembrandt Peale, would include a brochure gratis with the visitor's admission fee, but Morse charged 25 cents for admission plus an extra 6½ cents for his pamphlet. Those who purchased the *Descriptive Catalogue* may have been disappointed in their investment. Many exhibition handouts used dramatic text to describe the painting, often testifying to the artist's arduous study of the subject, but

Morse's somewhat rambling description is dryly matter of fact. The understated final sentence is the closest he comes to personal testimony: "The painting of this picture has occupied fourteen months of the closest application." The text also neglects to mention one of the most important facts about the composition: that Morse had composed *Gallery of the Louvre* with old master paintings compiled from different parts of the Louvre's collection, rather than simply documenting a specific installation on view there.

One component of the brochure, the "Key to the Paintings," serves the basic function of identifying the artist and title of each of the paintings Morse reproduced, but not in a clear or coherent manner. Rather than offering viewers an easy-to-read tool for identifying the paintings, the artist retained the Louvre's numbering system— nonsequential numbers ranging from 74 to 1252. This means that Morse's key requires preexisting knowledge or another guidebook to be fully understood, which must have seemed confusing and deliberately opaque to many American viewers. Through their very obliqueness, however, the discontinuous numbers of the paintings hint at (but never specify) the fact that Morse chose works of art from various parts of the museum, acting as curator for his own idealized gallery.

Morse's key is likely to have originated during the creation of the painting, while he was working in close proximity to the originals. This decision to keep the Louvre's own numbering system reminds us that the painting was produced under unusual circumstances, within the Louvre's galleries—a very public space. Morse's good friend the writer James Fenimore Cooper often came to visit and watch, recounting to William Dunlap that "crowds get round the picture, for Samuel has made quite a hit in the Louvre."[12] Viewers in the galleries might even have made a game of tracing Morse's progress, tracking down the originals for comparison.

Indeed, Morse's period of working within the Louvre was the painting's apex as an exhibition piece.

FIG. 39 Morse's ad for the exhibition of *Gallery of the Louvre* in the *New York Commercial Advertiser*, October 11, 1833

The Louvre offered an ideal environment for viewing and comprehending Morse's painting in progress. To the appreciative onlookers, his basic intent—copying and translating a selection of the Louvre's old masters for American audiences to learn from—would have been clear, and the challenges of accurately rendering these great paintings would have been equally evident. The popularity of Morse's painting-in-progress must have lulled him into anticipating that the admiring Louvre visitors would be replicated in America. Sadly, this proved not to be the case.

Upon his return to New York, Morse wrote to Cooper, optimistic that he had found accommodations at Broadway and Pine Street. "I am now in excellent apartments over the bookstore of the Carvills," he wrote, noting that "one of them will make an excellent Exhibition room for the picture."[13] Although Morse lacked practical exhibition and promotion skills, he had the sense to ask for help. The artist William Dunlap, who had considerable experience with exhibiting and touring paintings, recounted in his diary on September 30, 1833, that Morse "called to consult on the exhibition of his picture of the Gallery of the Louvre," and the next day Dunlap visited Morse's room to "assist in arranging his picture."[14] Preparing a large painting for public display could be an elaborate process, and some artists hired carpenters to assist with installing a painting, adding curtains and fabric backdrops as well as

other features such as elaborate frames, guardrails, and artificial lighting. These additions would increase a painting's theatrical appeal, often mimicking the look and feel of a stage. Morse undoubtedly benefited from Dunlap's help, probably using green baize or another dark fabric to frame the painting and enhance its presentation.[15] A review of the exhibition in the New York *Evening Post* noted that the picture was "well lighted and in every respect eligibly situated for exhibition."[16]

Morse took the basic steps required to advertise his painting to the public, printing an identical, no-frills notice in three New York newspapers throughout the exhibition's run, from early October to mid-December 1833.[17] A look at other "Amusements" advertised below Morse's ad in the *New York Commercial Advertiser* (fig. 39) reveals the competition faced by the artist. Readers were tempted by a "Grand Gallery of 100 splendid paintings by the old masters," which could be seen for the same twenty-five cent admission just a block or so away, and the American Museum, located even closer, promised the "unprecedented attraction" of "two enormous Serpents," a "Grand Cosmorama" with "Three hundred splendid Views," daily musical performances, and glass-blowing demonstrations, all for twenty-five cents.[18] Given such offerings, it is easy to see why so few New Yorkers were tempted by Morse's exhibition.

By late November it was clear that the show was ailing. Richard Morse, who ran the exhibition while his brother Samuel was painting portraits in Albany, sent him the week's dismal receipts, which averaged just under three dollars (about twelve visitors) a day, along with dire tidings: "The receipts from the Louvre are not yet quite sufficient to pay the balance of rent, $80."[19] Morse subsequently tried a brief exhibition of the painting in the spring of 1834 at Franklin Hall in New Haven, but there too the painting was doomed to fail.[20] A short time later he sold *Gallery of the Louvre*, writing to the purchaser, George Hyde Clarke, that it had cost him "so many anxieties."[21]

Despite Morse's exhaustive efforts to plan and paint an original history painting to make European art accessible and encourage American art appreciation, *Gallery of the Louvre* failed to interest the public, due to its relatively small size, its lack of action and narrative, its compositional shortcomings, and the artist's inattention to promotion and publicity. Morse gave Americans what he thought they needed, rather than asking or investigating what they wanted. In an era of increasing Jacksonian populism, Morse's inability to create didactic art for a shifting mainstream public reminds us of the difficulty of his task. Even though touring paintings had great potential, they were an experiment dependent on trial-and-error to determine which subjects and circumstances would find favor with a geographically diverse and mercurial American audience. The work required to paint, promote, and tour paintings was tremendous, and failures like Morse's were crushing. By the early 1830s, many of the ambitious artists who had first embraced touring exhibitions withdrew from the practice, and it remained for the next generation of artists to find greater success with paintings of the American landscape.

Notes

1 For an incisive and thorough discussion of both paintings, see Paul J. Staiti, *Samuel F. B. Morse* (Cambridge: Cambridge University Press, 1989), 71–101, 175–206. *The House of Representatives* opened at John Doggett's gallery in Boston on February 21, 1823, and admission receipts dropped to fifteen dollars a day (sixty visitors) barely a week into the exhibition. Henry Cheever Pratt to Morse, March 15, 1823, Samuel F. B. Morse Papers, 1793–1944, Manuscript Division, Library of Congress, Washington, D.C. The reception in New York was similar, and although Morse sent it to several smaller cities in the Northeast where competition was not as stiff, the painting was a resounding failure.

2 Morse to his parents, December 22, 1814, Samuel F. B. Morse Papers, 1793–1944, Manuscript Division, Library of Congress, Washington, D.C.

3 For the history of the short-lived South Carolina Academy of Fine Arts, see Staiti, *Morse*, 34–70; Anna Wells Rutledge, *Artists in the Life of Charleston: Through Colony and State from Restoration to Reconstruction* (Philadelphia: American Philosophical Society, 1949), 136–41; and Maurie McInnis, "The Politics of Taste: Classicism in Charleston, South Carolina, 1815–1840" (PhD diss., Yale University, 1996).

4 Morse to James Fenimore Cooper, February 21, 1833, Samuel F. B. Morse Papers, 1793–1944, Manuscript Division, Library of Congress, Washington, D.C. Morse's published reply to Trumbull specified that at his Academy, income "is derived entirely from exhibitions" and that, by necessity, there would be fewer exhibitions of old masters and mostly those by living, American artists. Samuel F. B. Morse, "Examination of Col. Trumbull's Address . . . ," *Evening Post* (New York), February 26, 1833.

5 Morse to Sidney and Richard Morse, July 18, 1832, Samuel F. B. Morse Papers, 1793–1944, Manuscript Division, Library of Congress, Washington, D.C.

6 Staiti, *Morse*, 207.

7 Touring paintings were exhibited at Charles Bird King's gallery in Washington, D.C., Rembrandt Peale's museum in Baltimore, Thomas Sully and James Earle's gallery in Philadelphia, John Vanderlyn's Rotunda in Manhattan, and frame maker John Doggett's gallery in Boston. See Tanya Pohrt, "Touring Pictures: The Exhibition of American History Paintings in the Early Republic" (PhD diss., University of Delaware, 2013).

8 Rembrandt Peale to a friend in Philadelphia, "*Great Moral Picture*," Poulson's American Daily Advertiser (Philadelphia), July 12, 1820. Peale's *The Court of Death* earned over nine

thousand dollars in admissions and was seen by over thirty thousand viewers during in its first year. Its venues, in 1820–23, were: the Peale museum, Baltimore; Mr. Labbe's Ballroom, Philadelphia; the American Academy of the Fine Arts, New York; Doggett's Repository, Boston; Salem, Massachusetts; Albany, New York; South Carolina Academy of Fine Arts, Charleston; Savannah, Georgia; Philadelphia; and Doggett's Repository again.

9 Granet's painting offered an illusionistic view of the interior of the choir of Santa Maria della Concezione, a church near the Piazza Barberini in Rome. Mysterious, foreign, and immersive, Granet's scene combined an awe-inspiring architectural interior with subjects engaged in spiritual reverie, all rendered with such dramatic illusionism that viewers often described the sensation of being pulled into the scene and becoming virtual participants. On this idea of virtual escape, particularly in illusionistic exhibition paintings, see Wendy Bellion, *Citizen Spectator: Art, Illusion, and Visual Perception in Early National America* (Chapel Hill: University of North Carolina Press, 2011), 295–96. Morse knew the appeal of the *Capuchin Chapel* and tried to achieve a similar effect of deep illusionistic space in his 1822–23 *The House of Representatives*. William Dunlap, *History of the Rise and Progress of the Arts of Design in the United States* (New York: George P. Scott, 1834); and Edward Spencer, "Artist-Life of Morse," *Appleton's Journal of Literature, Science and Art* 7 (May 11, 1872): 516.

10 "Gallery of the Louvre," December 16, 1833, *Commercial Advertiser* (New York), 2.

11 Morse explained to his brothers that by finished, he meant "that part of it which can only be completed there [at the Louvre], viz. the copies of the pictures, all the rest I hope to do at home in N.York, such as the frames of the pictures, the figures, etc." Morse to Sidney and Richard Morse, July 18, 1832, Samuel F. B. Morse Papers, 1793–1944, Manuscript Division, Library of Congress, Washington, D.C.

12 James Fenimore Cooper to William Dunlap, March 16, 1832, in William Dunlap, *Diary of William Dunlap* (New York: New-York Historical Society, 1930), 3:608.

13 Morse to James Fenimore Cooper, February 21, 1833, Samuel F. B. Morse Papers, 1793–1944, Manuscript Division, Library of Congress, Washington, D.C.

14 Dunlap, *Diary*, 3:747.

15 That artists favored green baize as a background for their single-painting displays is documented in numerous sources. For example, in late 1818 John Trumbull purchased twenty yards of green baize for $17.50 in preparation for the exhibition of his *Declaration of Independence* at Boston's Faneuil Hall. Receipt from Robinson and Parker of Boston, November 28, 1818, Trumbull College Manuscript Collection, Beinecke Rare Book and Manuscript Library, Yale University, GEN MSS 331, box 1, folder 33. In preparation for the tour of *Christ Rejected*, William Dunlap recorded on March 22, 1822, paying ten dollars for green baize, and a few days later, on March 27, spending $2.50 for more baize. Dunlap, *Diary*, 3:586.

16 *Evening Post* (New York), October 14, 1833, 2.

17 Morse's ad appeared in three New York papers—the *American*, *Commercial Advertiser*, and *Evening Post*—between October and December 1833.

18 "Amusements," *Commercial Advertiser* (New York), October 11, 1833, 3.

19 For the week of November 22–27, the number of daily visitors ranged from a low of five to a high of twenty-four. Richard Morse noted that the three days with the fewest visitors were "very stormy," which undoubtedly contributed to the low attendance. Richard Morse to Morse, November 28, 1833, Samuel F. B. Morse Papers, 1793–1944, Manuscript Division, Library of Congress, Washington, D.C.

20 For a review of *Gallery of the Louvre* in New Haven, see *Connecticut Herald* (New Haven), May 20, 1834.

21 Morse to George Hyde Clarke, July 26, 1834, Samuel F. B. Morse Papers, 1793–1944, Manuscript Division, Library of Congress, Washington, D.C.

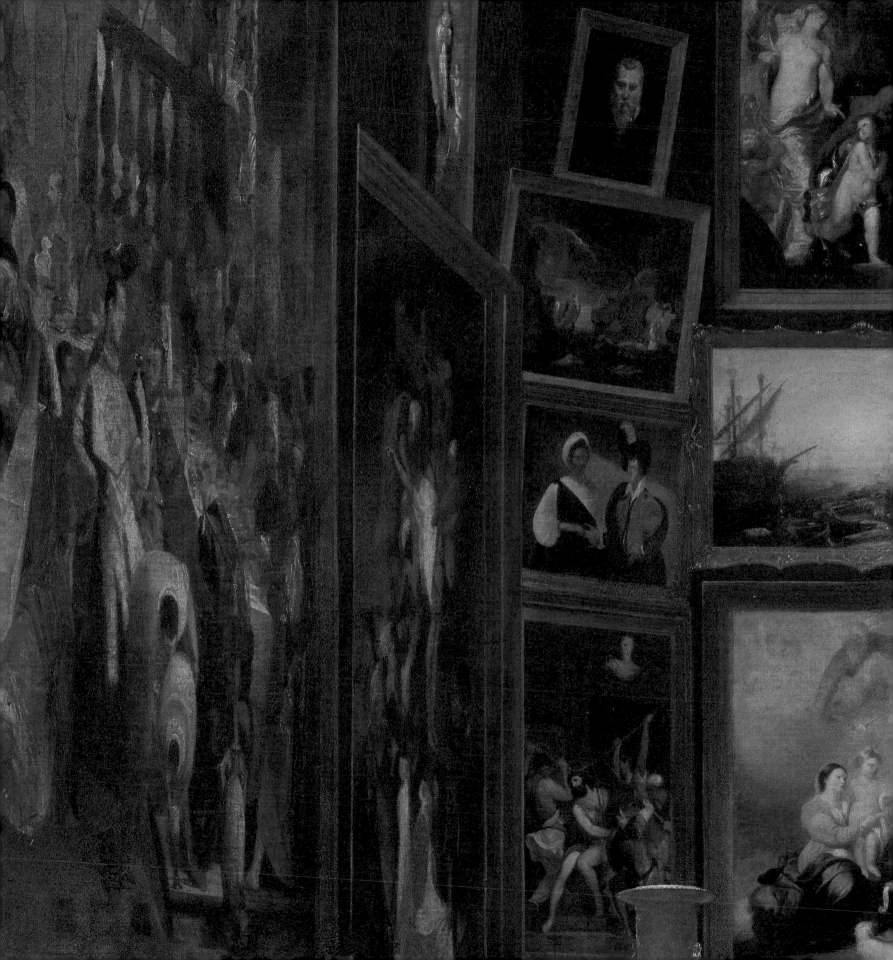

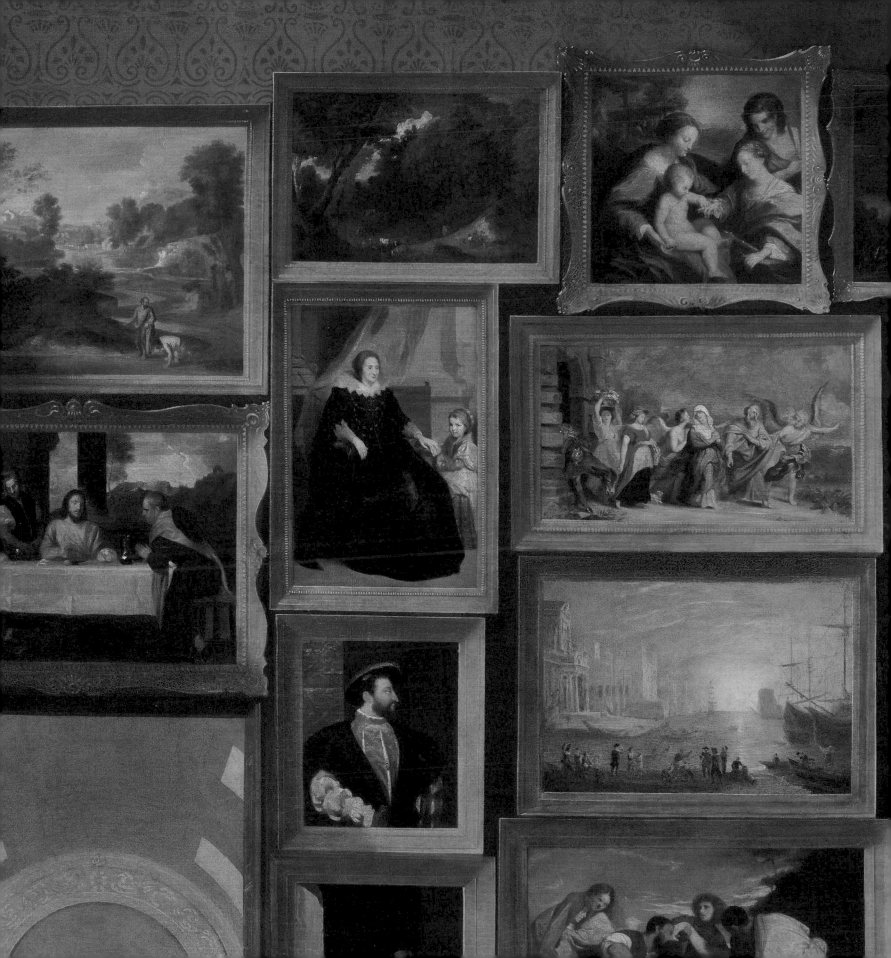

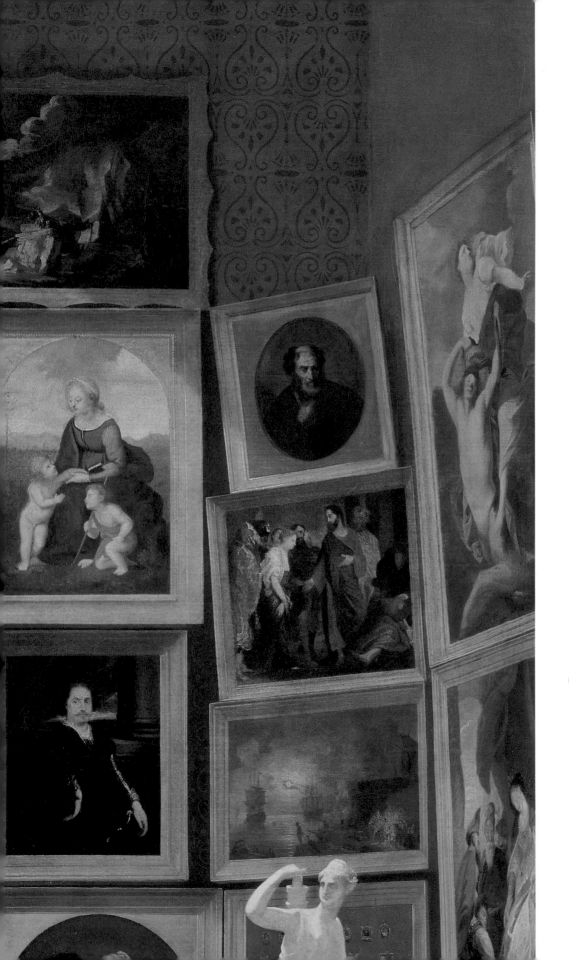

Contents

The Sculpture Club

WENDY BELLION

PAINTING GETS ALL the attention in *Gallery of the Louvre*. And for good reason. Morse's canvas features copies of thirty-eight paintings. He included four figures who are making paintings or drawings. He envisioned *Gallery of the Louvre* as proof of his own painterly talents. And he hoped it would educate his countrymen about European art.

But painting isn't the only art here. Positioned atop a plinth in each corner are two of the Louvre's most celebrated antiquities (figs. 40 and 41). The statue of a hunter and deer—variously called *Diana of Versailles*, *Diana the Huntress*, or *Artemis with a Doe*— is a Roman copy after a presumed bronze original by the Greek artist Leochares (to whom the *Apollo Belvedere*, *Diana*'s divine twin, is also attributed). *Diana* figured among the Louvre's earliest acquisitions and was widely known through reproductions. The marble in the opposite corner was a more recent prize: the massive Borghese Vase, modeled in Athens during the first century BC, unearthed in Rome in 1566, and purchased by Napoleon in 1808.[1] Overshadowed by the paintings (the vase, quite literally), these classical icons fared little better in histories of the Louvre. Morse neglected to identify them in his "Key," and scholars have likewise overlooked them, as if confirming the second-class status of sculpture.[2] "It is surprising how little people here know or care about Sculpture," one New Yorker complained to the novelist James Fenimore Cooper in 1832.[3]

Morse would have sympathized, yet in many ways, sculpture reinforced his close relationship with Cooper and the sculptor Horatio Greenough. In New York, Morse and Cooper had belonged to an artistic and literary circle called the Bread and Cheese Club.[4] In Europe, with Greenough, they forged what I would call "the Sculpture Club"—their friendship cohered around experiences of imagining, making, and writing about sculpture. In Morse's own career, moreover, sculpture exerted a centering force. Morse studied, modeled, collected, and exhibited plaster casts and classical statuary; more than once, he contemplated becoming a sculptor.[5] Much as the *Diana* and the Borghese Vase anchor the Salon Carré's corners, Morse's work as a painter was grounded in classical statuary. By incorporating these objects in his picture, Morse highlighted two of the Louvre's classical treasures while signaling the role of sculpture in his professional and personal life.

When Morse first visited Paris in 1830, neither the *Diana* nor the Borghese Vase occupied the Salon Carré. The Borghese Vase was displayed one floor below, in the Salle des Caryatides; the *Diana* stood nearby in the Salle de Diane, the name of the gallery a measure of the statue's celebrity.[6] Aptly, given its representation of Diana on the hunt, the sculpture had traveled extensively before settling into this space. A gift from Pope Paul IV to Francis I or Henri II, *Diana* was displayed at Fontainebleau in 1586 and sent to the Louvre by Henri IV in 1602, where it was restored and became a centerpiece of the Louvre's Salle des Antiques.[7] Louis XIV moved the *Diana* to Versailles (thereby occasioning one of the statue's titles); it returned to Paris in 1798, when the post-Revolution Louvre was reconceived

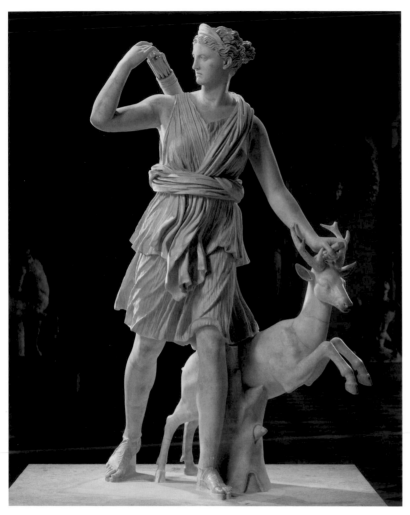

FIG. 40 *Artemis with a Doe*, called *Diana of Versailles*. Roman copy after Greek original attributed to Leochares, 1st–2nd century AD. Marble, h. 78¾ in. (200 cm). Musée du Louvre, Paris, MA 589

FIG. 41 Borghese Vase. Greek, 1st century BC. Marble, h. 67⁵⁄₁₆ in. (171 cm). Musée du Louvre, Paris, MA 86

FIG. 42 Hubert Robert (French, 1733–1808). *La Salle des Saisons du Louvre*, 1802–3. Oil on canvas, 14¹⁵⁄₁₆ × 18⅛ in. (38 × 46 cm). Musée du Louvre, Paris, RF 1964-35

as a public museum, and was placed in the newly designed Salle des Saisons (fig. 42).[8] When the *Apollo Belvedere* entered the collections following Napoleon's plunder of Rome, the *Diana* was installed alongside its long-lost sibling.[9] The triumph of the sculptures' reunion, though, came at the expense of *Diana*'s reputation as the foremost example of classical art in France.[10] The statue endured a more material displacement in 1822, when the acclaimed *Venus de Milo* entered the Louvre and was temporarily given *Diana*'s pedestal.[11] By 1830 *Diana*'s canonical status had been reaffirmed. Accounts of the Louvre in American periodicals reckoned the sculpture the "finest representation" of the subject existing.[12] A multivolume guide to European art published during Morse's time in Paris likened the sculpture's "perfection" to that of the *Apollo Belvedere*, *Medici Venus*, and *Venus de Milo*. One volume illustrated the "magnificent" Borghese Vase, lauding its "beauty of form, and the bas-relief that adorns it."[13]

Morse may have known about both objects before he saw them in person. Although he was probably unfamiliar with the many copies of the *Diana* in marble and bronze that graced European gardens or with the paintings that featured the sculpture as an agent of divine intercession, perhaps he recognized a formal echo of *Diana* in Eugène Delacroix's *Liberty Leading the People*, a highlight of the 1831 Salon, or encountered its earthenware cousins from English potteries, such as a Diana allegorically restyled as a native American princess (figs. 43 and 44).[14] Surely Morse, an avid collector of art books, had also seen the statue in prints and illustrations, including the plate that graced Thomas Piroli's book about antiquities in the Musée Napoléon (fig. 45).[15] Similarly, artists reproduced the Borghese Vase in paintings,

FIG. 43 Eugène Delacroix (French, 1798–1863). *Liberty Leading the People*, 1831. Oil on canvas, 102⅜ × 127¹⁵⁄₁₆ in. (260 × 325 cm). Musée du Louvre, Paris, RF129

FIG. 44 *America*, as one of a set of Four Continents. Inspired by the antique Greek status of Artemis, known as "*Diane Chasseresse*," in the Louvre, 1760–63. Vauxhall Porcelain Factory, England. Soft-paste porcelain painted with enamels and gilded, 13⅛ × 6⁵⁄₁₆ × 5⅛ in. (33.4 × 16 × 13 cm). Victoria and Albert Museum, London, inv. 414:8-1885

engravings, and sculpture; Josiah Wedgwood even cast it in jasperware.[16]

The profusion of reproductions of the *Diana* and the Borghese Vase raises a question: could Morse have relied upon prints to depict them? He was admittedly pressed for time to finish his picture in Paris, and he remarked, in an oft-quoted letter, that he planned to paint the frames and foreground figures onto the canvas back in New York.[17] Perhaps he added the sculpture and the vase there, too.[18] Notably, he chose to depict *Diana* from the angle most commonly seen in contemporary prints, including Piroli's.[19] Further, he rendered both the sculpture and the vase in broad, flat strokes; they lack not only modeling but also the definition and coloring that characterize the old master copies that Morse made on the spot. The white paint of the *Diana* is fugitive and translucent, likewise suggesting that the

sculpture was painted over the red wallpaper at a later time.

Morse's *Diana* and Borghese Vase have the visual quality of plaster rather than marble. Perhaps it was no coincidence, then, that Morse had plaster casts of both objects close at hand in New York. The National Academy of Design (NAD) counted two heads of *Diana* by the 1830s, and the Boston Athenaeum, where Morse exhibited work in 1828 and 1829, acquired a full-size cast in 1822 (fig. 46).[20] A cast of the Borghese Vase went to the NAD courtesy of James Fenimore Cooper, who worked with Morse to select and ship plasters from Paris.[21] Cooper was praised for his gift when the cast was included in the

Academy's 1832 exhibition.[22] Honoring Cooper's generosity, Morse pictured his friend pointing upward to the Borghese Vase in *Gallery of the Louvre*.

Plaster casts had preoccupied Morse from his earliest years as an artist—one of the ways sculpture shaped his painterly development. Well before sailing to England in 1811, he had learned that drawing from the antique was the foundation of academic painting, and he copied the *Farnese Hercules* (Museo Archeologico Nazionale, Naples) from an Italian anatomy book. In London, he drew from casts of the *Hercules*, a *Gladiator*, a *Demosthenes*, and the *Laocoön*—"the most difficult of all the statues" according to Morse, and the drawing that earned him entry to the Royal Academy of Arts, where he had access to even more casts.[23] With his roommate, Charles Robert Leslie, he studied the Elgin Marbles at Burlington House, and he longed to travel to France "to improve myself for a year in drawing," presumably by depicting the Roman marbles at the Louvre.[24] Back in Boston, Morse scrounged "a fine 'Venus de Medicis,'" as he told his mentor, Washington Allston, and a broken Apollo. "I have, however, after a great deal of trouble, put it together entirely, and these two figures, with some fragments,—hands, feet, etc.,—make a good academy."[25]

FIG. 45 *Diane*, in *Les monumens antiques du Musée Napoléon, dessinés et gravés par Thomas Piroli, avec une explication par J. G. Schweighaeuser* (Paris, 1804), 1:116, pl. 51. General Research Division, New York Public Library, Astor, Lenox, and Tiden Foundations

FIG. 46 Albert Sands Southworth (American, 1811–1894) and Josiah Johnson Hawes (American, 1808–1901). *Sculpture Gallery, Boston Athenaeum*, ca. 1855. Daguerreotype, 7⁵⁄₁₆ × 5³⁄₈ in. (18.6 × 13.7 cm). The Rubel Collection, Purchase, Ann Tenenbaum and Thomas H. Lee and Lila Acheson Wallace Gifts, 1997, The Metropolitan Museum of Art, New York, 1997.382.40. Photo © The Metropolitan Museum of Art. Image Source: Art Resource, NY

However committed a student of the antique Morse may have been, drawing from sculpture was not easy for him. His letters home expressed frustration, and one early attempt at parlaying antique poses into a painting—*The Judgment of Jupiter* (1814–15; The Yale University Art Gallery)—resulted, as Paul Staiti has observed, in "hackneyed pastiches of Classical statuary."[26] Morse had better luck with a clay study and a plaster cast that he modeled in preparation for painting *Dying Hercules* (fig. 84). In 1813 that picture was applauded at the Royal Academy, and his cast won a gold medal at the Royal Society of Arts exhibition.[27] Morse's efforts, which elicited praise from Allston and Benjamin West, solidified his understanding of the relationship of sculpture and painting. He hastened to ship his cast home to his parents, insisting, "It will convince you that I shall make a painter."[28]

Some of his contemporaries might have questioned Morse's assurance. British artists—especially those interested in the aesthetics of naturalism—were increasingly voicing skepticism about the Royal Academy's dependence on cast drawing.[29] In the United States, casts were more highly valued but also became a matter of contestation. Obtaining plasters had been the first order of business for the American Academy of the Fine Arts (AAFA) when it was founded in New York in 1802. When West wrote from London to offer a copy of Jean-Antoine Houdon's famous *Écorché* (*Flayed Man*), the AAFA gladly accepted. However, it generally favored work from Paris in assembling its collection. This was likely because, as John Vanderlyn noted, "almost every picture or statue of any fame" had been transplanted to the Louvre during the Napoleonic wars.[30] After the French casts arrived in New York, they were publicly displayed for a short time at the city's customs house. The AAFA lacked a permanent home, however, and soon the casts were consigned to storage in the basement. Washington Irving pitied the Capitoline Venus: "poor wench, to be cooped up in the cellar with not a single grace to wait upon her!"[31]

This trouble was minor compared to the controversy that arose in 1825–26, when John Trumbull, the AAFA's irascible president, denied two art students permission to draw from the Academy's casts. Local artists, led by Morse, angrily rallied against the decision by forming the New-York Drawing Association and, subsequently, the NAD. Initially, the association members drew from half a dozen casts borrowed from the AAFA. Artists sensitive to this irony encouraged the purchase of new casts, observing that plasters would enable students to copy "in their native country those sublime works of the ancient Greeks."[32]

Through such assertions, the NAD's founders reaffirmed the educational value of cast drawing for American artists. As NAD president, Morse organized an "Antique School" that convened three evenings a week.[33] Following the example of the Royal Academy, he oversaw annual competitions for drawings from plaster casts, awarding premiums for the best. In his own art, he demonstrated the enduring vitality of the antique: his much-lauded portrait of the Marquis de Lafayette (1825–26; Art Commission of the City of New York, City Hall) was modeled on the recognizable pose of the *Apollo Belvedere*.[34] In a newspaper review of the NAD's second exhibition, in 1827, Morse offered readers a primer on sculptural processes and recommended studying figures in the round (the *Apollo Belvedere* and the *Laocoön*) as well as bas-reliefs (Trajan's Column), busts, and ornament (including vases).[35] A fellow artist, Charles Edwards, reiterated the importance of Greco-Roman statuary in a series of lectures about antique casts delivered at the NAD in 1833.[36]

While abroad during 1829–32, Morse further enhanced the school's sculptural resources by acquiring books, prints, and plaster casts in Italy and France. Unfortunately, the Academy lacked the funds to cover the exorbitant freight charges, and Morse's efforts inadvertently bankrupted the NAD. Worse, it was denied loans to cover its debts.[37] However

regrettable, this embarrassment helps explain a curious aspect of Morse's *Louvre*: why it includes only one classical statue. Morse was aware of the financial distress caused by his shipment of casts; he was also thinking ahead to displaying his own painting in New York. By depicting only the *Diana*, he found a way to acknowledge the pedagogical significance of ancient sculpture while avoiding the criticism that might have resulted from crowding his canvas with statues. If Morse could not feature the most canonical sculpture of all—the *Apollo Belvedere*, which had been returned to Rome in 1815—then the *Diana* offered the next best thing.

Morse's choice of the *Diana* had personal resonance, too. For one, the image of a hunter on the move aptly epitomized his work chasing down paintings at the Louvre. Diana's role as a divine healer also seems relevant: cholera plagued Paris during Morse's stay, and he was visibly anxious about it. ("Samuel was nervous even unto flight—nay so nervous he could not run," Cooper confided to Greenough.)[38] Perhaps the statue even signified Morse's missing friend: Greenough, like the *Belvedere*, had left France for Italy. Morse and Greenough had shared an apartment in Paris during the autumn of 1831; the previous spring and summer they had lodged together in Florence with Thomas Cole and John Cranch, an American portraitist.[39]

Along with Cooper, Morse and Greenough shared a robust friendship grounded in their identities as artists abroad and as Americans committed to advancing the arts in the United States.[40] Correspondence between the friends vividly registered their mutual affections. "Morse has not yet cut his throat, and I have hopes of getting him safe through the winter," Cooper assured Greenough after the latter's return to Florence in December 1831. "He looked doleful enough, for a few days after your flight, but I have managed to open his mouth, and you know that is making a material change in friend Samuel's physiognomy." In the same letter Cooper playfully threatened an imperial sort of visit: "Morse and I

think seriously of invading Italy on a picture speculation," he teased, invoking Napoleon's acquisition of paintings and sculptures in Rome.[41]

Greenough, for his part, had looked forward to a future reunion even while still enjoying Paris. "S.F.B. Morse and H. Greenough," he mused, "will be in the city of N.Y. decidedly the merriest and best fellows in the place."[42] Alone in Florence, he longed to be with Morse "again in Paris for a few short days—I would risk the Cholera and all to be seated in your snug little chamber with Cooper too—now talking seriously and now letting ding any how [*sic*]—."[43] To Cooper, he bemoaned the geographical dislocation necessitated by his trade. "Like the ass between 2 bundles of hay I cast my eye from continent to continent and sigh that I can't plant one foot in the states and the other on the boot—chisel here with one hand and hold [*sic*] up to the christening font there with the other."[44]

Morse was just as frank. "Come home in the spring, do," he urged Cooper from New York in 1833. "Mr. dear Sir, you are wanted at home; I want you, to encourage me by your presence." He invoked one of Cooper's novels, *The Pioneers* (1823), to strengthen his plea: "I find the Pioneer business has less of romance in the reality than in the description, and I find some tough stumps to pry up, and heavy stones to roll out of the way, and I get exhausted and desponding, and I should like a little of your sinew to come to my aid at times, as it was wont to come at the Louvre."[45]

Sculpture featured prominently in the art experienced by the three friends both individually and together. In Rome, Morse deplored the "idolatry of the Virgin" and derided an "execrable" bronze statue of Saint Peter, its foot worn away by pilgrims' kisses. In Venice he was more generous to Catholic statuary, describing as "sublime" a gilded angel backlit by a lightning storm.[46] Greenough was less impressed by the Italian sculpture he saw in France. "I have found a great deal to delight me at the Louvre," he told Allston. But, alluding to the requisition of Roman

marbles in 1815, he complained that "the statue gallery has been shorn of its beams since you were here. 'Tis but so so after Italy."[47] They were both attentive to modern sculpture too. Morse admired the Neoclassical work of Bertel Thorvaldsen, a Danish expatriate resident in Rome, and secured two of his marbles for the NAD, to the delight of William Dunlap, who had assumed leadership of the Academy during Morse's absence from New York.[48] Greenough thought the current Parisian sculptors inferior, criticizing as clumsy failures the colossal statues of French worthies that decorated the Pont Louis XVI (now Pont de la Concorde).[49]

Greenough's own sculpture connected his friends affectively even when geography kept them apart. He had begun carving a bust of Cooper in Florence during 1829. After returning to Italy from Paris in 1831, he re-chiseled the incomplete head into a portrait of Morse. He kept it close at hand in his studio, and his friends were delighted by the symbolism of kindred souls lodged within the same block.[50] Cooper wryly remarked that Morse was "much tickled with the transformation, for I suppose he remembers that Minerva was knocked out of the head of Jupiter, by means of a hammer."[51] Dunlap was happy to receive Greenough's "capital" bust of Morse, together with one of Cole, in New York the following summer.[52] By that time, the NAD was lamenting the long absence of its guiding light; the marble head of Morse materially elided the distance.

So did letters. Cooper provided generous financial and moral sustenance to Greenough during the 1830s, and his patronage kept sculpture alive in the friends' correspondence. He actively promoted the American tour of Greenough's first success, the *Chanting Cherubs* (1829–30; unlocated), and both men tried to diffuse Morse's irritation when the sculpture was shown at the AAFA instead of the NAD. Cooper also arranged a sitting with Lafayette for a marble bust—the commission that brought Greenough to Paris. Cooper sang his protégé's talents to President Andrew Jackson, encouraging a commission for a statue of George Washington. The potential

design must have been a topic of conversation between Morse and Cooper in Paris, for they insistently cautioned Greenough against making the statue too big. "Both Morse and I think you are getting the statue too large, in embryo. Twelve feet is enormous."[53] Greenough replied in a way that illuminates their collective participation in a sculptural imaginary: he invited Cooper to picture his work in a familiar space. "Go into the Louvre . . . and imagine the statue. It won't be heavy—depend on it."[54] But Cooper was reluctant to revisit the museum even before he received Greenough's suggestion. After his friends had departed Paris, he could sense only their absence: "Our old set is quite broken up."[55] Greenough was just as lonely on a return visit in 1833. "The very Louvre," he sighed to Morse, "seems mediocre."[56]

Nonetheless, the Louvre remained the place that reunited the friends, if only in their imaginations. Morse's *Gallery of the Louvre* contributed to that fantasy. His self-portrait marks the apex of a triangle that links Cooper and the Borghese Vase, in one corner, to *Diana* in the other. In this "family portrait" of Morse's Parisian cohort, as David McCullough has described the painting, Greenough is not literally present.[57] Instead, where a likeness of the Neoclassical sculptor might be expected to complete the triangle, Morse pictured a coded substitute: a classical sculpture.[58] White, like the ghost of a departed friend, and fugitive—as if already exiting the scene—*Diana* conjures beloved twins returned to Italy; a sculpture club "quite broken up"; a friendship reconstituted in paint and memory.

Notes

I wish to thank Sarah Beetham, Peter John Brownlee, Emily Casey, David Dearinger, Rachael DeLue, and Katie Wood Kirchhoff for their suggestions and research assistance on this essay.

1 Francis Haskell and Nicholas Penny, *Taste and the Antique: The Lure of Classical Sculpture, 1500–1900* (New Haven: Yale University Press, 1981), 196–98, 315. At least one pair of casts representing the *Diana of Versailles* and the *Apollo Belvedere* was publicly visible in London during Morse's return trip to England in 1829: the pair graced the elegant Regent Street library of the architect John Nash. For an illustration of the casts in situ, see Terence Davis, *John Nash: The Prince Regent's Architect* (London: Country Life, 1966), 63. Like the *Diana*, which was often paired with casts of the *Apollo Belvedere*, the Borghese Vase was coupled in art and literature with the Medici Vase (Galleria degli Uffizi, Florence).

2 For a rare analysis of the role of the *Diana of Versailles* in *Gallery of the Louvre*, see Hugh R. Crean, "Samuel F. B. Morse's *Gallery of the Louvre*: Tribute to a Master and Diary of a Friendship," *American Art Journal* 16 (Winter 1984): 80.

3 Peter Augustus Jay to James Fenimore Cooper, February 21, 1832, in James Fenimore Cooper, *Correspondence of James Fenimore-Cooper, Edited by His Grandson, James Fenimore Cooper* (New Haven: Yale University Press, 1922), 1:262.

4 On the Bread and Cheese Club, see James F. Beard, Jr., "Cooper and His Artistic Contemporaries," *New York History* 35 (October 1954): 480–95.

5 "I could easily be a sculptor, and bring all my former study to bear advantageously in that profession. It will be a field in which I cannot have . . . a single competitor in the United States," Morse wrote to his wife, Lucretia Pickering Walker Morse, on August 16, 1823; quoted in Paul J. Staiti, "Samuel F. B. Morse and the Grand Style," in Paul J. Staiti and Gary A. Reynolds, *Samuel F. B. Morse* (New York: Grey Art Gallery and Study Center, New York University, 1982), 43. Four years later he told his cousin Sarah Ann Breese, "I am a sculptor, as well as painter, something of a musician, and can write poetry." Quoted in Paul J. Staiti, "Ideology and Politics in Samuel F. B. Morse's Agenda for a National Art," in *Samuel F. B. Morse, Educator and Champion of the Arts in America* (New York: National Academy of Design, 1982), 75 n.4.

6 For a contemporary description of the *Diana of Versailles* in the Salle de Diane, see Frédéric de Clarac, *Description du Musée Royal des Antiques du Louvre* (Paris, 1830), 81–83.

7 On the restoration, see René Dussaud, "Artémis Chasseresse, marbre du Louvre dit *Diane à la Biche*," *Revue Archéologique*, 3rd ser., 28 (January–June 1896): 60–66; and Suzanne Favier, "À Propos de la restauration par Barthélemy Prieur de la 'Diane à la Biche,'" *Revue du Louvre et des Musées de France*, no. 2 (1970): 71 77. On the multivalent significations of the goddess Diana in European art, see *Diane, une figure de légende: Sa présence dans les parcs et jardins* (Nantes: Éditions du Conseil Général de Loire-Atlantique, 2004).

8 Haskell and Penny offer a thorough account of the statue's history and peregrinations in *Taste and the Antique*, 4, 38, 112, 150, 196–98, 328. See also Jean-Pierre Cuzin, Jean-René Gaborit, and Alain Pasquier, *D'Après l'antique* (Paris: Réunion des Musées Nationaux, 2000), 65, 67, 79, 407–8.

9 The coupling of the *Diana of Versailles* and the *Apollo Belvedere* at the Musée Napoléon occasioned debate about Leochares as the maker of both sculptures; see *The Diary of Joseph Farington*, ed. Kenneth Garlick and Angus Macintyre (New Haven: Yale University Press for the Paul Mellon Centre for Studies in British Art, 1978–84), 5:1820, 1831, 1851. Sculpture—from ancient to modern, and marble to plaster reproductions—was the focus of intense critical and political interest in Paris during the decades immediately preceding Morse's sojourn at the Louvre. See Andrew McClellan, *Inventing the Louvre: Art, Politics, and the Origins of the Modern Museum in Eighteenth-Century Paris* (Cambridge: Cambridge University Press, 1994); and Jean-Luc Martinez, "Les moulages en plâtre d'après l'antique du Musée du Louvre: Une utopie du XIXe siècle," in Cuzin, Gaborit, and Pasquier, *D'Après l'antique*, 78–82.

10 In 1806 a Philadelphia critic delivered a backhanded compliment to *Diana*: "It was without doubt the most perfect of all the *antiques*, which were to be found there, before the conquest of Italy enriched France with so many *chef d'oeuvres*." "Original Papers—Miscellany. For the Port-Folio . . . Catalogue of the Sculptures and Busts," *Port-Folio*, June 3, 1807.

11 Haskell and Penny, *Taste and the Antique*, 198.

12 "Description of the Louvre and the Gallery of Antiques at Paris—by a Traveller," *Literary Magazine and American Register*, June 1805, 461. See also "Notes of a Traveller," *Christian Advocate* 8 (July 1, 1830): 350.

13 Étienne Achille Réveil and Jean Duchesne, *Museum of Painting and Sculpture, or, Collection of the Principal Pictures, Statues and Bas-Reliefs, in the Public and Private Galleries of Europe* (London and Paris, 1829–34), 7:462, 12:798.

14 On sculptural reproductions of the *Diana*, see Haskell and Penny, *Taste and the Antique*, 196–98. Hubert Robert featured Barthélemy Prieur's bronze copy of the sculpture, originally cast for Fontainebleau, in the center of one of his paintings of the Grande Galerie at the Louvre. Eustache Le Sueur, whose painting *Christ Carrying the Cross* is featured in *Gallery of the Louvre*, included the statue in *Saint Paul Preaching at Ephesus* (1649; Musée du Louvre); the Louvre's *Diana of Versailles* was sometimes linked to the Temple of Artemis at Ephesus. The Victoria and Albert Museum houses a half-dozen eighteenth-century porcelain and earthenware statuettes of Diana, most representing the figure with a dog instead of a deer.

15 *Les monumens antiques du Musée Napoléon, dessinés et gravés par Thomas Piroli, avec une explication par J. G. Schweighaeuser* (Paris, 1804), 1:117–20.

16 On depictions and reproductions of the vase, see Haskell and Penny, *Taste and the Antique*, 39, 315.

17 See Morse to Sidney and Richard Morse, July 18, 1832, in Samuel F. B. Morse, *Samuel F. B. Morse: His Letters and Journals*, ed. Edward Lind Morse (Boston: Houghton Mifflin, 1914), 1:426.

18 As late as July 1834, when Morse offered to sell *Gallery of the Louvre* to George Hyde Clarke, he was still contemplating adding more figures to the foreground: namely, Clarke's family or the Marquis de Lafayette and William Cabell Rives, the American minister to France. David Tatham suggests that Morse intended to add these figures "near the pedestal of the statue of Diana." David Tatham, "Samuel F. B. Morse's *Gallery of the Louvre*: The Figures in the Foreground," *American Art Journal* 13 (Autumn 1981): 44.

19 In addition to Piroli's engraving, contemporary prints of the *Diana of Versailles* appeared in Antoine Michel Filhol, Armand Charles Caraffe, and Joseph Lavallée, *Galerie du Musée Napoléon* (Paris, 1809), 6:lix–lx, plate 3; and "Musée du Louvre. Sculptures et antiques. La Diane à la Biche," *Le magasin pittoresque* 3 (1835): 399–400.

20 John Frazee and Asher Brown Durand donated busts of Diana to the NAD (David Dearinger, email to the author, June 25, 2013). See also *Catalogue of Statues, Busts, Studies, Etc. Forming the Collection of the Antique School of the National Academy of Design* (New York, 1846), 4. Augustus Thorndike donated three busts and eight full-size casts, including the *Diana*, to the Athenaeum in 1822 (David Dearinger, email to the author, June 20, 2013). The renown of the Athenaeum's cast is suggested by its mention in an article in a children's periodical: "Sculpture," *Juvenile Miscellany* 4 (May 1828): 191. On the Southworth and Hawes daguerreotype of the cast (fig. 46), see Malcolm Daniel, "Divine Perfection: The Daguerreotype in Europe and America," *Metropolitan Museum of Art Bulletin*, new ser., 56 (Spring 1999): 44, 46. The Pennsylvania Academy of the Fine Arts purchased a bust of Diana in 1806; see "Original Papers," *Port-Folio*, June 3, 1807. Casts of the *Diana of Versailles* were commonly produced as part of sets that included the *Apollo Belvedere*, *Antinous*, *Hercules Commode*, and *Borghese Gladiator*; see Geneviève Bresc-Bautier, "Copier l'antique à la cour de Louis XIV," in Cuzin, Gaborit, and Pasquier, *D'Après l'antique*, 65.

21 "There are now on the way to the Academy some casts from me," Cooper informed William Dunlap, who had temporarily assumed the NAD's leadership during Morse's absence, in March 1832. "All the Casts, but the Vase were . . . chosen by Morse." James Fenimore Cooper, *The Letters and Journals of James Fenimore Cooper*, ed. James Franklin Beard, vol. 2 (Cambridge, Mass.: Belknap Press of Harvard University Press, 1960), 238.

22 "Fine Arts. National Academy of Design. The Seventh Exhibition," *New-York Mirror*, June 2, 1832, 382.

23 Morse to his parents, November 6, 1811, quoted in William Kloss, *Samuel F. B. Morse* (New York: Harry N. Abrams in association with the National Museum of American Art, Smithsonian Institution, 1988), 22.

24 Ibid., 32; Morse to his parents, September 9, 1814, in Morse, *Letters and Journals*, 1:149.

25 Morse to Allston, February 4, 1819, in Morse, *Letters and Journals*, 1:221. Several years later, while bored in Albany, Morse complained to his wife, "If there were any pictures or statuary where I could sketch and draw, it would be different." Ibid., 1:248.

26 Paul J. Staiti, *Samuel F. B. Morse* (Cambridge: Cambridge University Press, 1989), 31.

27 Later, during the 1820s, Morse's sculptural inventiveness extended to designs for a machine to copy and carve sculptures in marble. See Kloss, *Morse*, 69.

28 Morse to his parents, September 20, 1812, quoted ibid., 25–26.

29 Martin Postle, "Naked Authority? Reproducing Antique Statuary in the English Academy, from Lely to Haydon," in *Sculpture and Its Reproductions*, ed. Anthony Hughes and Erich Ranfft (London: Reaktion Books, 1997), 77–99.

30 John Vanderlyn to John Murray, 1804, quoted in Nancy Elizabeth Richards, "The American Academy of Fine Arts, 1802–1816, New York's First Art Academy" (master's thesis, University of Delaware, 1965), 52. See also Mary Bartlett Cowdrey, *American Academy of Fine Arts and American Art-Union: Introduction, 1816–1952* (New York: New-York Historical Society, 1953).

31 Jeremy Cockloft [Washington Irving], "The Stranger at Home; or, a Tour in Broadway," *Salmagundi*, June 27, 1807, quoted in Richards, "American Academy of Fine Arts," 54.

32 A Lay Member, "To the Editors of the New-York American," reproduced in Thomas S. Cummings, *Historic Annals of the National Academy of Design* (1865; repr., New York: Kennedy Galleries, 1969), 93. For primary sources documenting these events, see pp. 23–104. See also Eliot Clark, *History of the National Academy of Design, 1825–1953* (New York: Columbia University Press, 1954), esp. 188–89.

33 For a description of the drawing room, see Cummings, *Historic Annals*, 119.

34 Kloss, *Morse*, 94.

35 [Morse], "The Exhibition of the National Academy of Design," *United States Review and Literary Gazette* 2 (July 1827), reproduced in *American Art to 1900: A Documentary History*, ed. Sarah Burns and John Davis (Berkeley: University of California Press, 2009), 178, 180.

36 Charles Edwards, *The Antique Statues: Lectures Delivered at the National Academy of Design, New York* (New York: Osborn and Buckingham, c. 1830).

37 Cummings, *Historic Annals*, 123.

38 Cooper to Greenough, [April 22, 1832], in Cooper, *Letters and Journals*, 2:244.

39 Nathalia Wright, *Horatio Greenough: The First American Sculptor* (Philadelphia: University of Pennsylvania Press, 1963), 80.

40 Beard, "Cooper and His Artistic Contemporaries"; Wright, *Greenough*, 80–81.

41 Cooper to Greenough, December 24, 1831, in Cooper, *Letters and Journals*, 2:163.

42 Greenough, quoted in Wright, *Greenough*, 90.

43 Greenough to Morse, April 23, 1832, in Horatio Greenough, *Letters of Horatio Greenough, American Sculptor*, ed. Nathalia Wright (Madison: University of Wisconsin Press, 1972), 120.

44 Greenough to Cooper, January 29, 1833, ibid., 154.

45 Morse to Cooper, February 28, 1833, in Cooper, *Correspondence*, 1:311. Cooper published *The Pioneers: The Sources of the Susquehanna; a Descriptive Tale* in 1823.

46 Morse, *Letters and Journals*, 1:377, 340, 394.

47 Greenough to Allston, October 1831, in Greenough, *Letters*, 87–88.

48 Dunlap to Cooper, September 20, 1831, in Cooper, *Correspondence*, 1:242.

49 Greenough to Allston, October 1831, in Greenough, *Letters*, 86–87, 93 n.4.

50 The head "was made from the *1st* block out of which I had tried to *extract* yours," Greenough informed Cooper on January 14, 1832. "The bust sits within a few feet of me looking as grim as Goliath—I hope to make something of it yet." Greenough, *Letters*, 108. See also Wright, *Greenough*, 67, 83.

51 Cooper to Greenough, December 24, 1831, in Cooper, *Letters and Journals*, 2:166.

52 "Samuel's is the most perfect thing of the kind I ever saw," Dunlap commented to Cooper, [n.d., c. August 11, 1832], in Cooper, *Correspondence*, 1:277.

53 Cooper to Greenough, [July 14?, 1832], in Cooper, *Letters and Journals*, 2:268. Cooper's patronage is documented in his voluminous correspondence. See esp. 2:44–166, 233–36, 367–68.

54 Greenough to Cooper, January 29, 1833, in Greenough, *Letters*, 154.

55 Cooper to Dunlap, November 14, 1832, in Cooper, *Letters and Journals*, 2:361.

56 Greenough to Morse, August 24, 1833, in Greenough, *Letters*, 179.

57 David McCullough, *The Greater Journey: Americans in Paris* (New York: Simon and Schuster, 2011), 96. Morse's Paris roommate Richard West Habersham is probably the figure painting at the easel, as first suggested in Tatham, "Figures in the Foreground," 44. Other scholars, including McCullough, have speculated that Greenough is the fashionable man in the doorway of the Grand Galerie glancing toward the *Diana*. But Greenough sported a mustache and whiskers in Paris; Morse's figure is clean-shaven. See Greenough to Henry Greenough, October 14, 1831, in Horatio Greenough, *Letters of Horatio Greenough to His Brother, Henry Greenough*, ed. Frances Boott Greenough (Boston: Ticknor, 1887), 87–88: "I have not told you how happy I have been in seeing Cooper. Morse and I went one morning, and were about to leave our cards, when we spied him peering at us from the other side of the court-way. 'Ah,' he said, 'I know you now, as soon as I see you walk; Greenough, whiskered and mustached!'"

58 Morse, of course, would soon realize his talent for code of another sort in the telegraph. On languages of code in both *Gallery of the Louvre* and telegraphy, see Lisa Gitelman, "Modes and Codes: Samuel F. B. Morse and the Question of Electronic Writing," in *This Is Enlightenment*, ed. Clifford Siskin and William Warner (Chicago: University of Chicago Press, 2010), 120–35.

Morse and "Mechanical Imitation"

SARAH KATE GILLESPIE

FOR MOST PEOPLE, the name Samuel F. B. Morse conjures up something entirely different from his *Gallery of the Louvre*: the dashes and dots that make up Morse code and its attendant device, the electromagnetic telegraph. The oft-told story regarding Morse is that his career consisted of two discrete parts: his early years as an artist and, when he was unable to achieve the kind of artistic success he craved, his later years as a technologist and inventor. Morse, however, had long held an interest in *both* technology and the fine arts, even during his most productive and successful period as a painter. One of the constants that links these two seemingly disparate careers was his abiding interest in mimetic reproductive technologies, which he utilized in his artistic endeavors prior to his work with the telegraph. Morse discussed the importance of mimetic reproduction in his *Lectures on the Affinity of Painting with the Other Fine Arts*, at the New York Athenaeum in 1826, in which he stressed the importance of "mechanical imitation." This concept connects the majority of Morse's chief endeavors, manifesting itself in his painting, his work with the daguerreotype, and arguably culminating in the telegraph, in which electricity is used to physically reproduce or mechanically transcribe the mark of the letter or number in Morse code onto the device's receiving tape.[1] One of the most remarkable examples of Morse's commitment to mechanical imitation and its potential usefulness for art is his daguerreotype *Still-Life* (fig. 50), coproduced in 1840 with the chemist John William Draper, which has striking parallels with *Gallery of the Louvre*.

BEFORE THE TELEGRAPH

Most of Morse's technological experimentation prior to his work with the telegraph was directly related to the mechanical replication of an existing subject. His first experiment is the sole exception: in 1817–18, soon upon his return to the United States after having studied in England, Morse and his younger brother, Sidney, attempted to invent a flexible piston-pump, which they hoped to market for use on boats and fire engines. Morse hoped the pump would be "not only profitable to us, but beneficial to the community. From its cheapness, it will be within the reach of every village."[2] Though the Morse brothers received endorsements from several prominent scientists, including Samuel's former Yale professor Benjamin Silliman, the device failed to pump any water at a public demonstration, and the brothers abandoned the project.

The first of Morse's experiments directly related to mechanical imitation took place in New Haven. By chance, Silliman was the Morses' next door neighbor, and during the summers of 1820 and 1821 Morse and Silliman often worked together on various chemical and electrical experiments. At some point the two conducted proto-photographic experiments, attempting to affix an image to a chemically treated surface via exposure to light.[3] They succeeded in producing

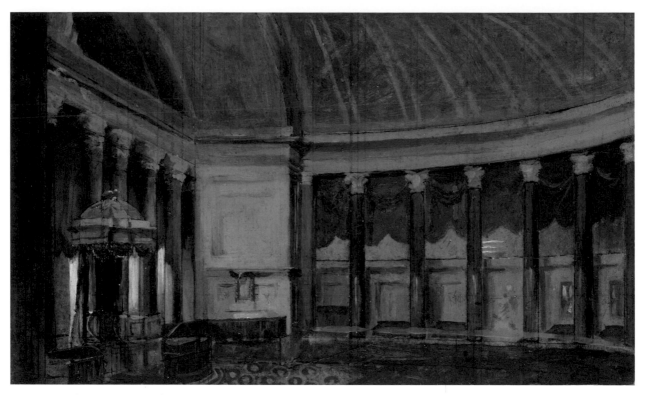

FIG. 47 Samuel F. B. Morse. *Study for The Old House of Representatives,* ca. 1821. Oil on panel, 8¼ × 13¾ in. (20.9 × 35 cm). Museum purchase through a grant from the Morris and Gwendolyn Cafritz Foundation, Smithsonian American Art Museum, Washington, D.C.

what in essence was a negative image; however, like the other proto-photographers Thomas Wedgwood and Humphry Davy, they were unable to create a positive image or to fix the image so that it would stop continuing to develop.[4] Another instance of Morse's dedication to mechanical reproduction is his attempt to create a marble-carving machine for the replication of sculpture. He designed the machine sometime in the winter or spring of 1823, and by that summer he hired a local mechanic, Hezekiah Augur (an accomplished self-taught woodworker and sculptor), to construct the design. By December, Morse's machine had produced a successful copy of a bust of Apollo. However, after discovering that a patent for a similar machine had been granted to Thomas Blanchard in 1820, Morse moved on.

While exploring these mechanical attempts to replicate an existing subject, Morse was also pondering the intellectual ramifications of the process. In his *Lectures on the Affinity of Painting with the Other Fine Arts*, he outlined his ideas regarding "mechanical

imitation" and "intellectual imitation." According to Morse, these two types of imitation could be combined to create the highest class of painting—the historical epic. The artist would copy nature exactly, utilizing "mechanical imitation," and then would incorporate these copies, using "intellectual imitation" to create the final work. Morse noted: "A *picture* then is not merely a copy of any work of Nature, it is constructed on the *principles of nature*. While its parts are copies of natural objects, the whole work is an artificial arrangement of them." Mechanical imitation, therefore, was essential to achieving intellectual imitation: "Is not Mechanical Imitation in Painting a necessary excellence through every step even to the highest grade of epic? . . . There is no reason why every thing that is selected to be represented should not be imitated exactly. . . . down to the minutest fold of the drapery."[5]

"Imitated exactly": this is precisely what Morse was attempting to do both with the proto-photographic work and with the sculpture-replicating machine—to

copy exactly what was before him. He put these principles into action in what are arguably his two most important paintings: *The House of Representatives* of 1822–23 (fig. 5) and *Gallery of the Louvre* of 1831–33 (plate 1). In both, he used a technological device to assist him, the camera obscura.[6] As Paul Staiti has demonstrated, Morse had trouble reproducing the perspective of the interior of the House of Representatives—in the Rotunda of the Capitol Building, Washington, D.C.—in his preparatory sketches (fig. 47). With the camera obscura, he obtained exact views of the interior, which were then assembled to create the final painting. In *Gallery of the Louvre*, Morse used the camera obscura to copy old master paintings culled from various parts of the Musée du Louvre, which he re-created in his larger canvas. One such copy that survives is his study of Titian's *Francis I* (fig. 11). The National Academy of Design owns a tracing of this painting in reverse, probably made with a camera obscura (fig. 48). Like a telegraphic message, these paintings each contain mechanically transcribed parts that were assembled into a complete whole.

Morse's use of the camera obscura to create these paintings is rarely contextualized within his interest in the mechanical and in reproductive devices, or in the larger framework of American technology, yet his willingness to use technological means to create paintings demonstrates both his awareness of the importance of technology for the growing nation and his commitment to the concept of mechanical imitation. Invention and technology came to play an increasingly important role in American culture in the early to mid-nineteenth century. Historians of technology have argued that "a much exaggerated emphasis came to be placed on invention" in the decades following the Revolution, in response to the nation's increasing population and the need for economic expansion.[7] Morse was acutely aware of this emphasis, and participated in it, stating that the telegraph, for example, would be successful in America due to a national "'*Go-ahead*' character."[8] Morse's repeated efforts at invention prior to his work with

FIG. 48 Samuel F. B. Morse. *Sketch of Francis I (Study for "Gallery of the Louvre")*, ca. 1831–32. Graphite on tracing paper, sheet size: 13⁵⁄₁₆ × 8¼ in. (33.8 × 20.9 cm); image size: 9½ × 7¹¹⁄₁₆ in. (24.1 × 19.5 cm). National Academy of Design, New York, 1980.60

FIG. 49 Unknown photographer (possibly Samuel F. B. Morse). *John William Draper*, ca. 1840. Daguerreotype. Department of Physical Sciences, Division of Work & Industry, National Museum of American History, Smithsonian Institution, Washington, D.C.

the telegraph indicate his awareness of the potential impact of technology on the culture and his desire to be associated with this particularly American brand of modernity.

MORSE AND THE DAGUERREOTYPE

Morse was already deeply invested in the idea of mechanical replication when, on the ship home from Paris after painting *Gallery of the Louvre*, he began tinkering with what would eventually become the telegraph. He continued to work on the telegraph as he completed *Gallery of the Louvre* and moved on to other paintings. In 1839 another new technology was introduced—the daguerreotype—and Morse seized upon it as a possible means of bridging these two areas of his production. In essence, he began and

ended his painting career with experimentation related to the science of photography.

Morse was quite possibly the first American to view a daguerreotype in person. By happy accident, he was promoting his telegraph in Paris in January 1839 when the French government announced Louis-Jacques-Mandé Daguerre's new invention. Morse wrote to Daguerre and requested to view some actual plates, offering to show Daguerre his telegraph in return. The meetings between the two men took place on March 7 and 8, first at Daguerre's residence and "Maison du Diorama," and the next day at Morse's rooms at 5 rue Neuve des Mathurins. Morse instantly recognized that the daguerreotype's marriage of the visual with the technological would be revolutionary, and he embraced its possibilities. "The [daguerreotype] impressions of interior views are Rembrandt perfected," Morse wrote, "No painting or engraving ever approached it."[9]

Morse returned to New York soon after his meeting with Daguerre, and he was able to have a camera constructed almost as soon as the manual describing Daguerre's process became available in America that September. Looking for a partner to help him master the daguerreotype process, Morse turned to the scientist John William Draper (fig. 49), who was a fellow professor at the University of the City of New-York (now New York University) and who had also engaged in proto-photographic experimentation prior to the release of Daguerre's manual.[10] Morse and Draper had already been experimenting independently on the new technology in their rooms at the university before they joined forces in late March or early April 1840, opening a portrait studio on the roof of the university building on the east side of Washington Square.[11]

Other American artists were considerably less excited about the daguerreotype than Morse. Around the time that he was opening his studio with Draper, the members of the National Academy of Design, of which Morse was president, asked him to address the new technology. Morse obliged, and in his lecture he attempted to reassure the academicians that

the daguerreotype was no threat to their profession; in fact, he insisted, the ability of the daguerreotype to record nature exactly would make it a great asset to painters. "By a simple apparatus, easily portable, [the artist] now has it in his power to furnish his studio with *fac-simile* sketches of nature, landscapes, buildings, groups of figures, &c."[12] The new technology could also help artists solve problems of perspective and proportion, as well as teach them precious lessons about light and shade. Morse was basically reiterating the same concepts he had outlined in his *Lectures* in 1826, though utilizing slightly different language: once again, he was stressing the ways that mechanical imitation could be essential to good painting. The daguerreotype was simply an additional new tool.

STILL-LIFE AND GALLERY OF THE LOUVRE

There are very few extant daguerreotypes by Morse, but at least one of them does relate to *Gallery of the Louvre* and possibly illustrates his faith in how the medium could assist painters. The plate is from the Morse-Draper partnership and illustrates an "interior view"—what today would be called a still life (fig. 50). The combined references to art and science in the image were clearly intended to suggest the pair's collaboration. Draper is represented by the label on the spine of the chemistry textbook that rests on the ledge at the bottom of the work. The label reads "Hare's chem.," carefully written backward so it would be legible to the viewer in the finished plate. (Dr. Robert Hare was a chemist who had been Draper's professor at the University of Pennsylvania.)[13] Morse's involvement is indicated

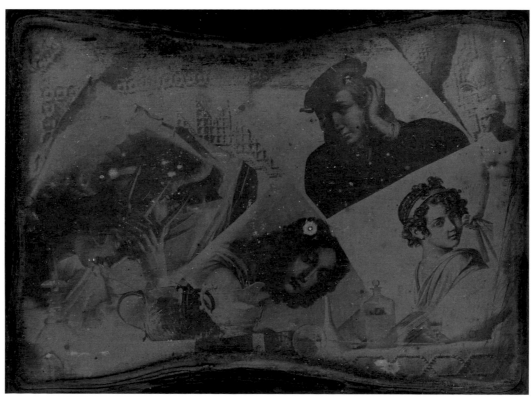

FIG. 50 Samuel F. B. Morse and John William Draper (American, 1811–1882). *Still-Life*, spring 1840. Quarter-plate daguerreotype. Department of Physical Sciences, Division of Work & Industry, National Museum of American History, Smithsonian Institution, Washington, D.C.

by the group of prints after paintings that are the dominant elements in the work. Twice he wrote about attempting to photograph a still life: first, in a November 1839 letter to Alfred Vail, his partner on the telegraph ("I have taken an interior view, busts, books, rugs, etc."), and again in February 1840, when he recorded in a notebook an attempt to capture a group of prints assembled upon cloth. "Arranged objects on the roof in the open air, just without the window. bright sun . . . A little wind agitates the drapery and prints after 5 minutes a gust of wind deranged all the prints."[14]

Photographing works of art was not uncommon among early practitioners. Both Daguerre and Hippolyte Bayard (who created a direct-positive photographic method that failed to win the same governmental support as the daguerreotype) produced works that featured groupings of sculpture. The same is true of François Gouraud, a student of Daguerre's who was in the United States in late 1839 through the early 1840s, selling French daguerreotype equipment and offering demonstrations and lessons in the medium, and with whom Morse quarreled in the press.[15] Other early French plates by makers such as François Alphonse Fortier and Baron Armand Pierre Séguier also typically feature groups of sculpture with a painting or print included. William Henry Fox Talbot, the Englishman who introduced a paper photographic method, produced images of single sculptures, most famously his *Bust of Patrocles* (1843), and various images of prints. Morse surely observed some of the French still lifes either at Daguerre's studio in Paris or those exhibited in the United States by Gouraud. *Still-Life* differs from other early examples, however, in its direct representation of art and science; it also seems to be the earliest-known photograph that features a collage of prints as its primary subject, with sculpture relegated to a secondary position.[16]

Morse was surely attracted to these particular prints because of their formal qualities. Each features a clear view of a face reproduced from a painting, easily read by the viewer. The two faces on the right side of the plate gaze outward, inviting the viewer to join them in contemplating this extraordinary new technology. The top image is a print after the Louvre's *Portrait of a Young Man*, which has been variously attributed to Raphael, Parmigianino, Correggio, or Perino del Vaga. The image at bottom right remains unidentified, but the female figure's short curls, headband, and draped shoulder are similar to Neoclassical works dating from the late eighteenth or early nineteenth century, such as those by Elisabeth Louise Vigée-LeBrun. The two other faces in the daguerreotype seem to contemplate, and thus draw our attention toward, the array of scientific instruments arranged on the shelf underneath them. The bottom figure is a detail from Leonardo's *Virgin of the Rocks*, also in the Louvre, illustrating the face and shoulders of that painting's angel.[17] Morse seems to have positioned the print on the left with intentional humor: head in hand, the helmeted face examines the scientific instruments with apparent anxiety, as if slightly overwhelmed by this new technology. This print is a detail from Baron François Gérard's painting *Ossian Evoking Ghosts on the Edge of the Lora* (1801; Kunsthalle, Hamburg), and the face shown is Fingal—Ossian's father and a main hero in Ossian's cycle of poetry.[18]

Still-Life bears an obvious formal resemblance to *Gallery of the Louvre*, with its works of art similarly chosen and arranged by Morse, but the two share important ideological similarities as well. *Gallery of the Louvre* was one of Morse's greatest efforts to elevate standards of public taste, and he made parallel arguments that the daguerreotype, too, could be used as a pedagogical tool to educate the public and uplift American taste. When he initially encountered the process, Morse marveled to his friend Washington Allston: "Art is to be wonderfully enriched by this discovery. . . . Artists will learn how to paint, and amateurs, or rather connoisseurs, how to criticise . . . and therefore how to estimate the value of true art." He continued this line of thinking in his speech to the National Academy of Design, proclaiming, "It is clear that in so far as individuals are interested

FIG. 51 Detail of fig. 50

in observing [the daguerreotype's] wonderful production, their taste must be improved."[19]

Even more important, *Still-Life* offers a promise regarding the medium of photography: that the daguerreotype has the potential to start a revolution in art through its relationship to the sciences and technology. By showing how clearly the daguerreotype captures the details of the diverse elements within the plate (the glass of the beakers, the texture of the fabric that serves as a backdrop, the curling edges of the prints; fig. 51), Morse was underscoring his argument that the mechanical imitation provided by the daguerreotype would be a great aid to artists. He encouraged the assembled academicians to consider how art could be improved by the new medium: "Think how perspective, aerial as well as linear, is illustrated and established by [the daguerreotype's] results, and, as a consequence, proportion also. How the problems of optics are confirmed and sealed for the first time by Nature's own stamp!"[20] This image is visual proof of Morse's concept of mechanical imitation, showing artists how to "imitate exactly" what they saw before them and to use those technologically manufactured copies to augment their intellectual work.

The Morse-Draper partnership disbanded by the fall of 1840, and Morse opened his own studio in his brother Sidney's *New-York Observer* building. Though he abandoned both daguerreotyping and painting by 1841, turning his full attention to the telegraph, there is an unswerving path from his early experimentation with reproductive devices, to his use of mechanical copying tools in his most important paintings, to his interest in and work with the daguerreotype, to the telegraph. Far from being discrete, these various endeavors are all linked by Morse's commitment to his own principle of mechanical imitation. His long-held interest in mimetic reproductive technology demonstrates his awareness of its critical importance to the making of art and to the explosive growth of technology in general in mid-nineteenth-century America.

Notes

1 One of the earliest photographic methods, the daguerreotype consists of a unique image on a silvered-copper plate.

2 Morse to Lucretia Pickering Walker, July 1817, quoted in Samuel Irenaeus Prime, *The Life of Samuel F. B. Morse, LL. D., Inventor of the Electro-Magnetic Recording Telegraph* (New York: D. Appleton, 1875), 103.

3 The term "proto-photographic" was coined by Geoffrey Batchen, *Burning with Desire: The Conception of Photography* (Cambridge, Mass.: MIT Press, 1997), 50.

4 Morse's roommate during his 1832 stay in Paris, Richard West Habersham of South Carolina and Savannah, Georgia, later claimed that Morse had described these experiments during their time abroad; see Samuel F. B. Morse, *Samuel F. B. Morse: His Letters and Journals*, ed. Edward Lind Morse (Boston: Houghton Mifflin, 1914), 1:421. There is no way to confirm that Morse actually did so. On Wedgwood and Davy, see Geoffrey Batchen, "Tom Wedgwood and Humphry Davy, 'An Account of a Method,'" *History of Photography* 17 (Summer 1993): 181.

5 Samuel F. B. Morse, *Lectures on the Affinity of Painting with the Other Fine Arts*, ed. Nicolai Cikovsky, Jr. (Columbia: University of Missouri Press, 1983), 112, 61.

6 On Morse's use of the camera obscura for *The House of Representatives*, see Paul J. Staiti, *Samuel F. B. Morse* (Cambridge: Cambridge University Press, 1989), 81–82. On his use of the device for *Gallery of the Louvre*, see William Kloss, *Samuel F. B. Morse* (New York: Harry N. Abrams in association with the National Museum of American Art, Smithsonian Institution, 1988), 130.

7 Brooke Hindle and Steven Lubar, *Engines of Change: The American Industrial Revolution, 1790–1860* (Washington, D.C.: Smithsonian Institution Press, 1986), 75–76.

8 Morse, quoted in Kenneth Silverman, *Lightning Man: The Accursed Life of Samuel F. B. Morse* (New York: Alfred A. Knopf, 2003), 187. The term "go-ahead" was widely used in mid-nineteenth-century America to express the idea that technological innovation was a national trait. "Go-A-Head is a word in general use, all over the country—and implies perseverance, enterprise, and assiduity, in the performance of some labor, with the view of obtaining some object." Bramble Brae, "Go-A-Head," *Mechanics' Mirror* 1 (April 1846): 77.

9 Morse to Sidney Morse, March 9, 1839, quoted in "The Dagguerreotipe [sic]," *New-York Observer*, April 20, 1839, 62.

10 On Draper's involvement with the daguerreotype, see Sarah Kate Gillespie, "John William Draper and the Reception of Early Scientific Photography," *History of Photography* 36 (July 2012): 241–54.

11 Donald Fleming, *John William Draper and the Religion of Science* (Philadelphia: University of Pennsylvania Press, 1950), 21.

12 Morse's speech to the National Academy of Design is reprinted in "Annual Supper of the National Academy of Design," *New-York Commercial Advertiser*, April 27, 1840, 2.

13 Draper's involvement in making the plate is also strongly suggested by its inclusion in the Draper Collection, which was donated by the Draper family to the National Museum of American History, Smithsonian Institution. The collection contains over one hundred daguerreotype plates and other photographs made by Draper and his descendants.

14 Morse to Alfred Vail, November 4, 1839, Vail Telegraph Collection, Smithsonian Institution Archives, Smithsonian Institution, Washington, D.C.; and Morse, "Memoranda of Daguerreotype," February 1840, Samuel F. B. Morse Papers, 1793–1944, Manuscript Division, Library of Congress, Washington, D.C.

15 On Morse and Gouraud's argument, see Sarah Kate Gillespie, "Samuel F. B. Morse's Daguerreotype Practice," *Daguerreian Annual* (2008): 100–104.

16 Bates Lowry and Isabel Lowry posit that the Morse-Draper daguerreotype was made in direct reaction to Morse's having viewed still lifes by Daguerre at their March 1839 meeting in Paris. Bates Lowry and Isabel Lowry, *The Silver Canvas: Daguerreotype Masterpieces from the J. Paul Getty Museum* (Los Angeles: J. Paul Getty Museum, 1998), 141–42. Geoffrey Batchen reads *Still-Life* as a collaboration of art and science, and he suggests that the work "speaks to a new kind of visual culture in which everything is soon going to be transformed into a seamless, multi-directional flow of reproductions." Geoffrey Batchen, "Electricity Made Visible," in *New Media, Old Media: A History and Theory Reader*, ed. Wendy Hui Kyong Chun and Thomas Keenan (New York: Routledge, 2006), 36.

17 I am grateful to Guy Jordan, who suggested considering the connection to Leonardo. The Louvre now attributes *Portrait of a Young Man* to Parmigianino. Sydney J. Freedberg, however, asserts that the work is by Perino del Vaga and that the sitter is Parmigianino. See Sydney J. Freedberg, *Painting in Italy, 1500–1600* (New Haven: Yale University Press, 1993), 692 n.62. I have not been able to determine with certainty to whom the painting was attributed in 1839.

18 Ossian was said to be a third-century Scottish bard. His epic poems, first published in 1760 and popular in both Europe and America during the late eighteenth and nineteenth centuries, offered good subjects for Neoclassical and Romantic paintings. See Henry Okun, "Ossian in Painting," *Journal of the Warburg and Courtauld Institutes* 30 (1967): 237–356.

19 Morse to Washington Allston, probably spring 1839, quoted in Prime, *Morse*, 405; and Morse, quoted in "Annual Supper of the National Academy of Design," 2.

20 Morse, quoted in "Annual Supper of the National Academy of Design," 2.

Inscribing Information, Inscribing Memories: Morse, *Gallery of the Louvre,* and the Electromagnetic Telegraph

JEAN-PHILIPPE ANTOINE

WHY DID THE PAINTER of *Gallery of the Louvre* (plate 1) invent the electromagnetic telegraph? To answer this question, we must go back to the fall of 1832, when these two inventions crossed paths.

Today, Morse's painting is displayed for museum audiences in a manner quite close to what he had originally envisioned for its exhibition (fig. 52). Let us imagine it for a moment in a very different state: lying belowdecks on the packet ship *Sully* during the five weeks between October 6, 1832, when the boat carrying both Morse and his painting sailed from Le Havre, France, and November 15, when it arrived at the Rector Street Wharf in New York (fig. 53). Rolled up, and still a little sticky, the painting was not only invisible to the public eye, it was also unfinished. During his year in Paris, Morse had completed copying onto the canvas all the pictures from the Musée du Louvre that he intended to insert, with the single exception of Rembrandt's *The Angel Leaving the Family of Tobias* (fig. 86).[1] But he had not yet painted any of the human figures, nor the homogenized modern frames that surround the pictures. As he wrote to his brothers in New York on July 18, 1832: "I am diligently occupied every moment of my time at the Louvre finishing the great labor which I have there undertaken. I say *finishing* I mean that part of it which can only be completed there, viz. the copies of the pictures, all the rest I hope to do at home in N.York, such as the frames of the pictures, the figures, etc."[2]

The winter following his return to his cherished American republic, Morse went back to work on all of these, and by August 1833 he had added the various figures that now occupy the Salon Carré and the perspective into the Grande Galerie.[3] Most are friends and acquaintances who had been with him in Paris, and it is as if by inscribing them on canvas once back in New York, Morse was resurrecting his largely public experience of making the painting, as described in his correspondence and that of his friends.[4] The work of completing these figures took so long largely because neither their number nor their identity had been entirely determined before sailing, as opposed to that of the copied pictures. Indeed, when Morse finally sold the picture a year later to George Hyde Clarke, a wealthy relative and neighbor of his friend James Fenimore Cooper, Morse offered to add "two or three full-length portraits of your family." These portraits were to occupy the space around the sculpture of the hunting Diana (which remains empty). Originally, this portion of the picture was going to accommodate "the portraits of Lafayette, Mr Rives the American minister at Paris, and one or two other friends," but this politically freighted vignette never materialized.[5]

In his letter to his brothers, Morse had insisted on the distinction between what "can only be completed there [at the Louvre], viz. the copies of the pictures," and "all the rest . . . such as the frames of the pictures, the figures, etc." As he later wrote to Thomas Cole, these "can be as well completed there as elsewhere."[6] He thus established a strong contrast between a located copying, which requires the physical contact of eye and hand with the object being

FIG. 52 Patricia Leslie. *Gallery of the Louvre* installed at the National Gallery of Art, 2012

FIG. 53 *Samuel Morse (1791–1872) on Board the Cruise Ship* Sully, 1832. Engraving from the book, *Album of Science Famous Scientist Discoveries*, 1899

copied, and a non-located copying, which doesn't need to be executed on the spot and relies instead on memory, as well as on mobile aids such as prints. This contrast informs Morse's request to borrow back the copy he had made for Cooper of Rembrandt's *The Angel Leaving the Family of Tobias* so that he could finish its integration into *Gallery of the Louvre*: "I shall have to finish the Rembrandt when I get home temporarily from the print, but when your copy that I made shall arrive it can easily be corrected if I should not have finished it properly."[7] The print would serve him as a temporary aide-mémoire, but only Morse's contemplation of, and contact with, the first physical copy, based on directly perceived visual information, would guarantee the integrity of the second one and the legitimate transmission of the primitive visual information.

✤ ✤ ✤

This contrast helps distinguish between two different strands of information that Morse's endeavor attempted to knit together. The first one—"the copies of the pictures"—aimed at accurately reproducing the object through its analogous transport onto another surface.[8] Morse's burning desire for exactitude recalls that of the "proto-photographers" at work during "the thirty years prior to the actual introduction of a marketable photography in 1839," whose efforts he had integrated with his and Benjamin Silliman's attempts at "fixing the image on the Mirror" in 1821–22.[9] As we shall soon see, it also resonates with his ambition for the telegraph: to allow for the retrieval, at a distance and without loss, of information transported from another location.

The second strand consists of a different, "unlocated" kind of information. In the case of the neutral modern frames imposed by Morse on nearly all the copied pictures, this absence of location is easily understandable. By deliberately suppressing the original frames, he aimed to bring the old masters into the present of the new picture, as opposed to reinforcing their ancient pedigrees.[10] The case is different, though, with the figures occupying the

FIG. 54 Samuel F. B. Morse, "Key to the Pictures," from his *Descriptive Catalogue of the Pictures, Thirty-seven in Number, from the Most Celebrated Masters, Copied into the Gallery of the Louvre*, 1833. Yale University Art Gallery, Rare Books

FIG. 55 Marcel Broodthaers (Belgian, 1924–1976). *White Room (Salle blanche)*. Wood, chipboard, plywood laminated on photography, painting on wood, plaster, metal, polyurethane foam, light bulb, 153½ × 132¼ × 259 in. (390 × 336 × 658 cm), Designed, produced, and presented in Paris at the exhibition of the artist at the National Center of Contemporary Art, Berryer Street in the fall of 1975, purchased 1989, Centre Pompidou, Paris, AM 1989-201

duplicated space of the Salon Carré. most if not all of them are linked to Morse's social life in Paris between October 1831 and July 1832, when he was copying the paintings he had elected to include in his "great canvas." Their reproduction would seem to require the same proximity as the copying of the pictures. And yet, while the rolled canvas was traveling to its intended destination, both their number and their identity were left to be pondered later, back in New York.

To treat the most intimate information offered in *Gallery of the Louvre*—a record of the participants in Morse's daily activities during his months at the museum—as something that could "be as well completed there as elsewhere" may sound paradoxical. Indeed, one could think of the delay in completing the figures as purely incidental. Had Morse, instead of embarking for New York, acceded to Cooper's last-minute invitation to join him and his family in Switzerland for the fall and to "finish the Louvre" there, these figures would quite likely have been added promptly and in the presence of at least some of the sitters, guaranteeing the accuracy of those particular likenesses.[11] But the painter chose not to accept Cooper's generous offer, sailing to New York

without further delay. In doing so he sanctioned the difference between the public information already painted on the canvas and the postponed addition of what would eventually amount to a memory image of the making of the picture.

This distinction is given further sanction in the "Key to the Pictures," published by Morse in 1833 as part of the catalogue for the New York exhibition of the painting (see the Appendix in this volume). The Louvre seen in this print is devoid of any human presence; emphasized instead is the perspectival depth of the Grande Galerie and the resistance against its pull exerted by the frontal wall of pictures in the Salon Carré. The pictures themselves consist of empty framed rectangles displaying their Louvre catalogue numbers (fig. 54). *Gallery of the Louvre* is here reduced to public information, in an image that today evokes the chance meeting of René Magritte and Marcel Broodthaers (fig. 55) with American conceptual art.

A DREAM OF INSTANT TRANSPORTATION: THE ELECTROMAGNETIC TELEGRAPH

Another reason why reworking the picture took so long, in addition to the slight restoration work needed to repair it after transit, is that immediately upon his return to New York, Morse engaged in experiments tied to the great idea he had hit upon during his voyage home—that of the electromagnetic telegraph. While the rolled canvas was tucked away in the dark hull of the *Sully*, the artist benefited from conversations with several of his dozen fellow passengers, including the aforementioned William Cabell Rives and Charles Thomas Jackson, a young scientist returning to Boston from three years of study in Paris.[12]

The five-week sailing provided an opportunity to renew thoughts long held by Morse and initially expressed in a letter written to his parents on his first trip to Europe, shortly after his arrival in England in mid-August 1811:

> I think you will not complain of the shortness of this letter; I only wish you now had it to relieve your minds from anxiety; for while I am writing I can imagine Mama, wishing that she could hear of my arrival, and thinking of thousands of accidents which may have befallen me; *& I wish that in an instant I could communicate the information; but 3000 miles are not passed, over in an instant*, & we must wait 4 long weeks, before we can hear from each other, but I hope Mama will always imagine the best; & think no news good news; for a thousand accidents may cause letters to miscarry &c.[13]

The symmetrical opposition of the 1811 and the 1832 voyages is striking: the first one, that of a young man venturing abroad for the first time to learn his trade as a historical painter; the second one, that of an acclaimed artist and lecturer on the arts, founder and president of the National Academy of Design, sailing back from the long-delayed three-year Continental tour designed to polish his artistic and professional education, transporting the "exhibition picture" that was going to demonstrate to his countrymen

FIG. 56 Samuel F. B. Morse. Sketch for electromagnet. Letterbook—2 June 1854–8 October 1855, pg. 102. Library of Congress, Washington, D.C., Manuscript Division

his ability both to rival the old masters (through accurately copying them) and to make them available to the New World of democratic America.

The memory—whether conscious or not—of Morse's earlier wish for a way of communicating information instantly across long distances may well account for his reaction, one day at dinner, to Jackson's account of having recently witnessed a demonstration of electromagnetism at the Sorbonne and his assertion of its logical consequence: "If the presence of electricity can be made visible in any part of the circuit, I see no reason why intelligence cannot be transmitted instantaneously by electricity."[14]

When dealing with Morse's first sketching of his invention onboard the *Sully*, multiple warnings are in order, for very few materials precede the patenting controversies and lawsuits that prompted, early on, the search for an authorized narrative of the

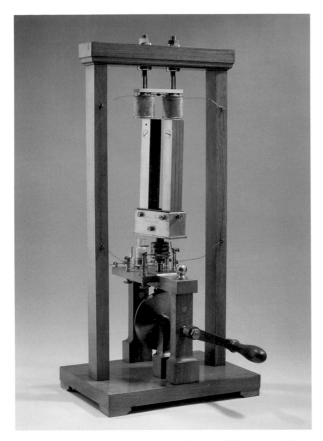

FIG. 57 Eugène Adrien Ducretet, Reproduction of Hippolyte Pixii's 1832 Electromagnetic Generator (*Machine magnéto-électrique de Hippolyte Pixii 1832*), before 1891. Conservatoire des Arts et métiers, Paris, inv. 12190

generator, made that same year in Paris by the scientific-instrument maker Hippolyte Pixii according to instructions from the French physicist André-Marie Ampère (fig. 57).[16]

In early 1827 Morse had attended James Freeman Dana's popular lectures on electricity and electromagnetism at the New York Athenaeum, where a few months before he had presented his own *Lectures on the Affinity of Painting with the Other Fine Arts*.[17] He was thus not a total stranger to the subject, but his scientific knowledge was no match for that of Jackson, who was acquainted with the most current research on electromagnetism in Europe.[18] There is little doubt about the important role Jackson played in imparting to Morse what was then the state of the art in electromagnetic studies, but I will concentrate instead on another facet of the invention much less studied, even today: that of the code, or language, first conceived by Morse. Onboard the packet ship, he could closely observe merchant-marine signaling, a mode of communication at sea, or between sea and land, that had been given new importance by the rapid growth of transatlantic sailing. Maritime telegraphy had acquired a new technical sophistication in the first decades of the nineteenth century. Indeed, Morse's use of a dictionary coupled with the numbering of words, described by Jackson in one of his judicial accounts of the voyage,[19] reprises the technique used in navy signal books (fig. 58), one of which was certainly owned by John Pell, captain of the *Sully*—whether it was the book of Le Havre or, more likely, that of the ship's berth, New York Harbor.

Moreover, the new developments in merchant-marine signaling did not depend just on the progress of military navy signals that had started in the last part of the eighteenth century; they were also linked to the development of optical telegraphy. Invented during the Revolution by the Chappe brothers and thereafter controlled exclusively by the French government, the technology was widespread in 1830s France and very much a topic of debate in Paris at the time Morse was there. The theoretical possibility of an electric telegraph (acknowledged by Ampère as

discovery and that prompted, as well, aggressive alternative versions of the tale. Without dwelling on Morse's claims to have single-handedly invented the telegraph, one may safely advance that the electromagnetic aspect of the invention was the least developed at the time, as shown by the inventor's persistent problems with it over the next five years. And while the drawing of an electromagnet in his *Sully* sketchbook (fig. 56) points to the very element needed for building a telegraph (though without an "intensity battery," which had actually already been invented by the American scientist Joseph Henry but was yet to be presented to Morse),[15] in all likelihood the painter was steered in the direction of this startlingly new development by Jackson. The young scientist carried onboard the *Sully* not a canvas but the newest European model of an electromagnetic

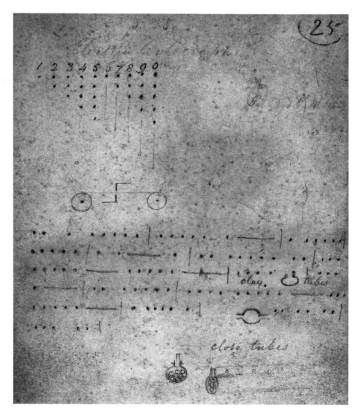

FIG. 59 Samuel F. B. Morse. Page from his Sully sketchbook with his first plans for the telegraph and numerical code, 1832. Division of Work & Industry, National Museum of American History, Smithsonian Institution

FIG.58 John R. Parker, Cover for *The New Semaphore Signal Book: In Three Parts, Containing the Marine Telegraph System, with the Appendix, the United States Telegraph Vocabulary, and Embracing the Holyhead Signals* (Boston: Light and Stearns, 1836), VK 391.P24, University of Michigan Library

early as 1822), and the efforts of a number of other European inventors, seemed to put the long-term future of optical telegraphy in question, while the death of Ignace Chappe the elder in 1829 stimulated public discussion of its viability as well as its potential extension to the private and commercial sectors.[20]

Morse's interest in these debates was noted by Richard West Habersham, a younger fellow painter who was his roommate in Paris in the spring of 1832 and who is likely the figure seated at an easel on the left-hand side of *Gallery of the Louvre*, painting a Salvator Rosa–like landscape (fig. 69):

The Louvre was always closed on Monday to clean up the gallery after the popular exhibition of the paintings on Sunday, so that Monday was our day for visits, excursions, etc. On one occasion I was left alone, and two or three times during the week [Morse] was absent. This was unusual, but I asked no questions and made no remarks. But on Saturday evening, sitting by our evening lamp, he seemed lost in thought, till suddenly he remarked: "The mails in our country are too slow; this French telegraph is better, and would do even better in our clear atmosphere than here, where half the time fogs obscure the skies. But this will not be fast enough— *the lightning would serve us better.*"

These may not be the exact words, but they convey the sense, and I, laughing, said: "Aha! I see what you have been after, you have been examining the French system of telegraphing." He admitted that he had taken advantage of the kind offer of one in authority to do so. . . .[21]

Several drawings in Morse's *Sully* sketchbook help to define the nature of his involvement in telegraphing (fig. 59). What he called his "type and apparatus to arrange the numbers for transmission" should thus be seen in the context of contemporaneous attempts to simplify and speed up the transmission of telegraphic messages.[22] The ten numerals employed to represent all numbers and words correspond to the method already in use in the Chappe telegraph system. And the numbered words composing two different messages on the same page point to then-current "dictionary" practices used both in semaphore and in maritime telegraphing.

ITINERANT PICTURES

Morse had taken an interest in the French semaphore telegraph system, "with a view to its introduction into America,"[23] while in the thick of his work at the Louvre. There he copied old master paintings in order to convey across the ocean their images, as well as that of the vast repository to which they had been relocated, and to make both available to his fellow citizens back in America. The kinship between the two projects is hard to deny. The aim in each case is to transport information—"intelligence," to use Morse's own wording—from one place to another, while keeping its deterioration to a minimum. Indeed, the whole point of telegraphy is the loss-free transmission of information across great distances, along with remarkably accelerated communication. As long as no human errors are made and as long as the quality of the mechanical transmission is maintained, the receiver will retrieve the original message intact.

This point also applies to Morse's picture and to the logic of copying that lies at its core, though in a less obvious manner. To begin with, *Gallery of the Louvre* both summarizes and elevates to another plane Morse's European endeavor: to copy old master paintings.[24] When he sailed to England in early November of 1829, "for the purpose of study and practice in his profession," he had about thirty

orders for pictures—"copies or originals . . . à la discrétion."[25] The copies were to be mostly of masters such as Nicolas Poussin, Claude Lorrain, Peter Paul Rubens, Carlo Dolci, Raphael, Titian, Tintoretto, and Bartholomé Estebán Murillo, and Morse added to this list during the next two years. As early as 1814, in a letter from London to his parents in Boston, he had written, "In order to create a taste . . . , pictures, first-rate pictures, must be introduced into the country, for taste is only acquired by a close study of the old masters."[26] *Gallery of the Louvre* can be considered his attempt to introduce to Jacksonian America the old masters he deemed indispensable to refined taste. In order to achieve this, it was necessary to select the best available paintings, copy them as accurately as possible, transport them from Europe to the United States, and exhibit them to the largest possible audience. I would like to examine each of these seemingly distinct goals.

The governing principle of Morse's activity as a copyist may be found in the second of his *Lectures on the Affinity of Painting with the Other Fine Arts*, delivered at the New York Athenaeum three and a half years before his second European trip. There he states that "Mechanical Imitation in Painting [is] a necessary excellence through every step" and, furthermore, that "there is no reason why every thing that is selected to be represented should not be imitated exactly."[27] This emphasis on exact imitation *of any object whatsoever* separates Morse from earlier theorists, including those he repeatedly favored, such as Joshua Reynolds.[28] It also helps illuminate his copying practice, and his otherwise incomprehensible disregard for making engravings and prints. Aside from one youthful effort, Morse never turned to engraving. Prints of his works, remarkably scarce, are always linked to collective efforts, such as the 1830 annual *The Talisman*. And whereas he was seriously involved in the daguerreotype process, which produced a unique image, he was never interested in paper negatives, with their potential to yield multiple copies of the same image.

In Morse's practice, painting an accurate copy of a painted image does not amount to a return to an archaic mode of manual imitation, in opposition to (and destined to be displaced by) the surge of mechanical reproduction. Rather, his painted copies should be considered as a parallel engine of reproduction, able to reproduce faithfully a variety of aspects—such as color and texture—that prints could not capture, except through extremely codified and fairly abstract modes of transposition/reduction.[29]

Of course, painted copies could not compete with the capacity of prints to be mechanically multiplied, in order for the conveyed image to exist simultaneously in several distant places. But what had constituted a huge limitation on paintings (and a major contribution to the modern success of prints) when they belonged mostly in private houses or were set in churches and palaces from which they could not be moved, proved less a handicap once paintings started to be exhibited to mass audiences.

In his essay "The Work of Art in the Age of Mechanical Reproduction," Walter Benjamin remarks on the crisis brought about in painting by this new situation:

> The simultaneous contemplation of paintings by a large public, such as developed in the nineteenth century, is an early symptom of the crisis of painting, a crisis which was by no means occasioned exclusively by photography but rather in a relatively independent manner by the appeal of art works to the masses. . . . In the churches and monasteries of the Middle Ages and at the princely courts up to the end of the eighteenth century, a collective reception of paintings did not occur simultaneously, but by graduated and hierarchized mediation. The change that has come about is an expression of the particular conflict in which painting was implicated by the mechanical reproducibility of paintings.[30]

Benjamin rightly points out that the "simultaneous contemplation of paintings" by a mass audience radically transformed their reception, but one may observe that the circulation of copies of famous paintings actually answers to the new conditions assigned to painting—an answer not to be confused with the challenge that mechanical reproduction caused to painting. Nor is it to be confused with the contemplation of "originals." For, as expressed in the choice given to Morse by his New York patrons on the eve of his departure, the distinction between "copies or originals" ceases to be significant when applied to contemporary works.[31] In this regard, at least, painted copies destined for a mass audience do not fundamentally differ from mechanically produced images and from a technique of reproduction that "[detaches] the reproduced object from the domain of tradition." In his essay, Benjamin notes: "By making many reproductions it [mechanical reproduction] substitutes a plurality of copies for a unique existence. And in permitting the reproduction to meet the beholder or listener in his own particular situation, it reactivates the object reproduced."[32]

Painted copies do not "substitute a plurality of copies for a unique existence," but they do "meet the beholder . . . in his own particular situation," and they do so through the medium of traveling public exhibitions. Commenting on Thomas Sully's successful completion in 1821 of a copy of François-Marius Granet's *Choir of the Capuchin Church in Rome* (fig. 38), produced because of "the noise which Granet's picture . . . made at that time," the American writer William Dunlap observed: "It was justly thought that a good copy would be a profitable exhibition picture, especially as the original was the property of a man of fortune, and not visited with the same freedom as one feels when paying twenty-five cents for admission—a kind of ease similar to one's enjoyment 'in mine own inn.'"[33] A "good copy" will make "a profitable exhibition picture," because its accuracy provides its viewers with the same information as the picture it is drawn from, while its mobility spares them the effort and expense of visiting the original.

At this stage, it is worth remembering that *Gallery of the Louvre* was conceived from the start as a picture

designed for exhibition in the United States.[34] We will probably never know how much of it harks back to Morse's 1829 project of soliciting contributions for a large picture to be painted in Europe, a project that then transmogrified into multiple commissions for individual "copies or originals." What is certain is that *Gallery of the Louvre* was painted "on speculation"; that James Fenimore Cooper was brought into that speculation early on by Morse; and that said speculation involved a planned tour of major cities in the United States.[35]

With this new exhibition picture, Morse was attempting the same maneuver he had once performed with his *The House of Representatives* (fig. 5), prompted by the success of Granet's *Capuchin Church*.[36] After causing a sensation at the Paris Salon of 1819, Granet's "exhibition picture" had toured for several years in multiple versions, including three different copies in the United States alone at the beginning of the 1820s—the most famous being Sully's. Both *The House of Representatives* and *Gallery of the Louvre* similarly introduce a prospective mass audience to memorable faraway places filled with a certain class of people, and present them to the public eye with the utmost accuracy.[37] How closely this "class of pictures" is related to panoramas may be glimpsed in comments by John Vanderlyn, another American painter-entrepreneur trained in Europe, about the specific virtues of panoramic exhibitions:

> Panoramic exhibitions possess so much of the magic deception of the art, as irresistably to captivate all classes of Spectators, and to give them a decided advantage over every other description of pictures; for no study nor a cultivated taste is required fully to appreciate the merits of such representations. They have further the power of conveying much practical and topographical information, such as can in no other manner be supplied, except by actually visiting the scenes which they represent, and if instruction and mental gratification be the aim and object of painting no class of pictures have a fairer claim to the public estimation than panoramas.[38]

The distant information conveyed by "panoramic exhibitions" and "exhibition pictures" is presented to their viewers *here and now*, "in their own situation," without rupturing the domestic ease that William Dunlap compared to "one's enjoyment 'in mine own inn.'"

As we know too well, both of Morse's "miniature panoramas" failed miserably. As Dunlap memorably wrote after *Gallery of the Louvre* was shown in New Haven, "every artist and connoisseur was charmed with it, but it was 'caviare to the multitude.'"[39] I suggest that the reason for the failure of these two paintings goes beyond the mere unpredictability of the market. It is instead linked to the very nature of the information these paintings attempted to impart—which brings us back to the telegraph, and to its ambition to accurately copy and transport information across great distances.

THE SPEED OF ART

In his book *Communication as Culture*, James W. Carey remarks: "The activities we collectively call communication—having conversations, giving instructions, imparting knowledge, sharing significant ideas, seeking information, entertaining and being entertained—are so ordinary and mundane that it is difficult for them to arrest our attention."[40] The activities represented in *The House of Representatives* (fig. 60)— conversing, reading (a speech, a book, a journal), writing, sending and receiving mail—are all linked to communication in its most unspectacular form. Maybe this very ordinariness made it (and still makes it) difficult to recognize the subject of Morse's picture: not just the great Hall of the House of Representatives, nor the individuals who occupy its space, but the multiple activities of communication they indulge in, sanctioned by the new social and political space they occupy.

Ten years later, Morse's preoccupation with public communication was demonstrated once again in *Gallery of the Louvre*. In his second attempt at a large exhibition picture, the painter portrays the most

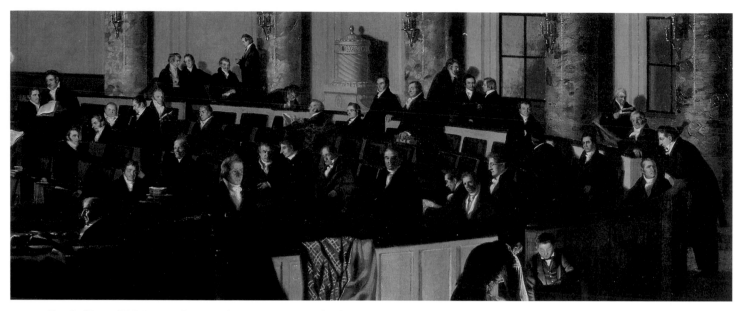

FIG. 60 Detail of Samuel F. B. Morse, *The House of Representatives*, completed 1822, probably reworked 1823. Corcoran Gallery of Art, Washington. See fig. 5

celebrated space (the Salon Carré) in the most famous embodiment (the Musée du Louvre) of a most typical post-Revolution democratic institution: the museum. As in *The House of Representatives*, the attitudes and activities of the figures occupying the space implement the exchange, reproduction, and transmission of information. In the Grande Galerie and at the threshold of the Salon Carré, visitors gaze at the pictures displayed on the walls, in several cases reading from guidebooks or catalogues. In the Salon, several conversations are in process. A couple reviews the work of a seated young copyist (as we know, they are James Fenimore Cooper, his wife, and their daughter); a man gives advice to a young woman drawing (the man is Morse himself).[41] But the activities of looking at pictures, reading, and conversing are topped by the act of *copying*, which is at the core of the picture and of Morse's own endeavor in making it.

For Dunlap, a good copy was a perfectly adequate substitute for a contemporary work, as long as the copy was being exhibited to a popular audience, an audience willing to pay for the pleasure of viewing pictures detached from tradition and conveying

visual intelligence that didn't depend on the unique aura of an original. Yet making a good copy required at least several months of work, and the capacity of copies to be seen and to generate profits did not depend only on their multiplication but also on the continued mobility of each copied picture—which is different. And with this last statement, we reach a significant limit to the comparison being made between painted pictures and the electric telegraph. For as much as we may compare the circulation of paintings—whether copies or originals—to the sending and receiving of telegraphic messages, there remain a few important differences.

In the third of his *Lectures on the Affinity of Painting with the Other Fine Arts*, Morse had defined the improvement that Art brings to Nature as the power to speed up natural processes:

There are certain methods in Nature by which many operations are performed which are too slow to suit the necessities, the conveniences, or the wishes of man. It is here that Art comes in and by its mechanism helps to quicken the sluggishness of a natural process. The tide or wind will naturally

move a boat without the assistance of Art, but Art constructs the sail and the rudder and gives it additional velocity and any desired direction. Art improving on art applies the steam engine to the more rapid accomplishment of the same original and natural movement.[42]

Morse then extended this analogy specifically to the "Fine Arts": "Nature is full of objects that naturally affect the imagination; some making but a faint and evanescent, some a strong and lasting impression. The mere mechanical imitation or copying of some of these striking objects will excite strongly the same emotions as their originals."[43]

The making of *Gallery of the Louvre* embodies the combination of these two factors. The act of copying increases the speed with which the information conveyed in the paintings is disseminated throughout social space. The accuracy of the copies (which requires their being painted copies, as opposed to prints) guarantees the transfer of the affective power of the copied image from its original to its new location, wherever it may be. Considered in this light, *Gallery of the Louvre* presents its audience with a shortcut to European painting, speeding up its apprenticeship by exhibiting what was the museum's own summary of European painting.[44] The description of the project by a well-informed writer in Boston's *Daily Evening Transcript* of November 15, 1832, goes in this same direction:

> The canvas represents one side of the Large Hall at the entrance of the gallery; a view of which forms one part of the picture. The paintings are of course not those really in the room, (excepting two or three) but are selected from different parts of the gallery, and are all chef d'oeuvres. This happy thought of Mr Morse, which he has executed in an admirable manner, enables him to *exhibit in one view*, specimens of the most remarkable style in each school, and will enable our countrymen who have not visited the large European collections, to estimate the various peculiarities of the artist.[45]

Speed and ease characterize the "happy thought of Mr Morse." The painting allows the viewers to annihilate time and space,[46] both because it will transport them instantly inside the Louvre and because they can simultaneously embrace nearly forty paintings there at a single glance. But while the fine art of exact visual imitation here emulates the speed of telegraphy by enabling the simultaneous presentation of otherwise distant objects, the transportation across the ocean of the visual intelligence inscribed in the picture still required, as acknowledged moments ago, *conveying the physical body of the painted canvas*. It was—and still remains, to this day—impossible to telegraph a painting.

Moreover, by the time the picture was finally exhibited, in addition to the "practical and topographical information" identified in its "Key," another kind of information had become inscribed in it: that embodied in the figures spread around the Salon Carré. In his various accounts, Morse paradoxically treats this circumstantial information as "unlocated" or to be inscribed later—"with all kinds of delay," as Marcel Duchamp would later say.[47] This delay in Morse's inscribing the figures tells us the most about their nature and role in the picture. Only after they had been removed from the location they originally belonged to did it become possible for Morse to paint them.

From that point of view, *Gallery of the Louvre* can be compared to its predecessor, *The House of Representatives*. Morse painstakingly had all sixty-eight members of the House sit for their individual portraits, which he painted while working in his studio next to the House chamber, struggling with the perspective of the Hall. He then went back to his New Haven home to paint the picture, and in July 1822 a reporter from the Charleston *Courier* could write that "all the objects of the picture are already drawn upon the canvas, and have received their first colouring, or dead colour, *except the figures*."[48] In his *Key to Morse's Picture of the House of Representatives*, written for the picture's exhibition in New Haven in 1823, the artist had already stated the difference

between the painted description of the place, to which most of his text was devoted in excruciating detail, and the figures located in it, expedited in a few lines: "The primary design of the present picture is not so much to give highly-finished likenesses of the individuals introduced as to exhibit to the public a faithful representation of the National Hall, with its furniture and business during the session of Congress. If the individuals are simply recognized by their acquaintances as likenesses, the whole design of the painter will be answered."[49]

The figures in the painting, as opposed to the topographical particulars or the copied pictures, do not need to be depicted with the utmost "located" exactitude. They are not vehicles carrying previously unknown information to its viewers. They are vehicles for memories. Their task is to prompt the recall of those who, because they were there or recognize the likenesses of their protagonists, may remember scenes akin to the ones presented on the surface of the painting. And once this has been effected, "the whole design of the painter will be answered."

INFORMATION AND/OR MEMORY

With his remarks in the *Key*, Morse revealed the deeply divided nature of his two attempts at delivering a new, contemporary type of history painting. *The House of Representatives*, like the later *Gallery of the Louvre*, works as a dual, split vehicle. On one hand, it brings home to the public the distant topographical and visual information that is the staple of exhibition pictures and panoramas. On the other hand, it provides a different, unsolicited type of experience: that of watching memories—someone else's or, for a small minority in the audience, their own—inhabit the painted scene. And while the topographical accuracy of the picture is meant to be believed in by every one of the spectators, the recognition of the figures by only a minority of cognoscenti points to the logic of memory here at work and to the relationship between inscription, transport, and

location commanded by this "configuration of space and manners."[50]

Morse's physical proximity to the object and its circumstances implied by the located copying of the place actually liberates the information presented in the picture from its dependence on original circumstances. For, once authenticated by this physical link, the picture can travel anywhere and be seen by anyone, while conveying and delivering the same information. Once again, this logic may be termed "pre-photographic," and it foreshadows Morse's enthusiasm for the daguerreotype.

The delay in inscribing the figures, though presented by Morse as stemming from an indifference to place, actually emphasizes the dislocation necessarily effected by the workings of memory. If the figures of James Fenimore Cooper, his wife, and their beloved daughter were not inscribed on canvas while in Paris, it is because they still belonged—as did, at one time, the numerous portrait studies of the House members executed in Washington—to the located present of copying. Only through their removal to another, distant place do they acquire the potential to become memory images and to be inscribed as such on the canvas, for the inscription of the memory image has to be delayed in respect to the circumstances it transmutes into visuality. (Its "unlocatedness," in this sense, is only provisional.) But in terms of the transmission of information, this inscription possesses a restricted address: its privileged addressee seems to be its maker, and its apprehension as a memory image by other viewers depends on their recognizing at least a measure of the original circumstances surrounding the scene they are presented with.

In view of all this, the public failure of Morse's painted efforts becomes more understandable, for two parallel reasons. First, as much as they push in the direction of displaying panoramic information, Morse's paintings also exhibit a strong resistance to the informational logic at work in that kind of public visual display. And this resistance was no doubt felt, if not fully recognized, by their audiences. While "every artist and connoisseur"—people who could

relate to the likenesses disseminated in the work and to their belonging to personal memories— "was charmed" by them, "the multitude" could only perceive the figures as an obstacle to deciphering the unknown "practical and topographical information" simultaneously presented to their eyes.

This difficulty was compounded by the fact that Morse, far from acknowledging the dual nature of his exhibition pictures, favors in his written presentations the logic of copying, with its informational dimension, over the memory aspect also present in the paintings. When he characterizes the figures as able to be completed "there as elsewhere," he allows the ubiquity of information to stand for a feature that has more to do with time, delay, and the construction of memory. The invention of the telegraph, with its annihilation of the circumstantial time of memory, sums up this overinvestment in the informational component of image making and in the type of dissemination of meaning it allows. Not only does the telegraph transmit instantly and to any destination whatsoever any codified information entrusted to it, it also records that information at its intended place of destination, whether or not the addressee is actually present to receive it.[51] A mechanical record replaces the memory, awaiting future use by anyone interested in the information it conveys.

Interestingly, at a time when his bitter disappointment in the public career of his exhibition pictures, coupled with the long-awaited success of his telegraph, led him to abandon painting altogether, Morse chose to salvage the very function of painting that he had refused to acknowledge until then. In yet another letter to Cooper, he wrote:

> alas! my dear Sir, the very name of *pictures* produces a sadness of heart I cannot describe. Painting has been a smiling mistress to many, but she has been a cruel jilt to me. I did not abandon her; she abandoned me. I have taken scarcely any interest in paintings for many years. Will you believe it, when last in Paris, in 1845, I did not go into the Louvre, nor did I visit a single picture gallery. I sometimes indulge a vague dream that I may paint again. It is rather the memory of past pleasures when hope was enticing me onward, only to deceive me at last. Except some family portraits, valuable to me from their likenesses only, I could wish that every picture I ever painted was destroyed.[52]

The one element exempted from imaginary destruction in this overly dramatic letter is family portraits—i.e., images made for the exclusive purpose of remembering loved ones and destined to be seen by only a few. All the other paintings that had carried the hope—unduly, Morse now implies—of simultaneously transporting information and memories, and imparting them to *anyone* among the multitude of potential viewers, are now meant to be destroyed. Their task has been transferred once and for all to the telegraph. No longer relevant, pictures will best be left to their own decay (or even to their independent success, as unlikely as it may be).[53]

Why did the painter of *Gallery of the Louvre* invent the electromagnetic telegraph? Perhaps because he was obsessed by the growing chasm between the accurate conveyance of information across distances and the visual transmission of memories. Why did he eventually renounce painting? Perhaps because the failure of contemporary audiences to recognize these antagonistic dimensions in his work became unbearable. The telegraph then became the exclusive refuge of an informational aspect previously embodied equally in Morse's pictures, providing it with much stronger social traction. Painting, to the contrary, was to be narrowed to a space of likeness-making devoid of any larger social relevance. Memory, now restricted to the private sphere, became divorced from a newly coded type of information.

CODA

The deeply nostalgic (if bitter) tone of the letter quoted above should not blind us to the modernity of the task that Morse had once assigned to the two "exhibition pictures" he brought to completion. Let

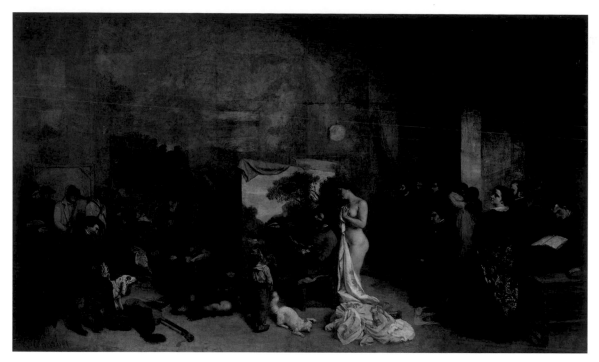

FIG. 61 Gustave Courbet (French, 1819–1877). *The Artist's Studio: A Real Allegory Summing Up Seven Years of My Artistic and Moral Life*, 1854–55. Oil on canvas, 142⅛ × 235⁷⁄₁₆ in. (361 × 598 cm). Musée d'Orsay, Paris, RF2257

us retrace our steps back to Paris, this time a good twenty years after the finishing of *Gallery of the Louvre*. Let us take a peek, in the Pavillon du Réalisme newly built by Gustave Courbet during the 1855 Exposition Universelle, at his painting *The Artist's Studio: A Real Allegory Summing Up Seven Years of My Artistic And Moral Life* (fig. 61). There we will find a "configuration of space and manners" in many ways similar to Morse's *Gallery of the Louvre*. A panoramic view of Courbet's Paris studio, including a few of his pictures, serves as a foil for the display of more than thirty figures. In a famous letter addressed to his friend Champfleury, a critic and champion of Realism, the painter describes his painting as "the moral and physical history of my studio," which once again privileges the depiction of place. He also fills this place with a host of open or disguised portraits of acquaintances or topical figures of Parisian life linked to the painter since 1848.[54]

The striking resemblance between the two projects includes their common insistence on depicting ordinary duration and repetitious time, as opposed to singling out an event. But in Morse's case, the circumstantial evidence of the "moral and artistic life" of the painter was either presented as information or went unacknowledged—at least in his own writing. Courbet, through his inventive categorization of the picture as a "real allegory," does not suppress the mnemonic nature of his constructed image. He even acknowledges its undecidability: the contemporary figures spread around the studio are simultaneously "allegorical" social types and recognizable likenesses,[55] and this dual status endows this "personal picture"[56] with its ultimately nontelegraphic mystery.[57]

Why did Morse not fully recognize *Gallery of the Louvre* as the "personal picture" that it also was, thus condemning the visual inscription of the memory of its making to remain unrecognizable by most of its potential audience? Perhaps because he chose to privilege the speed and ease of codified communication over the mysteries of circumstantial image

making. Two recent images demonstrate that this dilemma is not altogether a thing of the past. Both of them are photographs, and both are such large prints that their dimensions compete with the kind of "exhibition picture" that Morse had attempted with *Gallery of the Louvre*.

In Thomas Struth's *Louvre III* (fig. 62) we recognize two of the Titian paintings copied by Morse: *Francis I* and *Supper at Emmaus* (figs. 79 and 80), in quite as close a relationship, though reversed, as in Morse's picture. We will not recognize the Grande Galerie, since the paintings have long since been moved to another place. Nor will we recognize, in eight seated figures, the active copyists at work in Morse's Salon Carré. Mere looking has replaced copying, and even though the pose of the man on the left-hand side of Struth's photograph recalls that of the male copyist at left in Morse's painting, he no longer holds a brush in his hand.

In Andreas Gursky's picture of the new German Parliament in Berlin (fig. 63), we may recognize an heir to Morse's *The House of Representatives*, his first attempt at creating a miniature panorama. One could comment on the way the single, huge Argand chandelier in Morse's painting gives way, in Gursky's photograph, to the shattered light that the glass reflections democratically disperse all around the space. I will not analyze this in any detail. Instead, I will conclude with a single observation.

It is now possible to digitally transmit images such as these by Struth and Gursky across great distances and with great exactitude, both because they are photographs and because the ease and speed with which they circulate does not significantly alter them. But the monumental scale of the prints and the way they are framed will not be digitally transmitted, and they actively resist this kind of codified reduction. "Exhibition pictures," with the contentious relationship to information they embody, are here to stay, as much as their telegraphic nemeses.

FIG. 62 Thomas Struth. *Louvre 3, Paris 1989*, cat. 4031. Chromogenic print, frame: 66¼ × 59 in. (168 × 152 cm)

FIG.63 Andreas Gursky (German, born 1955). *German Parliament (Bundestag)*, 1998. Color photograph on paper, 111¹³⁄₁₆ × 81½ in. (284 × 207 cm). Presented by the Friends of the Tate Gallery 1999, Tate Art Gallery

Notes

1 Destined for his friend James Fenimore Cooper, the picture was one of the first individual copies made by Morse on his return to Paris from Italy, and he could thus afford to postpone its transfer to *Gallery of the Louvre*. Back in New York, on February 28, 1833, Morse wrote to Cooper: "Could you send me the copy of Rembrandt's *steamboat* that I made for you? I should be glad to retouch the copy of the same in the great picture." James Fenimore Cooper, *Correspondence of James Fenimore-Cooper, Edited by His Grandson, James Fenimore Cooper* (New Haven: Yale University Press, 1922), 1:311. The "steamboat" was the nickname given to the picture by Cooper's wife, Susan, quite likely because of the billowing dark clouds sustaining the angel's flight.

2 Morse to Sidney and Richard Morse, July 18, 1832, Samuel F. B. Morse Papers, 1793–1944, Manuscript Division, Library of Congress, Washington, D.C.

3 See Morse to Cooper, August 9, 1833: "My Picture, *c'est fini*; I shall be glad to show it to you: perhaps I may sell it to the Bostonians; may I not for 2500 dollars?" Cooper, *Correspondence*, 1:320.

4 See Cooper to William Dunlap, March 16, 1832: "[Morse] is painting an Exhibition picture that I feel certain must take. He copies admirably and this is a (picture) drawing of the Louvre with copies of some fifty of its best pictures." Cooper also mentions the "little school" informally held by Morse in the galleries. See Cooper to Peter Augustus Jay, January 2, 1832: "I shall send out, by some early packet, a copy of Rembrandt made by Mr. Morse for me. It is capitally done, though one of the most difficult pictures in the Louvre to be done. I know no artist that has improved as much as Mr. Morse. He really has created a sensation in the Louvre, having a little school of his own, who endeavor to catch his manner." James Fenimore Cooper, *The Letters and Journals of James Fenimore Cooper*, ed. James Franklin Beard (Cambridge, Mass.: Belknap Press of Harvard University Press, 1960), 2:239, 172. See also Paul J. Staiti, *Samuel F. B. Morse* (Cambridge: Cambridge University Press, 1989), 194. The sculptor Horatio Greenough, the writer Nathaniel Parker Willis, the geographer and naturalist Alexander von Humboldt, and the archaeologist and museum curator Alexandre Lenoir were among Morse's many visitors while he was at work in the Louvre.

5 See draft of a letter from Morse to George Hyde Clark, July 25, 1834, Samuel F. B. Morse Papers, 1793–1944, Manuscript Division, Library of Congress, Washington, D.C., quoted in David Tatham, "Samuel F. B. Morse's *Gallery of the Louvre*: The Figures in the Foreground," *American Art Journal* 13 (Autumn 1981): 44. The "political" nature of this grouping involved the liberal-leaning circle of American expatriates gathered around Rives and the Marquis de Lafayette. See Robert E. Spiller, "Fenimore Cooper and Lafayette: The Finance Controversy," *American Literature* 3 (March 1931): 28–44.

6 Morse to Thomas Cole, August 25, 1832: "The picture I shall finish in New York as the frames of the different pictures, etc. can be as well completed there as elsewhere." Thomas Cole Papers, New York State Library, Albany, quoted in Tatham, "Figures in the Foreground," 42.

7 Morse to Cooper, Paris, September 6, 1832, in Cooper, *Correspondence*, 1:292–93.

8 With the notable exception of size. The size of copies was routinely different from that of the copied original, and in *Gallery of the Louvre*, Morse played quite significant games with scale. See Staiti, *Morse*, 191.

9 Geoffrey Batchen, *Burning with Desire: The Conception of Photography* (Cambridge, Mass.: MIT Press, 1997), 56. Morse's and Silliman's attempts are recorded and discussed 39–42.

10 The similarity between those frames and the one actually framing *Gallery of the Louvre* itself establishes a further equivalence between the painted *Gallery* and the many painted copies it incorporates.

11 Cooper to Morse, September 1 and 5, 1832, in Cooper, *Letters and Journals*, 2:323 and 2:330.

12 Charles Thomas Jackson had arrived in Paris in 1829, fresh from Harvard Medical School. Though officially there to complete his medical studies, he devoted much of his time to the study of geology and, in 1831–32, electricity. Jackson had been introduced to Cooper in Paris in June 1831. See Cooper, *Letters and Journals*, 1:94.

13 Morse to his parents, August 16–17, 1811, Samuel F. B. Morse Papers, 1793–1944, Manuscript Division, Library of Congress, Washington, D.C. The underlining of the sentence is quite likely a later addition by Morse, who at some point penciled on the back of the letter: "A longing for the telegraph even in this letter."

14 Samuel Irenaeus Prime, *The Life of Samuel F. B. Morse, LL. D., Inventor of the Electro-Magnetic Recording Telegraph* (New York: D. Appleton, 1875), 252. This may be a rewording of Morse's reply to the circular issued by Levi Woodbury, Secretary of the U.S. Treasury, on March 10, 1837, "with a view of obtaining information in regard 'to the propriety of establishing a system of telegraphs for the United States.'" In it Morse stated:

"About five years ago, on my voyage from Europe, the electrical experiment of Franklin, upon a wire some four miles in length, was casually recalled to my mind in conversation with one of the passengers, in which experiment it was ascertained that the electricity traveled through the whole circuit in a time not appreciable, but apparently instantaneous. *It immediately occurred to me that, if the presence of electricity could be made VISIBLE, in any desired part of this circuit, it would not be difficult to construct a SYSTEM OF SIGNS by which intelligence could be instantaneously transmitted.* The thought, thus conceived, took strong hold of my mind in the leisure which the voyage afforded, and I planned a system of signs, and an apparatus to carry it into effect." Ibid., 316. (Italics in the original.) Morse's mention of Benjamin Franklin's earlier "experiment," as opposed to André-Marie Ampère's recent ones, and his omission of Jackson's name point to his reworkings of the history of his invention, linked to his contentious attempts at patenting the "electromagnetic telegraph."

15 Henry's experiments and invention were reported in Benjamin Silliman's *American Journal of Science and Arts* in January 1831. Furthermore, Henry demonstrated "the practicability of an electromagnetic telegraph" in numerous experiments in Albany and Princeton during the next two years. But in 1836 Morse's first prototype still used William Sturgeon's electromagnet, an improved Ampère-like apparatus; it was through his colleague Leonard Gale, professor of chemistry at New York University, that Morse learned to use both Henry's "intensity battery" and his powerful electromagnet. See David Hochfelder, "Joseph Henry: Inventor of the Telegraph?," accessed August 7, 2013, http://siarchives.si.edu/history/jhp/joseph20.htm.

16 See Jackson's testimony in Richard J. Wolfe and Richard Patterson, *Charles Thomas Jackson, "The Head Behind the Hands": Applying Science to Implement Discovery and Invention in Early Nineteenth Century America* (Novato, Calif.: History of Science.com, 2007), 269. Jackson later claimed that he was coinventor of the telegraph, if not its solo inventor.

17 Samuel F. B. Morse, *Lectures on the Affinity of Painting with the Other Fine Arts*, ed. Nicolai Cikovsky, Jr. (Columbia: University of Missouri Press, 1983).

18 Jackson had attended Claude Pouillet's celebrated lectures in the preceding months. A pupil of Joseph Louis Gay-Lussac who taught at École Polytechnique and at the Conservatoire des Arts et Métiers, Pouillet had already used "a copy or version of Henry's 'quantity magnet'" in his 1831–32 lectures. See Wolfe and Patterson, *Charles Thomas Jackson*, 134. Jackson's "Notice

of the Revolving Electric Magnet of M. Pixii, of Paris"—dated December 25, 1832, and published in Benjamin Silliman's *American Journal of Science and Arts* 24 (1833): 1, 146–47—testifies to his thorough knowledge of the apparatus and of the experiments conducted with it.

19 "Within a few days after my first conversation above mentioned, I think the third day after I had a conversation with Mr. Morse as to the practicability of devising a system of signs which could be readily interpreted, I proposed an arrangement of punctured points or dots to represent the ten numerals. Mr. Morse proposed to reduce it to five numerals, & zero, saying that all numbers could be represented thereby. Mr. Morse took a Dictionary and numbered the words and then tried a system of dots against it. We assigned to each word selected for that purpose, a separate number, and the numbers were indicated by dots and spaces. We took our respective places at the opposite sides of a table. He would send me dispatches written in numerals which I would examine with the aid of the marked dictionary which I held in my hand, and I found no great difficulty in reading them; and then we would change, he taking the dictionary and I sending the words. Mr. Morse took the principle [sic] part in arranging the system of signs and deserves the greatest credit for it. Mr. Morse made notes of the system of signs so far as we had completed it, in his note book, either fully or partially." Jackson, quoted in Wolfe and Patterson, *Charles Thomas Jackson*, 301.

20 See Ignace Chappe, *Histoire de la télégraphie* (Paris, 1824), 12–14.

21 Habersham, quoted in Samuel F. B. Morse, *Samuel F. B. Morse: His Letters and Journals*, ed. Edward Lind Morse (Boston: Houghton Mifflin, 1914), 1:417–18. Prime offers a slightly reworded account in his *Morse*, 230.

22 Morse to Charles Thomas Jackson, December 7, 1837, quoted in Wolfe and Patterson, *Charles Thomas Jackson*, 93. For examples of other attempts, see, for instance, Chappe, *Histoire de la télégraphie*, 135–36.

23 Habersham, quoted in Prime, *Morse*, 230.

24 As exemplified by Morse's remark on his first visit to the Louvre, in January 1830: "On the walls [of the Grande Galerie] are twelve hundred and fifty of some of the *chefs-d'oeuvre* of painting. Here I have marked out several which I shall copy on my return from Italy." Morse, letter from Paris, January 7, 1830, quoted in Prime, *Morse*, 182.

25 See the "Commissions for Pictures," dated September 25, 1829, in Prime, *Morse*, 172–73.

26 Morse to his parents, March 12, 1814, quoted in Cikovsky, introduction to Morse, *Lectures*, 17. This does not contradict Morse's later assertion, in his 1827 lecture on academies of art, that a disease affecting the American republic was "the propensity for collecting *Old Pictures*," quoted in Staiti, *Morse*, 163. Indeed, a good and exact copy of a masterwork educates much better than a second-rate deteriorated work of dubious provenance.

27 Morse, *Lectures*, 61.

28 This is demonstrated by a fuller quotation of the text: "But, it may be asked, is not Mechanical Imitation in Painting a necessary excellence through every step even to the highest grade of epic? *I have allowed that it is, and to a greater degree than Sir Joshua Reynolds is disposed to admit.* There is no reason why every thing that is selected to be represented should not be imitated exactly." (Italics mine.)

29 In a pioneering study, Jennifer L. Roberts recently explored a "set of shared concerns about coding, replication, and transmission shared by both telegraphy and visual media." Analyzing prints and paintings by Morse's friend and colleague Asher Brown Durand, she gives special attention to Durand's line engraving of John Vanderlyn's *Ariadne* and demonstrates the "print's profound ambivalence about the very project of printing, its mission of replication and displacement." See Jennifer L. Roberts, "Post-Telegraphic Pictures: Asher B. Durand and the Non-Conducting Image," *Grey Room*, no. 48 (Summer 2012): 12–35. Seen in this light, Morse's lack of interest in prints (except as visual aids in his public lectures) is even more striking.

30 Walter Benjamin, "The Work of Art in the Age of Mechanical Reproduction," 1936, in Walter Benjamin, *Illuminations*, trans. Harry Zohn, ed. Hannah Arendt (New York: Schocken Books, 2007), 234–35.

31 Another element confirms the substitutability of copies and originals from the point of view of the commercial circulation of painted images: Morse's and Cooper's projected scheme of "invading Italy on a picture speculation" in late 1831—which supposedly involved their buying old master paintings in Italy to be resold in Paris—is put on equal footing with the Louvre exhibition picture, with its "copies of fifty of its best pictures." Both schemes were meant "to put money in our pockets, while we befriend the arts." Cooper to Horatio Greenough, December 24, 1831, in Cooper, *Letters and Journals*, 2:165.

32 Benjamin, "The Work of Art in the Age of Mechanical Reproduction," 221.

33 William Dunlap, *History of the Rise and Progress of the Arts of Design in the United States*, ed. Rita Weiss (1834; repr., New York: Dover, 1969), 2:i:134.

34 See Cooper's remarks in his letter to Greenough, note 4 above, and the text in the *Daily Evening Transcript*, note 46 below.

35 Cooper wrote to Horatio Greenough on March 15, 1832: "We are all well, and Morse hard at work at *his* copy of the Louvre, in which a certain friend of yours has a finger. But this is mum." Cooper, *Letters and Journals*, 2:236. And at the end of December 1832, William Dunlap wrote from New York to Cooper in Paris: "Morse and Cole are with us, much to our satisfaction. *Your picture of the Gallery of the Louvre we have not yet seen.*" (Italics mine.) See Cooper, *Correspondence*, 1:305. How much Cooper's ownership of the painting was his idea or that of Morse is still debatable. By the time the latter finished the painting, he was planning to sell it to others. See note 3 above.

36 According to Dunlap: "The rumor reached him [Morse] of the great success of the Capuchin Chapel, as an exhibition picture, and his hopes of becoming an historical painter were revived by a plan he formed of painting an interior of the House of Representatives, at Washington, with portraits of the members. This he thought, might be sent with an agent to various cities, and the revenue derived from its exhibition would enable him to employ himself in the branch of art for which his studies in London had prepared him." Dunlap, *History*, 2:ii:314–15.

37 Cooper's description of the project in his letter to Dunlap, quoted above (note 4) also focuses on the painting as an exhibition picture and on its describing *primarily* a famous location (the Musée du Louvre), and only secondarily on the copies of the most famous works of art it contained.

38 John Vanderlyn, "To the Subscribers, Patrons, and Friends of the New York Rotunda," quoted in Kevin J. Avery and Peter L. Fodera, *John Vanderlyn's Panoramic View of the Palace and Gardens of Versailles* (New York: Metropolitan Museum of Art, 1988), 30–31.

39 Dunlap, *History*, 1:ii:317.

40 James W. Carey, *Communication as Culture: Essays on Media and Society* (Boston: Unwin Hyman, 1989), 24.

41 With *Gallery of the Louvre*, Morse states that American women as well as men have a legitimate stake in the public act of copying pictures. This is emphasized in Morse's *Descriptive Catalogue*: "Visitors are represented in various parts of the gallery, and artists, *male and female*, drawing and painting from the various pictures." (Italics mine.) See the Appendix in this volume, p. 196.

42 Morse, *Lectures*, 71.

43 Ibid.

44 As acknowledged by Morse in his *Descriptive Catalogue*: "The Gallery of the Louvre, in Paris, is the most splendid, as well as the most numerous single collection of works of art, in the world. It contains, at the present time, about *thirteen hundred* pictures, the works of the most celebrated painters of all countries, and of every age since the revival of painting in Italy in the 13th century." See the Appendix in this volume, p. 195.

45 *Daily Evening Transcript* (Boston), November 15, 1832, Merl Moore Papers, Library of the Smithsonian American Art Museum and the National Portrait Gallery, Washington, D.C. (Italics mine.)

46 As later noted about the electromagnetic telegraph by the Washington correspondent of the *Baltimore Sun*, May 31, 1844: "Prof. Morse's Telegraph has already, during the first week of its operations, been proved to be of the greatest public importance. Time and space has been completely annihilated."

47 "Avec tous délais." Marcel Duchamp, "La mariée mise à nu par ses célibataires, même (la boîte verte)," in *Duchamp du signe,* ed. Michel Sanouillet (Paris: Flammarion, 1975), 49. (Translation mine.)

48 See Staiti, *Morse,* 82. (Italics mine.)

49 Samuel Morse, *Key to Morse's Picture of the House of Representatives* (New Haven: C. Carvill, 1823), transcribed in Staiti, *Morse,* Appendix 1, 243–44.

50 To borrow Paul Staiti's felicitous expression. See Staiti, *Morse,* 99.

51 Morse repeatedly claimed the recording function of his electromagnetic telegraph as the most original feature of his invention. See, for instance, his September 4, 1838, note: "My invention differs from that of all others of more recent origin. . . . 3. In that mine writes one or any desired copies, simultaneously, of all intelligence sent by it, in permanent characters, while all others carry only momentary signs by motion of needle or by sound, and can furnish no duplicates of them. 4. Mine requires no attendance constantly at the place of delivery of intelligence, to render the communications made available—while others can be operated only by having one or more persons ready at all times to take down every sign transmitted at the time and in the order of their transmission." Quoted in Prime, *Morse,* 363–64.

52 Morse to Cooper, November 20, 1849, in Cooper, *Correspondence,* 2:637–38.

53 Or even to their independent success: Reacting to the serendipitous rediscovery in 1847 of his *The House of Representatives* in a New York store, Morse told his interlocutor, the painter Francis William Edmonds, that "he had devoted the best years of his life to the arts with but poor encouragement; he had since been divorced from her, and any offsprings of that union he disavowed and they must take their chances in the world—he cared no further about them." Quoted in Staiti, *Morse,* 98–99.

54 Courbet to Champfleury, 1854: "Dear friend, in spite of being assailed by hypochondria I have launched into an enormous painting, twenty feet by twelve, perhaps even bigger than the *Burial,* which will show that I am still alive, and so is Realism, since we're talking of that. It's the moral and physical history of my studio, part 1: all the people who serve my cause, sustain me in my ideal and support my activity; people who live on life, those who live on death; society at its best, its worst and its average in short, it's my way of seeing society with all its interests and passions; it's the whole world coming to me to be painted. . . . The scene is set in my Paris studio. It is divided into two parts, with myself in the middle, painting a picture. Quoted in *Gustave Courbet, 1819–1877* (London: Arts Council of Great Britain, 1978), 254.

55 On the occasion of the 1881 auction of Courbet's pictures, only four years after the painter's death and twenty-five after the first exhibition of the painting, Jules-Antoine Castagnary could already write: "*The Painter's Studio* contains a wholly topical side which escapes us through the death of nearly all of those congregated." Quoted in Hélène Toussaint, "Le dossier de 'l'Atelier' de Courbet," *Gustave Courbet (1819–1877)* (Paris: Éditions des Musées Nationaux, 1977), 260. (Translation mine.)

56 This is how Pierre-Joseph Proudhon characterizes the painting in his book *Du principe de l'art et de sa destination sociale* (1865): "[Courbet] makes a personal picture in his "Real Allegory." Quoted in Toussaint, "Le dossier," 271.

57 Eugène Delacroix first recognized the "amphibological" nature of the place depicted in *The Artist's Studio.* See his *Journal,* August 3, 1855, quoted ibid., 270–71. As to Courbet himself, he emphasized the painting's ambiguity or openness in his letter to Champfleury as well as in another letter to his friend Louis Français: "Maybe you would like to know the subject of my picture? It takes so long to explain that I will let you guess it when you see it. It is a history of my studio, what goes on there morally and physically. It is reasonably mysterious. Guess who may!" Ibid., 260–61.

Painting and Technology: Morse and the Visual Transmission of Intelligence

RICHARD READ

MY TITLE PLAYS ON Morse's prophecy of the elec-
tromagnetic telegraph: "If the presence of electricity
can be made visible in any desired part of the circuit
I see no reason why intelligence might not be trans-
mitted instantaneously by electricity."[1] This essay will
show how the transmission of intelligence applies to
painting as well as to technology at a time when the
boundaries between art and science in America were
still fluid and negotiable. My pairing of these media
revisits the foundational question in Paul Staiti's
essential book on Morse's art: "In what ways, both
spiritual and conceptual, did technology follow logi-
cally from painting" when Morse abandoned painting
for engineering in the 1830s?[2] Nicolai Cikovsky, Jr.,
had earlier framed this career change as a contradic-
tory, rather than a logical, narrative of failure: the
"dichotomous relationships between old and new,
ideality and reality, theory and practice" that mani-
fest themselves in Morse's *Lectures on the Affinity of
Painting with the Other Fine Arts* (1826) "were incapa-
ble of resolution within art itself, so he forsook art
for the practical realm of invention and business."[3]
By charting the implementation of principles from
Morse's *Lectures* in his construction of *Gallery of
the Louvre* (plate 1), I shall question both authors'
assumption that Morse's enthusiasm for painting
gave way to technical invention and show that the
two practices were fundamentally allied in his attach-
ment to a uniquely American conception of Techno-
logia that placed the physiological optics of painting
on a par with the communicative techniques of the
telegraph for the purposes of Protestant reform.[4]

PAINTING AND TELEGRAPHY

Nothing attests more vividly to the sense that
Morse was stepping down to a lower calling than the
mournful accounts of his studio at New York Univer-
sity when he turned it into a laboratory for develop-
ing the telegraph around 1834. According to Kenneth
Silverman, colleagues and students "remembered
galvanic batteries, wire lying about the floor or sus-
pended on the walls, the clockwork paper dispenser
feeding out a white ribbon that became covered with
Vs. 'We grieved to see the sketch upon the canvas
untouched,' one student added. 'We longed to see
him again calling into life events in our country's
history.'"[5] A fellow artist evoked the same mood in
visiting the studio in 1841. He noted that "dusty
canvases" were "faced to the wall, and stumps of
brushes and scraps of paper littered the floor."[6] The
elegiac mood recalls Hendrik Hondius's magnificent
seventeenth-century engraving, *The End Crowns the
Work* (fig. 64), in which the artist's last painting,
reversed on an easel next to a skull crowned with
laurel leaves, evokes the theme of the studio aban-
doned after death, with a statue of fame on a distant
building visible in the doorway through which the
artist has passed forever.

Morse's faith in his vocation prevented such
regrets, but Silverman reports that around 1837
Morse *was* uneasy about the French rivals who had
come to see the invention he had secretly been devel-
oping, fearing that the apparatus remained so crude
it would be ridiculed.[7] It comprised a transmitter and

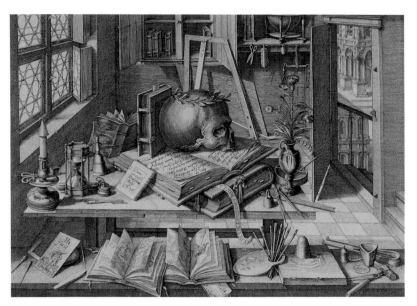

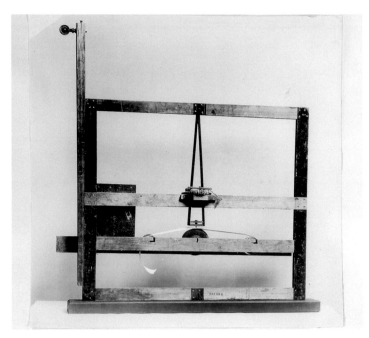

a receiver framed by a canvas stretcher (fig. 65). What else but a stretcher, we might ask, would an artist-turned-inventor use to frame a mechanical device constructed in his studio?—and yet an aura of significance persists around the inclusion of the frame. In one sense, it drew accidental attention to the fact that the telegraph was *not* a work of art but a self-writing machine that allowed no opportunity for artistic individuality. [8] Perhaps Morse's sense of shame regarding the appearance of his device was due not only to its crudity but also to the frame's continuing invitation to compare the machine with painting. Moreover, the technical and the aesthetic artifacts are not always wholly distinct. Just as the telegraph made manifest invisible messages over vast distances, so *Gallery of the Louvre* made European art visible in America, while the earlier *The House of Representatives* (fig. 55) had, in Staiti's words, made "the invisible federal government visible to the distant masses."[9] So too does Morse's *Landscape Composition: Helicon and Aganippe (Allegorical Landscape of New York University)* (fig. 66) employ the traditional genre of the capriccio to yoke together geographically

remote places, making the European Mount Helicon (sacred to Apollo) visually simultaneous with Manhattan.

Essential to the coherence of all those messages was the notion of impedance and interruption: the exclusion as well as the inclusion of signals. The current of Morse's first telegraph apparatus was transmitted by immersing a level in and out of cups of mercury on a stop/go basis of "on-off binaries" that was made visible first through zigzag drawings and later through the famous code of dots and dashes to which Morse gave his name.[10] So too in *Gallery of the Louvre* there are various kinds of impedance at work to stop and to send the painting's messages. Visual representation of this stop/go effect transmits intelligence in both the painting and the telegraph. The analogy is, of course, loose. Morse's dot/dash code would involve more than an interruption of current.[11] *Gallery of the Louvre* uses more than paintings to convey its meanings. Yet it seems fair to say that Morse's style of thinking in both media resembles the general sense of Friedrich A. Kittler's dictum "Nur was schaltbar ist, ist überhaupt."[12] Literally

translated as "Only that which is switchable is at all,"[13] this is the concept that any representation can be made in terms that resemble on/off binary logic. In this sense, *Gallery of the Louvre* is dense with cordoning devices, whether they apply to the exclusion or inclusion of paintings on view in the gallery; the way they are arranged on the walls of the Salon Carré; which types of people are included as artists or gallerygoers; the compositional factors that attract, impede, and otherwise direct the spectator's eye; and even the extent to which the depicted European gallery space is intended to join or to seal itself off from the American viewing spaces where it was intended to be seen. For example, the vista down the Grande Galerie ineluctably attracts the eye and makes the picture space continuous with our own (especially now that recent restoration work on the painting has seamlessly fused the vista's perspective with converging lines of tiles on the Salon Carré floor), whereas the four faces in profile and the

backs of paintings most parallel with the back wall tend to reinforce the picture surface as a barrier that excludes us from the scene.

There is something about paintings turned to the wall in Morse's abandoned studio and in his painting of the Louvre, as well as the exposed stretcher frame of his telegraph, that perhaps can best be understood by taking a step outside the period to Jean-Paul Sartre's striking distinction in *Being and Nothingness* between the "secret reverse side" of pictorial representation and the encompassing totality of electrical phenomena: "an electric current does not have a secret reverse side; it is nothing but the totality of the physical-chemical actions which manifest it. . . . No one of these actions alone is sufficient to reveal it. But no action indicates anything which is *behind itself*; it indicates only itself and the total series.[14]

However much he was prepared to break the circuits of vision in *Gallery of the Louvre* by showing "the secret reverse side" of paintings, it seems at first

FIG. 66 Samuel F. B. Morse. *Landscape Composition: Helicon and Aganippe (Allegorical Landscape of New York University)*, 1835–36. Oil on canvas, 22½ × 36¼ in. (57.2 × 92.1 cm). Purchase, The Louis Durr Fund, The New York Historical Society, 1917.3. Photo: Collection of the New York Historical Society

as if Morse embraced the totality of electrical phenomena in something like Sartre's sense when he used a neural metaphor to promote his invention to Congress in 1838. "It would not be long," he prophesied, "ere the whole surface of this country would be channelled for those *nerves* which are to diffuse, with the speed of thought, a knowledge of all that is occurring throughout the land, making, in fact, *one neighborhood* of the whole country."[15] Such metaphors, including his description of the transatlantic cable as "the great system of nerves that will make the world one great Sensorium," emphatically predate the totalizing experience of the spiritual telegraph, or "table rapping," that swept America in the craze for domestic séances later in the century.[16] Morse's efforts to put his invention at the disposal of the government align instead with eighteenth-century regulative optics. For example, when writing in 1787 about the penitentiary Panopticon, Jeremy Bentham proposed that the "nerve which conveys to the most distant extremity of this artificial body the all vivifying influence of the inspection principle—the line of communication, I mean"—has "its origin in the inspection-gallery."[17] Morse's neural metaphor was likewise meant to foster social order, just as the transatlantic cable would, in popular imagery, bind and tame the ocean.[18] After the young scientist Charles Thomas Jackson had inadvertently threatened the award of an appropriation from Congress by jovially comparing the telegraph to Mesmerism,[19] Morse guarded against misleading metaphors. As Charles Colbert has suggested, Morse "would scarcely dare to compare spiritual with material forces," and his first telegraph message—"What hath God wrought?"—was bent on celebrating God's glory, not usurping his supernatural realm.[20]

MECHANICAL AND INTELLECTUAL COPYING

To think of a telegraph wire as a nerve in the body politic is akin to a principle in Morse's *Lectures on the Affinity of Painting with the Other Fine Arts*: "The whole may become part of a greater whole and a part

FIG. 67 Detail, plate 1, the artist's initials on the back

become a whole in relation to smaller parts."[21] The relationship between wholes and parts in *Gallery of the Louvre* reflects the Neoclassical subordination of parts to wholes advocated in Joshua Reynolds's *Discourses on Art* (1769–90), to which Morse became ardently attached during his training at the Royal Academy of Arts in London between 1811 and 1815. This relationship of parts to wholes is articulated by two kinds of copying. Set forth in his *Lectures* of 1826, and based on Reynolds's second *Discourse*,[22] Morse's crucial distinction between "Mechanical" and "Intellectual" copying offers a blueprint for interpreting the composition of *Gallery of the Louvre*, begun five years later:

> An Imitation of nature is not necessarily the mere copying of what is created, but includes also that more lofty imitation, the making of a work on the Creator's principles. . . . In his Imitative efforts, however, man differs from his great original in this important point, he cannot create *something* out of *nothing*; in his humble creative attempts he must use materials already produced. His imitation is confined to the *combination* of these materials. He may combine them infinitely, but he is restrained within the limits of things already created.[23]

Gallery of the Louvre, too, recombines "things already created," albeit those made by man rather than God. A key to their combination is the reversed canvas leaning against the back wall on the far right (fig. 67), which bears Morse's initials and the date of composition in an impersonal font, as if it were labeled in readiness for transport. The effect of the signature is to claim authorship of both the individual copy turned to the wall and the entire painting of paintings. It yokes backs and fronts, parts and wholes in a dynamic equilibrium.

Morse gives meaning to this equilibrium by depicting himself at the center of the Salon Carré, teaching a young woman. Together the Americans are studying a medley of paintings from all over a Louvre pruned of aristocratic content that, it has been argued, he feared would have corrupted republican American culture.[24] Morse is consciously appropriating the tradition of *Kunstkammer* paintings —that is, paintings of collections by David Teniers II (fig. 22), Johann Zoffany (fig. 24), and others[25]— but he is displacing Dutch and English aristocrats admiring their own collections with American artists learning to paint one themselves. They are now the rightful inheritors of Western traditions that extend back through the Renaissance and Roman art to ancient Greece (note the Roman statue of Diana, based on a Greek original, in the right-hand corner). The groups and individuals have a nationalist flavor embodied by the well-known features of the popular American novelist James Fenimore Cooper, who with his wife instructs their daughter Susan at the left of the Salon Carré (fig. 72).[26] This loose congregation creates an impression of casual American freedom from which there emerges, nevertheless, an incipient symmetry between the four sites of copying. This prompts a thematic interpretation that marks the chief difference from John Scarlett Davis's *Salon Carré and the Grande Galerie of the Louvre, 1831* (fig. 29), which shares several compositional features with Morse's work.[27] Arranged in a circle, two groups face in opposite directions at front and back, while the solitary male student facing inward on the left is

FIG. 68 Detail, plate 1, Morse and his pupil

matched by the lone female student facing outward on the right.

This arrangement gives meaning to the sequence of alternating backs and fronts of paintings on which the artists work. Staiti's felicitous remark that "Morse figured himself in his picture as both conduit and buffer between the students and history" also applies to these fronts and backs.[28] There are sharp differences in the degree to which the copies that are visible match the originals on the wall. The difference is clearest in the contrast between the woman Morse mentors at the center (fig. 68) and the youth wearing a turban at far left, who may be Morse's roommate Richard West Habersham (fig. 69).[29] They provide very different "conduits" of attention toward possible subjects on the walls. The central artist's drawing board faces Paolo Veronese's *Wedding Feast at Cana* (fig. 75), which is shown in raked perspective on the left wall. She is making a mechanical copy, passive

FIG. 69 Detail, plate 1, the artist thought to be Richard West Habersham

FIG. 70 Detail, plate 1, female artist at right

both to the original painting and to the instruction she receives from Morse, especially compared to the virtuoso passage of perspective in which the actual Morse has rendered the "original." The male artist works with his foot holding down the easel, in an air of confidence and command. He is so active that, as Staiti observes, "he renders a Rosaesque landscape unlike any of the works on the walls."[30] His painting channels a vague, unfocused awareness of the paintings in the gallery, unlike the particular focus of the central artist. It is a copy of a general, "Intellectual"

kind because its invention is informed, not dictated, by European precedents. Thus, in keeping with the overall purpose of the painting, he conveys an ambivalence toward the Louvre as both an aid to American cultural independence and the symbol of an oppressive past inhibiting the progress of contemporary art.[31]

The drawing stand and the reversed canvas of the two other copyists serve as buffers rather than conduits because they prevent comparison with the originals and instead draw attention to the private

thought or conversation of those who paint them. "No one," Charles Colbert observes, "actually gazes at the images on display."[32] The woman at far right (fig. 70), who works in self-absorbed isolation on what appears to be a miniature turned away from us on a stand, seems to offer a paired contrast to the turbaned youth on the left, who also works alone. Perhaps they are both Intellectual copyists who have outgrown the need for instruction that the others still require, but their copies are, as Patricia Johnston first observed, implicitly gendered.[33] The youth's imaginary landscape is broad and outward looking; the young lady, for all her independence, is inward looking and her copy is reduced to the domestic scale of miniature painting—an effect accentuated by the reversal of its image, which seems to cut her off from any stimulus in the gallery and make her work seem reliant on conventions she already knows.

Also turned away from us is the image that Susan Fenimore Cooper is painting on her easel. Whatever work she is copying, her parents seem to mediate her access to it. Portrayed with her head sharply twisted,[34] she seems to turn with filial piety to her father, who lectures while her mother directs her actions. Her palette reveals a more complicated array of ready-made colors than that of the turbaned male artist, suggesting a lower level of skill in mixing them.[35] By comparison, therefore, she seems to be a Mechanical copier, dependent on others' instruction and ready-made paints. In sum, the copyists create a visual circuit that conveys a meaningful hierarchy of Mechanical and Intellectual abilities, while the pattern of frontal and reversed paintings is visually reinforced by the turned-up soles (three in all, if the toddler's are counted) of the various pairs of shoes across the gallery space.

The interdependence of Mechanical and Intellectual copying demonstrated by the artists is reenacted by Morse's own strategies. *Gallery of the Louvre* was intended to be an instrument of national education back in the United States, where copies of European art were notoriously inferior to their originals.[36] The spectrum between Mechanical and Intellectual

copying in the painting would not have been apparent without Morse's determination to be faithful to the European originals with an accuracy he was proud of: "I am sure it is the most *correct* of *its kind* ever painted, for every one says I have caught the style of each of the masters."[37] Mechanical copying had also been essential to *The House of Representatives* (fig. 5), because viewers would not have been able to recognize their congressmen without the lengthy sittings in which Morse captured each man's individual features (fig. 71). Yet Morse also marked his freedom from Mechanical copying by consciously manipulating his exact copies. Staiti uses the verbs "miniaturizes," "rearranges," "resizes," "recontextualizes," "stylizes," "emulates," "processes," "summons," and "repackages" to refer to the ways Morse handled his copies to assert the Intellectual copying that was

FIG. 71 Samuel F. B. Morse. *Joseph Gales*, 1822. Oil on academy board, 10⅝ × 8⅝ in. (26.9 × 21.8 cm). Corcoran Gallery of Art, Washington, D.C.

part of his process in depicting the thirty-eight canvases he selected to stand in for "twelve hundred and fifty of some of the *chefs d'oeuvre* of painting" in the Louvre.[38] Morse ordered this selection into an optically harmonious array that becomes a new master category of European art fit for a new American school.[39] It is telling that he would later protect his patent on the telegraph in Linnaean terms: "As he often put it, he had invented a genus as well as a species."[40] Once again, painting and invention display the same kinds of thinking.

Selection entailed rejection in at least three forms of aesthetic impedance that enhance the transmission of meaning in Morse's painting. First, he chose Roman, Renaissance, and Baroque works to displace the contemporary French Romantic paintings actually hanging in the Salon Carré at that time, which he dismissed as decadent. They are shown, allegedly in situ, in Nicolas Sébastien Maillot's *View of the Salon Carré of the Louvre in 1831* (fig. 18). Second, the only royal personage depicted on the walls is Titian's Francis I. A great collector, he may have been included as an example to contemporary American patrons. Alternatively, as William Kloss has suggested, by showing himself standing directly beneath Francis I, facing the opposite direction, Morse may have intended to suggest, as Cooper wrote about one of his own novels published in 1832, while the painting was in preparation, "how differently a democrat and an aristocrat saw the same thing."[41] Third, the aristocracy is banished from the Salon Carré.[42] This negation does not apply to the French bourgeoisie, the rightful inheritors of royal and aristocratic culture appropriated by the post-Revolution Louvre— the wonder-struck gentlemen wandering into the Salon, top hat in hand, appears to be a representative model—nor does it apply to the peasant mother and child in Breton costume leaving the Salon, but this does not mean that we, the spectators, are intended to identify with the scattering of distant visitors to the gallery.

The purpose of depicting European art traditions in the painting was to obviate the need for American artists to visit Europe, separating communication from transportation, as the telegraph would do too.[43] Morse had promised in letters home from England in 1814 that he would work to found a national institution of art in America so that "the arts be so encouraged, that American artists might remain at home, and not, as at present[,] be under the painful necessity of exiling themselves from their country and their friends."[44] Morse became vehemently opposed both to the abolition of slavery and to Catholic immigration, and eliminating the need for American artists to expatriate themselves was consistent with his increasing desire to exclude foreigners from his own country. Only two years after he completed *Gallery of the Louvre*, his political writings became so xenophobic that he claimed that the American people were justified in taking the lives as well as the liberty of unwanted immigrants.[45] The point of his painting was to take the best of European art and reject the rest, constituting, as Jennifer L. Roberts writes in a different context, "division and displacement as well as conjunction" between the two cultures.[46] This lesson may have had more influence than is usually supposed. Betsy Fahlman sees the sequestered studio insulated with gigantic canvases reversed against the wall in *An Artist's Studio*, painted by John Ferguson Weir in 1864 (fig. 91), as a "personal and native version" of Morse's painting. "If one painting is an appropriation of old world culture, the other asserts that an artist could be richly educated and stimulated in its traditions without crossing the Atlantic."[47] This is what Morse was trying to facilitate.

The placement of Murillo's *Holy Family* above the Cooper family seems to support a hierarchy of patriarchal values within the educational program of the painting, which is consistent with Morse's and his father's staunchly Trinitarian beliefs (fig. 72).[48] It is even possible that James Fenimore Cooper, also a staunch Trinitarian, is pointing to the painting as he speaks. As God the father and the Holy Ghost rise above the infant Christ in the painting, so the Coopers stand over their anxiously receptive

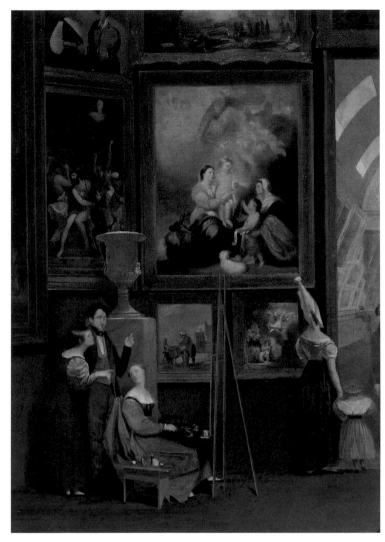

FIG. 72 Detail, plate 1, Cooper family and Murillo's *Holy Family*

on the thesis that the chief, though inadvertent, relevance of his *Lectures* to *Gallery of the Louvre* is to articulate values and techniques to be used in interpreting the painting. We must turn to a dialectic of scientific and artistic priorities in the *Lectures* to understand the techniques of communication that the painting implements.

ART, SCIENCE, AND TECHNOLOGIA

At first sight, the case for science in the *Lectures* is not auspicious. From the beginning, Morse was determined to distinguish the fine arts from the "arts of industry" or "*useful* arts."[49] In this, he was again influenced by Reynolds. According to the *Discourses*, the "'different branches of our art'... promote 'different truths,' a 'greater' and a 'lesser': the 'larger and more liberal idea of nature,' which 'addresses itself to the imagination,' and 'the more narrow and confined,' which 'is solely addressed to the eye.'"[50] Hence Morse's distinction between Mechanical and Intellectual copying.

Paul Gilmore has claimed that Morse attempted to combine Reynolds's Neoclassical definition with a "more romantic celebration of the imagination" based on Samuel Taylor Coleridge's *Biographia Literaria* (1817).[51] Morse is likely to have read the book, subtitled *Biographical Sketches of My Literary Life and Opinions*, a few years after he met the poet in London, where he had been exhilarated by his conversation.[52] In Gilmore's view, "the making of a work on the Creator's principles" in Morse's theory of Intellectual copying reflects Coleridge's definition of the Imagination as "a repetition in the finite mind of the eternal act of creation in the infinite I AM," while Mechanical copying approximates Coleridge's lesser faculty of Fancy: a "mode of Memory," dealing only with sensible "fixities and definites" instead of "ideas."[53] But if this is so, then science is explicitly ruled out by Intellectual copying because, according to Coleridge, "a poem is that species of composition which is opposed to works of science, by proposing for its immediate object pleasure, not truth."[54] But

daughter and Morse stands in *loco parentis* over the female student at the center, his hand echoing the gesture of Michelangelo's God creating Adam. But Morse's *Lectures* do not generally address religious dogma or iconography directly. Rather, his inclination was to analyze formal effects, as if paintings were machines for producing moral instruction and imaginative pleasure. This raises the possibility that in writing, painting, and technological invention Morse wanted to develop and implement a kind of communication theory. Accordingly, I retreat from the religious uses of paintings to concentrate instead

for all Morse's attempts to distinguish the imaginative allure of the liberal arts from the utilitarian values of the sciences or useful arts, he erased the division forthrightly on other occasions: "All the Arts and Sciences arbitrarily separated by man depend so absolutely on each other, run so imperceptibly into one another, that no one can be pursued to any great extent without having encroached into the territory of its neighbor."[55]

Despite Morse's subordination of the useful arts to fine arts, his sense of imagination was easily seduced by the charisma of technological advance: throughout his *Lectures*, mechanical interests vie for the reader's attention with enthusiasm for art. No sooner has he enunciated the superior aesthetic principle of Intellectual copying than he reaches for analogies with the steam engine to illustrate it.[56] In one of the most eloquent passages in the *Lectures*, the working of a steam engine is tacitly counted as a "work of Nature" and serves better than a painting to illustrate the aesthetic principle of Unity.[57] Such sentiments were inevitably yoked to nationalist goals, despite Morse's avowed support for Reynolds's injunction that the artist should "divest himself of all prejudices in favour of his age or country: he must disregard all local and temporary ornaments, and look only on those general habits which are every where and always the same."[58] Writing in about 1828, Morse advocated an American view of progress in the fine arts in which their "place in the arch of civilization is in the train of the *useful arts*, and these, *their avant couriers*, have long and eminently occupied a distinguished place in our country."[59] In fact, the idea that the mechanical arts precede and elevate the liberal arts is at the heart of the equivocal meaning of art in early American Puritan discourse.

Morse would have read Reynolds's *Discourses* and Coleridge's *Biographia Literaria* through the prism of the Calvinist ministry of his father, Jedidiah Morse. In respect to art and science, the *Lectures* offer a mixed message, indebted to the early Puritan concept of Technologia as Morse inherited it from the intellectual tradition of the Great Awakening, in which

the arts and sciences are equals rather than alternatives. Elizabeth Flower and Murray G. Murphey explain in their *History of Philosophy in America* that "In Technologia the term art is extended to include science, so that all knowledge is referred to as art. . . . It can mean abstract knowledge, or it can mean a set of practical rules for making something. . . . What harmonizes these two meanings . . . is the belief that what is science to us must be art to God, since our science can be at most a description of God's mode of acting in creating and governing the universe."[60] When Morse writes in the *Lectures* that the Intellectual copyist undertakes "the making of a work on the Creator's principles," his debt to these practical theological ideas is greater than to Coleridge's "repetition in the finite mind of the eternal act of creation." For Morse, it was the circular interchange of art and purposeful action that allowed man to emulate God's creative power. The spiritual and communal purpose of this interchange transformed and exalted the mechanical basis of copying. The stalwart Deocentrism of this inheritance is the chief difference between Morse's *Lectures* and Reynolds's and Coleridge's formulations of the imagination. In conflating the intellectual and practical aspects of art and science, American Puritans clung to the Aristotelian maxim that "Every art and every inquiry . . . is thought to aim at some good." In this sense, Morse's paintings were already "mechanisms" of social, political, and religious betterment well before he constructed the telegraph.

In considering the character of the man who took these initiatives, it is important to note that Morse had been as prone to veer away from art in the direction of a religious vocation as toward a scientific one, if he felt "he could be more useful to others than as a painter."[61] He turned to politics in the same spirit. Yet Morse was still thinking of using funds from the telegraph to finance a return to painting long after he had given up art. These sudden changes of direction undoubtedly reflect a restless and quixotic spirit, but they also reflect a larger Puritan mission that, later in life, became a grueling determination to protect the

patent for and disseminate the telegraph. Dieter Daniels contends that Morse, like Louis-Jacques-Mandé Daguerre, belongs to the nineteenth-century phenomenon in which "art had to be shut down for traits of genius to be shifted to inventors."[62] In Morse's case, the shift was activated by his continuing attachment to the Calvinist tradition of Technologia, in which the desire to be useful motivated leadership in art, science, and politics. What mattered was not single, simultaneous, or successive careers but the conviction that through any or all of them, a great man might emerge to change America for the better. Edward Lind Morse's verdict on his father's letters and diaries was that they revealed "an almost childlike religious faith, a triumphant trust in the goodness of God even when his hand was wielding the rod" and "a conviction that he was destined in some way to accomplish a great good for his fellow men."[63]

When it comes to the diverse means that Morse used to achieve his nationalist ambitions, it is worth stepping back for a long-term institutional perspective. Alan Wallach has powerfully argued that the precondition for the establishment of an American national gallery of art was a "centralized state power with the ability to create and sustain national institutions," which became possible only in postbellum America.[64] Likewise, David Hochfelder explained in his recent book, *The Telegraph in America*, why the telegraph and social change must be considered in dynamic interaction with each other: "Telegraphy did not fulfill its potential as a driver of social change until its users reshaped their actions, organizations, perceptions, and expectations around it. This development occurred fully after about 1860."[65] In 1826, while preparing his *Lectures* for the Athenaeum, Morse was deeply engaged in establishing the National Academy of Design, an institution through which he succeeded, over two decades, in professionalizing American art. In this and in building the telegraph empire, his talents were "more organizational than technological."[66] If *Gallery of the Louvre* failed as a harbinger of American national art it was

nevertheless intended to promulgate a dynamic interaction with American viewers anticipated in the *Lectures*. Interpreted in their light, the painting can be seen as incorporating compositional devices that were designed to evince and control viewers' responses.

In adopting the Royal Academy of Arts as his model for the National Academy of Design in New York, Morse contrived a permutation of the late-eighteenth-century reclassification of the liberal and mechanical arts that Paul Oskar Kristeller defined in his classic essay "The Modern System of the Arts" (1951). Once the European bourgeoisie had transformed one part of the old form of life through commerce and scientific discovery, the aristocracy reacted by inventing the liberal arts to transform those parts of the old form of life where the values of taste and individual talent would be less easily eclipsed by scientific progress.[67] Substituting the American educated bourgeoisie for European aristocracy as the disinterested custodians of fine art, Morse continued to exclude from the Pantheon "all who depend for food on bodily labor."[68]

In this he was also committed to implementing what Lawrence W. Levine has called "sacralization"—a process by which the hybrid forms of high and low culture in America were elevated to purer forms for more exclusive audiences.[69] Morse's adaptation of the European *Kunstkammer* paintings of Zoffany and others, for example, illustrates an American recapitulation of European processes of sacralization. European representation of collections filled exclusively with paintings reflected a dramatic change in which eighteenth-century encyclopedic collections were split into "art," away from "natural history" and "physics cabinets" (for scientific instruments). Similarly, Levine has shown that in nineteenth-century America, "museums went through a familiar pattern of development from the general and eclectic to the exclusive and specific."[70] Charles Willson Peale's antebellum *The Artist in His Museum* (fig. 31) is a case in point. Down its vast hall, portraits of the heroes of the American Revolution are interspersed with cases

of natural history specimens. By introducing American spectators to the almost exclusively pictorial array of the Louvre, Morse was attempting the wholesale sacralization of American culture by cleaving the temple of art from the museum of science. But even though he excluded the scientific subject matter that Americans expected from his display, science returns in a powerfully indirect manner in the physiological principles behind his compositional methods.

For all that Morse attempted to distinguish the imaginative appeal of the liberal arts from the practicality of the useful arts, he nevertheless retained, according to Gilmore, "a mechanistic model of how art works, how its effects are actually registered on individuals" in his analyses of works of art in the *Lectures*.[71] This includes an account of how physiological reactions to pictures work upon the viewer's imagination based on the philosophy of John Locke and the idealist associationism of the Scottish Common Sense School.[72] The detailed relevance of this account to *Gallery of the Louvre* has never been addressed, but in the following section I will show how passages of the *Lectures* are likely to have served as templates for the impact that Morse intended his painting to have on the viewer's imagination—for he is likely to have taken his own advice before anyone else's in painting it. Despite the clear ascendancy of imaginative values in his aesthetic, and despite his denial of aesthetic sensibility to the menial classes, Morse wished to base the foundation of taste "on principles in the constitution of human nature, hidden, indeed, from the classes we have excluded, but discoverable to an enlightened philosophy."[73] For this purpose he resorted to quasi-mechanical principles that also inform the structure of *Gallery of the Louvre*. It is therefore possible to imagine an ideal route through the optical circuits of *Gallery of the Louvre* based on passages from the *Lectures* placed in a new order.

AN ORDER OF VIEWING

"In a picture," Morse averred in his *Lectures*, "the first thing that strikes us is the general effect."[74] This complies with the "law of *Order*" that dictates "we naturally survey a whole before its parts."[75] In *Gallery of the Louvre*, the first impression was likely to have been the colored glow of copies spread across the surface to please and instruct the viewer. This would have seemed novel for Americans accustomed only to black-and-white reproductions of European art. The shaft of diagonal light from the skylight above the Salon Carré contributes to the overall first impression by imposing a stripe that flattens and unifies the plane of pictures and prevents their many vanishing points from competing too strongly with the dramatic vista of "real" space through the doorway of the Grande Galerie.

"Having given a hasty glance at the whole, we at once fix our eye on the most prominent part which is rendered so in various ways by *size*, by *light*, by *dark*, or by *color*."[76] This would surely be the vertiginous perspective of the quarter-mile Grande Galerie, which draws our eye down the sublime vista of cultural storage space that had celebrated precedents in Hubert Robert's depictions of the Louvre as an indoor landscape (figs. 15 and 26) and in Peale's *The Artist in His Museum*.[77] This swift flight of vision down a sharp perspectival regress complies with the most original principle, "at the basis of all the Arts of Design," articulated in the *Lectures*: *There is a motion of the eye as it travels over objects in a state of rest, which affects the imagination in a similar manner to the motion of objects passing in review before it and according to the order in which they are surveyed.*"[78]

Motions of the spectator's eye replace the narrative motion of figures in history paintings. That is why, in *The House of Representatives*, Morse was more preoccupied with static architecture than with human narrative, for architectural perspective helps marshal the viewer's attention across meaningful circuits of vision. Like many other American visitors to Europe, Morse would have relished the Louvre

as a feat of architectural engineering on a scale unprecedented in his own country.[79] As Sarah Monks observes, the "exaggerated tunnel at its centre" is "already indicative of his intentions: the transportation to America of a wholesale encounter with European high art," which removes the necessity of visiting the originals.[80]

Morse observed in his third lecture that artificial speed allows us to cross the boundaries between natural, intellectual, and imaginative processes. To add a sail and a rudder to a boat propelled merely by tide and wind will "quicken the sluggishness of a natural process," which a steam engine will quicken still further.[81] So it is "that art comes to the aid of nature and by her philosophical . . . combinations quickens the sluggish emotion; here an Intellectual Machinery is brought into operation to produce that effect which the objects themselves unassisted by art could not produce."[82] The term "Intellectual Machinery" perfectly captures the oxymoronic relations of the mechanical and the intellectual, the scientific and the imaginative, the engineered and the poetic in Morse's thinking, while acceleration equally applies to boats and emotions. Given that the flow of persons and products across the Atlantic had stimulated the invention of theories of electricity, it is fascinating to consider Morse's acceleration of the viewer's consciousness down the perspectival vista of the Grande Galerie as a foretype of the telegraph system eventually connecting Europe and America, particularly since the French gallery in the painting was intended to be seen in America.[83] As Morse wrote to his father: "A man to judge properly of his country must, like judging of a picture, view it at a distance."[84] Perhaps it is a stretch to associate perspective with telegraphy in this way, but we should not underestimate Morse's uncanny gift of premonition, as when he pondered the sluggish pace of the American postal system around this time and concluded that "*lightning would serve us better.*"[85]

Morse had anticipated the global reach of *Gallery of the Louvre* in one of his earliest paintings, *The Morse Family*, of about 1810 (fig. 36), which shows

Jedidiah, "The Father of American Geography,"[86] leading a family discussion of a large globe. Staiti draws a parallel between Jedidiah's role in this early painting and Morse's position in the Louvre teaching art,[87] but more than leadership is at stake in his central location. Placed in profile on the central axis of the painting and shown gazing at a particular point on his student's drawing while making a Michelangelesque gesture, Morse's alter ego occupies the crux of the composition, where two principles of motion defined in the *Lectures* intersect. Morse had written:

> The eye while in the act of perception cannot keep its attention long fixed upon a single point with more facility than the mind can keep its attention fixed upon a single idea; if our eye is at any time fixed it is *when it does not perceive*, when we are absorbed in thought; and if we observe another with his eye rivetted to a particular spot, we conclude without hesitation that he is in deep thought. The circle of motion may be confined indeed to a small space, as in the examination of some microscopic object, but it is no less certain that in scrutinizing the minutest object the eye travels from point to point with more or less rapidity through the whole process of perception.[88]

At the center of *Gallery of the Louvre* we witness a concatenation of these two opposite effects: our eye either fixes on Morse's profile or whistles past it to the specks of bourgeois visitors shrinking to the vanishing point, where they resolve themselves into the equivalents of points on a microscopic object, creating a "circle of motion" for our attention. Countervailing the lightning progress of our gaze down to the distant points in the vista is Morse's sideways gaze, which travels at right angles to our own as he fixes "in deep thought" on his student's drawing. The correspondence between text and painting is loose, for in the picture Morse observes at the same time as he thinks and speaks, but the structure of the painting makes the viewer confront an antithesis between intellectual instruction and kinetic pleasure—the one pertaining to the making of art, the other to its

enjoyment. One cannot concentrate on one without losing the other—a switching effect that resonates with the major themes of transmission and impedance in the painting.

I have illustrated the transition from an overall impression of the painting to a crucial point of divided focus at its center. The *Lectures* and the painting also articulate a fascinating intermediary stage. Morse speaks of a necessary phase of bewildered disorientation in moving attention between wholes and parts. He does not leave it to the spectator alone to discover this oscillating mode of attention. Rather, he models it for us vicariously through the behavior of the bourgeois gentleman who crosses the threshold from the Grande Galerie into the Salon Carré in such a state of distraction that he barely avoids bumping into the departing child. This models how we, in turn, should respond to the Salon from the opposite vantage point. His gait, ocular mobility, and near collision with the child suggest that he is too distracted to look where he is going, making him a model of the curiosity and wonder that we too should feel at the treasures assembled in the gallery. His whole manner evokes an exalted form of the customary process by which initial surprise and confusion at a wonderful spectacle subside into conscious assembly of its components and the adoption of a primary focus of interest. A passage in the *Lectures* virtually scripts this:

> In visiting the interior of some splendid building, we first naturally turn suddenly about and give a hasty glance above, below and on all around, dwelling on no particular part; to this succeeds a more deliberate survey; the eye selects that which is most obtrusive. Objects are soon classed according to their superficial importance, whether rendered so by light or dark, size, form, or color. We then consider particulars; each object is successively made a part and a whole until the examination is completed.[89]

For our benefit the gentleman models the response of being visually overpowered before scanning the scene with "a hasty glance above, below and on all around" to regain control before "a more deliberate survey." Just as the light in the tunnel behind him is the primary focal point for our eyes, so perhaps will his gaze finally settle on the bright, white sculpture at the bottom right of the slanting shaft of light, which is a secondary focal point of interest for us too. As the light down the Grande Galerie is the initial magnet for our eyes, so the light in the corner might be his. Perhaps light, as the counterpart of invisible transmissions like electricity, is the communicative principle of the whole painting, directing us around its prearranged circuits.

One such circuit is the color-coded itinerary marked out by the patterns of reds and blues that Peter John Brownlee traces across the paintings on the wall (see his essay in this volume). This is crossed by the diagonal shaft of light that I argue was necessary to distinguish the perspectives of the many landscape paintings from the real space down the gallery. As the time of day changes, this light is on the move, inferring another trajectory for the eye. The fact that it will soon move out of conjunction with the diagonal composition of tone in many of the paintings confers upon static imagery the "*law of Change*" devolving from the law of "*Motion*" that all paintings usually resist in freezing their subject matter. "The Sun never declines to the West but he has passed over a world of objects advanced a day further in this march of everlasting mutation," Morse wrote.[90] Perhaps the westward setting of the sun suggested by this moving light implies the inevitable progress of civilization from Europe to America, according to Bishop George Berkeley, whose cultural writings were a "significant part" of the Morse family's "intellectual patrimony."[91]

Every painter's final consideration is how to "fix the attention, and make permanent impressions on the memory," as Morse wrote in his *Lectures*. Memories must be rehearsed to cohere. The ultimate burden falls on the detail with which this essay began: the reversed painting inscribed with Morse's initials that leans against the back wall of the Salon. Although its unusual location takes time to discover,

it rewards the customary search for a signature. In claiming the artist's simultaneous authorship of both the canvas turned to the wall and the entire painting full of paintings, the signature puts us through a two-stage procedure akin to the production and dispersal of ocular bewilderment we have just examined. Impedance is intrinsic not just to the codes and messages of telegraphs and paintings. Morse had argued that human perception organizes its own "ramparts": "around every object of its thought," the mind "throws a circle of exclusion to all others, and secure in its temporary ramparts pursues undisturbed its quiet investigations." By analogy with the divine maker, the human mind then dilates to fix the part within the whole, so that "each object is successively made a part and a whole."[92] These are the observations of a man accustomed to scrupulous examination of visual experience. By zooming in and out between the microscopic part and the macroscopic whole, the mind gains godlike compass, though the ultimate impedance is that "it is the Divine mind alone that grasps in its full extent the stupendous whole of a vast creation, and at the same time regards with undiminished attention the less than microscopic atom."[93] Though only God can embrace the whole spectrum of existence, the artist contrives contractions and dilations, transmissions and impedances, conduits and buffers that open and close the visual circuits of the painting for the spectator. They are exercises that rehearse memories of optical actions that imitate the divine mind and so instill at one remove the lessons of his creation, as gleaned from the works of man.

Notes

1 Morse, September 1837, quoted in Kenneth Silverman, *Lightning Man: The Accursed Life of Samuel F. B. Morse* (New York: Alfred A. Knopf, 2003), 154.

2 Paul J. Staiti, *Samuel F. B. Morse* (Cambridge: Cambridge University Press, 1989), 222.

3 Nicolai Cikovsky, Jr., introduction to Samuel F. B. Morse, *Lectures on the Affinity of Painting with the Other Fine Arts*, ed. Nicolai Cikovsky, Jr. (Columbia: University of Missouri Press, 1983), 29.

4 In directing the study of academic disciplines toward practice, the sixteenth-century philosopher Petrus Ramus provided the impetus for seventeenth-century English Protestant divines at the University of Cambridge to develop Technologia as a mode of integrating knowledge of the humanities with the sciences and directing them toward God's purposes on earth. It became the basis for university curricula across America and permeated the reform movement known as the Second Great Awakening, of which Morse's father, the Congregational minister Jedidiah Morse, was the architect. See Douglas McKnight and Cecil Robinson, "From Technologia to Technism: A Critique on Technology's Place in Education," *THEN: Journal about Technology, Humanities, Education and Narrative* 3 (July 30, 2007), accessed October 10, 2013, http://www.thenjournal.org/feature/116/printable.

5 Quoted in Silverman, *Lightning Man*, 156.

6 Quoted in Staiti, *Morse*, 230.

7 Silverman, *Lightning Man*, 148.

8 See Dieter Daniels, "Artists as Inventors and Invention as Art: A Paradigm Shift from 1840 to 1900," in *Artists as Inventors, Inventors as Artists*, ed. Dieter Daniels and Barbara U. Schmidt (Ostfildern, Germany: Hatje Cantz, 2008), 35–37.

9 Staiti, *Morse*, 79.

10 The phrase "on-off binaries" is Lisa Gitelman's in "Modes and Codes: Samuel F. B. Morse and the Question of Electronic Writing," in *This Is Enlightenment*, ed. Clifford Siskin and William Warner (Chicago: University of Chicago Press, 2010), 132. For the mechanism of the first telegraph, see Silverman, *Lightning Man*, 148–50.

11 See Lydia H. Liu, *The Freudian Robot: Digital Media and the Future of the Unconscious* (Chicago: University of Chicago Press, 2010), 47–48.

12 Friedrich A. Kittler, "Nur was schaltbar ist, ist überhaupt," *Werkundzeit* 1, no. 90 (1990): 6–8.

13 Sybille Krämer, "The Cultural Techniques of Time Axis Manipulation: On Friedrich Kittler's Conception of Media Theory," *Culture and Society* 23, nos. 7–8 (2006): 108 n.1.

14 Jean-Paul Sartre, *Being and Nothingness: An Essay on Phenomeno-logical Ontology*, trans. Hazel E. Barnes (New York: Philosophical Library, 1956), 4.

15 Morse to F. O. J. Smith, February 15, 1838, in Samuel F. B. Morse, *Samuel F. B. Morse: His Letters and Journals*, ed. Edward Lind Morse (Boston: Houghton Mifflin, 1914), 2:85.

16 Morse to Cyrus Field, March 12, 1867, quoted in Silverman, *Lightning Man*, 417–18. See Jeremy Stotlow, "Techno-Religious Imaginaries: On the Spiritual Telegraph and the Circum-Atlantic World of the 19th Century," repr. *Globalization and Autonomy Online Compendium*, n.d., accessed January 4, 2013, http://globalautonomy.ca/global1/servlet/Xml2pdf?fn=RA _Stolow_Imaginaries, 6; and Charles Colbert, *Haunted Visions: Spiritualism and American Art* (Philadelphia: University of Pennsylvania Press, 2011), 250–55.

17 Jeremy Bentham, *Panopticon; or, The Inspection House*, postscript, part 1, in *The Works of Jeremy Bentham*, ed. John Bowring (Edinburgh: William Tait, 1843), 4:92. I am grateful to Peter Otto for alerting me to this connection.

18 See David Peters Corbett and Sarah Monks, "Anglo-American: Artistic Exchange between Britain and the USA," *Art History* 34 (September 2011): 641.

19 Silverman, *Lightning Man,* 221.

20 See Colbert, *Haunted Visions*, 250.

21 Morse, *Lectures*, 68.

22 Patricia Johnston, "Samuel F. B. Morse's *Gallery of the Louvre*: Social Tensions in an Ideal World," in *Seeing High and Low: Representing Social Conflict in American Visual Culture*, ed. Patricia Johnston (Berkeley: University of California Press, 2006), 47.

23 Morse, *Lectures*, 59.

24 See Staiti, *Morse*, 175–206, for Morse's nationalist strategy.

25 See Catherine Roach's essay in this volume and Desmond Shawe-Taylor, *The Conversation Piece: Scenes of Fashionable Life* (London: Royal Collection Enterprises, 2009), 124–37.

26 The nationalism is alleged by David McCullough in "Morse at the Louvre," podcast, recorded September 26, 2011, National Gallery of Art, Washington, D.C., accessed January 12, 2013, http://brightcove.vo.llnwd.net/pd18/media/1191289016001 /1191289016001_1275285445001_111411nl02.mp3. The most reliable guide to the identity of the figures is David Tatham, "Samuel F. B. Morse's *Gallery of the Louvre*: The Figures in the Foreground," *American Art Journal* 13 (Autumn 1981): 38–48.

27 For Morse and Scarlett, see William Kloss, *Samuel F. B. Morse* (New York: Harry N. Abrams in association with the National Museum of American Art, Smithsonian Institution, Washington, D.C., 1988), 128; and Catherine Roach's essay in this volume.

28 Staiti, *Morse*, 194.

29 Tatham, "Figures in the Foreground," 44.

30 Staiti, *Morse*, 193.

31 Paul Duro, "Copyists in the Louvre in the Middle Decades of the Nineteenth Century," *Gazette des Beaux-Arts* III (April 1988): 250. For the Franco-American background to the painting,

see Paul Staiti, "American Artists and the July Revolution," in *American Artists and the Louvre*, ed. Elizabeth Kennedy and Olivier Meslay (Chicago: Terra Foundation for American Art; Paris: Musée du Louvre, 2006), 54–71.

32 Colbert, *Haunted Visions,* 252.

33 See Johnston, "Morse's *Gallery of the Louvre*," 51–52. For a broader discussion of gendered copying in the Louvre, see Richard Read, "The Diastolic Rhythm of the Art Gallery: Originals, Copies and Reversed Paintings," *Australian and New Zealand Journal of Art* 10, no. 1 (2010): 57–77, particularly 69–71.

34 Johnston, "Morse's *Gallery of the Louvre*," 52.

35 For this insight I am grateful for a discussion with the restorers of the painting, Lance Mayer and Gay Myers, on April 21, 2012.

36 Staiti, "American Artists and the July Revolution," 64.

37 Morse to Sidney and Richard Morse, July 18, 1832, Samuel F. B. Morse Papers, 1793–1944, Manuscript Division, Library of Congress, Washington, D.C.

38 Morse to his father, January 7, 1830, in Morse, *Letters and Journals*, 1:184. See also Gitelman, "Modes and Codes," 126.

39 Staiti, *Morse*, 205.

40 Silverman, *Lightning Man*, 312. For "Morse's invention of the telegraph" as "a synthesis of available knowledge and technol-ogy," see also Cikovsky, introduction to Morse, *Lectures*, 21.

41 James Fenimore Cooper to Morse, August 19, 1832, in *The Letters and Journals of James Fenimore Cooper*, ed. James Franklin Beard, vol. 2 (Cambridge, Mass.: Belknap Press of Harvard University Press, 1960–68), 310. The novel was *The Heidenmauer, or the Benedictines—A Story of the Rhine* (1832). The connection with *Gallery of the Louvre* was made by Kloss, *Morse*, 130.

42 Ibid., 129.

43 See Menahem Blondheim, "When Bad Things Happen to Good Technologies: Three Phases in the Diffusion and Perception of American Telegraphy," in *Technology, Pessimism, and Postmodern-ism*, ed. Yaron Ezrahi, Everett Mendelsohn, and Howard P. Segal (Amherst: University of Massachusetts Press, 1994), 85; and Daniel J. Czitrom, *Media and the American Mind from Morse to McLuhan* (Chapel Hill: University of North Carolina Press, 1982), 11.

44 Morse to his parents, March 14, 1814, Samuel F. B. Morse Papers, 1793–1944, Manuscript Division, Library of Congress, Washing-ton, D.C. For the need to "cut the umbilical cord" with Europe to ensure development in American art, see Lillian B. Miller, *Patrons and Patriotism: The Encouragement of the Fine Arts in the United States, 1790–1860* (Chicago: University of Chicago Press, 1966), 9.

45 Samuel F. B. Morse, *Imminent Dangers to the Free Institutions of the United States through Foreign Immigration* (1835), quoted in Silverman, *Lightning Man*, 141.

46 Jennifer L. Roberts, "Failure to Deliver: *Watson and the Shark* and the Boston Tea Party," *Art History* 34 (September 2011): 675.

47 Betsy Fahlman, *John Ferguson Weir: The Labor of Art* (Cranbury, N.J.: Associated University Presses, 1997), 49.

48 See Morse, *Lectures*, 89 and 89 n.10.

49 Ibid., 43 and 48.

50 Joshua Reynolds, quoted in John Barrell, *The Political Theory of Painting from Reynolds to Hazlitt* (New Haven: Yale University Press, 1986), 83.

51 Paul Gilmore, *Aesthetic Materialism: Electricity and American Romanticism* (Stanford, Calif.: Stanford University Press, 2009), 44. For Morse's Romanticism, see also Cikovsky, introduction to Morse, *Lectures*, 25.

52 Morse, *Letters and Journals,* 1:95–96.

53 Samuel Taylor Coleridge, *Biographia Literaria; or Biographical Sketches of My Literary Life and Opinions* (London: Rest Fenner, 1817), 1:295–96.

54 Ibid.

55 Morse, *Lectures*, 63–64.

56 Ibid., 59.

57 Ibid., 69.

58 Joshua Reynolds, *Discourses on Art,* 1769–90 (London: Collier-Macmillan, 1966), 49.

59 Morse, c. 1828, quoted in Silverman, *Lightning Man,* 87.

60 Elizabeth Flower and Murray G. Murphey, *A History of Philosophy in America* (New York: Capricorn Books and G. P. Putnam's Sons, 1977), 1:21.

61 Morse to Lucretia Pickering Walker Morse, July 3, 1817, quoted in Silverman, *Lightning Man,* 46.

62 Daniels, "Artists as Inventors and Invention as Art," 18–53.

63 Edward Lind Morse, in Morse, *Letters and Journals*, 1:245.

64 Alan Wallach, *Exhibiting Contradiction: Essays on the Art Museum in the United States* (Amherst: University of Massachusetts Press, 1998), 22.

65 David Hochfelder, *The Telegraph in America, 1832–1920* (Baltimore: Johns Hopkins University Press, 2012), Kindle edition.

66 Staiti, *Morse,* 6.

67 Paul Oskar Kristeller, "The Modern System of the Arts: A Study in the History of Aesthetics. Part 1," *Journal of the History of Ideas* 12 (October 1951): 525–26.

68 Henry Home, Lord Kames, quoted in Morse, *Lectures,* 56.

69 Lawrence W. Levine, *Highbrow/Lowbrow: The Emergence of Cultural Hierarchy in America* (Cambridge, Mass.: Harvard University Press, 1988), 1–82.

70 Ibid., 146.

71 Gilmore, *Aesthetic Materialism,* 44.

72 Morse, *Lectures,* 62; and Gilmore, *Aesthetic Materialism,* 44.

73 Morse, *Lectures,* 57.

74 Ibid., 92.

75 Ibid., 63.

76 Ibid., 92.

77 Kloss, *Morse,* 128, notes that Morse had recently studied Raphael's *School of Athens* with its "long, vaulted gallery alternately dark and bright stretching beyond." For a large number of previous paintings of the Louvre, see Jean-Pierre Cuzin and Marie-Anne Dupuy, *Copier créer: De Turner à Picasso: 300 oeuvres inspirées par les maîtres du Louvre* (Paris: Réunion des Musées Nationaux, 1993).

78 Morse, *Lectures,* 62–63.

79 In his *Descriptive Catalogue of the Pictures, Thirty-seven in Number, from the Most Celebrated Masters, Copied into the Gallery of the Louvre,* 1833, Morse draws attention to the length of the gallery; see the Appendix in this volume, pp. 195–96.

80 Peters Corbett and Monks, "Artistic Exchange between Britain and the USA," 640.

81 Morse, *Lectures,* 71.

82 Ibid., 72.

83 Gilmore, *Aesthetic Materialism,* 21.

84 Morse to his father, April 21, 1812, in Morse, *Letters and Journals,* 1:48.

85 Richard West Habersham's reminiscences of 1831 in a letter to Morse, quoted in Morse, *Letters and Journals,* 1:417–18.

86 Silverman, *Lightning Man,* 10.

87 Staiti, *Morse,* 193.

88 Morse, *Lectures,* 63.

89 Ibid., 69.

90 Ibid., 62.

91 Staiti, *Morse,* 10.

92 Morse, *Lectures,* 68–69.

93 Ibid., 68.

Honey from the Louvre:
Gleaning God's Word
from the Old Masters

DAVID BJELAJAC

SAMUEL F. B. MORSE'S *Gallery of the Louvre* (plate 1) is a profoundly religious sermon in paint. Though modern, museum-trained eyes tend to see the picture in light of aesthetic appreciation and art connoisseurship, the devoutly Protestant Morse had cause to hope that at least some might read his painting as a Christian-encoded composition affirming the human soul's spiritual thirst for Christ's sin-atoning love. I wish to analyze Morse's most ambitious painting in relation to the subject matter of its thirty-eight copies of old master paintings, nearly half of which represent Christian or biblical themes. Characterizing *Gallery of the Louvre* as a modernizing painting, Patricia Johnston argues that Morse's Calvinism led him to paint it as a formalist liberation of art from the corrupt history of Catholic ritual and idolatrous image worship.[1] But I contend that while Morse's composition did formally mitigate the dangers of idolatry, he remained keen to communicate the religious, spiritual messages of his copies' subjects, explicitly Christian or not.

PROTESTANTISM AND VISUAL SIGNS OF GOD

After the anti-Christian iconoclasm of the French Revolution and its threatened spread to American shores, Morse's marriage of Calvinism and art found encouragement in the tutelage of the Anglo-American artists Benjamin West and Washington Allston. Their large-scale biblical history paintings contributed to the Second Great Awakening—a period of evangelical Protestant revivalism directed against irreligion, materialism, and the infidelity of liberal Unitarianism.[2] Morse remained the loyal, pious son of the Congregational clergyman Jedidiah Morse—a prolific author of American geographies and one of the most zealous evangelical guardians of the theocratic heritage descended from New England Puritanism. As Paul Staiti argues, Samuel Morse made "no distinctions between sacred and secular," and he approached *Gallery of the Louvre* with a nationalist sense of America's mission to stand as a divinely covenanted beacon of republican freedom and virtue.[3] As we shall see, nominally secular subject matter bore religious meanings for Morse, whose paintings descended from Puritan notions that God's elect are living images of Christ and that Creation and human nature are imprinted with signs of God's Trinitarian presence.[4]

Gallery of the Louvre manifests the obsessive, covetous fascination of American Protestants with Catholic Church art, architecture, and ritual, but its cargo-boxing of miniature copies for export to America discourages idolatrous focus upon any one magic-working icon. Morse possessed the perspective of the Archangel Raphael—a key narrator-educator in John Milton's Puritan epic *Paradise Lost* (1667), who educates Adam regarding Satan's apostasy and the six days of Creation, whereby God created a system of analogical correspondences between heavenly and earthly realms to assist human knowledge of God's benevolent works.[5] Appearing in Morse's copy of a Rembrandt, the Archangel Raphael plays an assisting role in *Gallery of the Louvre* as healing

facilitator of marital love and a winged messenger of God's word, his flight path leading our eye westward toward America.

Timothy Dwight—the president of Yale as well as a Calvinist clergyman and Milton-inspired poet—mentored Samuel Morse, who benefited from the donation to Yale of John Smibert's *Bermuda Group (Dean George Berkeley and His Entourage)* (1728; reworked 1739).[6] The painting introduced Morse to the Anglican clergyman-philosopher George Berkeley, whose idealism posited that sociable, civilized conversation itself manifests the reality of God's being. Berkeley's book *Alciphron* (1732) argues that the human body is merely an arrangement of visible signs through which we read an individual, invisible soul. This soul expresses itself through speech, emotive vocal tones, physiognomic expression, and bodily actions.[7] Similarly, Jedidiah Morse endorsed physiognomic readings, writing about one early colonial preacher: "Not only his voice, but his eyes, his hands, his every feature, spoke the holy ardour of his soul."[8]

If one admits the existence of individual souls by the evidence of human communication in all its variety, then how, asked Berkeley, can one not also admit the existence of God, who everywhere, at all times, speaks to our eyes with a visible language of signs that he arbitrarily wills into being? For Berkeley, as for the Morse family, religion ideally transcends sectarianism and is socially grounded in commonly held beliefs, values, and traditions in harmony with God's chain of being and his promise of a messiah following the biblical Flood.[9] Expressing desire for transoceanic dissemination of the Gospel, *Gallery of the Louvre* represents a circulatory flow of divine energy stemming from Christ's blood—a life-giving, golden red chain that circulates the globe, spiritually drawing together families, communities, nations, past and future generations.

Like Berkeley, Samuel Morse drew correspondences between the human mind and the Godhead: "The mind in its essential nature . . . is the same in the Deity and in Man, like those images of the Sun, which are seen during the progress of an eclipse,

FIG. 73 Bartolomé Estebán Murillo (Spanish, 1618–1682). *Beggar Boy*, ca. 1648. Oil on canvas, 53¹⁵⁄₁₆ × 45¼ in. (137 × 115 cm). Musée du Louvre, Paris, no. 933

marking the intervals between the shadows of the foliage of the trees."[10] Morse's later praise for the powerful contrasts of light and shadow bathing Bartolomé Estebán Murillo's *Beggar Boy* (fig. 73) takes on religious meaning, particularly when connected to Morse's claim that "an unperverted taste must discern traces of the Deity in every thing: not a leaf, or an insect but speaks the language 'the hand that made me is divine.'"[11] This would include the invisible fleas or lice that apparently plague the humble figure of fallen humanity in Murillo's *Beggar Boy*, a copy of which hangs on the right side of the doorway in *Gallery of the Louvre*.[12] The boy's dusty feet adjacent to a beautiful, perfectly formed clay pot remind us that "the Lord God formed man of the dust of the ground, and breathed into his nostrils the breath of life; and man became a living soul" (Genesis 2:7). Fleas remind us of sin-corrupted human souls thirsting for Christ's redemptive blood and its sacramental analogue in Eucharistic wine.

ART, MEDICINE, AND RELIGION

Painted during a cholera epidemic in Paris, *Gallery of the Louvre* draws analogies between art, medicine, and religion and constructs correspondences between nutritional care for the body and spiritual ministering to the human soul. Earlier in Rome, Morse had delivered a George Washington's birthday toast identifying himself and fellow "Americans abroad" as "bees from a common hive . . . roam[ing] among poisonous flowers" represented by the potentially corrupting luxuries of the Old World. Possessing the "wisdom of the bee," discriminating American tourists ideally would return to their homeland hive only "with the honey and not with the poison."[13] Saint Basil of Caesarea, a fourth-century Church Father, had influentially urged young Christian men to think of themselves as wisdom-seeking bees when culling the writings of pagan antiquity.[14] However, Morse's exhortation to glean honey from poison also echoes the sixteenth-century medical alchemist Paracelsus, who once asked, "What has God created that He did not bless with some great gift for the benefit of man? Why then should poison be rejected and despised, if we consider not the poison but its curative virtue?"[15] Paracelsian medicine, popularized in Shakespearean plays and myriad other sources, affirmed the benevolence of God's Creation and commercially expanded the mission of alchemy to all arts and crafts refining valuable products from the raw substances of nature. English Protestants praised the new chemical philosophy for demonstrating "divine unity in the Trinity," since Paracelsus argued that nature's medicines comprised three essential principles or substances, which divinely correspond with a triadic compound defining human nature: salt (body), sulfur (soul), and mercury (spirit).[16] The biblical liquid gold of "honey out of the rock" (Psalm 81:16) thus suggested a spiritual, immortalizing elixir for the soul drawn from Christ's body: "for they drank of that spiritual Rock . . . and that Rock was Christ" (1 Corinthians 10:4). Paracelsian faith in the medical value of poi-

sonous minerals comported with orthodox American Calvinists' theological belief that "God's greatest and most glorious work" is to transform earthly evils stemming from the Fall of Adam and Eve into "the means of the greatest good."[17]

A former pupil of Morse, the American artist Daniel Huntington, noted that Morse's painting career depended upon the artisanal mysteries of chemistry, a "delving into the secrets of pigments, varnishes, mixtures of tints, and mysterious preparations of grounds and overlaying of colors."[18] Morse's marriage of art and chemistry also led him to the poisonous materials and processes of daguerreotypes, Mother Nature's sketches produced by salted, light-sensitized plates, sulfurous solar rays, and mercury vapors—Paracelsus's triad of salt-sulfur-mercury. Morse assured his mentor Washington Allston that the new photographic invention would teach artists how to paint: "Our studies will now be enriched with sketches from nature [daguerreotypes] which we can store up during the summer, as the bee gathers her sweets for winter."[19] Hibernating for three winter months, bees traditionally signified Christ's three-day entombment.[20] An analogue for the spiritual nutrition provided by Christ's resurrected being, *Gallery of the Louvre* might be thought of as a Christian beehive stored with regenerative ideas from deceased old masters, a divine honey "for the imagination to feed upon."[21]

FREEMASONRY'S TRIADS AND THE CHRISTIAN HOLY TRINITY

Many American Protestants embraced Freemasonry's esoteric imagery inspired by the Genesis Creation story as well as by Old Testament accounts of building Noah's ark and Solomon's temple.[22] From pagan and Judeo-Christian building traditions, Freemasons appropriated the beehive as a natural analogue for the Masonic lodge, while golden honey itself suggested the light of divine wisdom.[23] The Reverend James Anderson, an eighteenth-century Scottish

Calvinist founder of modern Freemasonry, fancifully regarded Leonardo, Raphael, Michelangelo, and other Renaissance artists as Masons. American Masonic journals later reiterated Anderson's expansive claim, and nineteenth-century American Freemasons celebrated painters and art academicians whatever their Masonic or non-Masonic status.[24] Morse was not a Freemason, but his work was favorably reviewed in the *New-England Galaxy and Masonic Magazine*, and he valued the patronage of Freemasons led by two successive grand masters of New York's Grand Lodge: Governor DeWitt Clinton and Stephen Van Rensselaer III.[25] Morse's Calvinist hunger for ancient, Creation-based signs of the Holy Trinity found nourishment in the Freemasons' adoption of the sacred number three, with its triangles, pyramids, and hexagrams and its moral-aesthetic triads (e.g., Faith, Hope, and Charity; Doric, Ionic, and Corinthian orders) signifying the harmonic union of persons, ideals, and forms.[26] Bees' hexagonal honeycomb cells particularly express nature's fecundity in reproducing signs of Trinitarian unity: geometrically generated from six side-by-side equilateral triangles, the hexagon, a triadic multiple, fits completely within a circle, the image of God and cosmic oneness.[27]

During the fourth of his *Lectures on the Affinity of Painting with the Other Fine Arts*, presented before the New York Athenaeum in 1826, Morse openly dissented from Isaac Newton's *Opticks*, rejecting Newton's theory that seven primary colors constituted the spectrum of a rainbow. Instead, Morse argued that the simpler triad of red, yellow, and blue efficiently composed a rainbow, "one of the most beautiful natural examples of a Trinity in Unity."[28] Newton's seven primary colors numerically corresponded with the Mosaic hexameron: the biblical six days of Creation plus the seventh day of rest. However, Newton's mechanistic physics denied divine immanence or the occult presence of God's word in nature.[29]

Orthodox Trinitarian Calvinists, though rejecting a pantheistic identification of God with nature, resisted the materialist demystification of the rainbow's three primary colors, a triad they read as a divine communication. Echoing Henry Harington's Anglican treatise *Symbolon Trisagion; or the Geometrical Analogy of the Catholic Doctrine of Triunity* (1806), which found "triunity" in both light and sound vibrations, Morse argued against Unitarian skeptics.[30] In Morse's words, "This single fact, were there no others, of the existence of one entire perfect essence, *Light*, yet in mysterious union with *three* distinct essences, constantly separable in their nature from it into *three*, and three only, and resoluble again into perfect *oneness*, is such an example in nature of a mysterious union of *three* and *one*, as forever to bid cavil at the Theological doctrine of the Trinity as unphilosophical and absurd." For Morse, the triune rainbow was "an everlasting *emblem* of [God's] own mysterious existence."[31] Harmonizing with Masonic reverence for Noah's sturdy ark, the rainbow became God's covenantal token to future generations that "the waters shall no more become a flood to destroy all flesh" (Genesis 9:15).[32]

Morse's 1826 lectures on painting also drew upon the Trinitarian color theory of George Field.[33] Field's *Chromatics; or, an Essay on the Analogy and Harmony of Colours* (1817) bears a hexagram on its title page. The British pigment manufacturer had developed a triadic color system for resolving the dualism of light-dark, white-black contrasts—proof, according to one British commentator, of Freemasonry's "Egypto-platonic or geometrical philosophy."[34] Field's triads of primary (blue, red, yellow), secondary (purple, green, orange), and tertiary (olive, russet, citrine) colors mediated between light-dark opposites. The middle color of each triad (red, green, and russet) was the superior tint, and because red was a primary color, it was superior to the secondary and tertiary middle tones. Field regarded red as the supreme signification of God's Creation, a glowing synthesis of the light-dark dialectic in Genesis 1:3–5. Red also held a special relationship with the Holy Trinity, being the central primary color ray in composing triune white light.[35] The vermilion walls and

deep red accents of clothing and drapery in *Gallery of the Louvre* express both the redemptive blood and purifying baptismal fire of Christ (Luke 3:16).

During the late 1790s, in the wake of the French Revolution, Morse's father had warned American Freemasons against irreligious radicalism and the rationalist materialism of Enlightenment philosophy.[36] However, Jedidiah Morse distinguished subversive freethinking from Freemasonry itself, and in 1824 he paid tribute to King Solomon's Lodge of Charlestown, Massachusetts, for erecting a Revolutionary War monument memorializing General Joseph Warren, the Masonic grand master martyred at the Battle of Bunker Hill.[37] The following year, on the fiftieth anniversary of the battle, George Washington's Masonic brother, the Marquis de Lafayette, helped lay the cornerstone for a far grander Bunker Hill Monument, an Egyptian-style obelisk that Samuel Morse's mentor, Washington Allston, helped design.[38] Freemasonry's nonsectarian belief in a Divine Architect derived from ancient sun worship as expressed in skyward obelisks and triangular, pyramidal forms. But most Freemasons supported the Christianization of heliocentric mysticism in the worship of Jesus Christ. New York grand master Stephen Van Rensselaer thus led Freemasons in joining Protestant missionary societies and served with Jedidiah Morse on the American Board of Commissioners for Foreign Missions.[39]

ILLUMINATING GOD'S SWEET WORD AND CHRIST'S COMMUNAL BLOOD

Morse's *Gallery of the Louvre* meditatively distills from potentially dangerous art objects an aesthetic quality that Puritan theologians called "*suavitas*," a spiritual sweetness emanating from hearts receptive to the honey of God's word (Psalm 119:103).[40] Morse's temple of the arts is occupied by virtuous pilgrims bonded together by heartfelt friendship, kinship, and love for divine beauty, truth, and goodness. Enveloped by the painting's honeyed tones, Morse leans over the shoulder of a young woman absorbed

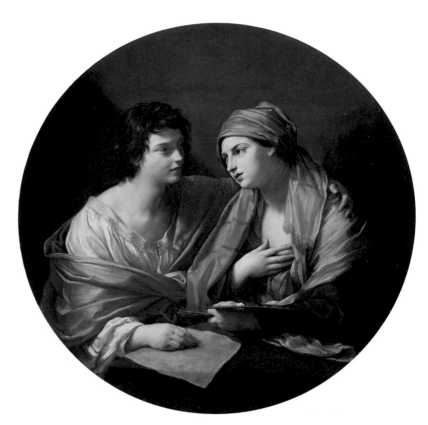

FIG. 74 Guido Reni (Italian, 1575–1642). *The Union of Design and Color*, ca. 1620–25. Oil on canvas, diameter: 47⅝ in. (121 cm). Musée du Louvre, Paris

by the mental activity of drawing. The artist appears to take a cue from his own copy of Guido Reni's ocular-shaped *The Union of Design and Color* (fig. 74), situated just to the left of an ancient Roman sculpture, copied after a Greek original, representing Artemis, or Diana the Huntress (fig. 40), moon goddess and guardian of maidenhood, childbirth, and maternal love.[41] Suggesting that art constitutes a virtuous hunt for divine beauty and wisdom, Reni's female personification of Color or Painting, armed with palette and brushes, chastely marries masculine Design or Drawing, whose youthful androgyny and chivalrous manner express a spiritual sweetness transcending sexual desire.[42]

Emulating the chaste emotional bond between Reni's Design and Color, Morse points his hand immediately above the drawing hand of his pupil, who is seated at proper viewing distance from Paolo Veronese's *Wedding Feast at Cana* (fig. 75). This vast

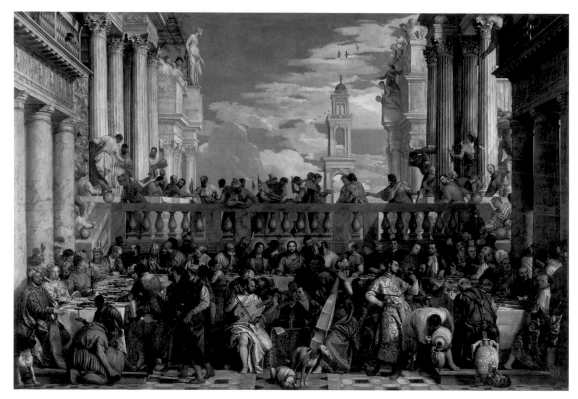

FIG. 75 Paolo Veronese (Italian, 1528–1588). *Wedding Feast at Cana*, 1563. Oil on canvas, 266½ × 391¼ in. (676.9 × 993.7 cm). Musée du Louvre, Paris

Venetian Renaissance painting hangs along the left edge of Morse's picture. Seen in foreshortened perspective and only partially visible, Veronese's composition seems to extend into real space: leaning forward, Veronese's servant appears to pour us wine. In Morse's illusionistic "real" space immediately below *Wedding Feast at Cana*, a red-turbaned artist sits at his easel painting an atmospheric, Venetian-style landscape. Apparently portraying Morse's American colleague Richard West Habersham,[43] this figure wears a wine-colored turban that connects him to Veronese's turbaned banqueting figures, who benefit from Christ's miracle of transforming water into wine.

Veronese's spectacle of Christ's first miracle (John 2:1–11) may appear to secularize biblical sub-ject matter by subordinating the divine narrative to a rendering of magnificent architecture, rhythmic figural movements, and the elaborate trappings of a sumptuous plein air banquet. This Renaissance

masterpiece once hung in the convent of San Giorgio Maggiore in Venice but was confiscated by Napoleon Bonaparte and badly damaged during its journey to Paris.[44] Having survived the French Empire's collapse, the restored picture remained in post-Napoleonic Paris, where it continued to awe the Louvre public with its operatic pageantry. Here, surely, was one of Morse's "poisonous flowers," since Joshua Reynolds, first president of Britain's Royal Academy, had warned art students against the superficial dazzle of Veronese's exotic banqueting pictures.[45]

However, Morse adopted the viewpoint of Washington Allston, his Harvard-educated painting mentor, who described the intense otherworldly feelings generated by *Wedding Feast at Cana*. For Allston, Veronese (and Titian) powerfully expressed divinity because the Venetian artists' oil-glazing technique transmuted pigmented matter into super-natural, ethereal light. Veronese's visual subordina-tion of Christ's figural representation in favor of a

nonsensuous, luminous atmosphere transported Allston's imagination, leading his soul upward toward the ethereal "dominion of music," sister art to painting and poetry.[46] Morse's cropped copy of *Wedding Feast at Cana* includes a partial, distorted view of a musician, whose sonorous wine red robe correlates with Christ's miracle of transforming water into wine. Morse's fragment excises Veronese's representation of Christ to focus on a wine-pouring servant whose action foreshadows the Last Supper as well as the moment during the Crucifixion when a soldier speared Christ's side "and forthwith came there out blood and water" (John 19:34). To assist viewers in making this biblical association, Morse painted a copy of Jean Jouvenet's *Descent from the Cross* (fig. 76) immediately to the right of *Wedding Feast*

FIG. 76 Jean Jouvenet (French, 1644–1717). *Descent from the Cross*, 1697. Oil on canvas, 167 × 123 in. (424 × 312 cm). Musée du Louvre, Paris, INV5493

at Cana. In Jouvenet's painting, the wound in Christ's side appears along the central axis, above a golden vessel collecting the sacred blood and water. Of particular appeal for Morse, Jouvenet painted austere religious pictures expressing the Calvinist values of Jansenism, a dissenting pietistic movement within the Catholic Church.[47] In *Gallery of the Louvre*, Morse's Jouvenet represents Christ's sin-redeeming death, an evangelical message intended for America, God's new chosen nation awaiting Christ's apocalyptic marriage to a New Jerusalem of elect souls (Revelation 21:2, 9).

A classical, arrow-wielding type for the American wilderness, Morse's *Diana* at the far right of the gallery dramatically attends to Veronese's *Wedding Feast*. This tamed antique sculpture of the hunting moon goddess includes a sexually ambiguous antlered doe, Diana's sacred Ceryneian hind.[48] In relation to Veronese's marriage feast, redolent with anticipation of Christ's apocalyptic marriage to saved souls, Diana's wilderness hind recalls the wedding imagery in the Song of Solomon (2:7), which charges the "daughters of Jerusalem, by the roes, and by the hinds of the field, that ye stir not up, nor awake my love, till he please." For New England Puritans, this passage expressed longing for the messianic coming of Christ.[49] The upward, over-the-shoulder gaze of Morse's goddess leads our eye toward the *Wedding Feast*. Christ's visual absence from Morse's copied fragment underscores the feeling of unconsummated love and waiting "till he please."

Diana appropriately stands beneath Morse's copy of Joseph Vernet's *Marine View by Moonlight*: the moon goddess governs oceanic tides, the circulation of waters, monthly menstrual cycles, seasonal rhythms of fertile nature, and human reproduction. From Morse's perspective, the moon's gently mediating reflection of otherwise blinding sunlight exemplifies the alchemical marriage of sensuous, fluid pigments with the mysterious internal light emanating from the artist's "spark of . . . Divinity," the human mind being a mediating, nonblinding likeness of "the great first cause, the Creator of all."[50]

FIG. 77 Peter Paul Rubens (Flemish, 1577–1640). *Tomyris, Queen of the Scyths, Ordering the Head of Cyrus Lowered into a Vessel of Blood*, ca. 1620–25. Oil on canvas, 103⁹⁄₁₆ × 78³⁄₈ in. (263 × 199 cm), inv. 1768. Musée du Louvre, Paris

Morse's *Diana* signifies the wilderness of fallen nature but does not warrant Christian condemnation. In his globally expansive *American Geography*, Jedidiah Morse remarked upon the ancient city of Ephesus in western Asia Minor as "famous for the temple of Diana," later destroyed not by iconoclastic Christians but by a vainglorious arsonist.[51] Acts of the Apostles acknowledges "that the city of the Ephesians is a worshipper of the great goddess Diana," whose sacred image, by cult legend, "fell down from Jupiter" (Acts 19:35). Knowing that silversmiths crafted "silver shrines for Diana" (19:24) and that numerous other craftsmen serviced the temple of Diana, "whom all Asia and the world worshippeth" (19:27), Saint Paul prudently refrained from criticizing Diana worship; in return, the Ephesians tolerantly allowed the preaching of Christ's Gospel (19:36–41).

On the far right wall of the Salon Carré, adjacent to the *Diana*, Morse situated a perspectively distorted copy of Peter Paul Rubens's *Tomyris, Queen of the Scyths* (fig. 77). The painting's narrative detail is drawn partly from Herodotus, who describes the military defeat and death of the Persian emperor Cyrus the Great upon the command of his would-be wife, Tomyris, widowed queen of the Massagetae, a sun-worshiping people living beyond the Caucasus Mountains and Caspian Sea "toward the east and the rising sun."[52] Embellishing the Herodotus narrative, Rubens represents Tomyris, the victorious barbarian queen, as she orders Cyrus's head to be placed in a wine vessel filled with human blood. Herodotus states that the queen intended this immersion as a posthumous rebuke to the bloodthirsty Persian emperor, but in Rubens's painting she incongruously appears to act not in anger but rather with gracious benevolence.

For Morse, Rubens's pagan subject matter possessed both contemporary and biblical associations. A pagan who practiced monotheistic sun worship, Queen Tomyris became a type for the Virgin Mary and the Church.[53] The twisted columns, barely legible in Morse's visually distorted copy, signify the remains of Solomon's temple, which, by legend, were recovered for the building of Saint Peter's Basilica in Early Christian Rome. The columns remind us that Cyrus had been the divinely chosen agent charged by "the Lord God of Israel" (Ezra 1:1–3) to free the Jewish people from their seventy-year captivity in Babylon, enabling their restoration to Jerusalem and the rebuilding of Solomon's temple. Having chastely resisted Cyrus's marriage overture, Queen Tomyris demonstratively shows us that ashen-faced Cyrus is a mere shadow compared to Jesus Christ. Indeed, below his copy of the Rubens, with its vessel receiving Cyrus's flesh and blood, Morse strategically placed a small copy of Pierre Mignard's *Madonna and Child*, also known as *Virgin of the Grapes*. Together these copies of Rubens and Mignard telegraph a message across Morse's exhibition space to remind

beholders of Veronese's *Wedding Feast* that grapes and wine symbolize Christ's sacrifice.

Morse's *Diana* sculpture visually confirms the beheaded Cyrus as a type for Christ: Diana's antlered hind leaps toward the decapitated head that Rubens represents descending into the wine vessel of blood. The hind heuristically recalls Psalm 42:1–2: "As the hart panteth after the water brooks, so panteth my soul after thee, O God. My soul thirsteth for God, for the living God: when shall I come and appear before God?" Diana's hind fed upon trefoil, a trileafed clover that Christians appropriated as an emblem of the Holy Trinity.[54] In his 1826 *Lectures*, Morse cited trefoil to exemplify the Creator's "universal principle of *Connexion*," which binds everything into a "mysterious chain" of being.[55] In *Gallery of the Louvre*, Diana's straining, trefoil-hungry hind appears to lunge toward the fleur-de-lis—a tripartite heraldic flower—decorating the tip of Queen Tomyris's golden scepter pointed toward the head of Cyrus.[56] Diana herself personified the sacred Trinity, being identified with the three-headed moon goddess Hecate. Morse's copy of *Diana*'s twisting, rotating head hints at the Holy Trinity's presence.[57]

PROTESTANT ORTHODOXY VERSUS UNITARIANISM

Morse's Trinitarian allusions recall his father's orthodox Protestant crusade against New England Congregationalism's theological drift toward Unitarianism. Jedidiah Morse attacked liberal Protestants who denied the Holy Trinity, Christ's coequality in the godhead, and the necessity of Christ's atoning death.[58] Despite his own diatribes against Catholic immigrants and the Catholic Church hierarchy, Samuel Morse found much to like in the affirmation of Christ's divinity and the Trinitarian doctrines in Catholic art. For orthodox Protestants, Unitarian disbelief conjured associations with deism, pantheism, Islam, and French Revolutionary Jacobinism—threats that seemed far more dangerous to Christian

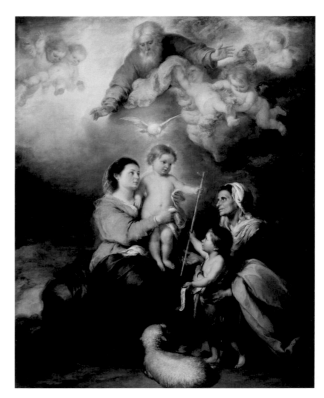

FIG. 78 Bartolomé Esteban Murillo: (Spanish, 1618–1682). *Holy Family*, also called the *Virgin of Seville*, 1665–70. Oil on canvas, 94½ × 74¹³⁄₁₆ in. (240 × 190 cm). Musée du Louvre, Paris

civilization than Catholicism's Marian cult and iconophilia. The Louvre's liberation of devotional imagery from Catholic control emboldened and professionally sanctioned Morse to display religious images supporting Christian belief.

Morse's copy of Murillo's *Holy Family* (fig. 78), prominently displayed immediately to the left of the doorway, also pointedly represents the Holy Trinity along the painting's central axis: a bearded heavenly Father at the top, followed by the white dove of the Holy Ghost hovering immediately over the golden-haired Jesus accompanied below by a small lamb symbolizing Christ's redemptive death. In launching his journal *Panoplist* in 1805, Jedidiah Morse identified orthodox Calvinists as "faithful followers of the Lamb," while liberal Unitarians were "enemies of the cross of Christ," disbelievers in his atoning death.[59]

A triad of primary colors—composed of modulated blue, yellow-gold, and light red—dominates Murillo's figural pyramid, suggesting a luminous analogy with the triune deity and reminding us of Morse's 1826 lecture on the Trinitarian rainbow prophesying a messiah. Above and to the left of Murillo's *Holy Family*, the destructive waters of the biblical Flood are represented in Morse's copy of Nicolas Poussin's *Deluge (Winter)*. This bleak, rainbowless view of the Flood situates itself between Jacopo Tintoretto's *Self-Portrait*, a haunting meditation on human mortality, and Caravaggio's *Fortune Teller*, representing a vice-ridden youth's vulnerability to reversals in life's fortunes. Stacked above Titian's *Christ Crowned with Thorns* and to the immediate left of Murillo's *Holy Family*, these pictures of sinful humanity and mortal flesh signify the burden that Christ bears. Christ keeps Jehovah's covenantal promise of Genesis 9:11–17 by lovingly substituting his "living fountains of waters" (Revelation 7:17) for the floodwaters.

Mainstream American Protestants insisted that Christ's death upon the cross had been necessary to redeem humankind from the inheritance of Adam and Eve's original sin. Contrary to Washington Allston's own orthodoxy, his Unitarian brother-in-law, the Reverend William Ellery Channing, opposed Jedidiah Morse by denying the efficacy of Christ's blood sacrifice. Channing professed to be "astonished and appalled by the gross manner in which 'Christ's blood' is often spoken of, as if his outward wounds and bodily sufferings could contribute to our salvation; as if aught else than his spirit, his truth, could redeem us."[60] Morse's *Gallery of the Louvre* implicitly rejects Channing and other Unitarians for spurning Christ's redemptive cross and instead invites beholders to become "faithful followers of the Lamb": below his copy of Murillo's *Holy Family*, Morse cannily placed David Teniers II's *Knife Grinder*. The Flemish knife grinder's gaze and hat feather lead our eye upward to the sacrificial lamb at the base of Murillo's *Holy Family*. Teniers's knife associatively

pierces the boundaries of the golden picture frames to threaten Murillo's lamb, emblematic of Christ's sacrifice. Though still an infant, Murillo's Christ stands upright upon his mother's lap, already anticipating his crucifixion and triumphant resurrection as he holds a reed cross passed from the young Saint John the Baptist.

Morse further emphasized redemptive blood by placing Titian's *Christ Crowned with Thorns* between Murillo's *Holy Family* and Jouvenet's grand-scaled *Descent from the Cross*, which abuts Veronese's *Wedding Feast at Cana*. At the base of Jouvenet's composition rests the golden vessel of Christ's blood and water (John 19:34), foreshadowed by the water and wine imagery in the adjacent Veronese. Morse's placement of an ancient Athenian krater next to Titian's *Christ Crowned with Thorns* also suggests the collection of Christ's blood and its identification with sacramental wine. Scholars have assumed that this monumental vessel represents the Louvre's *Borghese Vase*; its relief sculpture represents a procession led by Dionysius, or Bacchus.[61] God of wine and discoverer of honey hidden within a rotting tree, Bacchus constituted a pagan type for Christ's victory over death's sting.[62]

Another pagan Christological type appearing at the top of the right-hand wall expresses Calvinist faith in God's power to transform evil into good. Guido Reni's *Deianeira Abducted by the Centaur Nessus* (fig. 85), based on Ovid's *Metamorphoses* (book 9), includes the tiny background figure of Hercules, who has fired a deadly, Hydra-poisoned arrow at Nessus, the traitorous centaur raping Hercules's wife. Exemplifying the impenetrable mysteries of God's will, Nessus's blood-soaked shirt, a well-intended gift from the clueless Deianeira, later becomes the tragicomic instrument for poisoning a foolishly trusting Hercules. In fact, the copy of this Reni painting alludes to Morse's *Dying Hercules* (fig. 84), earlier exhibited at the Royal Academy, which represents Hercules's struggle to survive the poison from Nessus's shirt. Rather than dying, however, Hercules is

immortalized: "The Almighty Father carried him away . . . and stationed him among the shining stars" of the zodiac.[63] Countering rationalist Unitarians' overly confident faith in man, Morse's Calvinism taught that even Hercules required God's direct intervention to achieve heavenly immortality. As Reni's Nessus and Deianeira gaze longingly heavenward, they foreshadow Hercules's shedding of mortal flesh. The deceitful centaur is weighed down not only by his rape victim but, even more, by his lustful animal being. Meanwhile, the blood red drapery enveloping Deianeira points to the small background figure of Hercules, foreshadowing the flawed hero's celestial ascent and transmutation into a luminous type for Christ.

WESTWARD THE COURSE OF CHRISTIAN CIVILIZATION

Morse's copy of Titian's *Francis I* (fig. 79), situated on the right side of the doorway, celebrates a "Gallic Hercules" whose painterly red shirt radiates the splendor of Herculean apotheosis.[64] Francis I (r. 1515–47) had transformed his kingdom's courtly culture not through Napoleonic-style military plundering but through generous patronage of arts and learning, commissioning plaster-cast copies of famous ancient Roman sculptures and favoring the contemporary work of leading Italian Renaissance artists. A small copy of Leonardo's *Mona Lisa* hangs two levels below *Francis I*, a reminder that Leonardo da Vinci had lived his final years at Francis's court and, according to popular legend, had died in the king's arms.[65] In his *American Geography*, Jedidiah Morse wrote that Francis I "possessed a great and active mind," because he commissioned Giovanni da Verrazano and later Jacques Cartier to embark upon voyages of discovery, contributing to the westward progress of Christian civilization.[66] The subject of a Romantic-era royalist cult, Francis I was entombed in a hexagonal, star-shaped chapel that paralleled the hexagonal shape of the French

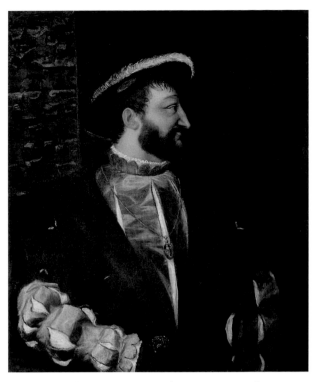

FIG. 79 Titian (Italian, 1488/89–1576). *Francis I*, 1539. Oil on canvas, 45¹⁵⁄₁₆ × 35¹⁄₁₆ in. (109 × 89 cm). Musée du Louvre, Paris, inv. 753

kingdom itself, a shape made possible by the Renaissance monarch's acquisition of Brittany, the northern province that points westward across the Atlantic toward North America.[67]

Within *Gallery of the Louvre*'s warm embrace, a Breton peasant woman and child are leaving the Salon Carré for the golden Grande Galerie, implicitly foreshadowing Morse's own westerly departure from Paris. Wearing Sunday-best regional costumes, the pair visually refers to Honoré de Balzac's *Les Chouans* (1829), a historical novel that narrates Brittany's peasant resistance to the French Revolution three decades earlier. Influenced by James Fenimore Cooper, Balzac compares Breton peasants, residents of a rugged western province, to tribal American Indians, specifically the Mohicans immortalized by Cooper in *The Last of the Mohicans* (1826). Parallel to Cooper's disappearing Indians, Balzac's Bretons constitute the remnant of an ancient "Gaelic,"

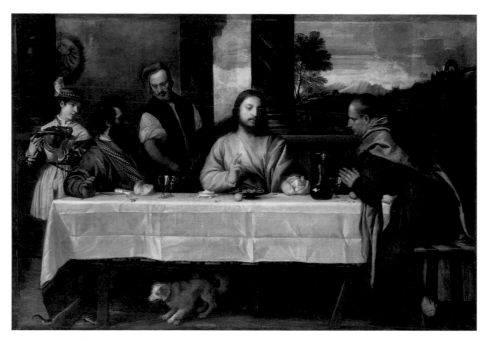

FIG. 80 Titian (Italian, 1488/89–1576). *Supper at Emmaus*, ca. 1530. Oil on canvas, 69⅟₁₆ × 96⅟₁₆ in. (169 × 244 cm). Musée du Louvre, Paris

"Gaulish," "Celtic" language and barbarian culture.[68] However, Morse's stately, well-dressed Breton figures are designed to convince culturally inexperienced Americans of art's refining, civilizing effects.

The family group headed by James Fenimore Cooper visually links with the Breton mother: Cooper's pointing index finger, the pyramidal apex of the Cooper daughter's easel, and the conical cap of the Breton mother all direct attention toward the sacrificial lamb and standing baby Jesus in Murillo's *Holy Family*. Meanwhile, Titian's *Supper at Emmaus* (fig. 80), the only old master narrative representing the resurrected Christ in *Gallery of the Louvre*, hangs immediately above the portal to the Salon Carré. Morse's placement of this Titian transforms the doorway into a quietly commemorative triumphal arch signifying Christ's victory over death. Morse's symbolic positioning of this unpretentious Titian underscores the idea that Christ's kingdom ultimately prevails not through imperial, military power but rather through the persuasive eloquence of verbal and visual sermons. As the Breton peasant mother

and child proceed together through the passageway overseen by the risen Christ, they figuratively express Christ's Sermon on the Mount: "Blessed are the meek, for they shall inherit the earth" (Matthew 5:5).

As she exits, the Breton woman brushes past Morse's copy of *The Angel Leaving the Family of Tobias*, by Rembrandt (fig. 86), a Cooper family favorite nicknamed the "steamboat" because the angel's powerful wings reminded Mrs. Cooper of the motion of the "sidewheels of a steamer."[69] This witty nickname suggests American technology's assistance to Christian missions and dissemination of the fine arts. The archangel Raphael originates from the apocryphal Book of Tobit, where he serves as a guardian of travel, a healer, and a patron of marriage: Raphael cures the blindness of Tobit (Tobit 11:8) and makes possible the marriage of Tobit's son Tobias by enabling him to exorcise a demon from his bride (Tobit 8:2–3).

From *The Angel Leaving the Family of Tobias*, the archangel's trajectory and Rembrandt's golden

tones carry us into the luminous Grande Galerie. The "longest room in the world," the Grande Galerie directs our gaze westward in anticipation of Morse's long oceanic passageway back to the United States.[70] Designed for transatlantic travel and American cultural enlightenment, *Gallery of the Louvre* alludes to Francis Bacon's narrative of Hercules voyaging the waters of Oceanus via the cup of Helios, the Titan sun god. Morse admired Bacon and, while in Paris, reportedly had extensive conversations with James Fenimore Cooper over Bacon's natural philosophy.[71] Bacon's treatises hailed Hercules as an exemplary explorer, daring to sail beyond the Mediterranean through the Straits of Gibraltar—the "Pillars of Hercules."[72] Morse's Grande Galerie displays pairs of spatially receding lofty columns, Pillars of Hercules symbolizing western exploration, discovery of the Americas, and the expanding limits of western civilization. In the Christian, millennial spirit of George Berkeley's frequently published "Verses on the Prospect of Planting Arts and Learning in America," Morse's Grande Galerie prophesies "another golden age," the "westward . . . course of empire" toward a "virgin earth," "where nature guides and virtue rules" in contrast to "pedantry of courts and schools" that "Europe breeds in her decay."[73]

Morse's red-turbaned painter seated below Veronese's oriental *Wedding Feast at Cana* begins an East-West line of cultural transmission toward the nobly exotic Breton mother and child—New World figural metaphors, perhaps, for Canada's Cape Breton Island, discovered in 1497 by the Venetian father-son explorers John and Sebastian Cabot.[74] The Breton peasants process not only from the Salon Carré to the Grande Galerie but also from the Old World to the New. High above the Breton woman, on the left side of the doorway, Morse's old master copies further allude to the westward course of history: Anthony van Dyck's *Venus at the Forge of Vulcan* represents a scene from Virgil's *Aeneid*, narrating how Aeneas, prince of Troy, voyaged westward from Asia to

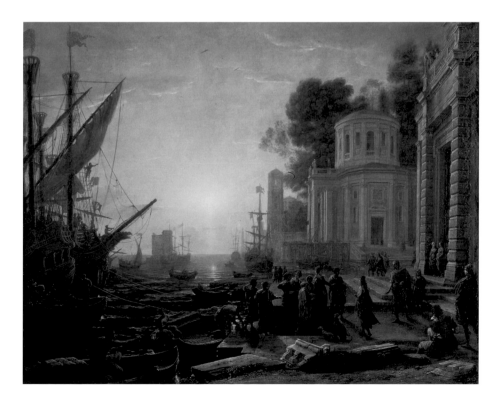

FIG. 81 Claude Lorrain (French, ca. 1602–1682). *Disembarkation of Cleopatra at Tarsus*, 1642–43. Oil on canvas, 46⅞ × 66⅛ in. (119 × 168 cm). Musée du Louvre, Paris

found the Roman empire. By legend, Brut or Brutus, the great grandson of Aeneas, became the ancestral founder of Albion and the English people.[75] Anglo-American poets and writers subsequently appropriated Aeneas as a type for New World exploration and territorial settlement.[76]

Immediately below this Van Dyck, Claude Lorrain's *Disembarkation of Cleopatra at Tarsus* (fig. 81) represents the Queen of Egypt meeting Mark Antony, the Roman leader with whom she would bear twins (named after Helios and Selene, gods of the sun and the moon)—a royal birth that Claude foretells in his liquid, atmospheric fusion of solar light and lunar waters. Descended from Egypt's ruling Greek dynasty begun under Ptolemy I (companion to Alexander the Great), Cleopatra identified herself as the "new Isis," the Egyptian moon goddess who governed the fertilizing waters of the Nile River.[77] Cleopatra's identification with both the Nile and the seaport of Tarsus suggests Morse's high regard for George Berkeley and the theologian-philosopher's most popular work, *Siris* (1744), a treatise on American pine tar (i.e., "Tars U.S.," a pun upon Tarsus) and its infusion into cold, fresh water to produce a widely used elixir.[78] Titled after the ancient Egyptian or Ethiopian name for the Nile River,[79] *Siris* leads the mind upward to contemplate tar-water's triadic marriage of mercury, sulfur, and salt as a natural hieroglyph for the Holy Trinity.[80]

Cleopatra's Nile River constitutes the most famous archetype for the Mississippi River, a powerful symbol of imperial expansion.[81] Jedidiah Morse prophesied that the United States "will comprehend millions of souls, west of the Mississippi," since "the God of Nature" never designed [the Mississippi] as the western boundary of the American empire."[82] The Egyptian pyramid capped by an all-seeing eye on the reverse side of the Great Seal of the United States emblematically expresses the westward transmission of ancient Egyptian wisdom.[83] The Great Seal's pyramid associatively delivers a latent message appealing to Protestants like Morse: that Egyptian-educated Moses facilitated this cultural transit from the land of the Pharaohs to "a land flowing with milk and honey" (Exodus 3:8; 13:5), typologically foreshadowing the Pilgrims' transatlantic flight from Old World corruption.[84]

Gallery of the Louvre visually expresses the astronomical, Christian perspective found in Jedidiah Morse's *American Geography*, which argues that "Shepherds, on the beautiful plains of Egypt and Babylon," invented Astronomy by distributing "the stars into a number of constellations . . . to which they gave the names of the animals which they represented." From this star knowledge, shepherds discovered "the manger where our blessed Saviour was born."[85] Reverend Morse's zodiacal chart first lists Aries, the constellation marking spring and the seasonal rebirth of life, as signified by a ram.[86] Alternatively, the Lamb of God could signify Aries, vernal renewal of the zodiac and the purity of resurrected being, as seen, for instance, in emblematic Masonic engravings and white lambskin aprons.[87] In *Gallery of the Louvre*, Morse's bent head and torso create a diagonal line leading to the Lamb of God in Murillo's *Holy Family*. Meanwhile, the departing Breton peasants create a visual, communicative link between Murillo's Christological Lamb and the resurrected Christ immediately above the doorway in Titian's *Supper at Emmaus*. The Breton child, wearing a rosy, flowerlike cap, underscores the astrological symbolism of Spring and the dawn-red fire of youth.[88]

Morse's profiled face, silhouetted against the golden Grande Galerie and energized by a horn-shaped tuft of hair, astrologically signifies his birth on April 27, 1791, under Taurus the bull, second sign of the zodiac. Taurus represents lunar divinities and Mother Earth's fertility.[89] Leonardo's *Mona Lisa* hangs as a maternal muse close behind Morse. In Ovid's *Metamorphoses*, Jupiter assumed the form of Taurus the bull to lure onto his back the royal maiden Europa, bearing her skyward to Crete.[90] The mythic rape of Europa signifies the zodiac's constellation of Taurus, but it also became a pagan type for Christ's human incarnation and his self-sacrificial bearing of redeemed souls to heavenly immortality.[91]

Watching over a Europa-like maiden, Morse's knees are bent in the manner of Taurus offering his back for seaward flight. Morse prepares a cargo of European old masters to bear to the New World as sermonizing witnesses for Christ. Along the Salon wall, the lower left corner of Veronese's *Christ Carrying the Cross* sharply points to Morse's back, while Eustache Le Sueur's nearby *Christ Carrying the Cross* constitutes a virtual Gemini twin in similarly calling attention to the American Taurus's shouldering of a Christian mission. A Jovian type for Christ, Morse exercises what he calls the "spark of divinity" that animates all human creativity.[92]

BECOMING A BRIDE OF CHRIST

At the top of Morse's Salon Carré, rising higher than any other copied painting, Correggio's *Mystic Marriage of Saint Catherine of Alexandria with Saint Sebastian* (fig. 82) endearingly represents the newborn Christ. As baby Jesus slips a wedding ring onto Saint Catherine's finger, he reveals himself as the messianic Bridegroom. Christian antitype to the pagan Cleopatra, Saint Catherine of Alexandria was an eloquent defender of persecuted Christians, scorning her profane imperial marriage to become a bride of Christ.[93] While Correggio's painting would seem a particularly poisonous flower of Catholic saint worship, Morse grasped the picture's spiritual message that Saint Paul advocated a simple, domestic understanding of Christian community: "For the husband is the head of the wife, even as Christ is the head of the church" (Ephesians 5:23). Morse also would have seen the symbolic import of the arrows held by Correggio's Saint Sebastian. According to Jedidiah Morse, arrows were metaphors for prayer.[94] Representing the zodiacal sign of Sagittarius, arrows expressed spiritual yearning for earthly transcendence during the darkening season of nature's "death" leading to the winter solstice.[95] Having survived martyrdom by arrows, Sebastian was not only the patron saint of archers but also of plague survivors.[96]

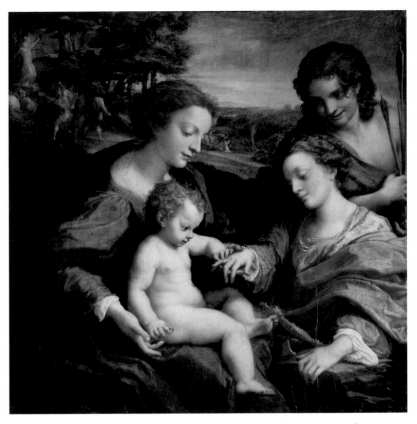

FIG. 82 Correggio (Italian, ca. 1489?–1534). *Mystic Marriage of Saint Catherine of Alexandria with Saint Sebastian*, 1526–27. Oil on wood, 41⅚6 × 40⅜6 in. (105 × 102 cm). Musée du Louvre, Paris

Gallery of the Louvre came to life during a deadly cholera epidemic. From plague-stricken Paris, Morse wrote to Thomas Cole: "It is indeed good to trust in [God], for in the darkest, most lowering moments, there springs up light, as if He intended to heighten our pleasure by the contrast."[97] Morse's ideal, devout beholders for *Gallery of the Louvre* would take moral and spiritual delight in the Creator's complementary laws of contrasts and connections whereby distinctions and bonds mysteriously coexist in a chain of being linking dark and light, poisons and cures. Expressing the sweet honey of divine love, *Gallery of the Louvre* identifies Christian faith with marriage, friendship, and the individual soul's union with the resurrected Christ, the Lamb of God. Pilgrims must prepare themselves "as a bride adorned for

her husband" in order to enter the heavenly "new Jerusalem," where there will be "no need of the sun, neither of the moon," for "the Lamb is the light thereof. And the nations of them which are saved shall walk in the light of it" (Revelation 21:2, 23–24).

In *Gallery of the Louvre*, Morse's Breton peasant woman prepares to walk through a heavenly, triumphal gate crowned by Titian's resurrected Christ. A penitential bride of the Lamb, the woman leans backward to receive the blessing of her betrothed, as Murillo's standing baby Jesus sweetly proffers his emblematic reed cross. *Gallery of the Louvre*'s Breton peasants, descended from the astronomer-shepherds at Christ's manger, bear Morse's hope that temples of art might Christianize America's expanding empire prior to Jerusalem's final, messianic descent.

Unfortunately, Morse's subtle invocation of the Apocalypse could not compete with the far more spectacular New York exhibition of Francis Danby's *Opening of the Sixth Seal* (1828), which attracted large crowds by virtue of its pyrotechnical representation of God's wrathful final judgment against wayward humankind.[98] While garnering praise from the artist-Freemason William Dunlap, a copyist of Benjamin West's large-scale biblical paintings, *Gallery of the Louvre* ultimately appeared to be a Morse-coded cacophony of old master voices for which uninitiated American audiences had little patience.

Notes

1 Patricia Johnston, "Samuel F. B. Morse's *Gallery of the Louvre*: Social Tensions in an Ideal World," in *Seeing High and Low: Representing Social Conflict in American Visual Culture*, ed. Patricia Johnston (Berkeley: University of California Press, 2006), 55–56.

2 David Bjelajac, *Millennial Desire and the Apocalyptic Vision of Washington Allston* (Washington, D.C.: Smithsonian Institution Press, 1988).

3 Paul J. Staiti, *Samuel F. B. Morse* (Cambridge: Cambridge University Press, 1989), 14, 186–89.

4 William J. Danaher, Jr., *The Trinitarian Ethics of Jonathan Edwards* (Louisville, Ky.: Westminster John Knox Press, 2004).

5 George F. Sensabaugh, *Milton in Early America* (Princeton: Princeton University Press, 1964), 169–71.

6 Staiti, *Morse*, 9–10.

7 George Berkeley, *Alciphron or the Minute Philosopher*, ed. T. E. Jessup, vol. 3 in *The Works of George Berkeley*, ed. A. A. Luce and T. E. Jessup (Edinburgh: Thomas Nelson and Sons, 1948), 147–61.

8 Jedidiah Morse and Elijah Parish, *A Compendious History of New England*, 3rd ed. (Charlestown, Mass.: S. Etheridge, 1820), 139.

9 Joseph W. Phillips, *Jedidiah Morse and New England Congregationalism* (New Brunswick, N.J.: Rutgers University Press, 1983), 161–228.

10 Samuel F. B. Morse, *Lectures on the Affinity of Painting with the Other Fine Arts*, ed. Nicolai Cikovsky, Jr. (Columbia: University of Missouri Press, 1983), 58.

11 Ibid., 58, 93–94.

12 Xanthe Brooke and Peter Cherry, *Murillo: Scenes of Childhood* (London: Merrell, 2001), 86–87.

13 Morse, quoted in "Celebration of the Birth Day of Washington at Rome—Feb. 22, 1830," *Daily National Journal* (Washington, D.C.), issue 2032 (June 9, 1830), column C; 19th Century U.S. Newspapers, accessed July 6, 2013, http://infotrac. galegroup.com.proxygw.wrlc.org/itw/informark.

14 Saint Basil, Bishop of Caesarea, "For the Young on How They Might Derive Profit from Hellenic Literature (364 AD)," in James T. Hanrahan, *St. Basil the Great, 329–379: A Life with Excerpts from His Works* (Toronto: Basilian Press, 1979), 58; Saint Basil, Bishop of Caesarea, *An Exhortation of Holye Basilius Magnus to Hys Younge Kynsemen*, trans. Willyam Berker (1557; repr., Early English Books Online: EEBO [Ann Arbor, Mich.: Proquest, 1999–]), image 13, accessed November 29, 2013.

15 Paracelsus, "Preparation of Remedies," in *Paracelsus: Selected Writings*, trans. Norbert Guterman, ed. Jolande Jacobi (Princeton: Princeton University Press, 1988), 95.

16 Allen G. Debus, *The Chemical Philosophy: Paracelsian Science and Medicine in the Sixteenth and Seventeenth Centuries* (1977; repr., Mineola, N.Y.: Dover, 2002), 162, 180–81.

17 Rev. Joseph E. Bellamy, quoted in Sydney E. Ahlstrom, *A Religious History of the American People* (New Haven: Yale University Press, 1972), 408.

18 Daniel Huntington, quoting Morse in Samuel Irenaeus Prime, *The Life of Samuel F. B. Morse: Inventor of the Electro-Magnetic Recording Telegraph* (1875; repr., New York: Arno Press, 1974), 713.

19 Morse to Allston, 1839, quoted in William Kloss, *Samuel F. B. Morse* (New York: Harry N. Abrams in association with the National Museum of American Art, Smithsonian Institution, 1988), 146.

20 Jean Chevalier and Alain Gheerbrant, *Dictionary of Symbols*, trans. John Buchanan-Brown (London: Penguin Books, 1996), s.v. "bee," 78–80.

21 Morse to Allston, 1839, quoted in Kloss, *Morse*, 146.

22 David Bjelajac, *Washington Allston, Secret Societies and the Alchemy of Anglo-American Painting* (Cambridge: Cambridge University Press, 1997); David Bjelajac, "Thomas Cole's *Oxbow* and the American Zion Divided," *American Art* 20 (Spring 2006): 75–80; and David Bjelajac, "Freemasonry, Thomas Cole and American Landscape Painting," *Journal for Research into Freemasonry and Fraternalism* 2 (Spring 2011): 79–108, www.equinoxpub.com/JRFF.

23 James Stevens Curl, *Freemasonry and the Enlightenment: Architecture, Symbols, and Influences* (London: Historical Publications, 2011), 20–21, 121, 271.

24 James Anderson, *The New Book of Constitutions of the Antient and Honourable Fraternity of Free and Accepted Masons* (1738; repr., Whitefish, Mont.: Kessinger Publishing's Rare Mystical Reprints, n.d.), 49–52; and J. W. S. Mitchell, "History of Free Masonry," *Signet and Mirror* 2 (July 1849): 97–106.

25 Staiti, *Morse*, 56, 98, 107, 126–27, 171–76; and Prime, *Morse*, 45, 133–34, 173.

26 Curl, *Freemasonry and the Enlightenment*, 309, 314, 320–21.

27 Stephen Skinner, *Sacred Geometry: Deciphering the Code* (New York: Sterling, 2009), 46, 48; and Ami Ronnberg and Kathleen Martin, eds., *The Book of Symbols: Reflections on Archetypal Images* (Cologne: Taschen, 2010), 228–30.

28 Morse, *Lectures*, 89.

29 Stuart Peterfreund, "Saving the Phenomenon or Saving the Hexameron?: Mosaic Self-Presentation in Newtonian Optics," *Eighteenth Century* 32 (1991): 139–65.

30 Henry Harington, *Symbolon Trisagion; or the Geometrical Analogy of the Catholic Doctrine of Triunity, Consonant to Human Reason and Comprehension Typically Demonstrated by the Natural and Indivisible Triunity of Certain Simultaneous Sounds* (Bath, England: W. Meyler, Grove, 1806), 14–15; and Bjelajac, *Washington Allston, Secret Societies*, 41–42.

31 Morse, *Lectures*, 89.

32 For a Masonic rainbow coupled with an emblem of Noah's ark, see John D. Hamilton, *Material Culture of the American Freemasons* (Lexington, Mass.: Museum of Our National Heritage, 1994), 44, fig. 2.27.

33 Morse, *Lectures*, 89 n.11.

34 Anonymous review in the *Court Gazette*, April 1, 1843, quoted in David Brett, "The Aesthetical Science: George Field and the 'Science of Beauty,'" *Art History* 9 (September 1986): 342.

35 Bjelajac, *Washington Allston, Secret Societies*, 43–59.

36 Steven C. Bullock, *Revolutionary Brotherhood: Freemasonry and the Transformation of the American Social Order, 1730–1840* (Chapel Hill: University of North Carolina Press, 1996), 174–75.

37 Jedidiah Morse, "An Appendix Embracing a Biography of the American Military Officers . . . ," in Jedidiah Morse, *Annals of the American Revolution* (1824; repr., Port Washington, N.Y.: Kennikat Press, 1968), 45.

38 Bjelajac, *Washington Allston, Secret Societies*, 76–80.

39 Bjelajac, "Thomas Cole's *Oxbow* and the American Zion Divided," 75–80; Stephen Van Rensselaer, Jedidiah Morse, et al., "Memorial of the American Board of Commissioners for Foreign Missions," *American Society for Promoting the Civilization and General Improvement of the Indian Tribes*, February 6, 1824, 65–71.

40 Terrence Erdt, *Jonathan Edwards: Art and the Sense of the Heart* (Amherst: University of Massachusetts, 1980), 65–66.

41 Francis Haskell and Nicholas Penny, *Taste and the Antique: The Lure of Classical Sculpture, 1500–1900* (New Haven: Yale University Press, 1981), cat. no. 30, 196–98.

42 Richard E. Spear, *The 'Divine' Guido: Religion, Sex, Money, and Art in the World of Guido Reni* (New Haven: Yale University Press, 1997), 30.

43 Johnston, "Morse's *Gallery of the Louvre*," 43.

44 Dorothy Mackay Quynn, "Art Confiscations of the Napoleonic Wars," *American Historical Review* 50 (April 1945): 456–57.

45 Joshua Reynolds, *Discourses on Art, 1769–90*, ed. Pat Rogers (London: Penguin Books, 1992), 125.

46 Allston, quoted in Jared B. Flagg, *The Life and Letters of Washington Allston* (1892; repr., New York: Benjamin Blom, 1969), 56.

47 Nigel Aston, *Art and Religion in Eighteenth-Century Europe* (London: Reaktion Books, 2009), 62.

48 Robert Graves, *The Greek Myths*, vol. 2 (London: Penguin Books, 1960), 110–12.

49 John Cotton, *A Brief Exposition of the Whole Book of Canticles, or Song of Solomon* (London: Philip Nevil, 1642), 59–61.

50 Morse, *Lectures*, 58.

51 Jedidiah Morse, *The American Geography* (1789; repr., New York: Arno Press and the New York Times, 1970), 524.

52 Herodotus, *Histories*, book 1:204–14, in *The Landmark Herodotus: The Histories*, trans. Andrea L. Purvis, ed. Robert B. Strassler (New York: Anchor Books, 2009), 109–14.

53 Robert W. Berger, "Rubens's 'Queen Tomyris with the Head of Cyrus,'" *Museum of Fine Arts Bulletin* (Boston) 77 (1979): 4–35, accessed July 7, 2013, http://www.jstor.org/stable/4171623.

54 Robert Graves, *The Greek Myths*, vol. 1 (London: Penguin Books, 1960), 85.

55 Morse, *Lectures*, 63–65.

56 Hans Biedermann, *Dictionary of Symbolism: Cultural Icons and the Meanings behind Them*, trans. James Hulbert (New York: Meridian Books, 1994), s.v. "lily," 207–8.

57 Edgar Wind, *Pagan Mysteries in the Renaissance*, rev. ed. (New York: W. W. Norton, 1968), 249–51; Morse, *Lectures*, 63–65; and J. E. Cirlot, *A Dictionary of Symbols*, trans. Jack Sage, 2nd ed. (1971; repr., Mineola, N.Y.: Dover, 2002), s.v. "Diana" and "Janus," 81, 161–62.

58 Richard J. Moss, The *Life of Jedidiah Morse: A Station of Peculiar Exposure* (Knoxville: University of Tennessee Press, 1995), 55–56, 84–107.

59 Jedidiah Morse, preface to *Panoplist* 1 (1805), quoted in James King Morse, *Jedidiah Morse: A Champion of New England Orthodoxy* (1939; repr., New York: AMS Press, 1967), 77.

60 William Ellery Channing, quoted in Daniel Walker Howe, *The Unitarian Conscience: Harvard Moral Philosophy, 1805–1861* (Cambridge, Mass.: Harvard University Press, 1970), 42.

61 Kloss, *Morse*, 129; Haskell and Penny, *Taste and the Antique*, cat. no. 81, pp. 314–15, fig. 166.

62 Ovid, *Fasti*, trans. Anne and Peter Wiseman (Oxford: Oxford University Press, 2011), book 3:59.

63 Ovid, *Metamorphoses*, trans. A. D. Melville, ed. E. J. Kenney (New York: Oxford University Press, 1986), book 9:207. On the Hercules constellation, see book 1:315 of Marcus Manilius, *Astronomica*, trans. G. P. Goold (Cambridge, Mass.: Harvard University Press, 1977), 28–29.

64 Barbara Hochstetler Meyer, "Marguerite de Navarre and the Androgynous Portrait of François Ier," *Renaissance Quarterly* 48 (Summer 1995): 299–300, accessed July 1, 2013, http://www.jstor.org/stable/2863067.

65 Janet Cox-Rearick, "Imagining the Renaissance: The Nineteenth-Century Cult of François I as Patron of Art," *Renaissance Quarterly* 50 (Spring 1997): 207–50, accessed August 1, 2013, http://www.jstor.org/stable/3039334.

66 Morse, *American Geography*, 22.

67 Andrew McClellan, *Inventing the Louvre: Art, Politics, and the Origins of the Modern Museum in Eighteenth-Century Paris* (Cambridge: Cambridge University Press, 1994), 168, 181, fig. 62; Nathaniel B. Smith, "The Idea of the French Hexagon," *French Historical Studies* 6 (Autumn 1969): 139–55, accessed August 1, 2013, http://www.jstor.org/stable/286162.

68 Honoré de Balzac, *The Chouans*, trans. Marion Ayton Crawford (1829; New York: Penguin Books, 1988), 52–53.

69 David Tatham, "Samuel F. B. Morse's *Gallery of the Louvre*: The Figures in the Foreground," *American Art Journal* 13 (Autumn 1981): 40, accessed July 13, 2013, http://www.jstor.org/stable/1594272.

70 Ibid., 44.

71 Prime, *Morse*, 231.

72 Francis Bacon, *New Atlantis*, in *Francis Bacon: The Major Works*, ed. Brian Vickers (Oxford: Oxford University Press, 2002), 467.

73 Berkeley, quoted in David Bjelajac, *American Art: A Cultural History* (Upper Saddle River, N.J.: Prentice Hall, 2005), 103.

74 James A. Williamson, *The Cabot Voyages and Bristol Discovery under Henry VII* (Cambridge: Cambridge University Press for the Hakluyt Society, 1962), 58.

75 Barbara W. Tuchman, *Bible and Sword: England and Palestine from the Bronze Age to Balfour* (New York: Funk and Wagnalls, 1956), 1–3.

76 John C. Shields, *The American Aeneas: Classical Origins of the American Self* (Knoxville: University of Tennessee Press, 2001).

77 Duane W. Roller, *Cleopatra: A Biography* (Oxford: Oxford University Press, 2010), 84.

78 George Berkeley, *Siris: A Chain of Philosophical Reflexions and Inquiries Concerning the Virtues of Tar Water* and "A Second Letter to Thomas Prior," ed. T. E. Jessup, vol. 5 in *Works of George Berkeley*, 1–164.

79 Berkeley, "Second Letter to Thomas Prior," 185 n.1; and G. S. Rousseau and Marjorie Hope Nicolson, "Praxis 1: Bishop Berkeley and Tar-Water," in G. S. Rousseau, *Enlightenment Borders: Pre- and Post-Modern Discourses: Medical and Scientific* (Manchester, England: Manchester University Press, 1991), 152.

80 David Bjelajac, "Mercurial Pigments and the Alchemy of John Singleton Copley's *Watson and the Shark*," in *Analyzing Art and Aesthetics*, ed. Anne C. Goodyear and Margaret Weitekamp (Washington, D.C.: Smithsonian Institution Scholarly Press, 2013), 151–59.

81 Thomas Ruys Smith, *River of Dreams: Imagining the Mississippi before Mark Twain* (Baton Rouge: Louisiana State University Press, 2007).

82 Morse, *American Geography*, 469.

83 Bjelajac, *American Art*, 124–27, fig. 4.18.

84 Timothy Dwight, *The Conquest of Canaan* (1788; repr., Westport, Conn.: Greenwood Press, 1970).

85 Morse, *American Geography*, 1.

86 Ibid., 6.

87 Mantle Fielding, "David Edwin, Engraver," *Pennsylvania Magazine of History and Biography* 29 (1905): 322–23, accessed October 16, 2013, http://www.jstor.org/stable/20085296; Hamilton, *Material Culture of the American Freemasons*, 96, 112, fig. 4.22; and Barbara Franco, *Bespangled, Painted and Embroidered: Decorated Masonic Aprons in America, 1790–1850* (Lexington, Mass.: Museum of Our National Heritage, 1980), 18, 85.

88 Matilde Battistini, *Astrology, Magic, and Alchemy in Art*, trans. Rosanna M. Giammanco Frongia (Los Angeles: J. Paul Getty Museum, 2004), 39–40.

89 Ibid., 41–43.

90 Ovid, *Metamorphoses*, book 2:847–75, 49–50.

91 James Hall, *Dictionary of Subjects and Symbols in Art* (Boulder, Colo.: Westview Press, 2008), s.v. "Rape of Europa," 267.

92 Morse, *Lectures*, 58.

93 David Hugh Farmer, *The Oxford Dictionary of Saints*, 3rd ed. (New York: Oxford University Press, 1992), s.v. "Catherine of Alexandria," 88–89.

94 Morse and Parish, *Compendious History of New England*, 133.

95 Battistini, *Astrology, Magic, and Alchemy in Art*, 56–57.

96 Farmer, *Oxford Dictionary of Saints*, s.v. "Sebastian," 429.

97 Morse to Thomas Cole, August 25, 1832, quoted in Staiti, *Morse*, 191.

98 Staiti, *Morse*, 199–201.

The Forest of the Old Masters: The Chiaroscuro of American Places

ALEXANDER NEMEROV

WHY IS IT that certain American places have the emotional intensity of old master paintings? The American places I have in mind do not literally look like paintings by Rembrandt, but they sometimes have the gravity and pathos, the infinite depth and unaccountable lightness, of profound pictures. If one could fall through the darkness of a Rembrandt painting forever, descending through level upon level without reaching an end, one might do so walking down Stratton Street in Gettysburg, Pennsylvania, for example—the street down which Sergeant Amos Humiston of the 154th New York ran before being shot on the first day of the battle there.[1] In the vicinity where Humiston died holding an ambrotype of his three young children, as I walk that place now, the darkness seems to travel directly through objects, the cricket hum of dusk to penetrate metal mailboxes. The evening sweeps across the road, lit by fireflies and scented with fertilizer, passing through my body as if it is not there.

By contrast, where is the pathos of nineteenth-century American painting? Too often I look for it in vain. The windswept cloud, the deer drinking, and the boy dipping his paddle in the river—such scenes are only charming. The ruffled surface of the lake, the moss-covered boulder, and the leafy glade lack the scudding chaos of a more devastating view of the world. The manacled slave and dead soldier in other American paintings allude to calamities, yes, but too often without the permeating quiet of real sorrow. Even when these paintings depict specific places, and even when they do so according to old master

prototypes, the effect is pleasant only, even when one discovers the compelling historical motivations for the mildness.[2] Asher Brown Durand's *Landscape—Composition: In the Catskills* is an idyll, a delight (fig. 83), but where are the pockets of darkness and the startling blasts of light in such paintings that might make them answer to the pathos of American experience, to enslavement, war, and a thousand other horrors, not to mention the most thrilling pleasures—buoyant laughter, for example—people felt then? To put it another way, why do I feel that the depths and exhilarations of nineteenth-century American life are now to be felt not in the art but in the actual *places* where events occurred, at the specific spots where people (real or imagined) smiled, suffered, or loved?

Samuel F. B. Morse's *Gallery of the Louvre* (plate 1), one of the most ambitious American paintings of the nineteenth century, offers a way to consider this question. Morse's painting portrays some thirty-eight works of the old masters and should therefore deliver a concentrated pathos of a kind that few American pictures could match. The old masters, after all, were never wrong about suffering, as the poet W. H. Auden would later put it.[3] But *Gallery of the Louvre* does not achieve this emotional intensity, and the reasons it fails to do so offer a case history of the failure of American art to portray—to internalize and make its own—the pathos-filled light and shade of the old masters.

Morse did not succeed with *Gallery of the Louvre*—that is well known. Living in Paris in fall 1831, he had

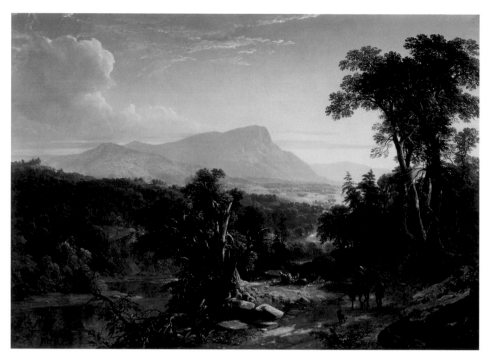

FIG. 83 Asher Brown Durand (American, 1796–1886). *Landscape—Composition: In the Catskills*, 1848. Oil on canvas, 30 × 42¼ in. (76.2 × 107.3 cm). Museum purchase with funds provided by the Gerald and Inez Grant Parker Foundation, The San Diego Museum of Art, 1974.72

conceived the idea of making a grand picture portraying old master paintings at the Louvre, a picture that he could then display back in the United States for the edification of his fellow citizens and at a profit for himself. Working "at a grueling pace," as Paul Staiti writes, Morse painted miniature versions of pictures by Leonardo, Raphael, Rembrandt, and others, arranging them in an imagined hanging in the Louvre's Salon Carré (no such display of works likely ever existed).[4] Despite a cholera epidemic sweeping through the city, Morse kept at the task and completed his monumental canvas (measuring some six by nine feet) in August 1833. When he displayed it on Broadway in New York that October, however, the painting was a critical and commercial failure: few came to see it. The following August, a bitterly disappointed Morse sold *Gallery of the Louvre* to a private collector, and soon he abandoned painting altogether, taking up experiments in electromagnetism. His invention of the telegraph in 1844 made him famous.

The failure of *Gallery of the Louvre* can be accounted for in two ways: one accurate and familiar to historians of American art; the second less familiar and even strange but perhaps equally accurate. Both concern the relation of the old masters to American experience. The first explanation, the correct and familiar one, goes as follows. Showing genteel figures politely discussing and copying the fine European pictures around them, Morse's painting depicts a society of erudition and discernment at a moment when the United States had become increasingly intolerant of such elitism.[5] The Second Great Awakening, the industrial and market revolutions, and other momentous social transformations of the years around 1830 were making the United States a very different place than it had been.

Morse, front and center in his own painting, where he comments on a young woman's picture (fig. 68), was out of touch with a newly populist America.[6] In contrast to his social and religious conservatism—the artist was "raised on Calvinist

doctrines of the elect and believ[ed] in Federalist notions of social order and elite rule," writes Staiti—the ex-soldier Andrew Jackson, president from 1829 to 1837, oversaw an increasing shift to the common man in American politics.[7] Amid such clamor, Morse's graceful calm was bound to fall on deaf ears. Against the moving spectacle of a barge of flour traveling smoothly down the Erie Canal, Guido Reni stood no chance.[8] The telegraph would be Morse's great address to the democratic multitude. Claude Lorrain and Bartolomé Estebán Murillo, by contrast, did not speak to Americans.

But here is the second explanation. Claude and Murillo—or any of the old masters—*could* have talked to Americans of the 1830s if only their work had not been rendered of so little consequence by Morse himself. At first this does not make any sense. Was not Morse the champion of the old masters—the one who braved the cholera epidemic and who for nearly two years broke off from his grand painting only to eat and sleep in order to bring the wonders of their art to his fellow Americans? Moreover, was he not the *only* person with such an ambitious aim? How then could he be the one who thought their work mattered so little?

The reason is this. Morse made the old masters into a sign of refinement when they might as easily have been made into a sign of broad American experience as it was then—the hardscrabble life of the docks, the gloom of the forests, the mercurial fortunes of the silk-clad, and the slaughter rags of the poor. Instead of quarantining the old masters as emblems of decorous behavior and cultural literacy, *Gallery of the Louvre* might have made the emotional range of the great old pictures answer to the light and dark of lived experience in the 1830s. Would not the wisdom of these paintings—with their miracles and lamentations, their blessed births and their cruelties brought down on the heads of the helpless—be every bit the stuff to portray the squalor and beauty of Morse's era?

The failure is all the more striking because Morse had started his painting career some twenty years

FIG. 84 Samuel F. B. Morse. *Dying Hercules*, 1812–13. Oil on canvas, 96¼ × 78⅛ in. (239.4 × 198.3 cm). Gift of the artist, Yale University Art Gallery, 1866.3

earlier with the attitude that the old masters *could* be a way of showing the lived experience of his time. His *Dying Hercules* (fig. 84), which he painted in 1812–13 while in London as a twenty-one-year-old student of Washington Allston, is a crude but ambitious adaptation of Michelangelo and the central figure of the famous Hellenistic statue group, *Laocoön*. More than that, the vast eight-by-six-and-a-half-foot painting strives to connect old master art to contemporary experience. It does so partly by allegory: Hercules, struggling with the poisoned cloak of Nessus, may be an emblem of the United States during the War of 1812, according to Staiti.[9] But more

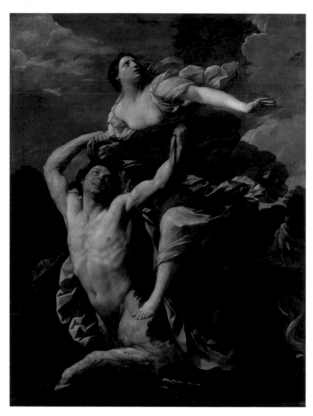

FIG. 85 Guido Reni (Italian, 1575–1642). *Deianeira Abducted by the Centaur Nessus*, 1617–21. Oil on canvas, 37⅟₁₆ × 29¹⁵⁄₁₆ in. (94.1 × 75.9 cm). Musée du Louvre, Paris, inv. 537

fundamentally, the lurid color, violent foreshorten-ing, and strange diagrammatic segmentation of the hero's body—the trilobite musculature of the abdomen, the X-ray of the left shinbone and toes—conspire to make the work into something more than allegory, something we could call *sensuous immedi-acy*, or at least a very good attempt at it. Hercules's agony is neither the shrill torture of an actual living soul nor an entirely persuasive emotional rendering of such pain but an exploitation of the young artist's awkwardness for all that it is worth, so that the power of the painting arises from the student crudity of each gesticulation, which somehow makes a slow and darkened map of suffering. The young Morse ends up persuading us of the hero's pain by portray-ing, mark for mark, the pains he took as an artist.

All that is gone, or almost gone, in the suavity of *Gallery of the Louvre*. There, twenty years later, on a

canvas basically the same size (imagine the *Dying Hercules* turned on its side, and you would have a canvas of nearly the same dimensions as *Gallery of the Louvre*), the flaming anguish of the larger-than-life hero has become the untroubled light of the Salon Carré. Almost all that remains of the *Dying Hercules* is the small copy at upper right of Guido Reni's great painting *Deianeira Abducted by the Centaur Nessus* (fig. 85), showing Hercules's wife and the centaur who has taken her away. Big has become small; passion and struggle have become the mildness of a mere cultural literacy: the old masters have been belittled. Morse's reduction of the old masters—no matter how it relates to the sheer practical consider-ations of his project (how to fit as many of these paintings as possible into one grand picture) and to the pictorial conventions of the *Kunstkammer* tradition he emulated—says a lot about his attempt to diminish, to scale down, the potential thunder and energy of their art and, by implication, its relation to American life.

Maybe that is why the painting has the quality of a parlor game. Perhaps because of the separate small copy he made for a friend of Titian's *Francis I* (one of the paintings shown in *Gallery of the Louvre*; fig. 11), all of the small pictures in Morse's grand painting have the quality of playing cards. As the monarch of France looks like a king drawn from the deck, so the other pictures in Morse's painting take on the quality of chits, counters, colorful playthings. Smallness and seriousness sometimes go together, but here they do not. The paintings have become markers in a game of cultural pretense. Instead of the flexing prehistoric chest and stomach of Hercules, we have only the segmentation of neat little frames, spread across the picture one by one, the torsion of muscular effort having become the play pieces of a refined relaxation. The anguished contraction of muscles, in their "hot red coloration,"[10] becomes the mellow glow of the Grande Galerie receding in perspective, promising more cultural enjoyment.

Even the depicted figures within their frames are at ease. If one looks at them closely, Morse's

rendition of Leonardo's *Mona Lisa*, Peter Paul Rubens's *Portrait of Suzanne Fourment*, and Raphael's Madonna in *La Belle Jardinière* do not have the same expressions they have in the original paintings. Morse's versions are cheery and benevolent, as if they succumb—happily, even—to the wan atmosphere of an enchanted land that has banished all struggle and strain. Leonardo's and Rubens's young women peer from their frames with kindly looks, as if with beneficent approval of the mild cultural enjoyment for which their paintings have become an occasion. Likewise, Raphael's Virgin looks down from her position higher on the wall as if to sanction the modesty and chastity of the cultural attainments she sees below her. There are no longer any herculean efforts in this picture that records the great achievements of the great painters, not even the herculean effort of Morse himself in making the picture. And when his grand attraction came to New York, it did not present an awe-inspiring spectacle the likes of which no one had ever seen, as another colossus (King Kong) was to do before a crowd of thousands in that city exactly one hundred years later. Instead, by the artist's own design, *Gallery of the Louvre* sat sedately in the most untroubled calm, and it did so, consequently, before an average daily audience of about a dozen people.[11]

The old masters themselves were not then at fault. There was nothing innate in their art that made it out of touch with Jacksonian America. It was instead Morse's decision to present their work so narrowly that caused the public's lack of interest. At first this seems unfair. Few Americans then could have called for a wise public art that would answer to lived experience, and Morse was not inclined to be such a person, for reasons of temperament and social background.[12] Only Ralph Waldo Emerson could see the "frescoes of Angelo" and "a squirrel leaping from bough to bough" as sights equally "beautiful" and "self-sufficing," each vision helping us to see the "immensity of the world" and "the opulence of human nature, which can run out to infinitude in any direction."[13] And even then, Emerson regarded these two visions only in parallel and not blended

together, as he would have needed to do in order to claim that the old masters were a medium for apprehending American experience. But it is still possible to be disappointed with Morse for missing his chance with *Gallery of the Louvre*. He, too, could have made the art of the past resonate with contemporary American experience. Arguably, he could have done so better than anyone, since his picture was the most extensive effort any American made in those years to imagine the old European paintings in relation to the United States of the 1830s.

It is even possible to think that the public indifference to *Gallery of the Louvre* was a form of ringing praise for the old masters, manifest as resentment that pictures of such feeling should be used in such a small-minded fashion. Even if he knew only remotely or hardly at all of such pictures before seeing versions of them in *Gallery of the Louvre*, a viewer could sense, examining his disenchantment in front of the picture (is that all there is?), that something more must be out there, even *is* out there—that these playing cards are a deceitful trick, that they are a full deck, yes, but of frauds, that something has been worked on a spectator regarded as all too gullible, as a rube or rustic, whom Morse's painting is counting on to be beguiled by this show of dexterity. In fact, the real world—and the capacity of certain works of art to portray it, forever, immediately, with power—did exist elsewhere, or so *Gallery of the Louvre* might have inadvertently announced. The big mistake Morse's painting makes is to give the viewer a clue that this more urgent world of art and life does exist—perhaps everywhere except in Morse's painting itself. The hall of facsimiles, meant to forestall further inquiry and to be a summation of all the old masters can and should be to Americans, prompts the earnest and even urgent question: if this be passion in small, fitted to such a narrow purpose, what must passion be like in an art that speaks largely to American life?

Despite its limitations, *Gallery of the Louvre* hints at an answer, in the form of Morse's friend James Fenimore Cooper. The novelist, newly famous for

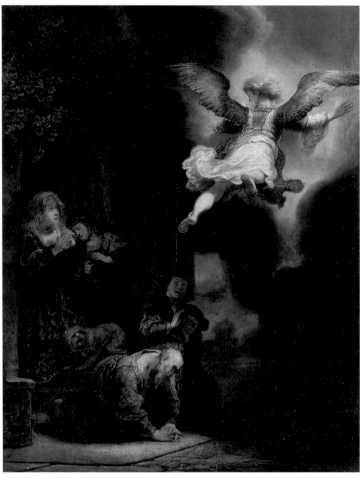

FIG. 86 Rembrandt van Rijn (Dutch, 1606–1669). *The Angel Leaving the Family of Tobias*, 1637. Oil on wood, 26¾ × 20½ in. (68 × 52 cm). Musée du Louvre, Paris, inv. 1736

to be similar.[15] But in his own work, Cooper did not belittle the old masters as Morse did, and his relation to their art is more dynamic.

Look again at Cooper in the painting. His gesture is about more than polite instruction; it is also about the relation between old master painting and his fiction, specifically between the light-dark schemes of these paintings and the "chiaroscuro" of his writing, as it has been termed by the literary historian Donald A. Ringe.[16] This chiaroscuro is an element of what D. H. Lawrence praised in 1925 as Cooper's pictorial imagination—namely, his capacity to make "Pictures! Some of the loveliest, most glamorous pictures in all literature."[17] And it is part of what Honoré de Balzac meant, in 1841, when he commended Cooper's "series of marvelous pictures" that afford "a school where the literary landscape painter should study."[18] Ringe, identifying the "arrangement of light and shadow" as an "important painterly technique" in Cooper's work,[19] invites us to think of *The Leatherstocking Tales* and the old masters as somehow rhymed together, as if around the chattering stream and lightning-shattered pine there gathered the thick and throaty and all but volumetric darkness of Rembrandt.

Consider one of the most famous sequences in Cooper's fiction—the one that takes place in the cave at Glens Falls in *The Last of the Mohicans*. The cave is the hiding place of Hawk-eye, Uncas, Chingachgook, Major Heyward, the preacher David Gamut, and the two daughters of Colonel Munro, Cora and Alice, as they make their perilous way to Fort William Henry. In vividly pictorial terms, Cooper describes the party's journey via canoe to the cave at night, giving their views of a darkened forest "of fantastic limbs and ragged tree-tops, which were, here and there, dimly painted against the starry zenith." Amid this "shadowed obscurity," behind the canoe, "the curvature of the banks soon bounded the view, by the same dark and wooded outline."[20] The scene is "painted," "bounded," and "outline[d]," all in accord with what Ringe calls Cooper's penchant for describing a view "as if it were literally a painting."[21]

novels such as *The Last of the Mohicans* (1826), appears in the painting standing next to his wife, Susan DeLancey Cooper, as they comment on the copying work of their daughter Susan, seated at her easel before them (fig. 72).[14] Cooper, it is true, appears at first as only another mild and genteel connoisseur. We can imagine him holding forth with complacent erudition (note his pointing hand) as he speaks about the old master pictures he loved to search for and collect with Morse. The two had known each other since 1823, had met up while abroad in 1830 in Florence and again the following year in Paris, and we could suppose the artistic tastes of the two politically conservative friends

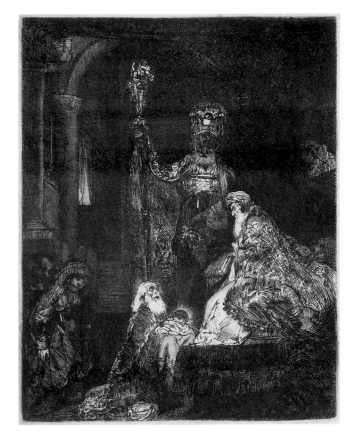

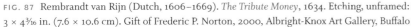

FIG. 87 Rembrandt van Rijn (Dutch, 1606–1669). *The Tribute Money*, 1634. Etching, unframed: 3 × 4³⁄₁₆ in. (7.6 × 10.6 cm). Gift of Frederic P. Norton, 2000, Albright-Knox Art Gallery, Buffalo

FIG. 88 Rembrandt van Rijn (Dutch, 1606–1669). *The Presentation in the Temple in the Dark Manner*, ca. 1654. Etching and drypoint, 8¼ × 6³⁄₈ in. (20.9 × 16.2 cm). Gift of Felix M. Warburg and his family, 1941. The Metropolitan Museum of Art, New York, 41.1.16. Photo © The Metropolitan Museum of Art. Image source: Art Resource, NY

Moreover, it is not any painting but specifically a Rembrandt-type darkness that is most striking in the Glens Falls scene. Again, Cooper's role in *Gallery of the Louvre* provides a clue. He stands close to Rembrandt's *The Angel Leaving the Family of Tobias* (fig. 86), the painting just to the side of Susan Fenimore Cooper's easel, between that easel and the woman wearing the tall pointed hat. Cooper admired this painting by Rembrandt and commissioned a copy of it from Morse. He also owned a Rembrandt print, *The Tribute Money*, that he had purchased from Morse and would offer to sell back to him in 1849 (fig. 87). Morse, in the fourth and last of his *Lectures on the Affinity of Painting with the Other Fine Arts*, delivered on April 12, 1826—lectures he had been preparing at least since November 1825, when Cooper was still at work on *The Last of the Mohicans*— discussed three engravings copied after Rembrandt, including *The Holy Family* and *The Presentation in the*

Temple in the Dark Manner (fig. 88).[22] Still earlier, ever since they first met in New York in 1823, the year before Cooper got the idea for his novel, the two men likely had talked about art and probably pored over Morse's collection of prints that he would use in his lectures, including the Rembrandts.

In *The Deerslayer*, published in 1841, Cooper describes the "dark Rembrandt-looking hemlocks" of a forest,[23] and perhaps the chiaroscuro in *The Last of the Mohicans* is the same. In the night at Glens Falls, Hawk-eye disappears into the "impenetrable darkness." That same night, Hawk-eye, Uncas, and Chingachgook "disappeared in succession, seeming to vanish against the dark face of a perpendicular rock." Slightly earlier that evening, as the canoe moves down the river, in "the thickening gloom which now lay like a dark barrier along the margin of the stream," Heyward notices "a cluster of black objects, collected at a spot where the high bank

threw a deeper shadow than usual on the dark waters." This dark is so dark, Hawk-eye says, that "an owl's eyes would be blinded by the darkness of such a hole," which turns out to be a cave. Intermittent dazzles of light, as in *The Angel Leaving the Family of Tobias* and *The Tribute Money*, are equally Rembrandtesque in the Glens Falls sequence—as when Hawk-eye holds "a blazing knot of pine" at "the farther extremity of [the] narrow, deep cavern."[24]

The angel in Rembrandt's *The Angel Leaving the Family of Tobias* suggests another old master effect in Cooper's Glens Falls—severely foreshortened figures that dangle, hang, and peer from above. Heyward and Hawk-eye, looking upward from the cave (situated at midlevel between the upper and lower cascades of the falls), see a Huron brave "floating over the green edge of the [water]fall" above them in the dawn light. The warrior tries to grasp a stump of vegetation at the crest of the fall and from that point to attack them, but he is whirled away at the last moment by the current. At that moment, he "appeared to rise into the air, with uplifted arms, and starting eye-balls, and fell, with a sullen plunge, into that deep and yawning abyss over which he hovered." Slightly later in the fight, another Huron warrior, shot in the upmost branches of the tree in which he had been hiding, "was seen swinging in the wind . . . grasp[ing] a ragged and naked branch of the tree. . . . dangling between heaven and earth."[25] Rembrandt's angel alike hangs in the air, as if to affirm the effects Cooper had already begun creating the previous decade.

Maybe he had a source for doing so, not pictures by the old masters but a painting meaningfully derived from their art. Morse's *Dying Hercules* also evokes these pained figures at the falls. Morse had taken the painting back with him to the United States when he returned in 1815 and exhibited it in Boston that year and in Philadelphia in 1816 but had never found a buyer for it.[26] It remained in his possession during his lifetime, and Cooper would have seen it in New York in the early 1820s. Consider the fate of Cooper's Huron flowing over the falls. He "struggled powerfully to gain the point of safety"

and was "already stretching forth an arm to meet the grasp of his companions" but then "appeared to rise into the air, with uplifted arms, and starting eye-balls," as "a single, wild, despairing shriek rose from the cavern."[27]

Or consider the second Huron, the one hanging mortally wounded from the bough of the tree in those "few moments of vain struggling . . . hands clenched in desperation." Eyeing the sufferer, the humanitarian Heyward "turn[ed] away his eyes in horror from the spectacle of a fellow-creature in such awful jeopardy."[28] Although the match between these passages and Morse's *Dying Hercules* is far from exact—and though indeed one would not expect it to be exact, for it is not plausible to think of Cooper deliberately basing scenes on a painting, stroke for stroke, sentence for sentence—the resemblance is near enough to indicate that Morse's first old masterly painting, or something like it, might be a basis for Cooper's strenuous wilderness chiaroscuro.

The key word here is *invention*. *Gallery of the Louvre* shows Cooper's inventiveness, his way of adapting the old masters to American scenes. It does so, however, not in the literal figure of Cooper himself, prim in his educational role, but in the painter at lower left, in the vicinity of the novelist and his family (fig. 89). Shown along the same axis as Cooper—the base of the wall connects them—this young man in a red turban may be Richard West Habersham, whom the art historian David Tatham identifies as "a painter from Georgia who shared rooms with Morse in Paris in 1832" and "an intimate of the Coopers."[29] But we can also regard him, there in proximity to Cooper, as a surrogate depiction of the word-painter himself, now removed from his persona as polite cultural instructor and given a much more heroic and solitary guise as an individual creator.

This young man is at work on a landscape (on his canvas, a waterfall flows from a smooth mountain lake just below his right hand). The picture corresponds to none of the paintings we can see in the Salon Carré. He is making an original picture, drawn

from the wall of sources before him. Accordingly, the painter exhibits an active, engaged relation to the dark picture on his easel. His weight resting on the right leg, just the right knee really, so that the sole of the right shoe appears, he assumes the unconsciously awkward stance of a person absorbed in making his work. For such a solitary creator, the array of pictures before him—not just landscapes, but all of them— amounts to a range of inspiration rather than a source to copy. Cooper's chiaroscuro is likewise an invention drawn from a gallery of sources.

Even so, the invention takes place in an atmosphere of copying. This is because copying artifacts from Europe and turning them into American inven-

tions was a method of the times. Cooper is alleged to have begun his writing career by deciding to emulate Sir Walter Scott's extremely successful Waverley novels, as though such emulation were easy. "Madly reasoning" that he could match Scott, Cooper "launched his own career in the expectation that it would solve all his financial ills," according to his biographer.[30] His forest chiaroscuro may have been a similarly brash borrowing. His inventive copying likewise calls to mind the American businessman Francis Cabot Lowell, who, in Manchester, England, just before the War of 1812, memorized the technology of the power looms he saw there. When he returned, he and his master mechanic, Paul

Moody, were able to fashion their own operational water-powered loom in Waltham, Massachusetts, in 1814, inaugurating the large-scale cotton textile industry in the United States.[31] Yankee ingenuity was one and the same with the perfect copy; the perfect copy, to put it another way, became an original when inventively adapted to a new situation. Susan DeLancey Cooper referred to Rembrandt's *The Angel Leaving the Family of Tobias* as "the steamboat," alluding to Robert Fulton's invention of the commercial steamboat in the first years of the nineteenth century. (The wings of Rembrandt's angel reminded her of a steamboat's churning side wheels.)[32] If Rembrandt was a pictorial inventor, so was the American novelist who copied from Rembrandt in painting his scenes.

There was an urgent cultural need for such invention. This need had to do not with the paucity of American arts and letters in the 1820s—the relative deficiency in cultural attainment that Morse, Cooper, and other culturally minded Americans felt at the time—nor with the emptiness of American places but rather with some combination of the two. It was a need to make the American arts answer to locations that already in the 1820s seemed to be not only empty spots, discouragingly overgrown and inelegant, but also the location of swarming historical associations both real and imaginary. Such places needed descriptions that would match their emotional power, stroke for darkened stroke. At Glens Falls, on an upstate New York trip in 1824 in company with several English travelers, Cooper got the idea to write a novel with a key scene set at the cave there.[33] Surveying this impressive yet blank place, crossed by a footbridge directly above it, and with the mills and other businesses of burgeoning Glens Falls all around it, Cooper probably felt acutely the problem of how to give it mysterious life.

The old masters, accordingly, might have supplied him with a machinery for making light and dark, a factory that could stream out chiaroscuro of the highest quality by the yard. In that place of industry, Cooper had his own mechanical invention near at

hand, his own source of commercial prosperity. So from a warehouse of splendor, for a sensibility so attuned, there would be a limitless supply of that profundity in such sharp demand when all there was in the American scene were some trees, some rocks, and a few holes in the ground. With their dark and tragic pictures of significant human actions and compelling human fates, the old masters offered to a nascent literary and artistic culture a vivid example of what profound emotion might look like. Their works were a starter kit of gravitas, pathos in a can, as if sprinkling some of that heroic darkness and those flecks of light would transform even the most inchoate and disappointingly blobby American scene from just patches of trees and shrubs, with here and there a human association, into a rich, time-smoked black on black, a patina of shadows lit with crepuscular or blazing glows, that consequently would have, made to order, the infinite depth of real art.

Is such gravity always absent in American nineteenth-century painting? Not necessarily. Consider John Ferguson Weir's *The Gun Foundry* (fig. 90), a picture that revises *Gallery of the Louvre*, acknowledging the earlier painting's failure to make proper use of the old masters. Painted between 1864 and 1866, *The Gun Foundry* shows the great munitions factory in Cold Spring, New York, across the Hudson from West Point, where Weir, born in 1841, grew up as the son of the accomplished artist and West Point art professor Robert Walter Weir. The younger Weir's large work—a multifigure composition measuring roughly four by five feet—shows a team of workers casting a Parrott gun, a high-performance cannon invented by Cold Spring resident Robert Parker Parrott. The foundry at Cold Spring produced some three thousand during the war.

The action in Weir's painting can be made out in detail. "A huge crucible of molten metal has been swung into place, held by a heavy chain supported by a timber crane," writes the art historian Betsy Fahlman. "Four men at a windlass struggle to lower it, while another helps steady it with a guide chain. Six more work to tip the heavy cauldron to pour

FIG. 90 John Ferguson Weir (American, 1841–1926). *The Gun Foundry*, 1866. Oil on canvas, 46½ × 62 in. (118.1 × 157.4 cm). Putnam History Museum, Cold Spring, New York

the spluttering and hissing thick molten iron in the mold," lighting up the darkened interior of the foundry.[34] To the far right, solemnly watching the event, are Parrott and his wife, Mary Kemble Parrott (the leftmost couple in the group); a Union officer and a woman in a red dress (possibly the Cold Spring native General Gouverneur Kemble Warren and his wife, Emily Chase Warren); and, seated next to them, an older man, Warren's namesake, Gouverneur Kemble, who started the foundry back in 1818.

Weir's painting, despite its markedly different subject, bears an oblique but powerful relation to *Gallery of the Louvre*. The young artist's most ambitious painting before *The Gun Foundry* had been *An Artist's Studio*, completed in January 1864, a depiction of his father, Robert, at work in the family's West Point home (fig. 91). *An Artist's Studio* shows

the elder Weir seated at a desk to one side of a large easel displaying his painting *Taking the Veil* and also includes several paintings on the walls, notably at right, as well as a painted sketch at left identified by Fahlman as a copy after Rembrandt's *Christ Preaching*. Calling *An Artist's Studio* "a personal and native version of Samuel Morse's *Gallery of the Louvre*," Fahlman perhaps goes too far, but the link between Morse and the Weir family is difficult to miss. Robert Weir had been a young faculty member at the National Academy of Design founded by Morse in 1826, and in 1833 West Point had considered hiring Morse as a drawing instructor before eventually settling the following year on Weir.[35]

Moreover, the young John Ferguson Weir would have known about Morse not only from his father's experience but because of Morse's summer home,

FIG. 91 John Ferguson Weir (American, 1841–1926). *An Artist's Studio*, 1864. Oil on canvas, 25½ × 30½ in. (64.7 × 77.4 cm). Gift of Jo Ann and Julian Ganz, Jr., Los Angeles County Museum of Art, M.86.307

Locust Grove, designed by Alexander Jackson Davis in 1847 and located twenty-six miles up the Hudson in Poughkeepsie.[36] When Weir himself became an art professor and the first dean of Yale's new School of Art in 1869, it made sense that Morse's reputation followed him there as well. Morse, a member of the Yale class of 1810, had sought to promote the arts even back then, and as the young Weir started his professorship, according to Fahlman, he "was carrying on the ambitious cultural work exemplified by Morse's *Gallery of the Louvre*."[37] Morse's painting had been hidden away since 1834 as part of the collection of George Hyde Clarke (on Otsego Lake, not far from Cooperstown), but its legacy remained as perhaps the most ambitious picture yet attempted by an American—the one that dared to offer a definition of artistic cultivation in the United States. Younger artists such as Weir were bound to know of it, by hearsay or legend at the least.

How he responded to it in *The Gun Foundry* is another question. In the painting's depiction of a large interior space with a very high ceiling, roughly equivalent to the interior of Morse's Salon Carré, there are of course no pictures. But that is just the point. The paintings, being nowhere present, have not exactly gone away; instead, they have been dispersed as the very atmosphere of the foundry, its furnace gloom of lights and darks, what a critic in the *American Art Journal* of May 1866 called "the grand intermingling of fire-light from the molten metal with the light from the roof and the floating fumes of the furnaces . . . amid the fumy obscurity."[38] Without quoting old master paintings, Weir created a visceral effect made with old masterly means.

Think of the relation between *Gallery of the Louvre* and *The Gun Foundry* in another way. The fiery sunsets visible in the paintings within Morse's picture— those of the two Claude Lorrain pictures on either side of the entryway, for example—have in Weir's picture jumped their frames and become instead no longer just art, but the liquid glow of the boiling iron in the cauldron. Likewise, the tenebrous dresses and murky lands of many another old master painting in Morse's picture, those of the Cornelis Huysmans and Salvator Rosa landscapes at upper right, for example, have become the spreading shadow of the foundry's cavernous interior. The viewer is consequently held "spell-bound and breathless," to use the terms of the *American Art Journal* critic, who called the painting the greatest picture on display at the 1866 National Academy of Design exhibition.[39] The point is not that *The Gun Foundry* achieves a power equivalent to that of a great old master painting—I believe it does not— but rather that it makes an impressive attempt to imagine how such a power might be let loose in American art. In Weir's painting, the old masters no longer need sit idle, static, and rather vainglorious on the walls as the objects of a merely respectful attention. Instead, they have become one and the same with the chiaroscuro of American experience that is the artist's subject. This is not a museum without walls but walls without a museum.

To put it this way, however, is to describe Weir's process too mildly. The old masters in his painting

must suffer a flaming death and a pulverizing dissolution in order to be so born again as the stuff of an American scene. No matter how much we might say *The Gun Foundry* resembles the lighting scheme of a Rembrandt—for example, the *Christ Preaching* that Weir had depicted in his father's studio—the point is not that he modeled *The Gun Foundry* on an old master template. He did not make the molten iron into a religious radiance, substituting an industrial epiphany for the glowing body of Jesus. Even though Gouverneur Kemble's own collection of old master paintings might have furnished him with a basis for *The Gun Foundry*,[40] and even though some of his father's prints and copies after seventeenth- and eighteenth-century European paintings might have been sources, Weir aimed for no one-to-one correspondence between those pictures and his. To do so would have left the old masters intact—would have implied that "fire-light" and "fumy obscurity" need be a matter only of switching a biblical or religious subject for a modern industrial one—when the point was to destroy these vaunted painters in order to let them live: to let their light and dark rain down across the whole scene rather than sit discretely enframed. Then the chiaroscuro could powder the atmosphere with the granular dust of these exploded pictures, allowing an ordinary American situation to acquire the emotional majesty of old master paintings even as those paintings themselves would, literally speaking, disappear from the scene. Here are the labors of Hercules portrayed by the light of Hercules's immolation. The hero is destroyed so that his atmosphere lives.[41]

For Weir, this was a matter of invention and hard work. In addition to Parrott, the designer of the cannon, *The Gun Foundry* emphasizes the heroic ingenuity of the laborers in their act of creation. The white-shirted foreman front and center, with his leather apron, expertly handles the guide chain that will help allow the boiling iron to be poured smoothly into the mold. Just to the left of the foreman, another laborer turns a stake in the earth, playing his part in the process. Both these men—perhaps

especially the latter one—evoke the front-and-center figure of Morse bending to the left in *Gallery of the Louvre*. Their relation to Morse is not exact. They correspond to him much as the phrase *Gun Foundry* does to *Gallery of the Louvre*: the matching "ou" and penultimate "r" of *Foundry* and *Louvre*, the matching "G" of the first word *Gun* and *Gallery*. But that relation is tantalizing nonetheless. Whereas Morse in his painting is the calm figure of discernment, commenting on the young woman's copy, the comparable men in *The Gun Foundry* define creation as heroic labor. It is as though Morse would have made a better painting had he chosen to depict his own indefatigable efforts while the cholera epidemic raged through Paris, or if he had chosen to portray the sheer labor required to paint so many copies of the old masters in such a relatively short period of time and in such stressful circumstances—rather than the placid composure concealing all that effort and stress. *The Gun Foundry*, showing intensive labor, may even be said to depict Morse's own hard work—his boiling of the light, his grinding of the shadows—as if it were Weir's respectful wish that, as the older man aged (Morse would die in 1872), his grand efforts to make his most ambitious picture should not be forgotten.

Weir's inventiveness, like Cooper's some forty years before, served an urgent cultural purpose. During the Civil War, what was more needed amid the brutality than the production of old master pathos? Better Rembrandt than the feckless representational bromides and timid allegories meant to address the horror in so many other contemporaneous works, even if those representations did achieve a widespread and superficial praise in that era. Walt Whitman wrote that the war's "interior history will not only never be written, its practicality, minutia of deeds and passions, will never be even suggested," and so much Civil War painting likewise never found that interior history.[42] Yet *The Gun Foundry* sets out on a much more ambitious project, akin to Whitman's poetry: namely, to depict not just the production of artillery for the Union but the making of a language of light and dark capable of

portraying the emotion of the times. Heroically laboring, the men embody Weir's own purpose, "the honest, intelligent industry which the artist has bestowed on his subject," as the *New York Times* put it on May 1, 1866.[43] He took the raw materials of the old masters and manufactured an endless supply of molten pictorial emotion, putting it into streaming production, so that no artist from that time, faced with a death or joy to paint, need ever again be without blasts of radiance and deep darkness to draw upon. The men in Weir's painting work so hard because the times depended on it. *The Gun Foundry* shows the making of chiaroscuro.

It matters that all this happens in a particular place. For an American painting to achieve the depth of an old master picture, it needed to be set in a specific location, *The Gun Foundry* implies. This was perhaps because in ways imprecise and, one feels, impossible to describe either for the artist or for a historian, the places themselves came, as it were, ready-made with a certain amount of this shadowy atmosphere. To match a manner of painting with those places, as Weir did in *The Gun Foundry*, was to combine like with like, spreading the diffused dust of a thousand destroyed old master paintings across a space whose own atmosphere only *seemed* blank beforehand. In fact, these empty places already contained a light and shade that saturates the rare pictures whose chiaroscuro matches their own.

Notes

1 For the story of Amos Humiston, see Mark H. Dunkelman, *Gettysburg's Unknown Soldier: The Life, Death, and Celebrity of Amos Humiston* (Westport, Conn.: Praeger, 1999).

2 See, for example, Bryan Jay Wolf, "All the World's a Code: Art and Ideology in Nineteenth-Century American Painting," *Art Journal* 44 (Winter 1984): 328–37; and Angela Miller, *The Empire of the Eye: Landscape Representation and American Cultural Politics, 1825–1875* (Ithaca, N.Y.: Cornell University Press, 1993).

3 W. H. Auden, "Musée des Beaux Arts," in *The English Auden: Poems, Essays and Dramatic Writings, 1927–1939*, ed. Edward Mendelson (London: Faber and Faber, 1977), 237.

4 Paul J. Staiti, *Samuel F. B. Morse* (Cambridge: Cambridge University Press, 1989), 191.

5 For an eloquent critique of the picture in these terms, see ibid., 205–6.

6 For the identification of Morse and the other figures in the picture, see David Tatham, "Samuel F. B. Morse's *Gallery of the Louvre*: The Figures in the Foreground," *American Art Journal* 13 (Autumn 1981): 38–48.

7 Staiti, *Morse*, 209; for the Jacksonian era, see Christine Stansell and Sean Wilentz, "Cole's America," in *Thomas Cole: Landscape into History* (New Haven: Yale University Press, 1994), 3–21; Paul E. Johnson and Sean Wilentz, *The Kingdom of Matthias* (New York: Oxford University Press, 1994); Sean Wilentz, *Andrew Jackson* (New York: Times Books, 2005); and Sean Wilentz, *The Rise of American Democracy: Jefferson to Lincoln* (New York: W. W. Norton, 2005).

8 For the barge of flour moving down the Erie Canal, see Paul E. Johnson, *A Shopkeeper's Millennium: Society and Revivals in Rochester, New York, 1815–1837* (New York: Hill and Wang, 1978).

9 Staiti, *Morse*, 22.

10 Ibid., 23.

11 Ibid., 199.

12 For Morse's temperament in relation to two other pictures, his *The House of Representatives* (1822–23; fig. 5) and *Landscape Composition: Helicon and Aganippe (Allegorical Landscape of New York University)* (1835–36; fig. 66), see Elisa Tamarkin, *Anglophilia: Deference, Devotion, and Antebellum America* (Chicago: University of Chicago Press, 2008), xv–xxii, 320–22.

13 Ralph Waldo Emerson, "Art," in *Ralph Waldo Emerson: Essays and Lectures* (repr., New York: Library of America, 1983), 433. Published as *Essays: First Series* in 1841.

14 For the identification of this figure as Cooper, see Tatham, "Figures in the Foreground," 40.

15 For Cooper's conservatism, see Staiti, *Morse*, 143–48; and Alan Taylor, *William Cooper's Town: Power and Persuasion on the Frontier of the Early American Republic* (New York: Vintage, 1995).

16 Donald A. Ringe, "Chiaroscuro as an Artistic Device in Cooper's Fiction," *PMLA* 78 (September 1963): 349–57.

17 D. H. Lawrence, *Studies in Classic American Literature* (New York: Viking Press, 1973), 55.

18 Honoré de Balzac, *Knickerbocker Review* 17 (January 1841): 75.

19 Ringe, "Chiaroscuro," 349.

20 James Fenimore Cooper, *The Last of the Mohicans* (1826; repr., New York: Signet, 1962), 56.

21 Ringe, "Chiaroscuro," 350.

22 Tatham, "Figures in the Foreground," 40, 48; and Samuel F. B. Morse, *Lectures on the Affinity of Painting with the Other Fine Arts*, ed. Nicolai Cikovsky, Jr. (Columbia: University of Missouri Press, 1983), 93.

23 Cooper, *The Deerslayer* (Philadelphia: Les and Blanchard, 1841), quoted in Ringe, "Chiaroscuro," 350.

24 Cooper, *Last of the Mohicans*, 57, 60, 55, 56, 60.

25 Ibid., 81, 87.

26 Staiti, *Morse*, 39.

27 Cooper, *Last of the Mohicans*, 81.

28 Ibid., 87.

29 Tatham, "Figures in the Foreground," 44, 44 n.24.

30 Wayne Franklin, *James Fenimore Cooper: The Early Years* (New Haven: Yale University Press, 2007), xx.

31 Daniel Walker Howe, *What Hath God Wrought: The Transformation of America, 1815–1848* (New York: Oxford University Press, 2007), 132.

32 Tatham, "Figures in the Foreground," 40.

33 Franklin, *Cooper*, 434–36.

34 Betsy Fahlman, *John Ferguson Weir: The Labor of Art* (Newark: University of Delaware Press, 1997), 80.

35 Ibid., 49; Staiti, *Morse*, 154, 157; and Fahlman, *Weir*, 17–18.

36 Fahlman, *Weir*, 21.

37 Ibid., 133.

38 "Art Criticism," *American Art Journal* 5 (May 2, 1866): 20.

39 Ibid.

40 William H. Truettner, "Prelude to Expansion: Repainting the Past," in *The West as America: Reinterpreting Images of the Frontier, 1820–1920*, ed. William H. Truettner (Washington, D.C.: Smithsonian Institution Press, 1991), 65.

41 Perhaps only during Weir's first trip to Europe, in December 1868, did he assume a properly respectful relation to the old master paintings he then saw in force for the first time. This would mean that *not* having seen these pictures was an advantage for him when he made *The Gun Foundry*, since he could more imaginatively conceive them as raw material to work with rather than venerable and untouchable masters worthy only of an emulation that was bound to be inadequate. For Weir's European trip, see Fahlman, *Weir*, 111–23.

42 Walt Whitman, *Memoranda during the War*, ed. Peter Coviello (New York: Oxford University Press, 2004), 7.

43 "Fine Arts: Carpenter's First Reading of the Emancipation Proclamation," *New York Times*, May 1, 1866, 5.

Gallery of the Louvre:
Glazing and Problems
of Preservation

LANCE MAYER AND GAY MYERS

SAMUEL F. B. MORSE'S *Gallery of the Louvre* (plate 1) is darker and more yellow than it was when it was new. Such discoloration of nineteenth century paintings is most often caused by a layer of varnish that was originally transparent but has changed color over time, and a conservator can usually thin or remove the discolored varnish to bring a painting closer to its original appearance. *Gallery of the Louvre* is quite a different case, as we discovered when we treated it during 2010–11. Close examination of Morse's painting showed that much of the darkness and yellowing lie not in an overall varnish layer, but in thick glazes that the artist used to model his shadow tones. These glazes are rich in medium and contain a large amount of mastic varnish in addition to oil.[1]

Small tests revealed that there was no difference between the solubility of Morse's glazes and that of the remaining layers of old varnish. In fact, there was abundant evidence that conservators had gotten into trouble when they had tried to clean the painting in the past. Many of the paintings that Morse depicted in the Salon Carré showed, to varying degrees, a spotty, uneven appearance caused by earlier conservators' unsuccessful attempts to thin the varnish. The ready solubility of Morse's paint had also led to localized thinning of the glazes and, in some cases, of the opaque colors as well. Equally disturbing was the fact that some paintings had been cleaned more than others, throwing the relationship between these and neighboring paintings out of balance. In fact, the paintings that looked best were those like Rembrandt's *Head of an Old Man* and *Beggar Boy*

by Bartholomé Estebán Murillo, which had been cleaned very little or not at all. In addition, the glazes that defined the shadows on the painted representations of picture frames had suffered badly in many areas (fig. 92).

It is clear that Morse was employing glazes not simply to imitate the techniques of the old masters whose paintings he was copying; he also used glazes to define the architecture of the walls, floors, and ceilings of the Louvre. One of the most important parts of the painting is the long, central view that leads the eye down the Grande Galerie. This had suffered in several ways. It is more yellow than other areas, and it also had many spots of badly discolored retouching from previous conservation treatments. Areas that had been locally cleaned looked very uneven, and there had been some damage to glazes. The darkened retouching, combined with light-colored areas that looked too clean, made the recession of space work poorly.

One might ask why Morse used glazes that contained so much varnish. He had studied under Washington Allston, who was famous for his experimental glazing techniques, and there is evidence that Morse himself experimented on some occasions with unusual painting materials like milk and beer.[2] Many painters at this time believed that the old masters had added varnish to their paint. Some American artists—Rembrandt Peale was one—actually believed that adding varnish to oil paint would keep it from discoloration and that this was one of the secrets of the old masters.[3]

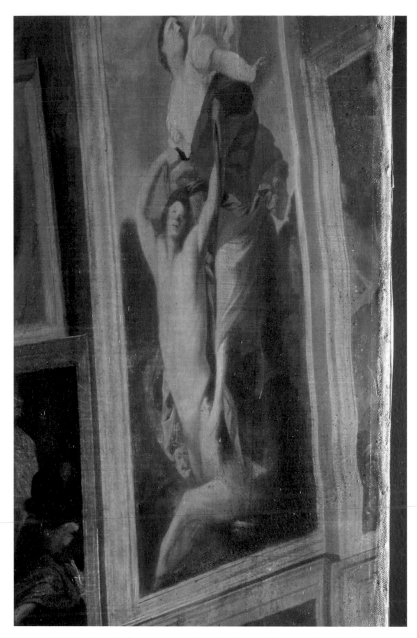

FIG. 92 Detail, plate 1, before treatment, showing abrasion from previous cleaning

FIG. 93 Detail, plate 1, showing damage probably caused by rolling up the canvas while the paint was still wet

Another motive for Morse might have been speed. Paint that has had a great deal of varnish added to it dries much faster than pure oil paint, and artists recognized this; some nineteenth-century painters referred to varnish as a "drier."[4] Thomas Sully once wrote that he added so much varnish that his paint actually dried faster than he wanted it to.[5] Morse was clearly in a hurry while he was painting *Gallery of the Louvre*, fearing that he would not finish before the Louvre closed for its August recess: "From nine o'clock until four daily I paint uninterruptedly."[6] Having done as much as he could in Paris, Morse then shipped his painting back to New York and completed it there. Numerous flake losses, in patterns that look very different from the way flake losses normally occur, seem to have resulted from rolling up the canvas for transport before it was completely dry: it apparently stuck to itself or to a protective sheet (fig. 93). Some of the losses were retouched in a rudimentary way, probably by Morse. Other areas were repainted more completely; for instance, it appears that Morse repainted most of the wall below the lowest row of pictures. He did not match the color exactly (the repainted part is more yellow than the other parts of the wall), and he skipped some spots. He also neglected to paint the

decorative pattern that is so prominent on the rest of the wall (fig. 94).

Our treatment of the painting in 2010–11 was, of necessity, very different from a typical conservation treatment. Further removal of varnish was judged too dangerous. We removed a very thin layer of grime, then applied a thin brush coating of varnish over the existing varnish. This resulted in increased saturation, which allows a viewer to better read the darker parts of the design. The aspect of the treatment that made the greatest improvement in the painting's appearance was the application of many small strokes of inpainting. The goal was to make the different parts of the design relate better to one another and to help make the illusion of space more convincing. Individual paintings that looked brighter than their neighbors because they had been cleaned more were toned back. A great deal of inpainting needed to be done to correct areas that appeared spotty because discolored varnish had been thinned unevenly. Abraded areas, such as the shadows on the picture frames that had been damaged during previous cleaning, were also inpainted.

In the view down the long hallway of the Grande Galerie, many large spots of badly darkened old retouching needed to be inpainted, and areas that had been overcleaned were toned back. Before treatment, it had been difficult to discern the pattern of coffering that defines the geometry of the ceiling, which Morse had painted using thin, reddish lines (fig. 95). As we corrected the darkened retouching and toned the spots that were too light, the coffering gradually reemerged. Inpainting also revealed more clearly the distant human figures in the hallway,

FIG. 94 Detail, plate 1, showing Morse's repainting of the damaged wall without the decorative design

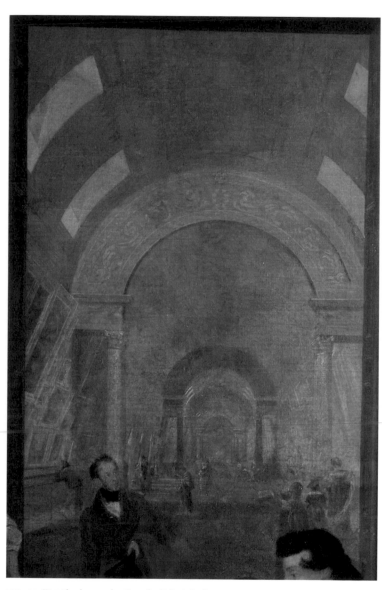

FIG. 95 Detail, plate 1, the Grande Galerie before inpainting

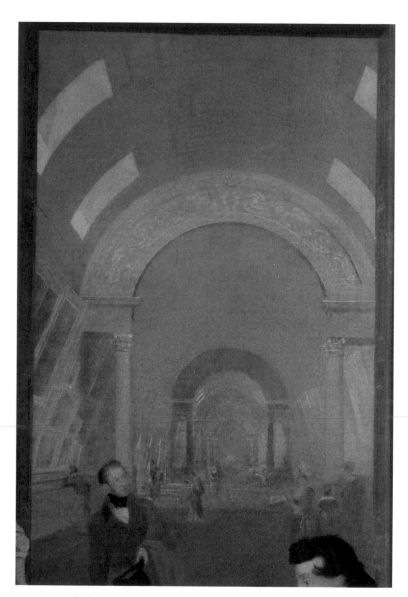

FIG. 96 Detail, plate 1, the Grande Galerie after treatment

and it allows the viewer to see the rows of picture frames more plainly, which also leads the eye back (fig. 96). To a lesser degree, inpainting the many areas of darkened retouching in the floor helps it to recede, in part by reestablishing the pattern of converging lines on the floor that makes the perspective work.

Although the painting is clearly darker than it once was, the taste of the 1830s favored the look of old paintings. Artists recognized that some paintings by Morse's teacher, Washington Allston, appeared old even when they were new.[7] In 1831, at about the time Morse was beginning *Gallery of the Louvre*, Allston instructed Thomas Sully to put a thin toning layer of the brown pigment asphaltum over every painting.[8] Sully said (about an earlier Morse painting, from 1825) that Morse was "too fond of process in his colouring—loading—glazing &c. &c. until the work looks soiled."[9] In Sully's jargon, "process" means preparing underlayers and then glazing as a separate step. The word "soiled" is intriguing, and it implies that at least some of Morse's paintings might have looked a little old and dirty even when new.

In the decades leading up to the middle of the nineteenth century, some American painters were becoming more cautious about glazing and about adding large amounts of medium to their paint.[10] Laughton Osborn's *Handbook of Young Artists and Amateurs in Oilpainting*, first published in 1845, which would become the most popular and most-reprinted nineteenth-century American book on technique, contains a long discussion of glazing. Osborn wrote that glazing was not used nearly so much at that time as it had been in the past, and he gave two reasons for this: glazes will turn brown because of the high proportion of medium they contain, and glazes can be accidentally removed by picture-cleaners.[11] Obviously, both of these concerns are relevant to *Gallery of the Louvre*. Conservators now know that the old masters did not normally add large amounts of varnish to their paint; in fact, the actual sixteenth- and seventeenth-century paintings in the Louvre have

lasted much better than Morse's nineteenth-century copies of them.

The old conservator's adage that "all paintings change" is emphatically true about *Gallery of the Louvre*, although it clearly looks better now than it has for many years. Morse's close connection with Allston, as well as Sully's quotation about Morse's paintings looking "soiled," hints that Morse himself would probably not be *too* unhappy to see that his painting is darker and more yellow than it once was.

Notes

1 For more detail on the treatment, see Lance Mayer and Gay
 Myers, "A Soluble Problem: Morse's *'Gallery of the Louvre,'* Glaz-
 ing, and Toning," *American Institute for Conservation Painting
 Specialty Group Postprints* 24 (2011): 53–60.

2 Lance Mayer and Gay Myers, *American Painters on Technique:
 The Colonial Period to 1860* (Los Angeles: J. Paul Getty Museum,
 2011), 67.

3 Ibid., 135.

4 Thomas Cole and Thomas Sully referred to adding varnish as
 a "drier" in 1837 and 1862, respectively. Ibid., 156.

5 Ibid., 11, 156.

6 Morse to his brother, May 6, 1832, quoted in Samuel Irenaeus
 Prime, *The Life of Samuel F. B. Morse, LL. D., Inventor of the
 Electro-Magnetic Recording Telegraph* (New York: D. Appleton,
 1875), 227.

7 Thomas Cole wrote of Allston that "in some of his pictures he
 imitated the effects of time." Cole Journals, [July–August 1843],
 Thomas Cole Papers, New York State Library, Albany. Allston
 also used a mixture for shadows that he called "Titian's dirt."
 Jared B. Flagg, *The Life and Letters of Washington Allston*
 (New York: Charles Scribner's Sons, 1892), 182–87.

8 Thomas Sully, [June 30, 1831], in "Hints for Pictures," 1809–71,
 2 ms. notebooks, Beinecke Rare Book and Manuscript Library,
 Yale University, New Haven, GEN MSS 196; for a typescript,
 see Archives of American Art (AAA), microfilm roll N18, frame
 128. Thomas Sully, "Memoirs of the Professional Life of Thomas
 Sully Dedicated to His Brother Artists, Philadelphia, November
 1851," Joseph Downs Collection of Manuscripts and Printed
 Ephemera, Winterthur Library, Winterthur, Delaware, 31;
 AAA, microfilm roll 4565; and Mayer and Myers, *American
 Painters*, 78–79.

9 Thomas Sully, [July 21, 1825], in Journal, vol. 1, 1801–37,
 Historical Society of Pennsylvania, Philadelphia; AAA, micro-
 film roll N18, frame 290. Sully did not specify which painting
 by Morse he saw.

10 John G. Chapman, *Chapman's American Drawing-Book, No. IV:
 Sketching from Nature—Painting* (New York: J. S. Redfield, 1857),
 213; and Mayer and Myers, *American Painters*, 104–5.

11 [Laughton Osborn], *Handbook of Young Artists and Amateurs in
 Oilpainting* (New York: Wiley and Putnam, 1845), 137–39, 148.

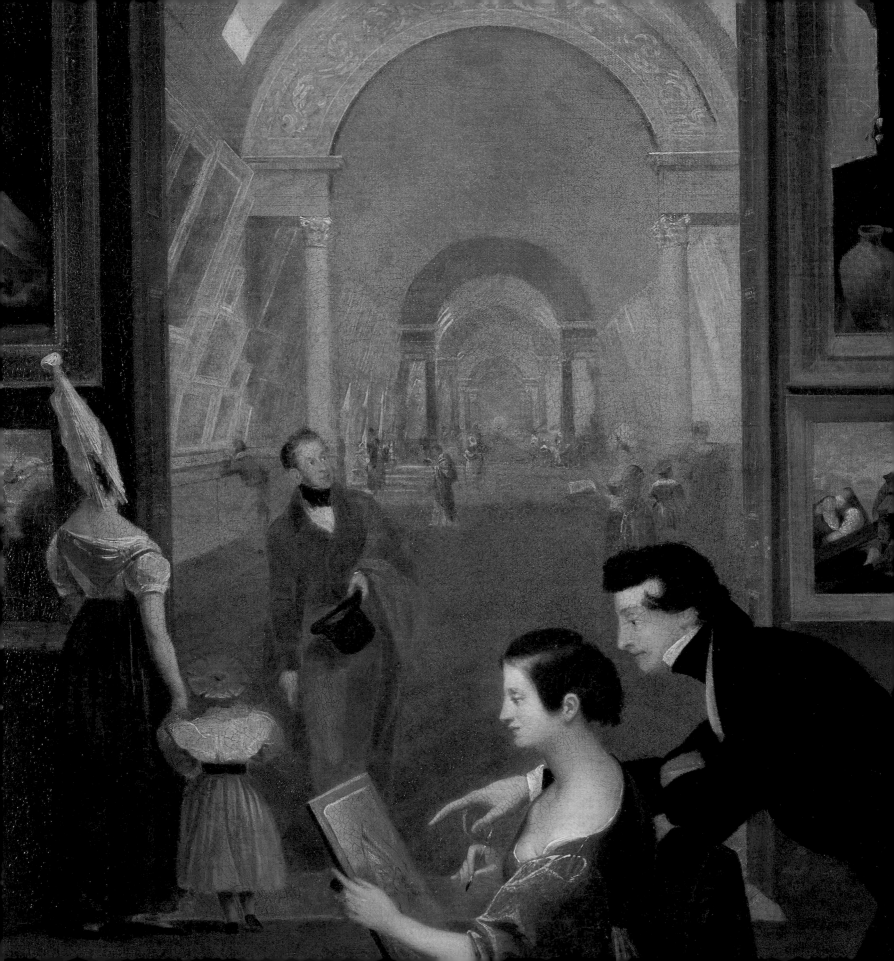

Descriptive Catalogue of the Pictures, 1833

DESCRIPTIVE

CATALOGUE

OF THE

PICTURES,

Thirty-seven in number,

FROM THE MOST CELEBRATED MASTERS,

COPIED INTO THE

GALLERY OF THE LOUVRE.

———

PAINTED IN PARIS, IN 1831–32,

By SAMUEL F. B. MORSE, P. N. A.

———

New-York:

PRINTED BY CLAYTON & VAN NORDEN,
No. 49 William-street.

——

1833.

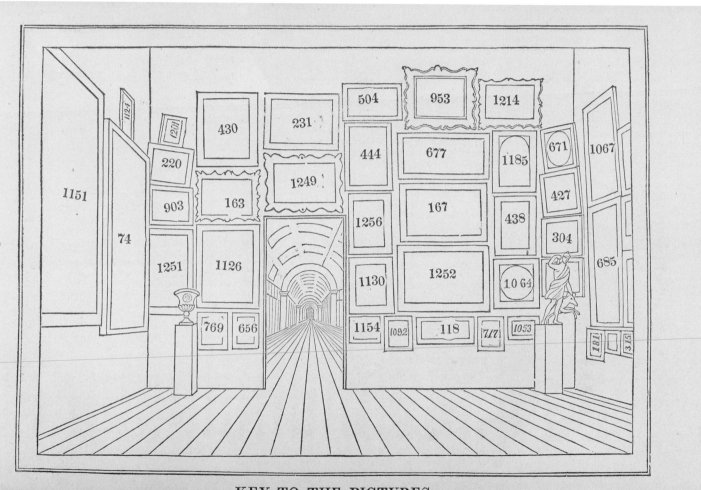

KEY TO THE PICTURES.

GALLERY OF THE LOUVRE.

THE Gallery of the Louvre, in Paris, is the most splendid, as well as the most numerous single collection of works of art, in the world. It contains, at the present time, about *thirteen hundred* pictures, the works of the most celebrated painters of all countries, and of every age since the revival of painting in Italy in the 13th century. The building which contains these treasures of art forms a beautiful front of more than a quarter of a mile in extent, on the northern bank of the Seine. All who are versed in the history of Napoleon, will remember with what superb additions he enriched this collection from the plundered galleries of Italy, Germany, and Holland, and with what bitter regrets the Parisians bemoaned their loss, when the allies compelled them to restore that which was stolen to the lawful owners. This magnificent gallery then appeared completely shorn of its splendour; nor did it seem possible, that its glory could, in any great degree, be recovered. Eighteen years, however, have not passed unemployed by the French government in gradually filling the unoccupied spaces of the gallery walls; and now the number of paintings at least equals, if it does not exceed that of the former collection. I have seen galleries in Italy more select, and of more equal excellence; for example, that of the Pitti Palace in Florence, and those of the Academy of Fine Arts in Bologna and in Venice; but they are smaller, and confined, mainly, to the Italian schools. I have seen none so large, and furnishing so good a specimen of the genius of the various schools of Europe, as the Louvre.

This picture of the Gallery was commenced in the autumn of 1831. It is designed to give, not only a perspective view of the long gallery, which is seen in its whole length

of fourteen hundred feet through the open doors of the great saloon, but accurate copies, also, of some of the choicest pictures of the collection, displayed upon the walls, amounting to thirty-seven in number. Visiters are represented in various parts of the gallery, and artists, male and female, drawing and painting from the various pictures.

The long gallery is divided into nine arched compartments, supported by double pillars, seen successively beyond each other. The pillars are of variegated marbles, supporting the marble entablatures, from which spring the arches. The ceiling is ornamented with Arabesque paintings, and the walls with the pictures of the various schools of European art, arranged according to their schools. The three first compartments are devoted to the French; the three next to the Flemish, Dutch, and German, and the three last to the Italian schools. The floor is of oak, and is kept highly polished. A globe, six or seven feet in diameter, and about ten feet from the floor to the top, is seen, apparently at the end of the gallery, but, in reality, standing at only half the distance. This splendid gallery is by no means uniformly well lighted : those compartments lighted from the ceiling alone show the pictures to advantage, while those having windows at the sides of the room, scarcely allow of a single picture in a favourable light. The painting of this picture has occupied fourteen months of the closest application.

SAMUEL F. B. MORSE.

CATALOGUE

OF

THE PICTURES

COPIED IN THE

PICTURE OF THE GALLERY OF THE LOUVRE.

☞ The Numbers are those of the French Catalogue of the Louvre, and commence on the right of the Picture. The corresponding Numbers are in the diagram.

No. 1067.—GUIDO.—*Dejanira and the Centaur Nessus.*—Hercules returns victorious with Dejanira, whom he had espoused, and intrusts her to Nessus, the centaur, to transport over the river Evenus. The centaur becomes enamoured, and desires to elope with her. But Hercules, from the opposite bank, discharges an arrow at him, which mortally wounds him.

No. 685.—RUBENS.—*Thomyris, Queen of the Massagetæ,* a Scythian nation.—After having vanquished Cyrus, king of the Persians, she caused his head to be cut off, and plunged into a vase of blood, using these insulting words: " Satisfy thyself with that blood, of which thou wast in thy lifetime so thirsty, and of which thou wast insatiable."

No. 315.—WATTEAU.—*Embarcation for the Isle of Cytherea.*—(A small portion only of the picture.)

No. 181.—MIGNARD.—*The Virgin Mary and Infant Christ.*—The Virgin presenting to the infant Jesus a bunch of grapes.

The statue in the corner is that of Diana and the Stag, an antique, which partly conceals a frame of miniatures.

No. 304.—VERNET.—*A Marine View by Moonlight.*—In the foreground, at the right, is seen a fire, round which are assembled men and women; beyond this group, in the mid-

dle distance, is a castellated edifice, and farther in the distance the entrance to the port.

No. 427.—VAN DYKE.—*The Adulterous Woman taken before our Saviour.*

No. 671.—REMBRANDT.—*Head of an Old Man*—nearly bald, with a long beard.

No. 1214.—SALVATOR ROSA.—*Landscape.*—A sportsman shooting a bird is seen in the foreground, and some warriors reposing on the summit of a rock.

No. 1185.—RAFFAELLE.—*The Virgin, Infant Jesus, and St. John,* known by the name of "*La Belle Jardinière,*" the beautiful gardener.

No. 438.—VAN DYKE.—*Portrait of a Man habited in black.*—His right hand is placed upon his side, and his left upon the hilt of his sword.

No. 1064.—GUIDO.—*The Union of Design and Colour.*

No. 1053.—GUIDO.—*The Repose of the Holy Family.*—The infant Jesus is held in the arms of his mother.

No. 717.—RUBENS.—*Portrait of a Female of the Family of Boonen.*—She holds a gold filigree chain.

No. 118.—LE SUEUR.—*Jesus bearing the Cross.*—Simon, the Cyrenean, comes to the succour of Jesus, who has fallen under the weight of the cross. St. Veronica (according to tradition) offers him a napkin, which receives the impression of his face.

No. 1252.—TITIAN.—*Christ borne to the Tomb.*

No. 167.—CLAUDE LORRAIN.—*Sunset. View of a Seaport.*—The quay is adorned with palaces, the sea is covered with ships and gondolas. In the foreground are seen two men fighting, and a military officer drawing his sword to separate them.

No. 677.—RUBENS.—*The Flight of Lot and his Family from Sodom, conducted by Angels.*—Above their heads in the clouds are seen groupes of demons, armed with lightning, entering the city over the walls; one of the demons stops to wreak his vengeance upon Lot's wife, who is turning back.

No. 953.—CORREGIO.—*Mystic Marriage of St. Catherine*

of Alexandria.—Seated upon the knees of the Virgin, Jesus, in presence of St. Sebastian, is represented as giving the nuptial ring to St. Catherine. In the back ground is shown the different deaths of the two martyrs.

No. 504.—HUYSMANS.—*Landscape.*—Among the figures in the foreground are seen men sawing and cutting wood; farther in the distance are perceived a flock of sheep, and a wagon.

No. 444.—VAN DYKE. *Portrait*—full length, of a lady in black, and her daughter.

No. 1256.—TITIAN.—*Portrait of Francis First, King of France.*—His head is covered with a cap ornamented with a white plume, and his hand is placed on the hilt of his sword.

No. 1130.—MURILLO.—*A Beggar Boy.*

No. 1092.—LEONARDO DA VINCI.—*The Portrait of Mona Lisa*—celebrated for her beauty, and the wife of Francesco del Giocondo. He was four years in painting this portrait.

No. 1154.—PAUL VERONESE.—Jesus, conducted towards Golgotha, falls under the weight of the cross.

No. 1249.—TITIAN.—*The two Disciples of Emmaus.*—If tradition is to be believed, the pilgrim on the right of our Saviour represents the Emperor Charles Fifth. The one on the left is Cardinal Ximenes, and the page is Philip Second, who was King of Spain.

No. 231.—N. POUSSIN.—*Landscape, Diogenes casting away his Cup.*—This philosopher, walking in the neighbourhood of Athens, met near a spring a young man, who, to quench his thirst, dipped up the water in the hollow of his hand : " *Thou hast taught me,*" said the Cynic, " *that I yet retain one superfluous article,*" and he threw away his cup from him.

No. 430.—VAN DYKE.—*Venus, accompanied by Cupid, entreats Vulcan for arms for Eneas.*

No. 163.—CLAUDE LORRAIN.—*Sunrise. The landing of Cleopatra.*—This Queen, obliged to give an account of her conduct to Mark Anthony, had embarked at Tarsus on board a magnificent vessel, and presents herself to her judge in the most costly attire.

No. 1126.—MURILLO.—*The Father and Holy Spirit contemplating the Son.*—Standing upon the knees of his mother, the infant Jesus receives a cross of cane offered to him by St. John. St. Elizabeth accompanies her son.

No. 656.—REMBRANDT.—*Tobit and his Family prostrating themselves before the Angel of the Lord.*

No. 769.—TENIERS, *the younger.*—*The Knife Grinder.*

No. 1251.—TITIAN.—*The Crowning with Thorns.*—Christ, with a reed sceptre in his hand, is seated at the gate of the prætorium. A soldier holds his hands bound with a cord. Others mock him, and force the crown of thorns upon his head. The bust of Tiberius Cæsar, placed above the gate, shows that it was under the reign of this emperor that Jesus was crucified.

No. 903.—CARAVAGGIO.—*The Fortune Teller.*

No. 220.—N. POUSSIN.—*Winter, called the Deluge*—A much celebrated picture. The sun is obscured. The lightning flashes from the clouds, the waters cover the buildings, and the ark of Noah and his family floats near the top of the mountains. The inundation forms a sort of cascade among the rocks ; a boat is precipitated down, and is about to be swallowed up with its wretched voyagers. Others are near being drowned with their horses. Reptiles crawl among the rocks to reach their summits. All nature presents the image of universal destruction. A woman in a boat, forgetting her own danger, raises in her arms her child towards her husband, who is upon the rock. The father reaches down to take it, but the distance makes his attempt unavailing.

No. 1201.—TINTORETTO.—*Portrait of himself.*

No. 1124.—MURILLO.—*The Virgin Mary.*

No. 74.—JOUVENET.—*The Descent from the Cross, and the Preparation for the Burial.*

No. 1151.—PAUL VERONESE.—Part of the celebrated Marriage Supper of Cana, seen in perspective.

Timeline

COMPILED BY ALISSA SCHAPIRO

1768

The Royal Academy of Arts is founded in London by King George III.

1769–90

Joshua Reynolds, the Royal Academy's first president, delivers his *Discourses on Art* at the Academy.

1772

Queen Charlotte, wife of King George III, commissions Johann Zoffany's *The Tribuna of the Uffizi*, the most famous British gallery painting.

1775

The Revolutionary War between Great Britain and its American colonies begins.

1776

The Continental Congress in Philadelphia adopts the Declaration of Independence, proclaiming freedom from British rule.

1783

The Treaty of Paris ends the Revolutionary War, recognizing the United States of America as a nation independent from Great Britain.

1784

Jedidiah Morse writes *Geography Made Easy*, the first textbook on the subject to be published in the United States.

1786

Charles Willson Peale opens America's first natural history museum, in Philadelphia.

1789

Jedidiah Morse publishes *The American Geography*, which establishes his preeminence in the field.

George Washington becomes first president of the United States.

The Constitution of the United States goes into effect.

The storming of the Bastille prison in Paris by a mob revolting against the French monarchy is one of several events that incite the French Revolution.

1790

The first federal census records more than 3.9 million inhabitants in the United States.

1791

Samuel Finley Breese Morse is born on April 27 in Charleston, Massachusetts, the eldest child of Reverend Jedidiah Morse, a Congregational minister and geographer, and Elizabeth Ann Finley Breese, granddaughter of a president of the College of New Jersey (later Princeton University).

French inventor Claude Chappe and his brothers develop the first version of the Chappe telegraph system, which becomes the basis for France's nationwide semaphore system of optical telegraphy.

1793

Eli Whitney patents the cotton gin.

The Muséum Central des Arts de la République (later the Musée du Louvre) opens in Paris. Admission is free, with priority given to artists; the general public is admitted only on weekends.

1794

Charles Willson Peale and others in Philadelphia organize the Columbianum Academy, the first artists' society in America.

1795

Jedidiah Morse publishes a children's primer, *The Elements of Geography*.

1796

Hubert Robert paints *Project for the Transformation of the Grande Galerie of the Louvre*, one in a series of paintings depicting the real and imaginary transformation of the Musée du Louvre.

1797

John Adams becomes second president of the United States.

1799

Napoleon Bonaparte stages a coup d'état and rises to power as the First Consul of France, becoming emperor in 1804. During his time in power, he expands the collections of the Musée du Louvre (christened Musée Napoléon in 1803) with art confiscated from aristocrats and the Catholic Church, plus spoils from conquests across Europe.

1801

Thomas Jefferson becomes third president of the United States.

1802

The American Academy of the Fine Arts is founded in New York.

1803

The Louisiana Purchase doubles the size of the United States with land acquired from France and opens the continent for westward expansion.

1803–6

Meriwether Lewis and William Clark, on orders from President Jefferson, explore the newly acquired territory of the Louisiana Purchase, traveling all the way to the West Coast. Native American objects collected by Lewis and Clark are installed in the "Indian Hall" at Jefferson's home, Monticello, in 1806.

1804

Oliver Evans patents a high-pressure steam engine adapted to a variety of uses in ships and factories.

1805

Jedidiah Morse launches the *Panoplist*, a conservative Calvinist periodical.

The Pennsylvania Academy of the Fine Arts is founded in Philadelphia.

1805–10

Samuel F. B. Morse attends Yale College in New Haven, Connecticut.

1807

Robert Fulton's *Clermont*, the first commercially viable steamship, sails from New York City to Albany.

Jedidiah Morse helps found the Andover Theological Seminary to reinforce Calvinist orthodoxy as part of the Protestant evangelical movement known as the Second Great Awakening.

1808–14

Alexander Wilson publishes his nine-volume *American Ornithology*, illustrating 268 species of North American birds, including descriptions of 26 new species.

1809

James Madison becomes fourth president of the United States.

1811

Morse sails to London with Boston artist and fellow Yale graduate Washington Allston. During his four years in England, Morse studies with the American expatriate Benjamin West, president of the Royal Academy, and exhibits *Dying Hercules* at the Royal Academy in 1813.

1812–15

The Anglo-American War of 1812, waged primarily between the United States and Great Britain, confirms American independence.

1815

Morse returns to the United States and opens an art studio in Boston.

Napoleon's defeat in the Battle of Waterloo leads to his imprisonment and exile and to the restoration of Louis XVIII as king of France.

1817

James Monroe becomes fifth president of the United States.

English chemist George Field publishes *Chromatics; or, an Essay on the Analogy and Harmony of Colours.*

1817–18

Morse and his younger brother Sidney attempt to invent a flexible piston-pump.

1818

Morse marries Lucretia Pickering Walker, with whom he later has three children.

Mary Shelley anonymously publishes *Frankenstein* in London.

Aloys Senefelder, inventor of the lithographic printing process, publishes *A Complete Course of Lithography Containing Clear and Explicit Instructions* in German; English and French editions appear the following year.

1818–19

John Trumbull sends his painting *The Declaration of Independence* (1818) on a tour to New York, Boston, Philadelphia, and Baltimore before it is installed in the Capitol Rotunda in Washington, D.C.

1818–21

Morse paints commissioned portraits in Charleston, South Carolina, and other major cities along the Eastern Seaboard.

1819

The Panic of 1819 initiates America's first major financial depression.

1820

Rembrandt Peale's painting *The Court of Death* is seen by over thirty thousand viewers during the first year of a successful tour to eastern and southern cities that continues through 1823.

1820–21

Morse and his former chemistry professor at Yale, Benjamin Silliman, conduct chemical and electrical experiments, including proto-photographic studies.

1821

Morse helps establish the short-lived South Carolina Academy of Fine Arts in Charleston.

Morse arrives in Washington, D.C., where he paints nearly one hundred portraits for *The House of Representatives*.

1822

Charles Willson Peale paints *The Artist in His Museum*.

1823

Morse completes *The House of Representatives* in January; he tours the painting to Boston, Manhattan, and several small cities in the Northeast, all with disappointing results.

Morse designs a machine for fabricating marble copies of sculptures.

President Monroe issues the Monroe Doctrine, warning European countries against further interference or colonization in the Western Hemisphere.

1824

Morse wins a one thousand dollar commission from the City of New York to paint a full-length portrait of the Marquis de Lafayette, a hero of the Revolutionary War.

James Fenimore Cooper organizes the Bread and Cheese Club, a social group of American writers, artists, and intellectuals, including Morse, which meets regularly in New York.

The National Gallery opens in London.

1825

Morse's wife, Lucretia, dies suddenly.

John Quincy Adams becomes sixth president of the United States.

The Erie Canal opens in New York State and connects the western United States with trading centers on the Eastern Seaboard.

English physicist William Sturgeon invents the first electromagnet, a key component in the later creation of the telegraph.

1826

Morse is one of the founders of the National Academy of Design in New York and is elected its first president.

Morse delivers his four *Lectures on the Affinity of Painting with the Other Fine Arts* at the New York Athenaeum.

James Fenimore Cooper publishes his novel *The Last of the Mohicans*.

1827

Morse publishes *Academies of Art: A Discourse*.

Morse attends a series of lectures on electricity and electromagnetism by James Freeman Dana at the New York Athenaeum.

John James Audubon publishes *The Birds of America*, with 435 life-size illustrations.

1829

Morse sails to London in November; he spends nearly three years painting in England, Italy, and France.

Andrew Jackson becomes seventh president of the United States.

1830

Morse visits Paris and the Louvre for the first time.

The July Revolution in France results in the abdication of Charles X and the installation of a constitutional monarchy under Louis-Philippe I.

The federal census documents over 12.8 million inhabitants, including 150,000 immigrants who arrived in the United States during the previous decade.

1831

Morse returns to Paris in September after traveling to several cities in Italy (including Rome, Florence, and Milan). He lodges with American sculptor Horatio Greenough and begins work on *Gallery of the Louvre*. While in Paris, Morse meets Alexander von Humboldt.

English artist John Scarlett Davis paints *The Salon Carré and the Grand Galerie of the Louvre*.

French artist Nicolas Sébastien Maillot paints *View of the Salon Carré of the Louvre in 1831*.

American scientist Joseph Henry experiments with using electromagnets to send electric signals across long distances.

A cholera epidemic strikes London, then moves to Paris the following year, where its death toll reaches 18,000; New York is infected in the summer of 1832.

1832

Morse rooms with American painter Richard West Habersham in Paris.

Morse completes most of his work on *Gallery of the Louvre*, and on October 6 he leaves France on the packet ship *Sully*. Onboard, he conceives of the electromagnetic telegraph through conversations with fellow passenger Charles Thomas Jackson. Morse, the painting, and his sketches for the telegraph arrive in New York, at the Rector Street Wharf, on November 15.

Morse accepts a position as professor of sculpture and painting at the University of the City of New-York (now New York University).

1833

Morse completes *Gallery of the Louvre* in August and exhibits the painting in Manhattan from early October through mid-December.

1834

Morse briefly exhibits *Gallery of the Louvre* in New Haven in the spring before canceling the tour due to lack of public interest. In August, Morse sells *Gallery of the Louvre* and its frame to George Hyde Clarke for thirteen hundred dollars.

Morse turns his studio at New York University into the laboratory where he will develop the telegraph.

1835

Morse publishes *Foreign Conspiracy against the Liberties of the United States* and *Imminent Dangers to the Free Institutions of the United States through Foreign Immigration*.

French historian Alexis de Tocqueville writes *Democracy in America*, a report on American society.

1836

Morse runs unsuccessfully for mayor of New York on a nativist American ticket.

Ralph Waldo Emerson publishes *Nature*, one of the key texts of Transcendentalism, a New England–based literary and philosophical movement.

1837

Morse is passed over by Congress for a commission to paint a mural for the Capitol Rotunda. He abandons art and turns his attention to the telegraph.

Morse partners with fellow professor and scientist Leonard Gale on a telegraph that includes an electrical relay system built with a canvas stretcher; it successfully transmits a message through ten miles of wire in Dr. Gale's classroom.

Martin Van Buren becomes eighth president of the United States.

The Panic of 1837, caused in part by the transfer of federal funds from the Bank of the United States to state banks, causes a major recession that lasts until the mid-1840s.

1838

Morse adopts a system for transmitting telegraph messages by using a numerical code for each letter of the alphabet.

Morse demonstrates his telegraph to President Van Buren and his cabinet, then sails to Europe to secure patents for it.

1838–39

The United States government forcibly relocates the Cherokee from their homelands east of the Mississippi River to a territory in present-day Oklahoma—a deadly march known as the Trail of Tears.

1839

The Académie des Sciences in Paris announces Louis-Jacques-Mandé Daguerre's invention of the daguerreotype photographic process on January 7.

Morse meets with Daguerre in Paris on March 7 and 8 to see some of his plates, making him possibly the first American to view a daguerreotype in person. Morse experiments with making his own daguerreotypes during the fall.

1840

Morse patents his telegraph in the United States.

Morse and scientist John William Draper open a daguerreotype portrait studio on the roof of a building overlooking Washington Square in Manhattan; Morse soon leaves Draper to establish his own studio.

1841

Morse stops making daguerreotypes.

Morse again runs unsuccessfully for mayor of New York.

William Henry Harrison becomes ninth president of the United States.

President Harrison dies suddenly, and Vice President John Tyler becomes tenth president.

P. T. Barnum takes over John Scudder's American Museum in New York.

1842

The Wadsworth Atheneum Museum of Art is founded in Hartford, Connecticut.

1843

Nearly one thousand people from Missouri convene a wagon train, dubbed "The Great Migration of 1843," to journey two thousand miles to Oregon Country.

1844

Morse's first intercity telegraph message—"What hath God wrought?"—is sent between Washington, D.C., and Baltimore.

The American Art-Union—a subscription-based organization for the exhibition of paintings and the distribution of paintings, prints, and medals to its members—is founded in New York.

1845

Morse resigns as president of the National Academy of Design.

James K. Polk becomes eleventh president of the United States.

Alexander von Humboldt publishes the first volume of *Cosmos: A Sketch of a Physical Description of the Universe*, his multivolume treatise on geography and the natural sciences.

John L. O'Sullivan coins the term "Manifest Destiny" in an article advocating the annexation of the Republic of Texas as part of America's divine right to settle the West.

1846

The United States Congress refuses a petition by American artists to award Morse the last available painting commission in the Capitol Rotunda.

Elias Howe invents the sewing machine.

1846–48

The Mexican-American War ends with the Treaty of Guadalupe Hidalgo, giving the United States more than five hundred thousand square miles of Mexican territory, from the Rio Grande to the Pacific Ocean.

1847

Morse buys Locust Grove, an estate on the Hudson River in Poughkeepsie, New York.

Richard M. Hoe patents the cylindrical rotary printing press, which exponentially increases the production and circulation of newspapers and periodicals.

1848

Morse marries Sarah Elizabeth Griswold, with whom he later has six children.

The Seneca Falls Convention assembles in New York to discuss the rights of women in America.

1849

Zachary Taylor becomes twelfth president of the United States.

The California Gold Rush spurs over eighty thousand Americans and immigrants to venture west in search of gold.

1850

President Taylor dies in office, and Vice President Millard Fillmore becomes thirteenth president of the United States.

1853

Franklin Pierce becomes fourteenth president of the United States.

1854

Morse runs unsuccessfully for Congress as a Democrat.

Morse's patent for the telegraph is upheld by the United States Supreme Court.

The British and French governments construct telegraph lines to use during the Crimean War.

1857

James Buchanan becomes fifteenth president of the United States.

1857–58

Morse partners with Cyrus W. Field in an attempt to lay a transatlantic telegraph cable.

1858

Queen Victoria sends the first transatlantic cable message to President Buchanan.

1859

Oliver Wendell Holmes publishes his essay "The Stereoscope and the Stereograph."

1861

Abraham Lincoln becomes sixteenth president of the United States.

1861–65

The American Civil War is waged; both Union and Confederate forces use the telegraph to communicate with troops and political officials.

1863

President Lincoln issues the Emancipation Proclamation on January 1, establishing the freedom of slaves in the ten southern states that had seceded from the Union. In November, Lincoln delivers his Gettysburg Address at the dedication of the Soldiers' National Cemetery in Gettysburg, Pennsylvania.

1865

Morse becomes one of the first trustees of Vassar College, located near his estate in Poughkeepsie, New York.

President Lincoln is assassinated, and Vice President Andrew Johnson becomes seventeenth president of the United States.

The 13th Amendment to the United States Constitution outlaws slavery throughout the country.

1866

Morse sails to France with his family to serve as honorary commissioner to the Universal Exposition of 1867.

1869

Ulysses S. Grant becomes eighteenth president of the United States.

The first transcontinental railroad is completed.

1870

The Metropolitan Museum of Art opens in New York.

1871

Morse transmits an international "farewell" telegraph message from New York around the world.

1872

Morse dies in Manhattan on April 2.

1884

Gallery of the Louvre is loaned to and then purchased by Syracuse University in New York, where it hangs in the studio arts department, fulfilling Morse's desire that the painting serve to instruct American artists.

1982

Chicago businessman and art collector Daniel J. Terra purchases *Gallery of the Louvre* and sends the painting on its first national tour.

Selected Bibliography

ARCHIVAL SOURCES

Samuel F. B. Morse Papers, 1793–1944. Manuscript Division, Library of Congress, Washington, D.C., http://www.loc.gov /collection/samuel-morse-papers/.

Samuel F. B. Morse Papers. Academy Archives, National Academy of Design, New York.

WRITINGS BY MORSE

Morse, Samuel F. B. *Lectures on the Affinity of Painting with the Other Fine Arts*. 1826. Edited by Nicolai Cikovsky, Jr. Columbia: University of Missouri Press, 1983.

———. *Academies of Art: A Discourse*. New York: G. and C. Carvill, 1827.

———. *Descriptive Catalogue of the Pictures, Thirty-seven in Number, from the Most Celebrated Masters, Copied into the Gallery of the Louvre*. New York: Clayton and Van Norden, 1833.

———. *Foreign Conspiracy against the Liberties of the United States: The Numbers of Brutus, Originally Published in the "New-York Observer."* New York: Leavitt, Lord, 1835.

———. *Imminent Dangers to the Free Institutions of the United States through Foreign Immigration*. 1835. Reprint, New York: Arno Press, 1969.

———. Speech to the National Academy of Design. In "Annual Supper of the National Academy of Design." *New-York Commercial Advertiser*, April 27, 1840, 2.

———. *Samuel F. B. Morse: His Letters and Journals*. Edited by Edward Lind Morse. 2 vols. Boston: Houghton Mifflin, 1914.

BOOKS AND ARTICLES

Batchen, Geoffrey. *Burning with Desire: The Conception of Photography*. Cambridge, Mass.: MIT Press, 1997.

Boime, Albert. *The Academy and French Painting in the Nineteenth Century*. New Haven: Yale University Press, 1986.

Coe, Lewis. *The Telegraph: A History of Morse's Invention and Its Predecessors in the United States*. Jefferson, N.C.: McFarland, 1993.

Cooper, James Fenimore. *Correspondence of James Fenimore-Cooper, Edited by His Grandson, James Fenimore Cooper*. 2 vols. New Haven: Yale University Press, 1922.

———. *The Letters and Journals of James Fenimore Cooper*. Edited by James Franklin Beard. 2 vols. Cambridge, Mass.: Belknap Press of Harvard University Press, 1960–68.

Corbett, David Peters, and Sarah Monks. "Anglo-American: Artistic Exchange between Britain and the USA." *Art History* 34 (September 2011): 641.

Cummings, Thomas S. *Historic Annals of the National Academy of Design*. 1865. Reprint, New York: Kennedy Galleries, 1969.

Cuzin, Jean-Pierre, and Marie-Anne Dupuy. *Copier créer: De Turner à Picasso: 300 oeuvres inspirées par les maîtres du Louvre*. Paris: Réunion des Musées Nationaux, 1993.

Cuzin, Jean-Pierre, Jean-René Gaborit, and Alain Pasquier. *D'Après l'antique*. Paris: Réunion des Musées Nationaux, 2000.

Dunlap, William. *History of the Rise and Progress of the Arts of Design in the United States*. 1834. Reprint, edited by Rita Weiss. 2 vols. New York: Dover, 1969.

Duro, Paul. "Copyists in the Louvre in the Middle Decades of the Nineteenth Century." *Gazette des Beaux-Arts* 111 (April 1988): 249–54.

"Gallery of the Louvre." *Commercial Advertiser* (New York), December 16, 1833.

Gilmore, Paul. *Aesthetic Materialism: Electricity and American Romanticism*. Stanford, Calif.: Stanford University Press, 2009.

Gitelman, Lisa. "Modes and Codes: Samuel F. B. Morse and the Question of Electronic Writing." In *This Is Enlightenment*, edited by Clifford Siskin and William Warner, 120–35. Chicago: University of Chicago Press, 2010.

Greenough, Horatio. *Letters of Horatio Greenough to His Brother, Henry Greenough*. Edited by Frances Boott Greenough. Boston: Ticknor, 1887.

———. *Letters of Horatio Greenough, American Sculptor*. Edited by Nathalia Wright. Madison: University of Wisconsin Press, 1972.

Haskell, Francis, and Nicholas Penny. *Taste and the Antique: The Lure of Classical Sculpture, 1500–1900*. New Haven: Yale University Press, 1981.

Hochfelder, David. *The Telegraph in America, 1832–1920*. Baltimore: Johns Hopkins University Press, 2012.

Howe, Daniel Walker. *What Hath God Wrought: The Transformation of America, 1815–1848*. New York: Oxford University Press, 2007.

Johnston, Patricia. "Samuel F. B. Morse's *Gallery of the Louvre*: Social Tensions in an Ideal World." In *Seeing High and Low: Representing Social Conflict in American Visual Culture*, edited by Patricia Johnston, 42–65. Berkeley: University of California Press, 2006.

Kennedy, Elizabeth, and Olivier Meslay, eds. *American Artists and the Louvre*. Chicago: Terra Foundation for American Art; Paris: Musée du Louvre, 2006. Published in French as *Les artistes américains et le Louvre*. Paris: Hazan, 2006.

Kloss, William. *Samuel F. B. Morse*. New York: Harry N. Abrams in association with the National Museum of American Art, Smithsonian Institution, 1988.

Larkin, Oliver W. *Samuel F. B. Morse and American Democratic Art*. Edited by Oscar Handlin. Boston: Little, Brown, 1954.

Mabee, Carleton. *The American Leonardo: A Life of Samuel F. B. Morse*. New York: Alfred A. Knopf, 1943.

McClellan, Andrew. *Inventing the Louvre: Art, Politics, and the Origins of the Modern Museum in Eighteenth-Century Paris*. Cambridge: Cambridge University Press, 1994. Reprint, Berkeley: University of California Press, 1999.

McCullough, David. *The Greater Journey: Americans in Paris*. New York: Simon and Schuster, 2011.

Menke, Richard. *Telegraphic Realism: Victorian Fiction and Other Information Systems*. Stanford: Stanford University Press, 2008.

Morse, Jedidiah. *The American Geography*. 1789. Reprint, New York: Arno Press and the New York Times, 1970.

"Morse's Magnetic Telegraph." *Niles' National Register* (Baltimore), June 22, 1844.

"Mr. Morse's Gallery of the Louvre." *New-York Mirror: A Weekly Gazette of Literature and the Fine Arts* 11 (November 2, 1833): 142.

Prime, Samuel Irenaeus. *The Life of Samuel F. B. Morse, LL. D., Inventor of the Electro-Magnetic Recording Telegraph*. New York: D. Appleton, 1875. Reprint, New York: Arno Press, 1974.

Read, Richard. "The Diastolic Rhythm of the Art Gallery: Originals, Copies and Reversed Paintings." *Australian and New Zealand Journal of Art* 10, no. 1 (2010): 57–77.

Reid, James D. *The Telegraph in America: Its Founders, Promoters, and Noted Men*. New York: Derby Brothers, 1879. Reprint, New York: Arno Press, 1974.

Reynolds, Joshua. *Discourses on Art*. 1769–90. Edited by Pat Rogers. New York: Penguin Books, 1992.

Samuel F. B. Morse, Educator and Champion of the Arts in America. New York: National Academy of Design, 1982.

Schulten, Susan. *Mapping the Nation: History and Cartography in Nineteenth-Century America*. Chicago: University of Chicago Press, 2012.

Shiers, George, ed. *The Electric Telegraph: An Historical Anthology*. New York: Arno Press, 1977.

Silverman, Kenneth. *Lightning Man: The Accursed Life of Samuel F. B. Morse*. New York: Alfred A. Knopf, 2003.

Staiti, Paul J. *Samuel F. B. Morse*. Cambridge: Cambridge University Press, 1989.

Staiti, Paul J., and Gary A. Reynolds. *Samuel F. B. Morse*. New York: Grey Art Gallery and Study Center, New York University, 1982.

Tamarkin, Elisa. *Anglophilia: Deference, Devotion, and Antebellum America*. Chicago: University of Chicago Press, 2008.

Tatham, David. "Samuel F. B. Morse's *Gallery of the Louvre*: The Figures in the Foreground." *American Art Journal* 13 (Autumn 1981): 38–48.

Wright, Nathalia. *Horatio Greenough: The First American Sculptor*. Philadelphia: University of Pennsylvania Press, 1963.

Index

Contributors

PETER JOHN BROWNLEE

Peter John Brownlee is associate curator at the Terra Foundation for American Art in Chicago. He was a member of the curatorial team that organized *Art Across America*, the first major survey exhibition of historical American art ever presented in South Korea (2013). He also recently co-organized the exhibition *Home Front: Daily Life in the Civil War North*, a collaboration with the Newberry Library in Chicago. Brownlee has contributed essays to a number of exhibition catalogues and his articles on nineteenth-century painting and visual culture have appeared in *American Art* and the *Journal of the Early Republic*.

ANDREW MCCLELLAN

Andrew McClellan is professor of art history at Tufts University. He is the author of numerous books and articles on the history of museums and eighteenth-century European art, including *Inventing the Louvre: Art, Politics and the Origins of the Modern Museum in Eighteenth-Century Paris* (1999), *Art and Its Publics* (2003), and *The Art Museum from Boullee to Bilbao* (2008). He is currently co-writing a book-length study entitled *Making Museum Men: Paul J. Sachs and the Museum Course at Harvard*.

CATHERINE ROACH

Catherine Roach is assistant professor of art history at Virginia Commonwealth University. She holds a BA from Yale University and a PhD in Art History from Columbia University. In 2010, she curated *Seeing Double: Portraits, Copies, and Exhibitions in 1820s London* at the Yale Center for British Art. Her scholarship has appeared in the *British Art Journal*, *Visual Culture in Britain*, *Museum History Journal*, and the *Huntington Library Quarterly*.

RACHAEL Z. DELUE

Rachael Z. DeLue is associate professor in the Art & Archaeology Department at Princeton University. She is the author of *George Inness and the Science of Landscape* (2004) and the co-editor, with James Elkins, of *Landscape Theory* (2008). Other recent publications include an essay on art and science in America and an essay on beauty and stereotype in the work of the contemporary artists Kara Walker and Michael Ray Charles. Forthcoming are a study of the twentieth-century American abstract painter Arthur Dove, to be published by the University of Chicago Press, and a series of volumes on concepts in American art for which she serves as editor-in-chief, in collaboration with the Terra Foundation for American Art. Professor DeLue is an affiliated faculty member at the Center for African American Studies at Princeton and an active member of Princeton's American Studies Program. She served as reviews editor for *The Art Bulletin* from 2012 to 2015.

TANYA POHRT

Tanya Pohrt is the Marcia Brady Tucker Curatorial Fellow in the Department of American Paintings and Sculpture at the Yale University Art Gallery. She received her PhD from the University of Delaware in 2013 with a dissertation entitled "Touring Pictures: The Exhibition of American History Paintings in the Early Republic." Her recent publications are "John Trumbull's *Declaration of Independence*" in the *Yale University Art Gallery Bulletin* (2013) and "Rembrandt Peale's 1820–21 Touring Exhibition of *The Court of Death*" in the forthcoming book, *Exhibiting Outside the Academy, Salon, and Biennial, 1775–1999*, edited by Andrew Graciano and published by Ashgate Press.

WENDY BELLION

Wendy Bellion is associate professor at the University of Delaware, where she teaches American art history and serves on the Executive Committee of the Winterthur Program in American Material Culture. She is the author of *Citizen Spectator: Art, Illusion, and Visual Perception in Early National America* (2011) and has lectured and published widely on the art and material culture of the British Atlantic world and early modern Americas. A forthcoming book, *What Statues Remember*, explores the

history of public monuments and iconoclasm in New York City. In 2015, Professor Bellion will be the Terra Foundation for American Art Visiting Professor at the Institut National d'Histoire de l'Art in Paris.

SARAH KATE GILLESPIE

Sarah Kate Gillespie is assistant professor of art history at York College, CUNY, where she teaches American art history and the history of photography. Her book on the intersections of art, science, and technology in the early American daguerreotype is forthcoming from MIT/ Lemelson Center, Smithsonian Press. Her work has been supported by fellowships from the Terra Foundation for American Art, the American Antiquarian Society, the Library Company of Philadelphia, and the Smithsonian Institution.

JEAN-PHILIPPE ANTOINE

Jean-Philippe Antoine is professor of aesthetics and contemporary art theory at Paris 8 University. His research bears on the relationship between images and the social construction of memory. He is also currently preparing a French translation of Samuel F. B. Morse's lectures. His recent publications include the first major monograph in French devoted to Joseph Beuys, *La travérsée du XXe siécle: Joseph Beuys, l'image et le souvenir* (Presses du Réel, Collection MAMCO, 2011); *Marcel Broodthaers: Moule, Muse, Méduse* (Presses du Réel, Dijon, 2006), and *Gerhard Richter: Landscapes* (Zwirner & Wirth, New York, 2004), as well as numerous articles. As an artist, he has shown paintings and installations, and performed lectures and sound works in France, Germany, Sweden, and the United States.

RICHARD READ

Richard Read is Winthrop Professor in art history at the University of Western Australia in Perth where writes he on art, criticism, theory, media, and literature. An expert on the British artist and critic Adrian Stokes, Professor Read published *Art and Its Discontents: the Early Life of*

Adrian Stokes (Pennsylvania State University Press, 2003), which was joint winner of the Art Association of Australia and New Zealand best book prize. His current research includes a book project on "The Reversed Painting in Western Art." Read's article, "The Diastolic Rhythm of the Gallery: Copies, Originals, and Reversed Canvases," was published in the *Australian & New Zealand Journal of Art*. His essay, "The Thin End of the Wedge: Self, Soul and Body in Rembrandt's Kenwood Self Portrait," will appear in *Conjunctions: Body and Mind from Plato to Descartes*, ed. Danijela Kambaskovic-Sawers in 2014. Professor Read has taught on many university residences and lectured internationally.

DAVID BJELAJAC

David Bjelajac is professor of art and American studies at The George Washington University, where he teaches American art as well as eighteenth-century European art. Professor Bjelajac is the author of several books, including *Millennial Desire and the Apocalyptic Vision of Washington Allston* (Smithsonian Institution Press: Washington, D.C., 1988); *Washington Allston, Secret Societies and the Alchemy of Anglo-American Painting* (Cambridge University Press: Cambridge, 1997), and *American Art: A Cultural History* (Prentice Hall, 2000; 2nd edition, 2005). Recent publications include "Mercurial Pigments and the Alchemy of John Singleton Copley's *Watson and the Shark*," in *Artefacts: Studies in the History of Science and Technology*, Vol. 9: *Analyzing Art and Aesthetics*, edited by Anne C. Goodyear and Margaret Weitekamp (Washington, D.C.: Smithsonian Institution Scholarly Press, 2013). Professor Bjelajac's current book project is "John Singleton Copley's Mercurial Leviathan and the American Revolution."

ALEXANDER NEMEROV

Alexander Nemerov is the Carl and Marilynn Thoma Provostial Professor in the Arts and Humanities at Stanford University, where he teaches and writes about American visual culture from the eighteenth to the

mid-twentieth century. His most recent article is "The Madness of Art: Georgia O'Keeffe and Virginia Woolf," *Art History* (2011) and his most recent books are *Wartime Kiss: Visions of the Moment in the 1940s* (2013) and *To Make a World: George Ault and 1940s America* (2011), the catalogue to the exhibition he curated for the Smithsonian American Art Museum. He is also the author of *Acting in the Night:* Macbeth *and the Places of the Civil War*, published in 2010. He is the author of a book on film—*Icons of Grief: Val Lewton's Home Front Pictures* (2005)—and two further books on painting, *The Body of Raphaelle Peale: Still Life and Selfhood, 1812–1824* (2001), and *Frederic Remington and Turn-of-the-Century America* (1995).

LANCE MAYER AND GAY MYERS

Lance Mayer and Gay Myers are independent painting conservators based in New London, Connecticut. In addition to Morse's *Gallery of the Louvre*, they have treated many important American paintings for museums and private collectors, including Rembrandt Peale's *The Court of Death* at the Detroit Institute of Arts, Emanuel Leutze's *Washington Crossing the Delaware* at the Metropolitan Museum of Art, and eleven paintings by Gilbert Stuart for the National Gallery of Art. For many years they have also studied documentary sources that shed light on the history of painting materials. They were recipients of a Winterthur Advanced Fellowship in 1999, in 2003 were Museum Scholars at the Getty Research Institute, and in 2005 received an FAIC/Kress Publication Grant. Their most recent publications include *American Painters on Technique: The Colonial Period to 1860* (Getty Publications, 2011), a chapter on Reginald Marsh's techniques in *Swing Time: Marsh in Thirties New York* (New-York Historical Society and D. Giles Ltd., 2012), and *American Painters on Technique: 1860–1945* (Getty Publications, 2013). In 2013 they were awarded the College Art Association/Heritage Preservation Award for Distinction in Scholarship and Conservation.

Photography Credits

Fig. 1: Courtesy of the Archives of American Art, Smithsonian Institution; figs. 2, 23: © 2014 Museum of Fine Arts, Boston; figs. 3, 25: Wadsworth Atheneum Museum of Art/Art Resource, NY; figs. 4, 31: Courtesy of Pennsylvania Academy of the Fine Arts, Philadelphia; figs. 5, 60: Corcoran Gallery of Art, Washington, D.C., USA/The Bridgeman Art Library; fig. 6: Courtesy of the High Art Museum; figs. 7, 9, 56: Library of Congress; fig. 10: Fenimore Art Museum, Cooperstown, New York (photographer: Richard Walker); figs. 11, 67–70, 72, 89: Terra Foundation for American Art, Chicago; fig. 12: Courtesy of the Saint Louis Art Museum; fig. 13: Division of Rare and Manuscript Collections, Cornell University Library; fig. 14: Courtesy of the Pierpont Morgan Library, New York; fig. 15: © RMN-Grand Palais/Art Resource, NY (photographer: Stéphane Maréchalle); fig. 16: Photo by Time Life, Pictures/Mansell/Time Life Pictures/ Getty Images; figs. 17, 20, 38, 46, 88: © The Metropolitan Museum of Art. Image source: Art Resource, NY; figs. 18, 26, 28, 41, 73–75, 80, 81, 85: © RMN-Grand Palais/Art Resource, NY; fig. 19: This item is reproduced by permission of The Huntington Library, San Marino, California; fig. 22: © National Trust Images/Derrick E. Witty; figs. 24, 32, 37: Courtesy of the Bridgeman Art Library; fig. 27: Courtesy of the Yale Center for British Art; fig. 29: © Crown Copyright: UK Government Art Collection; fig. 30: © RMN-Grand Palais/Art Resource, NY (photographer: C. Jean); figs. 32, 37: Courtesy of the Bridgeman Art Library; fig. 33: Courtesy of the American Philosophical Society; fig. 34: Alinari/Art Resource, NY; fig. 35: Courtesy of the Princeton University Library; figs. 36, 49–51, 59, 65: Courtesy of the National Museum of American History, Smithsonian Institution; figs. 40, 43, 76, 78, 86: © RMN-Grand Palais/Art Resource, NY (photographer: Hervé Lewandowski); fig. 42: © RMN-Grand Palais/Art Resource, NY (photographer: Jean-Gilles Berizzi); fig. 44: V&A Images, London/Art Resource, NY; fig. 45: Courtesy New York Public Library; fig. 47: Smithsonian American Art Museum, Washington, D.C./ Art Resource, NY; fig. 48: National Academy of Design, New York; fig. 52: © 2014 Patricia Leslie; fig. 53: Apic/Getty Images; figs. 54, 84, appendix images: Courtesy of the Yale University Art Gallery; fig. 55: © 2014 The Estate of Marcel Broodthaers/Artists Rights Society (ARS), New York/SABAM, Brussels. Photo: Philippe Migeat © CNAC/MNAM/Dist. RMN-Grand Palais/Art Resource, NY; fig. 57: © Musée des arts et métiers-Cnam, Paris (photographer: S. Pelly); fig. 58: Courtesy of the University of Michigan Library; fig. 61: © RMN-Grand Palais/Art Resource, NY (photographer: Gérard Blot/Hervé Lewandowski); fig. 62: © Thomas Struth; fig. 63: © 2014 Anreas Gursky/Artists Rights Society (ARS), New York/VG Bild-Kunst, Bonn, Courtesy Matthew Marks Gallery, New York, and Monika Sprüth/Philomene Magers, Cologne/Munich. Photo: Tate, London/Art Resource, NY; fig. 64: Courtesy of the Rijksmuseum, Amsterdam; fig. 66: Collection of the New York Historical Society; fig. 71: Courtesy of the Corcoran Gallery of Art; fig. 77: © RMN-Grand Palais/Art Resource, NY (photographer: Michel Urtado); fig. 79: © RMN-Grand Palais/Art Resource, NY (photographer: Daniel Arnaudet); fig. 82: © RMN-Grand Palais/Art Resource, NY (photographer: René-Gabriel Ojéda); fig. 83: Courtesy of the San Diego Museum of Art, www.sdmart.org; fig. 87: Albright-Knox Art Gallery/Art Resource, NY; fig. 90: Courtesy of the Putnam County History Museum; fig. 91: © 2014 Museum Associates/ LACMA. Licensed by Art Resource, NY; figs. 92–96: Terra Foundation for American Art, Conservation Department

This book accompanies the exhibition *Samuel F. B. Morse's "Gallery of the Louvre" and the Art of Invention*, presented at:

The Huntington Library, Art Collections, and Botanical Gardens (San Marino, CA)
January 24, 2015–Monday, May 4, 2015

Amon Carter Museum of American Art (Fort Worth, TX)
May 23, 2015–August 23, 2015

Seattle Art Museum (Seattle, WA)
October 1, 2015–January 10, 2016

Crystal Bridges Museum of American Art (Bentonville, AR)
January 23, 2016–April 18, 2016

Detroit Institute of Arts (Detroit, MI)
June 18, 2016–September 18, 2016

Peabody Essex Museum (Salem, MA)
October 8, 2016–January 8, 2017

Reynolda House Museum of American Art (Winston-Salem, NC)
February 16, 2017–June 4, 2017

New Britain Museum of American Art (New Britain, CT)
June 17, 2017–October 15, 2017

Iris & B. Gerald Cantor Center for Visual Arts at Stanford University (Stanford, CA)
November 15, 2017–March 18, 2018

Published by the Terra Foundation for American Art
© 2014 Terra Foundation for American Art

Terra Foundation for American Art
120 East Erie Street
Chicago, IL 60611
terraamericanart.org

Distributed by Yale University Press, New Haven and London
302 Temple Street
P.O. Box 209040
New Haven, CT 06520-9040
yalebooks.com/art

Library of Congress Cataloging-in-Publication Data

Terra Foundation for American Art.
Samuel F. B. Morse's Gallery of the Louvre and the art of invention / edited by Peter John Brownlee ; with essays by Jean-Philippe Antoine, Wendy Bellion, David Bjelajac, Peter John Brownlee, Rachael Z. DeLue, Sarah Kate Gillespie, Lance Mayer and Gay Myers, Andrew McClellan, Alexander Nemerov, Tanya Pohrt, Richard Read, and Catherine Roach.
 pages cm
 Includes bibliographical references and index.
 ISBN 978-0-300-20761-3 (hardback)
 1. Morse, Samuel Finley Breese, 1791–1872. Gallery of the Louvre.
 2. Morse, Samuel Finley Breese, 1791–1872—Criticism and interpretation. 3. Terra Foundation for American Art. I. Brownlee, Peter John, editor. II. Title.
 ND237.M75A65 2014b
 759.13—dc23
 2014017634

Produced by Marquand Books, Inc., Seattle
marquandbooks.com

Edited by Nancy Grubb and Mariah Keller

Designed by Susan E. Kelly

Typeset in Whitman and Metro Nova by Susan E. Kelly

Proofread by Sharon Vonasch

Index by David Luljak

Color management by iocolor, Seattle

Printed and bound in China by Artron Color Printing Co., Ltd.